drawing blood

Gerald Scarfe

drawing blood

forty-five years of Scarfe UNCENSORED

LITTLE, BROWN

TIME WARNER BOOKS

First published in Great Britain in November 2005 by Time
Warner Books

Copyright © Gerald Scarfe 2005

A CIP catalogue record for this book
is available from the British Library.

ISBN 0 316 72952 3

Typeset in Linotext Didot and Univers Condensed

Printed and bound in China

Design: David Costa and Sian Rance for Wherefore Art?

Time Warner Books
An imprint of
Time Warner Book Group UK
Brettenham House
Lancaster Place
London WC2E 7EN

www.twbg.co.uk

For my children and grandchildren

Katie,

Alexander,

Rory,

Rupert,

Araminta,

Ella,

Iggy

and Abel

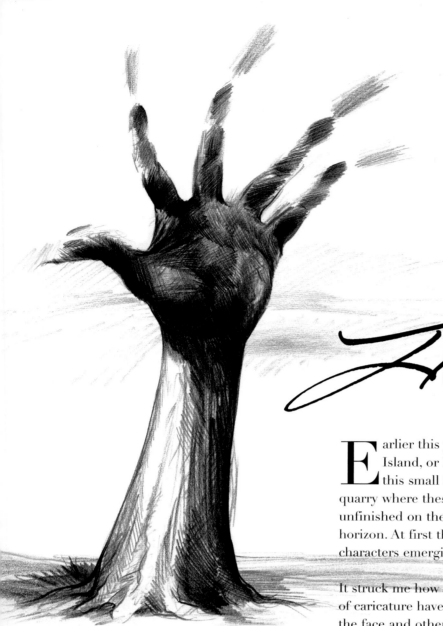

Above: Early drawing for *Pink Floyd The Wall*.
Below: The Drug Addict from *Scarfe's Seven Deadly Sins*.

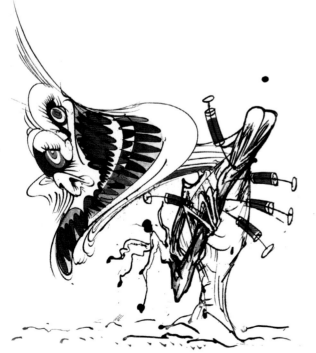

Introduction

Earlier this year, crossing the Pacific, while lecturing on a cruise ship, I visited Easter Island, or Rapa Nui. I'd always been fascinated by the solemn statues that dominate this small island and in the heat of the day, sketchbook in hand, I climbed to the quarry where these famous, mysterious Moai figures were carved. Many were lying unfinished on the hillside; others stood silently alone, gazing out to sea, as if searching the horizon. At first they all looked stylised and alike, but as I sketched I could see real characters emerging from beneath the stylisation, each one a distinctly different personality.

It struck me how caricatured they were and how since the earliest cave paintings elements of caricature have been evident in many areas of art. Caricature is the art of disassembling the face and other physical aspects of a person and rebuilding those elements, often in stylised, exaggerated form, in an attempt to reveal their true character. This technique is used not only in the world of cartoons but also in that of 'fine art'.

Think how Picasso and Bacon brutally tore the face and figure apart and, pushing and pulling, reassembled them. Think also of Goya's 'black paintings', with the caricatured faces in the Witches' Sabbath or of the telling but gentle caricatures of Lautrec's dancers at the Moulin Rouge and, more recently, of Philip Guston's drawings of Richard Nixon. Most paintings are interpretations of their subjects and artists generally deviate from a straightforward, photographic representation. It's the role of an artist to reinterpret the world and to freshen our stale vision, to make us see what we hadn't realised was there and change the way we look at things. It's impossible to say where caricature ends and 'fine art' begins: the borders are blurred. Both Daumier and Hogarth straddled these borders, and the work of Lichtenstein and Robert Crumb, among others, has successfully transferred comic art to the gallery wall.

Young people often ask me how they can become cartoonists: there doesn't seem to be any clear route. There are no schools teaching the art of caricature; there are no apprenticeships. In my case, it just happened – or evolved. They also ask why I draw the way I do: why do I have such a black view of the world, why are the drawings 'grotesque' and my vision so distorted? Of course, I don't know the answers for sure, but in an effort to explain I must look back to my childhood.

I was born in St John's Wood, London, in 1936. My mother was a schoolteacher and my father was in banking. I was an only child until my brother was born seven years later. From the age of one I developed chronic asthma, and for long periods was bedridden, at home

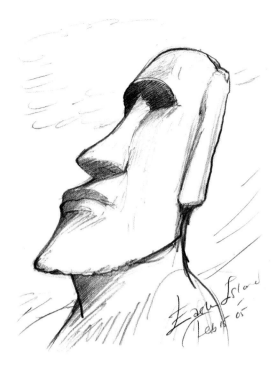

and in hospital. I had few friends, and those I had did not want to visit a sick child. I therefore spent much of my childhood reading, making plasticine models and toy theatres, listening to the radio and, above all, drawing. I think that drawing became my way of communicating; it certainly became my way of exorcising my fears, and from an early age I had many fears and anxieties.

In 1939, when I was three, the war broke out, and my father was enlisted in the RAF. He was posted to various towns around Britain and wherever possible my mother and I followed. We travelled to Shaftesbury, Kidderminster, Penarth and Cardiff. In Cardiff, I started primary school and have memories of my father, in the early morning, taking me on the crossbar of his bicycle down the hills to school. I also have memories of a German plane being shot down and the pilot baling out and eventually landing in some allotments, where he was captured by a band of locals and handed over to the police.

During bombing raids in London, we would go into the cellar beneath our house to shelter. I was petrified of the vicious wolf that I was convinced lived there. Hitler laying waste to London above my head didn't worry me, but the wolf did. I was also scared of having to wear my Mickey Mouse gas mask, so-called because, although otherwise identical to the adult version, two large round ears had been attached to the top in an effort to make it less daunting. It still seemed daunting to me: as an asthmatic, anything restricting my breathing was a nightmare. My memories of this horror resurfaced later in my design for the Frightened Ones in *Pink Floyd The Wall*, and later still in the costumes for the Mice in *The Nutcracker*.

At school in Cardiff I was renowned for being a 'good drawer' and was especially good at drawing the Welsh dragon. My schooling was spasmodic, because it was frequently interrupted by asthma attacks and I spent many weeks in hospital.

After the war we returned to London and although my asthma began to improve, I still missed a great deal of school, but I never gave up drawing. As for art training: when I was fifteen my headmaster suggested that I join an art school there and then, although it was a year before the normal enrolment age. He arranged an interview at a London art school and the principal asked to see my drawings. I hadn't brought any with me. 'Remember,' he said, 'you are an artist. Wherever you go from now on, never go without your portfolio. Maybe you're a bit young anyway.' So the opportunity was lost: by the following year I was already working and thus missed the chance of getting orthodox art-school training.

Top left: Drawing made on Easter Island.
Top right: Volcanoes erupting . . . 'Scarfe, why are you always drawing disasters?' Early drawing from schooldays.
Above: Terrorist Mouse from *The Nutcracker*.
Below: The Frightened One from *Pink Floyd The Wall*.

EAGLE ARTIST'S NIGHTMARE, drawn by GERALD SCARFE (aged 16), 160 Goldhurst Terrace, Hampstead, N.W.6.

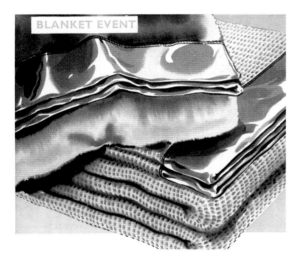

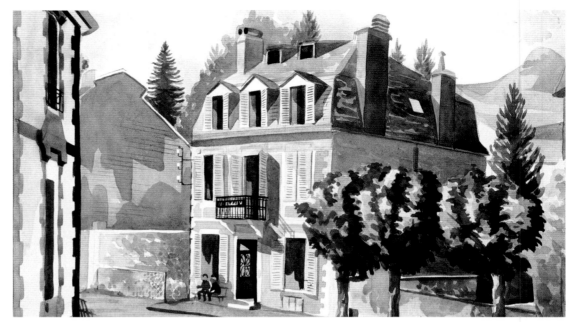

Top left: Eagle Artist's Nightmare – my first printed drawing in the *Eagle* comic.
Top right: The house in La Bourboule, Auvergne, France, where I stayed.
Above: Blanket event – the trick was to make them look soft and seductive when they were actually like bits of thin flannel.
Below: My first drawing on joining the studio. Andy Warhol's Campbell's soup can found fame, while my Robertson's Golden Shred jar fell into obscurity.

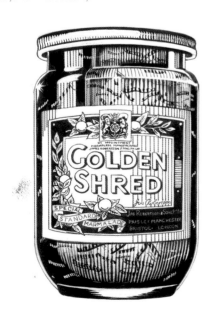

At the age of sixteen I sent a drawing to the *Eagle* comic and had it printed. I liked the feel of this, so I entered a competition in which I had to draw an advertisement for Ingersoll watches. To my astonishment I won first prize. Incidentally, if you look carefully you'll see a well-known consolation prize-winner from Bradford.

Around that time, I was sent to a spa at La Bourboule, in France, for more asthma treatment. I bathed in the water, douched with the water, drank the water – none of which did me a blind bit of good. This drawing is of the house that I stayed in. It's an example of the way I drew at that age – I suppose it's perfectly competent as a representative image, but I was so frustrated with the way that I drew. I seemed to be unable to break away from the conventional. I wanted to be more expressive and to say something more than the obvious.

My parents felt that I would be reliant on them for the rest of my life, so I had to get a job. My father arranged for me to have interviews at various banks, but with my record of absences through asthma and my lack of academic training, I failed them all. I ended up as a graphic designer in a small advertising studio run by an uncle at the Elephant and Castle in London, and spent five or six years there drawing domestic goods for press advertisements and catalogues: furniture, bedding, kitchen appliances. On the positive side it taught me to draw absolutely anything and everything from a bicycle to a banana. My uncle sent me for weekly life drawing classes at St Martin's School of Art, but this was to perfect my knowledge of the human figure so that I could become an illustrator for fashion catalogues – one of the highest paid branches of commercial art.

I was depressed because I felt I was prostituting my art, drawing things in an idealised way in order to sell them. I knew that I was lucky to be an artist and that the least I could do was to tell the truth. I needed to get away from boring commercial art but didn't know how to go about it. I'd always drawn cartoons, and this seemed as though it could be a bridge. I had long admired the drawings of the caricaturist Ronald Searle, who gave us the brilliant illustrations for St Trinian's and Molesworth in the 1950s, and I thought he might be able to help me. I knew where he lived in Bayswater, and many times I plucked up courage and cycled there from Hampstead with the intention of asking him how one became a cartoonist. As I cycled, I composed what I would say, but by the time I reached his door my resolve had evaporated and I stood before the doorbell unable to ring it. I would then despondently cycle round in circles in the road and eventually go home.

Many years later I met Ronald Searle in Paris and told him this story. Last year my wife arranged a surprise birthday lunch with him and his wife Monica at a restaurant in the small village where he lives in the South of France. As we sat down, there, on my place setting, was a beautifully wrapped and beribboned little parcel. When I opened it, I found a block of

marble and, carefully mounted on it, a doorbell. A little note stuck to it read: 'Please Ring Any Time'. It now sits on my drawing table in my studio.

In my twenties I still felt the need for academic training. I went for weekly drawing lessons at the Victoria and Albert Museum with a brilliant art teacher Leslie Richardson. He had a great effect on my work and suggested I apply to the Royal College of Art. I did so and was given a place; but after a few days I decided not to continue. By this time I had experienced the outside world and found it difficult to return to schooling – I think also it was just the acceptance I needed.

I decided to take a chance, leave the graphic studio and go freelance. My uncle fed me small commissions until I found my feet. I took my portfolio round the studios and gradually built up commercial clients of my own, and began to earn good money – but I was still dissatisfied and felt that I was in the wrong place. I started to send cartoons to newspapers and magazines, and they began to accept them. I remember the day when I rushed out to see my first cartoon in *Punch*. I was soon being published in many magazines and papers, and each one earned me seven guineas, so if I sold five in a week I could live very well. *Punch* accepted my drawings and I was soon working for them full time. But I gradually tired of drawing little men on desert islands putting messages into bottles: I still felt I had more to offer. I bought medical books and taught myself anatomy, and the anatomical detail began to feed into my drawings, giving them a grotesque quality. My efforts to draw anatomically led to caricatures that showed the workings of the body – the bones, sinews, muscles, skin, bulging flesh and veins – and sometimes the innards – the intestines, the heart, the lungs.

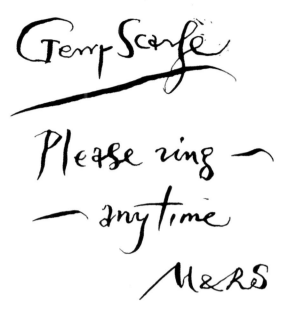

Above: The note from Ronald Searle.
Below: Lady before cosmetic surgery.
Below left: Ingersoll *Eagle* Competition.

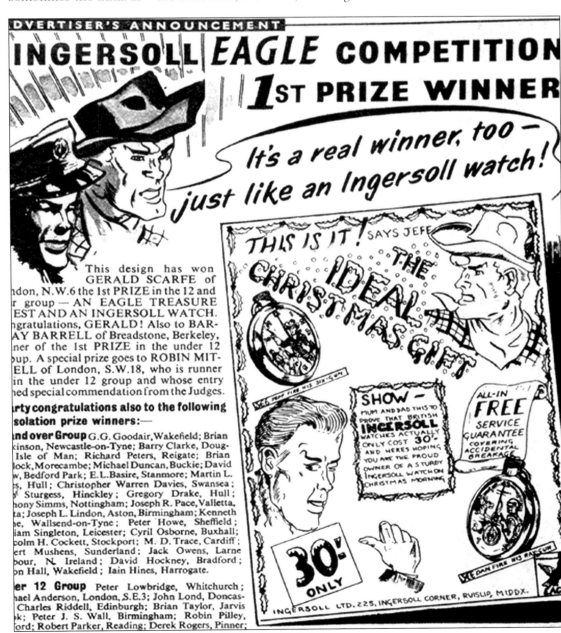

PRIVATE EYE

No 163
Friday
15 March 68 1/6

"Under the spreading Chestnut tree
The villain Smithy stands"

38, BRONDESBURY PARK,
LONDON. NW6 7DN
TEL: 01-459 4433

Feb. 25th

Dear Mr. Scarfe,

 For years your ugly and horrific caricatures
have disturbed me.
 While I appreciate the fact that you
must have talent to arouse one to this extent,
I also object to being subjected to the horrors
of your mind while reading a paper of my choice.

 To-day I can no longer contain myself. I
cannot send you a drawing to upset you. But I can
tell you how sorry I feel for you.

 I can simply tear up the paper. But you
have to live with your warped images for ever.
Poor you.

 Yours Sincerely,

 L.C. Sachs.

Top left: Ian Smith, *Private Eye* cover.
Above: Angry letter. I've always loved the 'yours sincerely'.
Right: Vietnam – the soldier behind me didn't like my drawing in the street and has a gun in my back.
Below: The Chernobyl dog gets out of control.

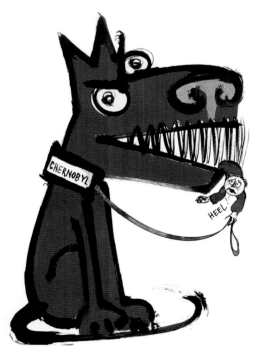

It all came in useful, because it was at about this time that I began to work for the satirical magazine *Private Eye* and I was able to use this style to its full-blooded extent. I felt I could let go and proceed at full rip. I could draw whom I liked and what I liked, warts, nipples, pubic hair and all. I hadn't known I wanted to draw these things but I had a great feeling of childish release when I did, like shouting 'bum' at the vicar's tea party. I have always had an urge to mention the unmentionable, to make jokes about the taboo. Nothing was sacred for me.

The general reaction to my work at that time was that it was cruel and grotesque. I began to receive angry and outraged letters. I was genuinely surprised by this response, since it was the way I drew naturally. I had become well known, not for inventing a cartoon character, like Disney had for Mickey Mouse or Schulz for Charlie Brown, but for a view of life and attitude of mind. I was lucky to have hit a public nerve at the right time.

I had already reported from Berlin for *Esquire* magazine and from Vietnam for the *Daily Mail* and when I joined the *Sunday Times*, the editor, Harold Evans, sent me off to make drawings from various news spots around the world. I took my place alongside the photographers and like the artists of a hundred years ago reported the news in pen and ink. I went down a coalmine in Lancashire, marched with the poor and the oppressed in Nashville, walked alongside the protestors against the Mafia in Sicily, sketched President Lyndon Johnson in Ohio, Robert Kennedy in Los Angeles, de Gaulle in Paris, the boxer Sonny Liston at Buzzards Bay and drew Muhammad Ali in Boston – 'Hush up! Hush up! There's an artist here drawing me.' Then, when he saw my effort, a disgruntled: 'Ah'm prettier than that'.

I realised my strength lay in making a comment and offering an opinion in my work, not just in reporting. Drawing from life helped me to realise a lot more about the art of caricature. Before, I had drawn cartoons from imagination or from photographs; now I began to visit the party political conferences at Brighton and Blackpool and sketched my subjects from life. I would make a series of drawings on the spot, often just a few simple lines which later could bring back the whole scene, just as a few words in a diary can bring back a whole day. It was important to capture the way they moved, sat, talked – everything about them. A caricature is not just a big head, nose or ears: it is the whole persona, boiled down until reduced and concentrated in a summary.

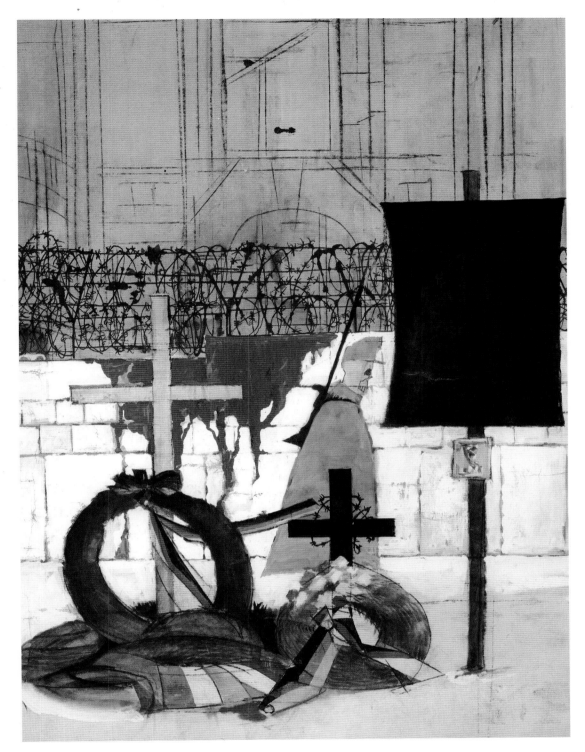

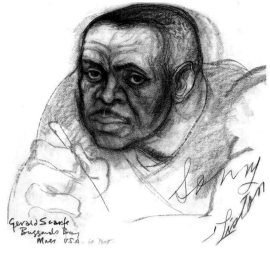

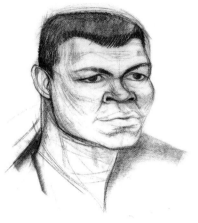

Left: A drawing made for *Esquire* Magazine in Berlin. Peter Fechter, a young student, was shot while escaping over the wall. He fell back onto the Eastern side and although only bleeding from a flesh wound, they left him there to die.
Above: I went to draw Sonny Liston and Muhammad Ali before their fight in Boston. Ali said, 'Hush up, there's an artist here trying to draw me.' But when he saw the results he said, 'Ah'm prettier than that.'
Below: Two drawings made in the Natural History Museum, London.

In the very early days I had felt the need to escape from the limitations of black-and-white pen-and-ink drawing and to find other media for expressing my ideas. As a child I'd always made things – glove puppets, marionettes, models, as well as toy theatres, and all this became writ large when I moved into theatre and film design.

Sculpture was another new challenge. Unlike my drawings, which are organised and presented to confine the viewer to one point of view, sculpture can be seen from every angle. One must retain a likeness and still convince the viewer from all points of the compass. I was no longer restrained by the edges of the paper and my contorted, cramped figures began to grow, bulge and spill from their paper boxes and unfurl their crooked limbs and spew and sprawl across the gallery floor.

When I start to caricature someone, I exaggerate their features or I may imagine them as something else entirely, a wombat or a vacuum cleaner. What I'm trying to do is simply to bring out their essential characteristics. I find a particular delight in taking the caricature as far as I can. It satisfies me to stretch the human frame about and recreate it and yet keep a

likeness. Sometimes there comes a point in that stretching process where, like a piece of stretched chewing gum, it breaks and the likeness is lost. I feel I am tearing the image apart and throwing the torn pieces of flesh randomly into the air and letting them land where they will. The advantage of working on a daily or weekly newspaper is that the readers can be slowly led over a period of time to accept the extremes of caricature. The subject will suggest the way he or she should be depicted. I could always draw Mrs Thatcher as something sharp and cutting – an axe or a knife. Whereas John Major could never be a knife – his character wouldn't allow it. Mrs T could bite his head off; he was always soft, bumbling and grey.

The whole process of drawing can be wonderful – ideas flowing, an urgency and necessity to get them down before they evaporate. When they rush onto the paper there is nothing better. But beware those days when nothing, nothing, nothing will happen. No wonder artists believe in the muse – but she is a bitch.

In general, the people I draw don't react to my drawings. Most of them are figures in public office and perhaps feel it's beneath their dignity to respond. But I think some of them enjoy it, and it's probably better to be portrayed as a dung beetle than not to be mentioned at all. It means they've arrived and are people of 'note'.

My drawings are, of course, made in the solitude of my studio, but when they leave my hands they escape into hundreds of thousands of copies and may be seen by millions of people. I don't think about that when I make the drawing – it's just between my imagination and the piece of paper – but if a drawing is particularly ferocious or overtly sexual and someone looks at it in my presence I have to admit to sometimes feeling shy; it's almost like undressing in public. Once I was about to deliver a lecture in Chelsea, London, and when I peeped out at the audience through the curtains I was appalled to see that it consisted almost entirely of blue-rinsed ladies of a certain age. I was worried about some of the sexual content of my drawings that were about to be projected to these unsuspecting ladies, and I mentioned it to one of the organisers backstage. 'Oh don't worry about them,' she said. 'They've probably seen far more than you have.'

I hope you, dear reader, are as tolerant as they were. I am known mainly as a political cartoonist, but this collection is an effort to show all aspects of my work, from ballet to rock and roll, from politics to opera. I have tried to balance these through the following pages,

Above: Maggie bites off John Major's head.
Below: George Bush senior on a poster for a Dutch exhibition.
Below right: My exhibition at the Grosvenor Gallery. On the left, Charles de Gaulle in the bath. On the right, Richard Nixon with his jowls spilling across the gallery.

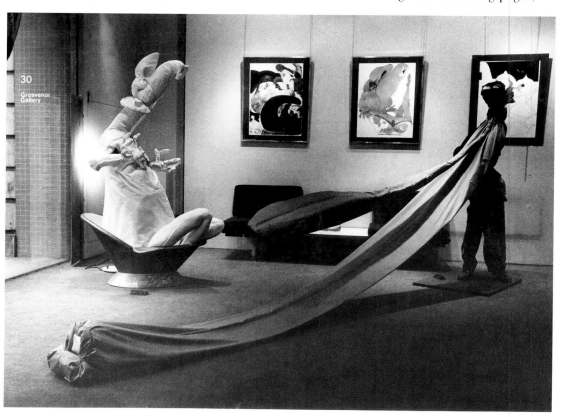

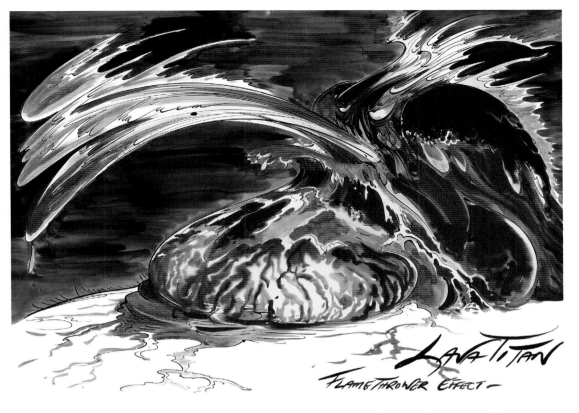

but, inevitably, featuring one means that others have had to take a back seat. As I draw most days, there was a tremendous amount of material – drawings, paintings and sculpture – to choose from, and enough to fill the book many times over, but I feel what I have picked gives a representative cross-section. The book is laid out chronologically, with as many dates included as possible: a few have been impossible to track down, and I apologise in advance for any inaccuracies that may have slipped in.

I am often asked if I think my drawings change anything. I don't believe they do, but on occasion I hope they may crystallise a mood or sum up an attitude. If I have succeeded in demonstrating this – or, even better, in making you laugh – then I can ask for no more.

Gerald Scarfe
September 2005

Top left: The Lava Titan – design for Walt Disney's *Hercules*.
Above: Enoch Powell as a rabid dog for *Private Eye*.
Below: Purple dogs – early drawing for *Pink Floyd*.

1960–62

Punch

To appear in *Punch* at this time was the height of a cartoonist's ambition. The magazine declined during the seventies and eventually met a sad end. The influence of Ronald Searle and André François is clearly seen in the work on these pages.

Above: 'Is this the second syllable they're acting or the whole word?': *Punch*, 19 September 1962.
Below left: I became the new face of *Punch*.
Below right: The Pleasure Seekers, marks the point where, frustrated with 'joke' cartoons, I tried to make observations on society through my work: the father with the son on his shoulders, so he has a better view of the accident; people sunbathing on the beach, shoulder to shoulder; a ridiculous game show etc.

Above: Feeding Time.
Below: The Vigil. I made many double-page spreads with stories and comment for *Punch*.

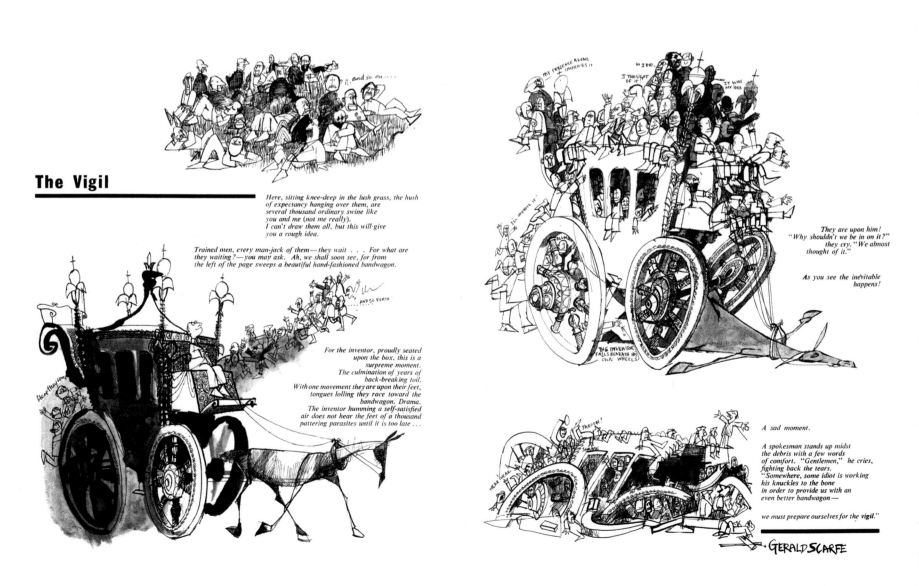

The Vigil

Here, sitting knee-deep in the lush grass, the hush of expectancy hanging over them, are several thousand ordinary swine like you and me (not me really). I can't draw them all, but this will give you a rough idea.

Trained men, every man-jack of them — they wait . . . For what are they waiting? — you may ask. Ah, we shall soon see, for from the left of the page sweeps a beautiful hand-fashioned bandwagon.

For the inventor, proudly seated upon the box, this is a supreme moment. The culmination of years of back-breaking toil. With one movement they are upon their feet, tongues lolling they race toward the bandwagon. Drama. The inventor humming a self-satisfied air does not hear the feet of a thousand pattering parasites until it is too late . . .

They are upon him! "Why shouldn't we be in on it?" they cry. "We almost thought of it."

As you see the inevitable happens!

A sad moment.

A spokesman stands up midst the debris with a few words of comfort. "Gentlemen," he cries, fighting back the tears. "Somewhere, some idiot is working his knuckles to the bone in order to provide us with an even better bandwagon —

we must prepare ourselves for the vigil."

GERALD SCARFE

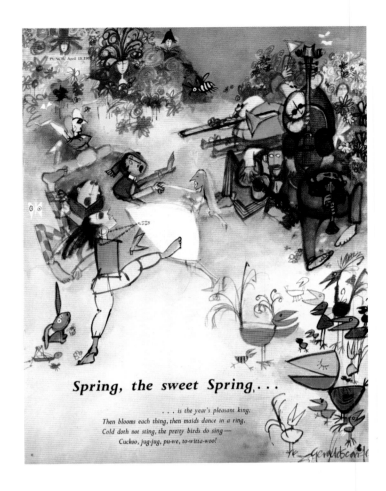

Spring, the sweet Spring...

... is the year's pleasant king,
Then blooms each thing, then maids dance in a ring,
Cold doth not sting, the pretty birds do sing —
Cuckoo, jug-jug, pu-we, to-witta-woo!

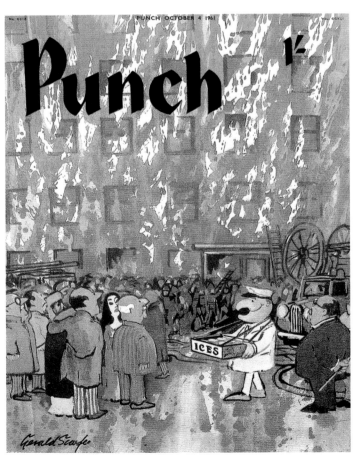

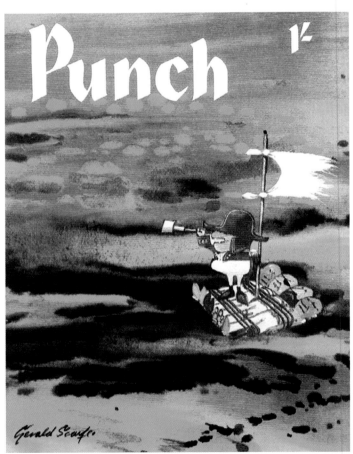

Top left: *Punch* cover, submitted but not accepted.

Top right: Spring, the sweet spring . . . : *Punch* 18 April 1962.

Above left: Punch selling ices at a fire: *Punch* cover, 4 October 1961.

Above right: Captain on a raft of shipmates: *Punch* cover.

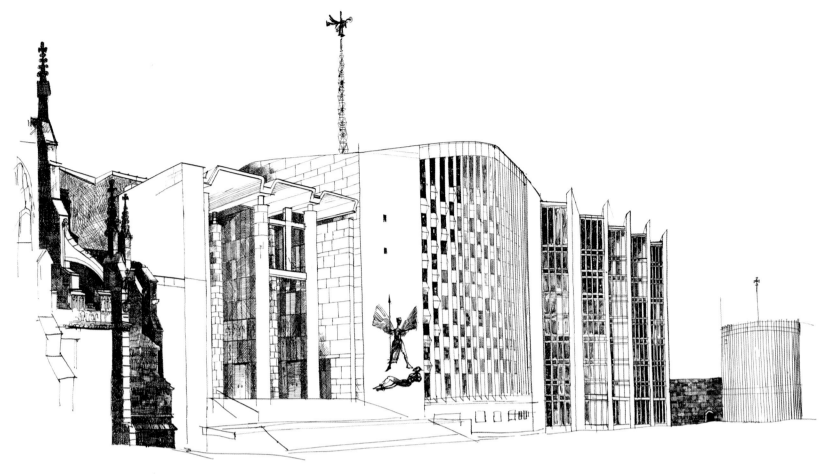

Sent to Coventry

Almost totally destroyed by German bombing during the Second World War, Coventry Cathedral was rebuilt by the architect Basil Spence. It included the work of contemporary artists Graham Sutherland and John Piper among others. *Punch* sent me there on my first reportage commission when it opened. Unfortunately, all the drawings were burnt in a fire at London's Liverpool Street station while on their way back from an exhibition.

Left: The tapestry designed by Graham Sutherland.
Below: The mosaic altar screen by Steven Sykes seen through the wrought-iron crown of thorns by Basil Spence.

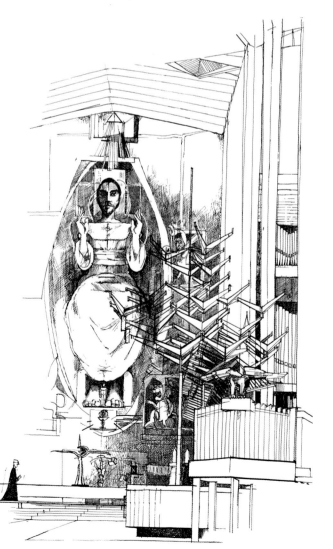

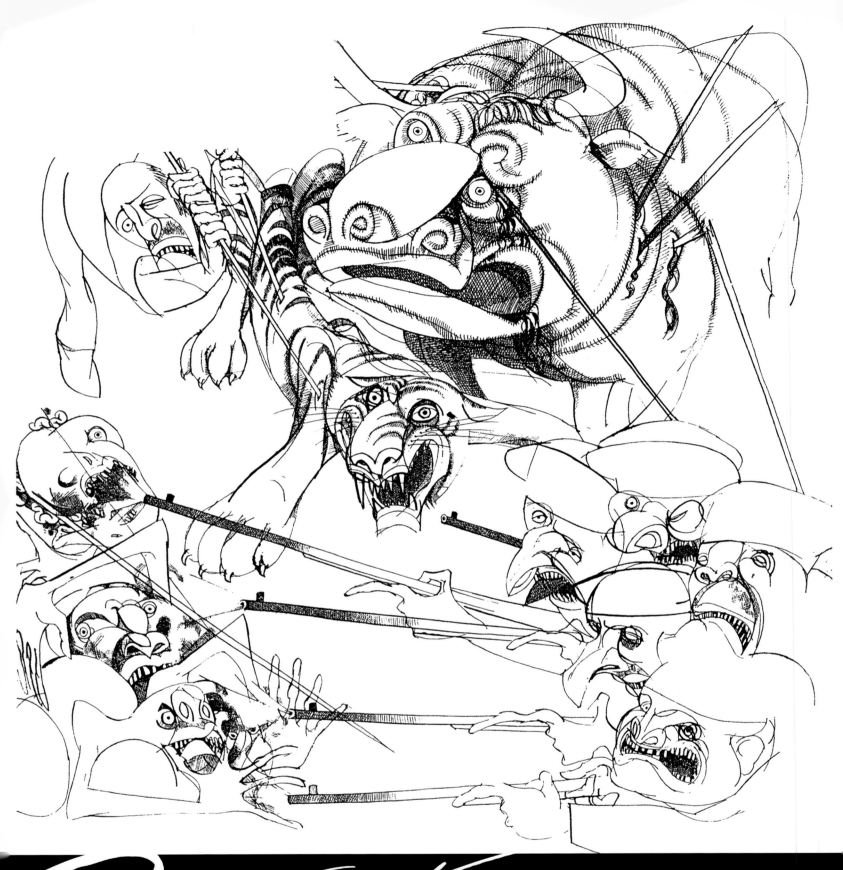

PRIVATE EYE 1963

It was among the sex shops and the strippers of Soho that I found my release. Over a betting shop the magazine *Private Eye* was born. And it was a breath of fresh air for me. They encouraged me to turn my pen towards the art of caricature and I was able to attack politicians and social subjects alike.

Spanish Bullfight with Tiger – drawing made for a Christophe Logue 'True Stories' column in *Private Eye*. Christopher rewrote bizarre stories and the surrealism gave me great freedom.

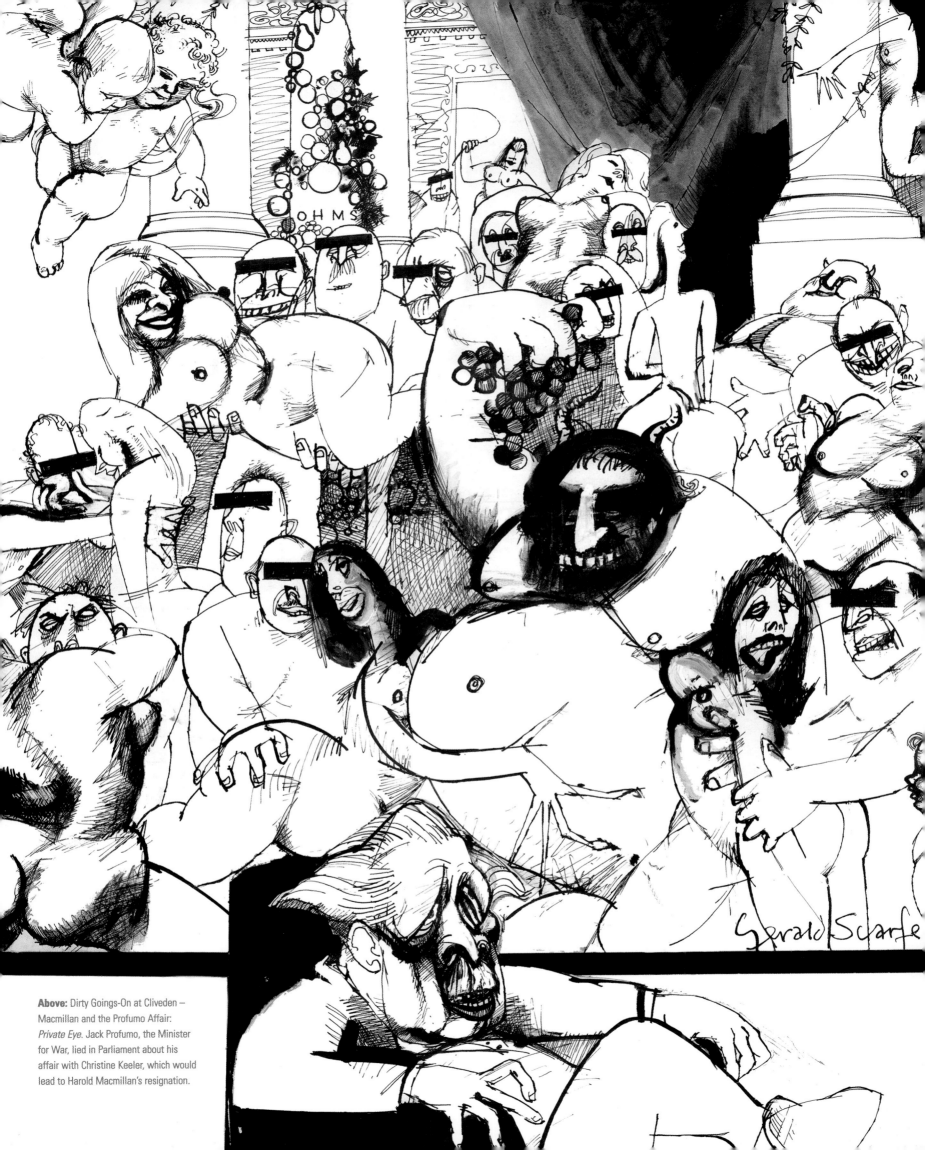

Above: Dirty Goings-On at Cliveden – Macmillan and the Profumo Affair: *Private Eye.* Jack Profumo, the Minister for War, lied in Parliament about his affair with Christine Keeler, which would lead to Harold Macmillan's resignation.

PRIVATE EYE

No 46
Friday
20 Sept. 63

Price 1/-

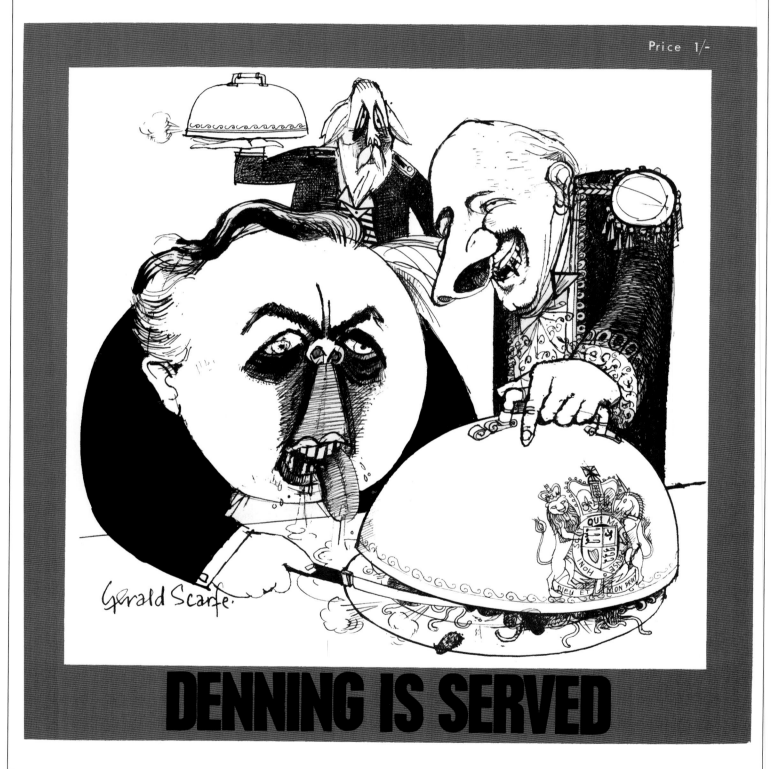

Gerald Scarfe.

DENNING IS SERVED

Lord Denning delivering his report on the case of the headless man. The Duchess of Argyle had been photographed administering oral sex to a headless man (his head had been cropped from a Polaroid photograph). Who was he? And was he a member of the government?

Above: *Private Eye* cover, 20 September: Denning Is Served.

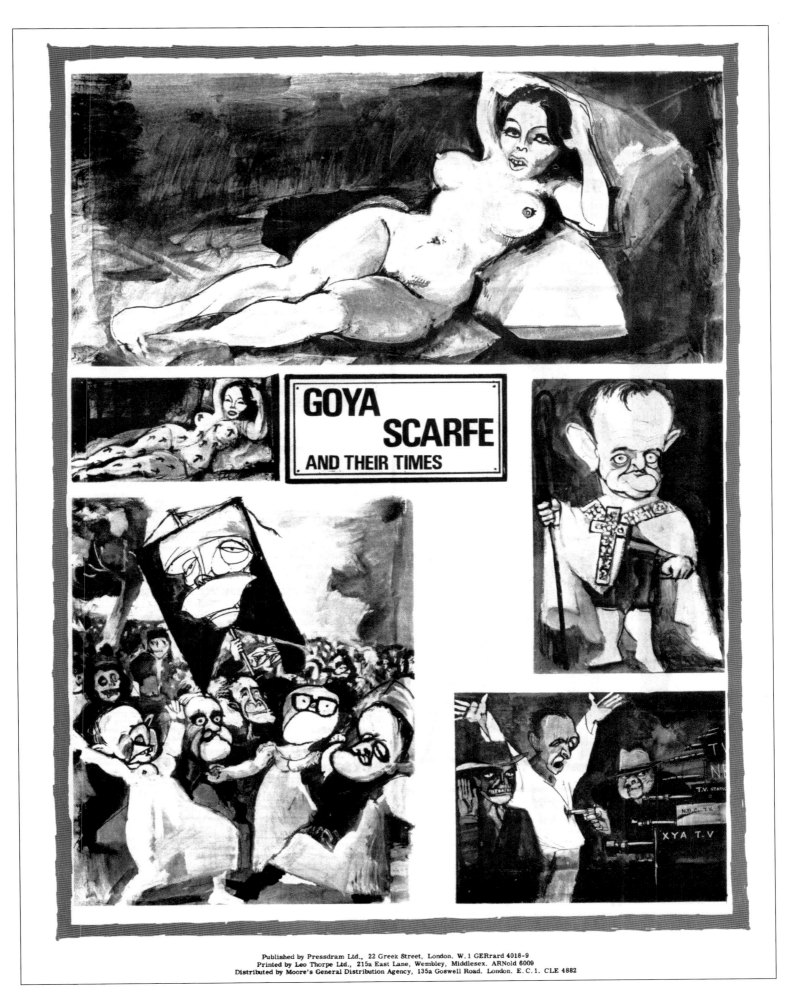

Published by Pressdram Ltd., 22 Greek Street, London. W.1 GERrard 4018-9
Printed by Leo Thorpe Ltd., 215a East Lane, Wembley, Middlesex. ARNold 6009
Distributed by Moore's General Distribution Agency, 135a Goswell Road. London. E.C.1. CLE 4882

Above: Goya Scarfe – Christine Keeler, Lord Hailsham, Lord Home, Selwyn Lloyd, Duncan Sandys, Reginald Maudling, Rab Butler, Lee Harvey Oswald, Jack Ruby: *Private Eye*, 27 December.

NO
HOME RULE
PROTEST VOTE RUSHTON

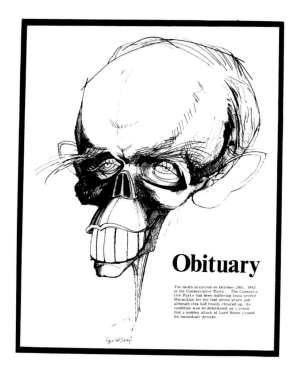

Obituary

The death occurred on October 18th, 1963 of the Conservative Party. The Conservative Party had been suffering from severe Macmillan for the last seven years and although this had finally cleared up, its condition was so debilitated as a result that a sudden attack of Lord Home caused its immediate demise.

The death occurred on October 18th, 1963 of the Conservative Party. The Conservative Party had been suffering from severe Macmillan for the last seven years and although this had finally cleared up, its condition was so debilitated as a result that a sudden attack of Lord Home caused its immediate demise.

PRIVATE EYE

No 44
Friday
23 August 63

Price 1/-

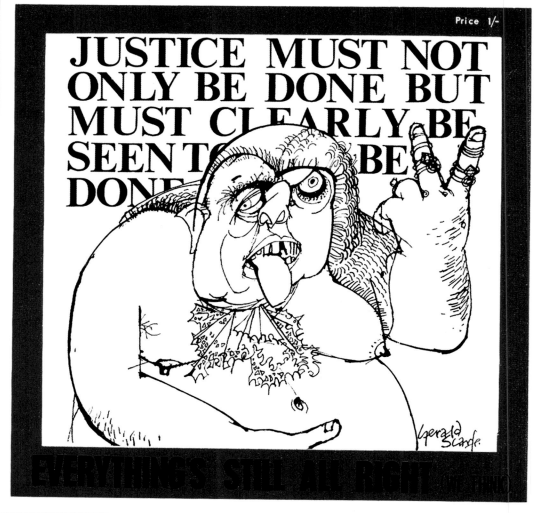

JUSTICE MUST NOT ONLY BE DONE BUT MUST CLEARLY BE SEEN TO BE DONE

EVERYTHING'S STILL ALL RIGHT (WE THINK)

Top left: Puppet Home: another Kinross election poster.
Above: Justice Must Not Only Be Done But Must Clearly Be Seen To Be Done: *Private Eye*, 23 August.

William Rushton stood as a protest candidate against Lord Home in Kinross, where this drawing was used as an election poster. I travelled up to Kinross and West Perthshire with Rushton, Richard Ingrams, Paul Foot and John Wells, and stayed at the home of the publisher John Calder for a spot of electioneering.

Above: Death of the Conservative Party – Alec Douglas-Home obituary: *Private Eye*, 18 October.

DEATH TO THE TORIES
PROTEST VOTE RUSHTON

Alec Douglas-Home had a habit of making naive remarks. Here he is among the gillies in Scotland. *Private Eye* portrayed Lord Home as a throwback to a feudal Conservative past and completely out of touch with the man in the street.

Right: *Private Eye*.

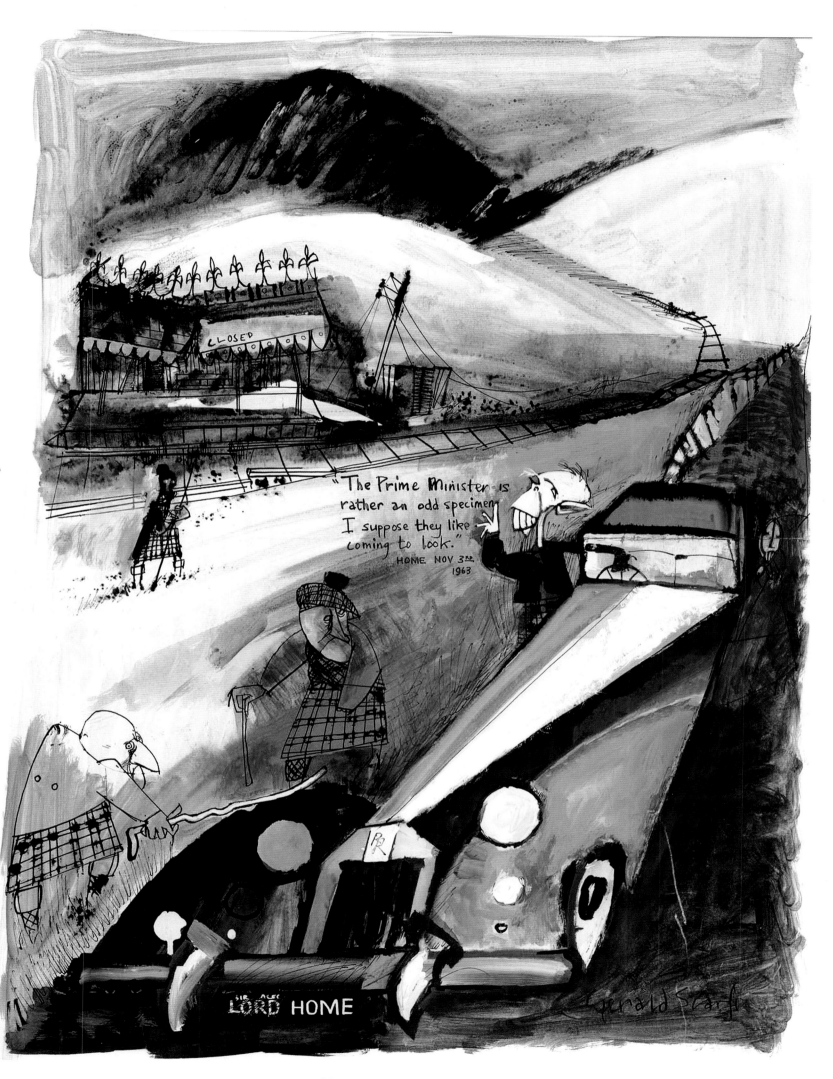

"The Prime Minister is rather an odd specimen. I suppose they like coming to look."

HOME NOV 3RD 1963

CLOSED

LORD HOME

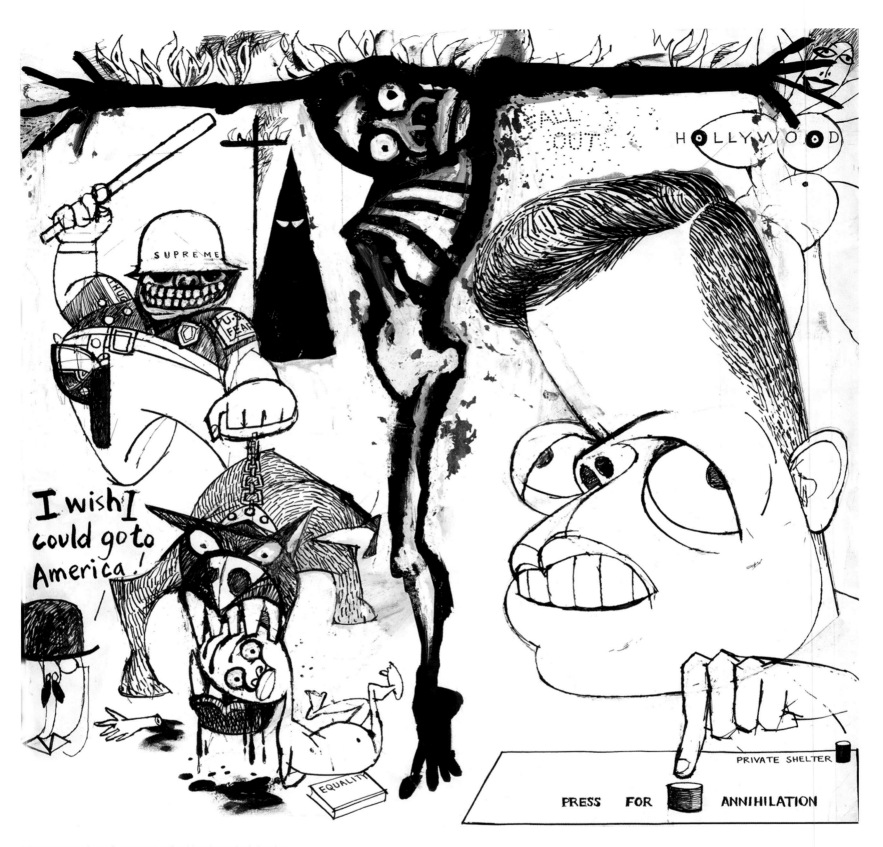

Above: I Wish I Could Go to America: President Kennedy. A drawing made for *Esquire* magazine. Kennedy was assassinated that year.

The respected art critic John Berger resigned from the *Observer* when the paper refused to print this drawing. He said it was the last straw.

Right: Male and Female.

Rumour has it that the 'satirical' movement is now over . . . if it stops, it will stop because a number of bright young men have arrived at their destination . . . But Scarfe will probably remain a satirist, will probably continue to bite the hand that offers to feed him . . . I do not know him personally, but his drawings suggest that he is that very rare thing – a natural satirical draughtsman. Gillray was one, Rowlandson wasn't. George Cross was one, but Low isn't. The supreme examples are Goya and Daumier. Such artists are not illustrators of ideas, however brilliant. They are only occasionally witty. What is essential to them is that they draw faithfully – and with pain – the ghosts that crowd in upon them. There is nothing improvised about their work, and the stylisation of the drawing is never self-conscious because they draw what they see.

The ghosts have real faces and sharp social, contemporary relevance. They are the ghosts of the unhappy possibilities of their time . . . They are conjured up by the artist's comparative innocence, by the contrast between his own expectations and reality as it confronts him. The resulting shock makes him visualise the extreme to which the present reality might be pushed. And he draws this extreme in an attempt to exorcise it . . .

Gerald Scarfe is 27 years old. It is very early to be certain, but I repeat that he seems to me to belong to the proper and rare tradition. Certainly I can think of no other draughtsman in Britain who, since the war, has shown more promise in this genre. Scarfe draws as though the scene were there in front of him as unambiguously as a

still life. He accepts unexpected angles, awkward foreshortenings – because that is how it is. And he draws, he composes. The composition gives to the finished drawing a unity which makes it a testimony instead of just a sketch for an idea or fantasy . . .

The most authentic thing about Scarfe is that his drawings suggest that he would like to be drawing something quite different. This reluctance is in marked contrast to the chop-smacking delight of some of his 'satirical' colleagues. But enthusiastic satirists are nearly always opportunists. And it is Scarfe's reluctance that will, I think, safeguard his integrity and make him dangerous.

THE RELUCTANT SATIRIST – JOHN BERGER, JANUARY 1964.

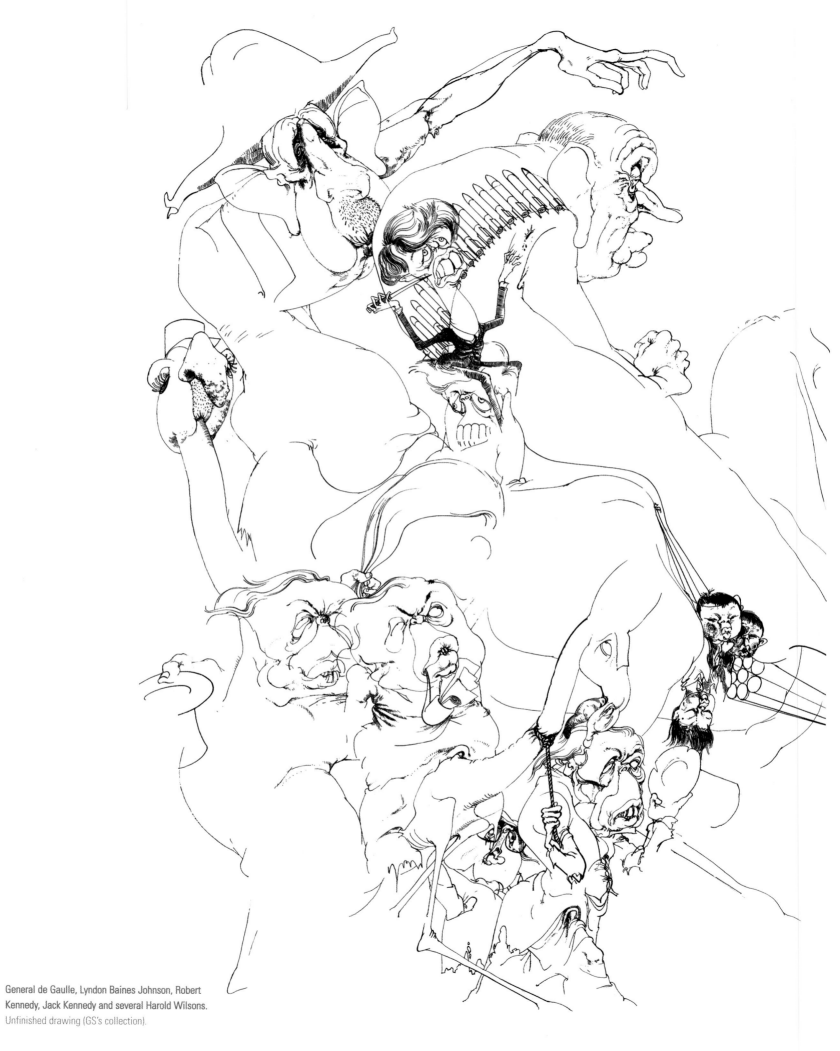

General de Gaulle, Lyndon Baines Johnson, Robert
Kennedy, Jack Kennedy and several Harold Wilsons.
Unfinished drawing (GS's collection).

TW3 was a hugely successful satirical TV programme that poked fun at politicians and celebrities. Shown here are Roy Kinnear, Lance Percival, Bernard Levin, William Rushton, Millicent Martin and David Frost.

Above: *That Was The Week That Was: Punch.*

Above: Trussed-Up Lady.

Peter Cook, who co-owned the Soho club, asked me to make this drawing. He found it ironic that the American comedian Lenny Bruce was banned from the Establishment for being obscene (he had appeared there in 1962, but wasn't allowed into Britain in 1963), while the Establishment itself was surrounded by sex shops, strip clubs and prostitutes.

Below: Establishment Club: *Private Eye*, 19 April.

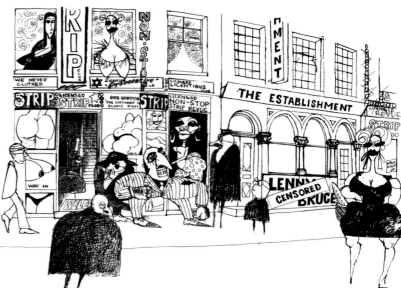

Nashville Tennessee

AMERICA 1964

My first visit to the States: throughout the dull 50s it seemed to me as if everything that was exciting and glamorous was in America – movies, Cadillacs and Elvis Presley. A great friend left with his family to live over there, and every so often he would send me bundles of American comics, which I'm sure influenced my later work.

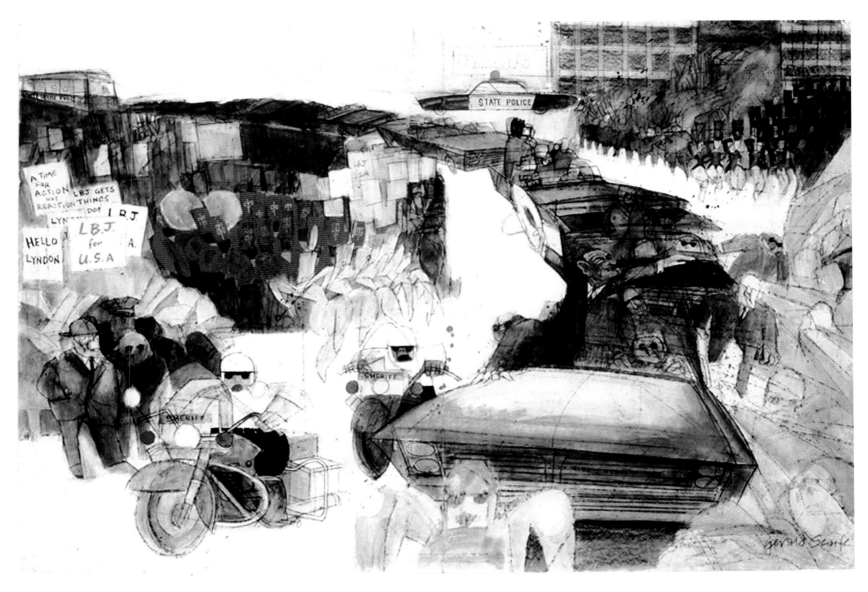

Reportage drawings of my trip to America to cover LBJ's electioneering campaign: I followed him from Illinois to Ohio, and in Indiana found myself in the thick of the impossible, exciting hurly-burly of an American whistle-stop campaign. The further south we went, the deeper the President's drawl became. I drew him while he drawled.

The President's jet climbs, at an impossibly steep angle, into the sky, engines screaming, silencers removed for extra power. Typewriters and briefcases bounce down the gangway. The jet levels out and dives to the next town: Indianapolis. It disgorges President, aides, reporters, et al. Motorcade to town, same speech but different place name, back in cars, airfield, take-off, climb, dive: Cleveland. Motorcade, same speech but different place name, back in cars, airfield, take-off, climb, dive: Louisville. I can be seen leaving the jet with his portfolio.

When I approached Johnson at a press conference with my very large rolled-up drawing in hand, he reeled back, and I was manhandled away by his minders, who were worried that I might assassinate him with the cartoon. He later signed it.

Opposite: LBJ's electioneering campaign – scene at the airport:
Sunday Times colour magazine, 1 November.
This page:
Top: LBJ cavalcade: Cleveland, Ohio – *Sunday Times* colour magazine, 1 November.
Right: Signed portrait of LBJ: *Sunday Times* colour magazine, 1 November.

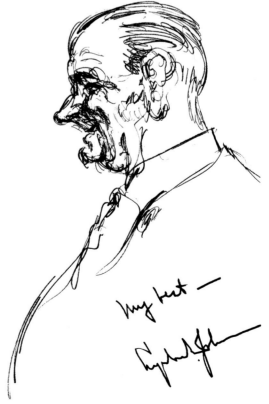

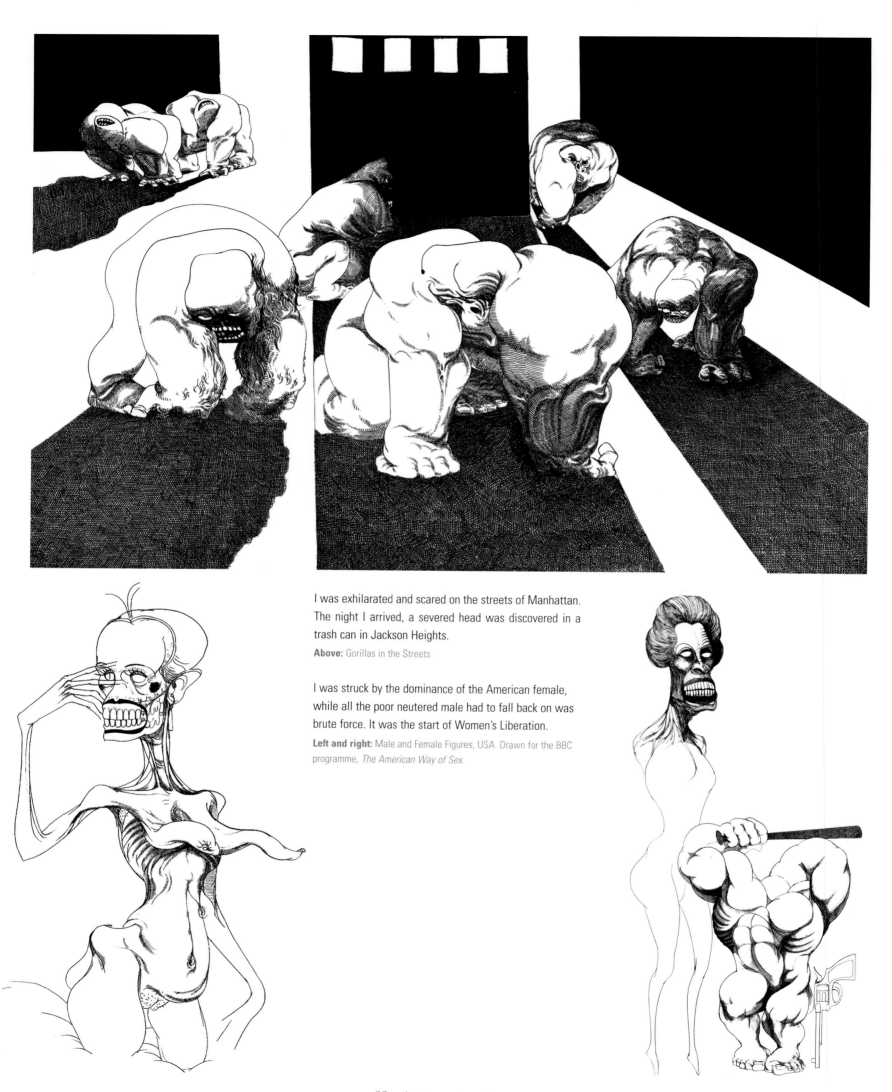

I was exhilarated and scared on the streets of Manhattan. The night I arrived, a severed head was discovered in a trash can in Jackson Heights.

Above: Gorillas in the Streets

I was struck by the dominance of the American female, while all the poor neutered male had to fall back on was brute force. It was the start of Women's Liberation.

Left and right: Male and Female Figures, USA. Drawn for the BBC programme, *The American Way of Sex*.

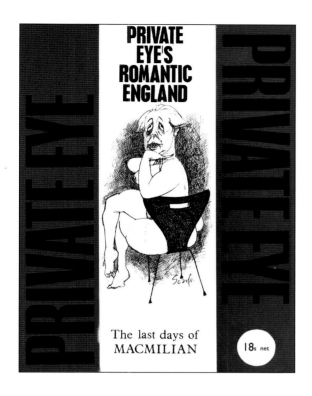

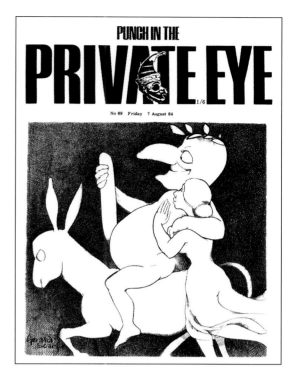

An annual produced in good time for the Christmas trade, *Romantic England*, published by *Private Eye* at 18s., was banned by the four biggest book wholesalers—W. H. Smith's, Wyman's, Boots' and Menzies. These firms objected to a cover used some time ago in the paper and showing a drawing of Mr. Macmillan as Christine Keeler.

The publishers, Weidenfeld & Nicolson, said that they had received a letter from W. H. Smith's telling them of the ban and the other wholesalers also made it clear that they would not handle the annual. More than 10,000 copies were printed: they were already on sale through independent shops.

It is extraordinary to think now that this rather innocuous drawing of Harold Macmillan in the famous Christine Keeler pose was thought so shocking that WHSmith banned it.

Top left: *Private Eye Annual* cover.
Top centre: Cutting – banning of *Private Eye Annual*.

Above: *Private Eye* cover, 7 August: Punch in the Eye. *Private Eye* adopted *Punch*'s symbol when the latter dropped it.
Below: Sex USA: I was commissioned by a television producer to draw my take on the American way of sex.

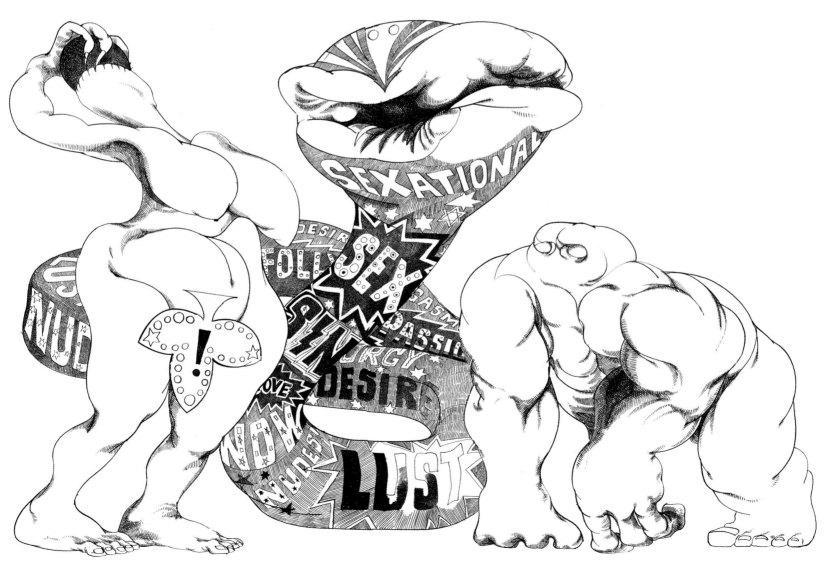

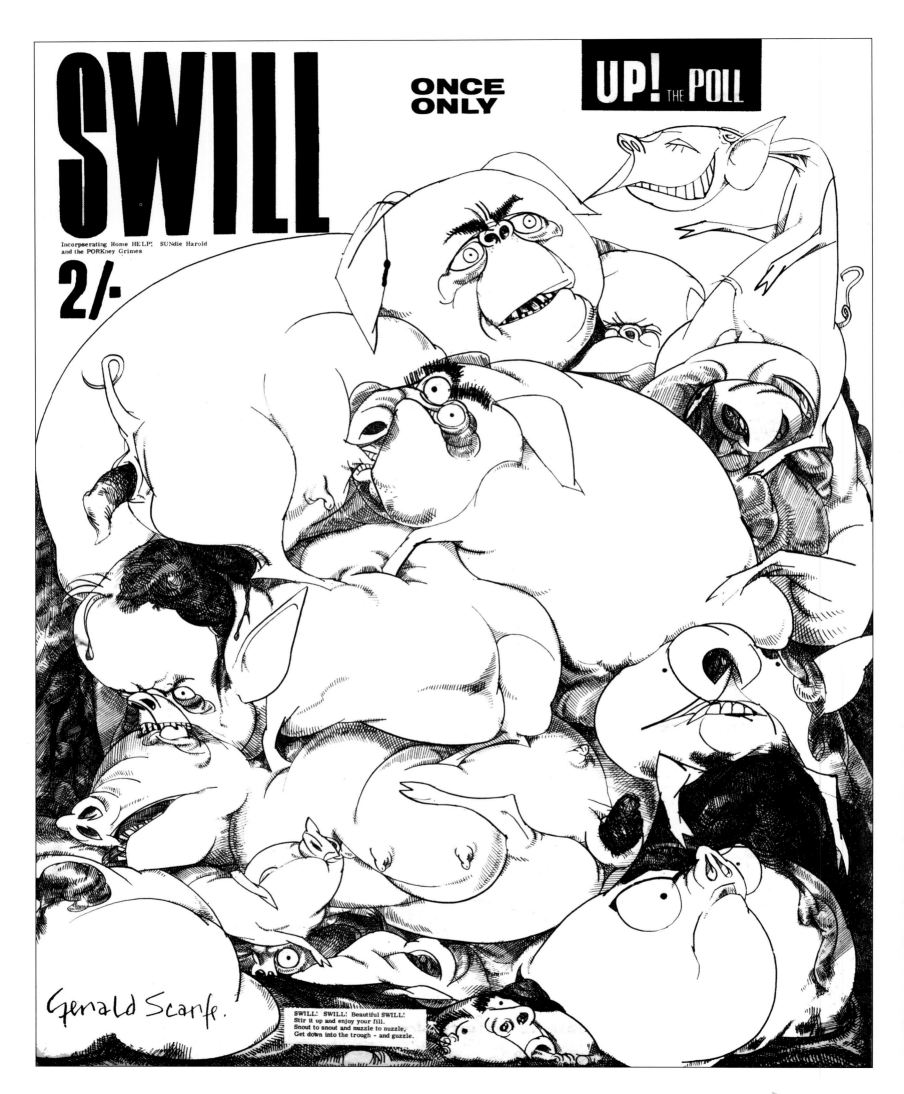

SWILL

ONCE ONLY

UP! THE POLL

Incorpserating Home HELP! SUNdie Harold and the PORKney Grimes

2/-

Gerald Scarfe.

SWILL! SWILL! Beautiful SWILL!
Stir it up and enjoy your fill.
Snout to snout and nuzzle to nuzzle,
Get down into the trough - and guzzle.

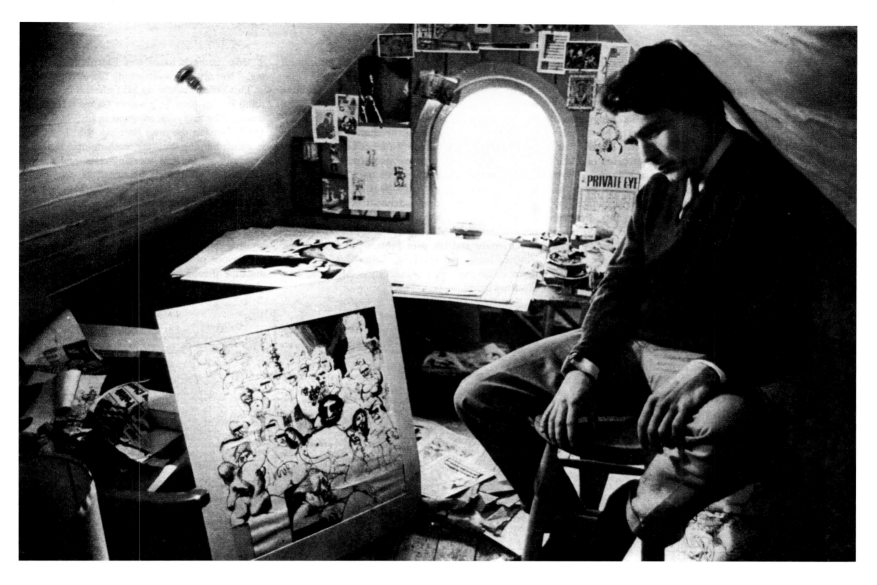

Gerald Scarfe's drawings are brilliant and disgusting. As the object of satire is to enrage and disgust, he is perhaps the only true satirist to have emerged from the whole over-publicised movement. You cannot imagine any of his 'victims' (for once the cliché really applies) asking for the original. In his drawings he has managed to translate mental disgust into physical shapes. There are two elements: boniness and floppiness. Throughout the drawings huge sacks of flesh full, it would appear, of semi-liquid putrescence, are gripped and torn by steely little claws and grinning jaws full of teeth. The famous picture of Macmillan as Keeler really works on a symbolic level because the realisation of the ageing flesh in the drawing forces you to see him as an old whore. In the orgy scenes there is no pleasure. Simple cruelty and disgust. I couldn't imagine what sort of person Gerald Scarfe might be. In fact he is young, extremely good-looking and upper middle class, still lives in Hampstead where he was born, and gets on well with his parents. I kept trying to discover a clue to his Swiftian horror in humanity. Was there a sadistic schoolmaster? No. He had never been away to school because as a child he had very bad asthma. He did find human beings rather disgusting as physical objects. He did worry rather about why he enjoyed sex while also finding it rather repulsive. He didn't feel especially strongly about politics. Very calmly and correctly, Gerald Scarfe ate his lunch.
GEORGE MELLY – *SUNDAY TIMES* COLOUR MAGAZINE.

Opposite: Pigs in Muck: *Swill* magazine (of which there was only ever one issue). The pigs are Harold Wilson, Jo Grimond, Lord Home, George Brown, Rab Butler, Lord Hailsham, Selwyn Lloyd and Reginald Maudling.
Above: GS in his Hampstead studio.
Right: Judge's Face: *Private Eye*, 7 February.

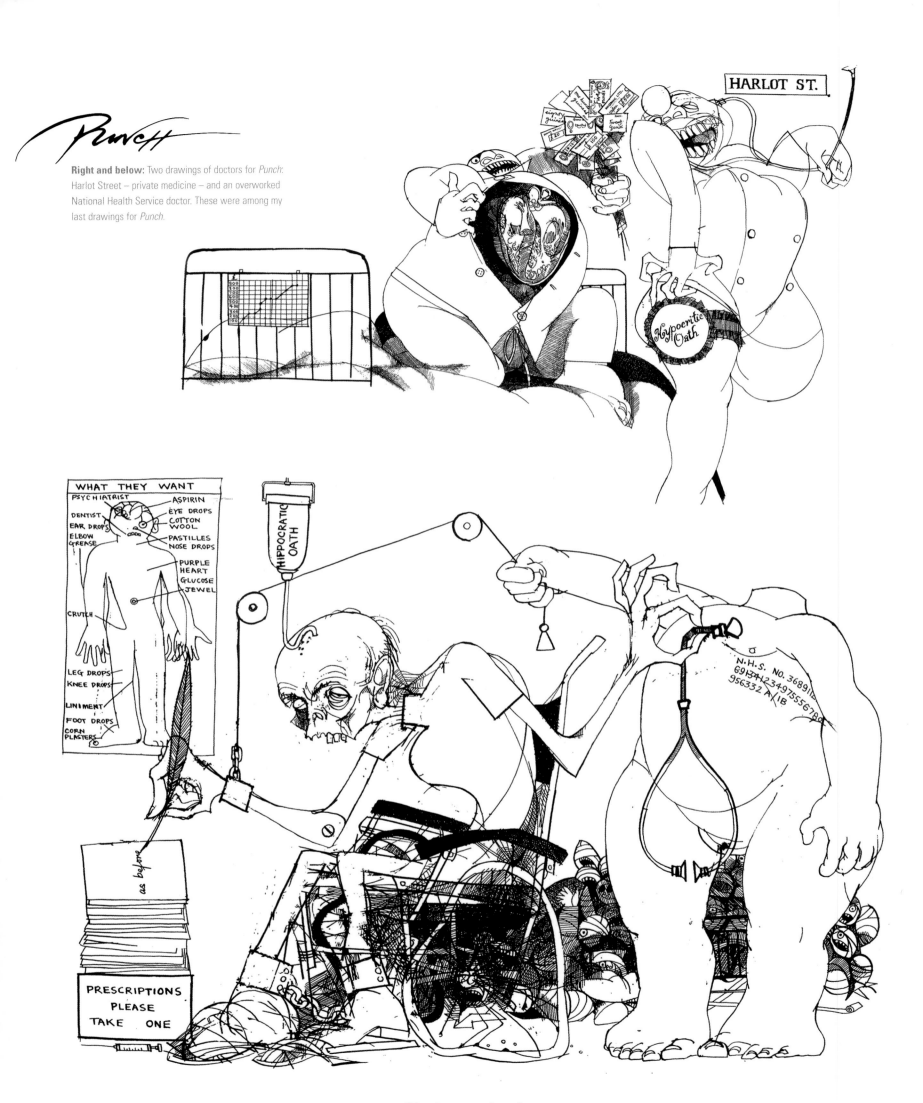

Punch

Right and below: Two drawings of doctors for *Punch*: Harlot Street – private medicine – and an overworked National Health Service doctor. These were among my last drawings for *Punch*.

HARLOT ST.

Hypocritic Oath

WHAT THEY WANT

PSYCHIATRIST — ASPIRIN
— EYE DROPS
DENTIST — COTTON WOOL
EAR DROPS — PASTILLES
ELBOW GREASE — NOSE DROPS
— PURPLE HEART
— GLUCOSE
— JEWEL
CRUTCH
LEG DROPS
KNEE DROPS
LINIMENT
FOOT DROPS
CORN PLASTERS

HIPPOCRATIC OATH

N.H.S. No. 3689110
69134123497555678
956332 A/1B

PRESCRIPTIONS PLEASE TAKE ONE

After many years in a commercial art studio, this was my reaction to what I felt to be the shoddy state of advertising design.

Above: Mass Commercial Design: *Punch*, 24 June.

I felt strongly about education, as mine had been so scattered and inadequate.

Above: Education: *Punch*, 10 June.

Above: Overcrowded Housing: *Punch*.

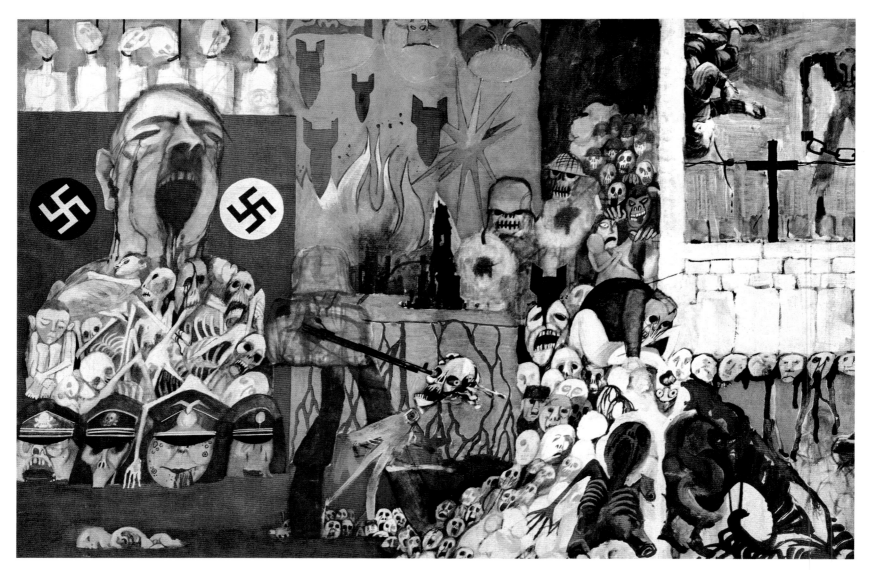

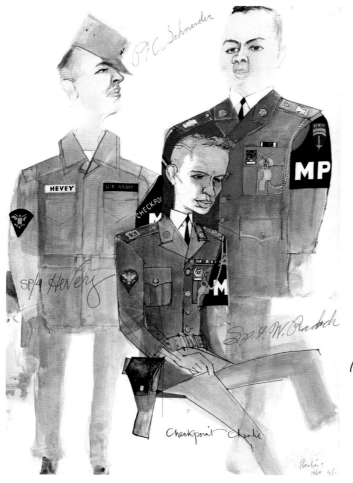

BerlIN Having published my Kennedy drawing, the American magazine *Esquire* commissioned me to visit the war-ravaged city of Berlin to produce several pages of drawings for its July edition.

This page: top: Kurfürstendamm, Berlin. The Kurfürstendamm was and is the main street in West Berlin. **Below left:** Three GIs at Checkpoint Charlie. Checkpoint Charlie was the infamous crossing-point through the Berlin Wall into East Germany. **Below right:** The city of Berlin torn apart.

Opposite: top: Post-war Berlin. **Below:** Checkpoint Charlie.

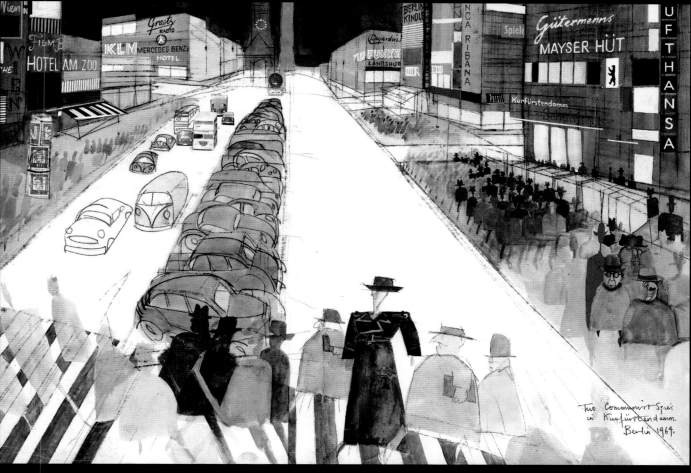

Two Communist Spies
in Kurfürstendamm.
Berlin 1964.

I wrote at the time about the wall: 'It is the height of a man, built in deceptively flimsy breeze blocks on top of a forked iron tongue scorched with barbed wire licks the length of it . . . everything it touches is transformed' Re-reading this in the July '64 edition of *Esquire*, I wonder if this affected the way I depicted Pink Floyd's Wall in the 1980s.

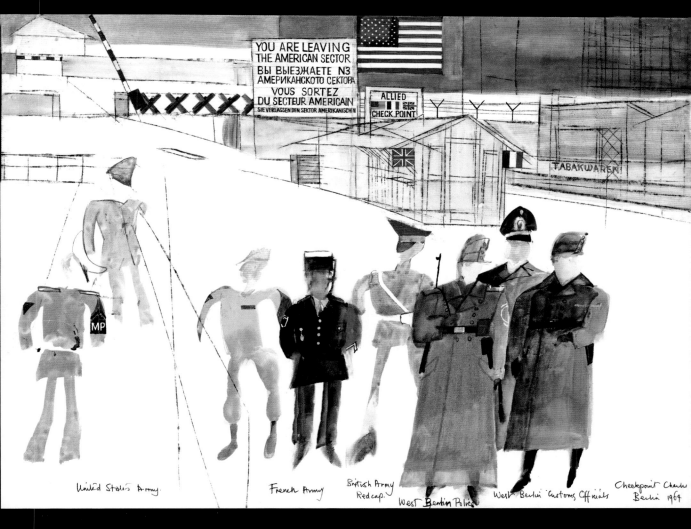

YOU ARE LEAVING
THE AMERICAN SECTOR
ВЫ ВЫЕЗЖАЕТЕ ИЗ
АМЕРИКАНСКОГО СЕКТОРА
VOUS SORTEZ
DU SECTEUR AMERICAIN
SIE VERLASSEN DEN SEKTOR AMERIKANISCHEN

ALLIED
CHECK POINT

TABAKWAREN

United States Army. French Army British Army West Berlin Police West Berlin Customs Officials Checkpoint Charlie
 Redcap. Berlin 1964

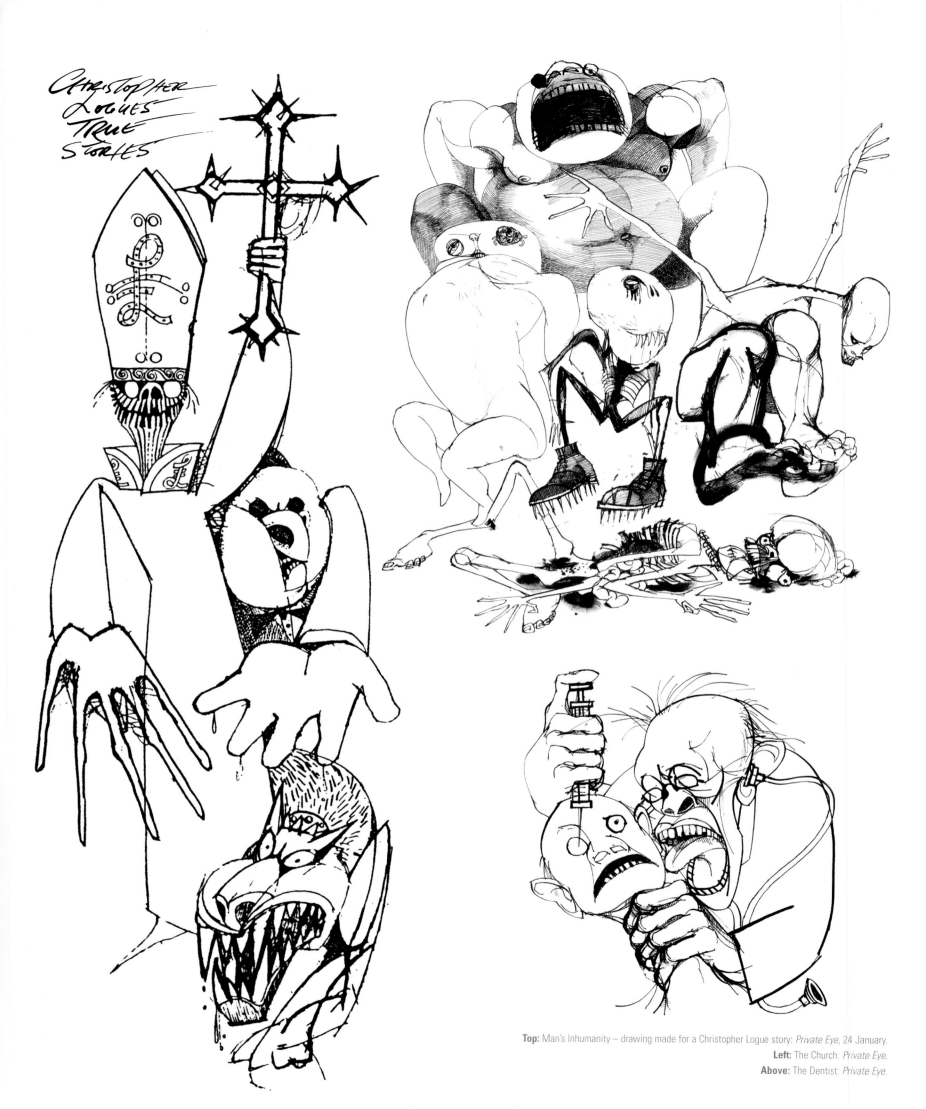

CHRISTOPHER
LOGUES
TRUE
STORIES

Top: Man's Inhumanity – drawing made for a Christopher Logue story: *Private Eye*, 24 January.

Left: The Church: *Private Eye*.

Above: The Dentist: *Private Eye*.

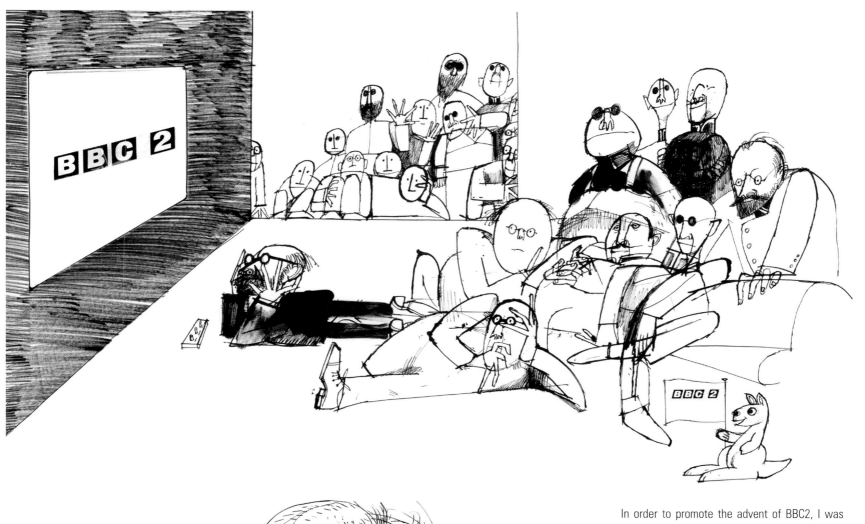

In order to promote the advent of BBC2, I was commissioned to produce a series of drawings to be screened on BBC1 in the weeks leading up to the first broadcast.

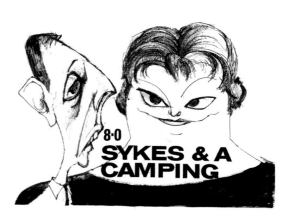

Left: Lord Boothby and John Freeman: *Private Eye*.
Above: Drawing for a BBC trailer for *Sykes and A . . .* a comedy series starring Eric Sykes and Hattie Jacques.

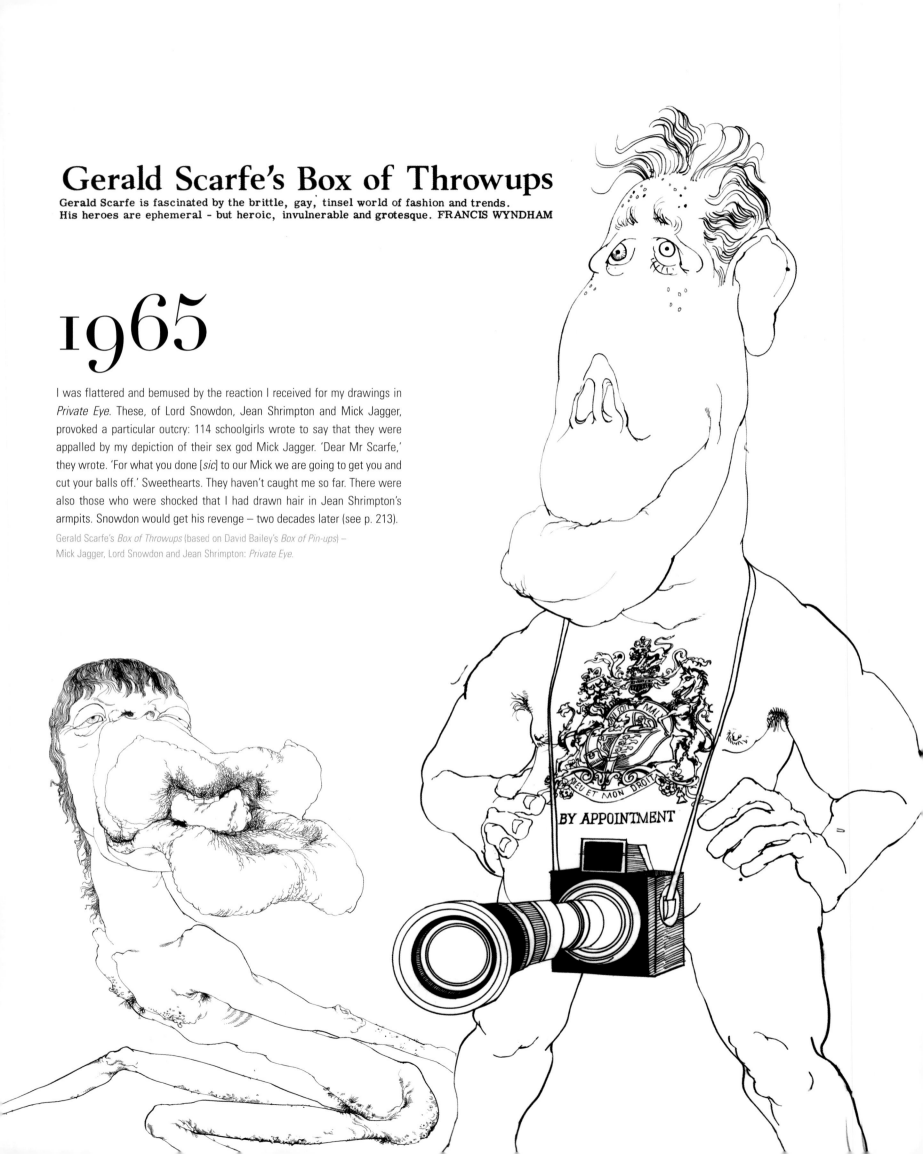

Gerald Scarfe's Box of Throwups

Gerald Scarfe is fascinated by the brittle, gay, tinsel world of fashion and trends.
His heroes are ephemeral - but heroic, invulnerable and grotesque. FRANCIS WYNDHAM

1965

I was flattered and bemused by the reaction I received for my drawings in *Private Eye*. These, of Lord Snowdon, Jean Shrimpton and Mick Jagger, provoked a particular outcry: 114 schoolgirls wrote to say that they were appalled by my depiction of their sex god Mick Jagger. 'Dear Mr Scarfe,' they wrote. 'For what you done [*sic*] to our Mick we are going to get you and cut your balls off.' Sweethearts. They haven't caught me so far. There were also those who were shocked that I had drawn hair in Jean Shrimpton's armpits. Snowdon would get his revenge – two decades later (see p. 213).

Gerald Scarfe's *Box of Throwups* (based on David Bailey's *Box of Pin-ups*) –
Mick Jagger, Lord Snowdon and Jean Shrimpton: *Private Eye*.

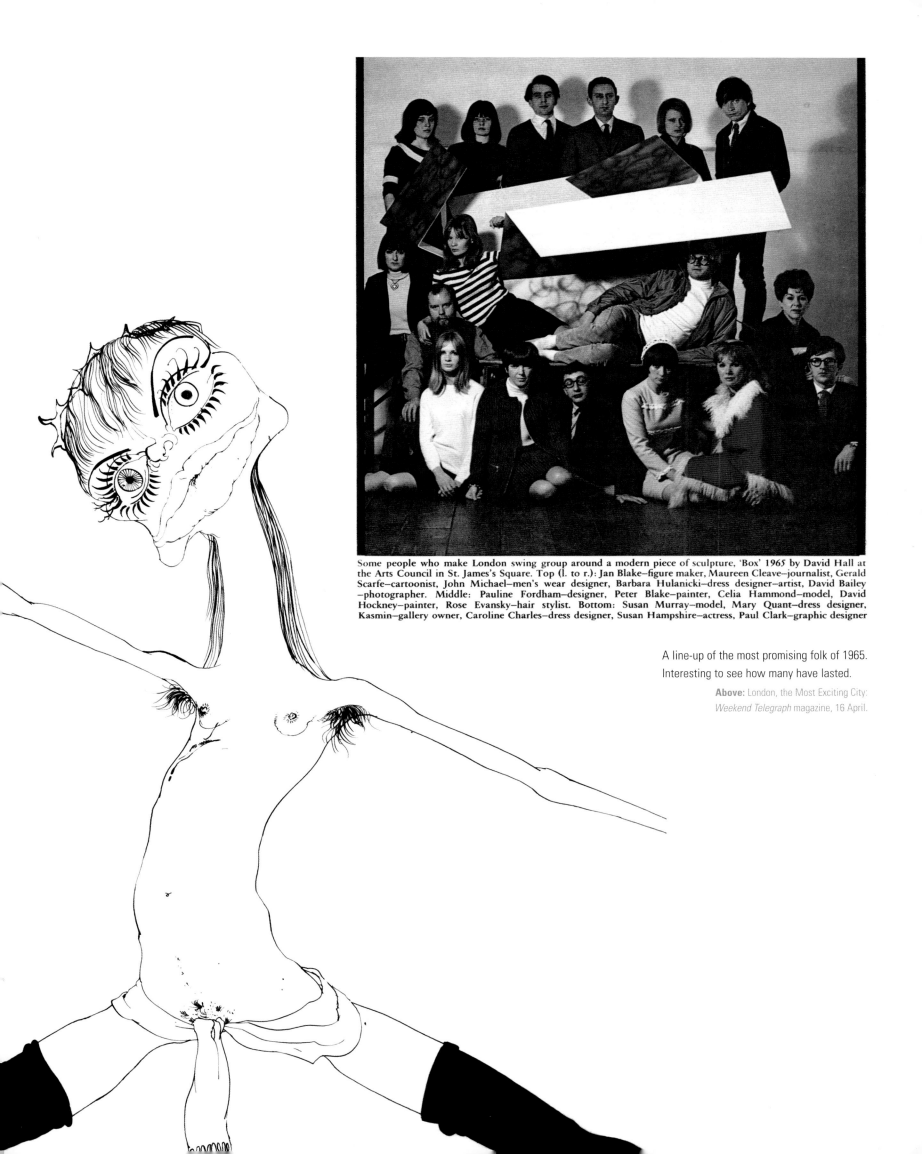

Some people who make London swing group around a modern piece of sculpture, 'Box' 1965 by David Hall at the Arts Council in St. James's Square. Top (l. to r.): Jan Blake—figure maker, Maureen Cleave—journalist, Gerald Scarfe—cartoonist, John Michael—men's wear designer, Barbara Hulanicki—dress designer—artist, David Bailey —photographer. Middle: Pauline Fordham—designer, Peter Blake—painter, Celia Hammond—model, David Hockney—painter, Rose Evansky—hair stylist. Bottom: Susan Murray—model, Mary Quant—dress designer, Kasmin—gallery owner, Caroline Charles—dress designer, Susan Hampshire—actress, Paul Clark—graphic designer

A line-up of the most promising folk of 1965.
Interesting to see how many have lasted.

Above: London, the Most Exciting City:
Weekend Telegraph magazine, 16 April.

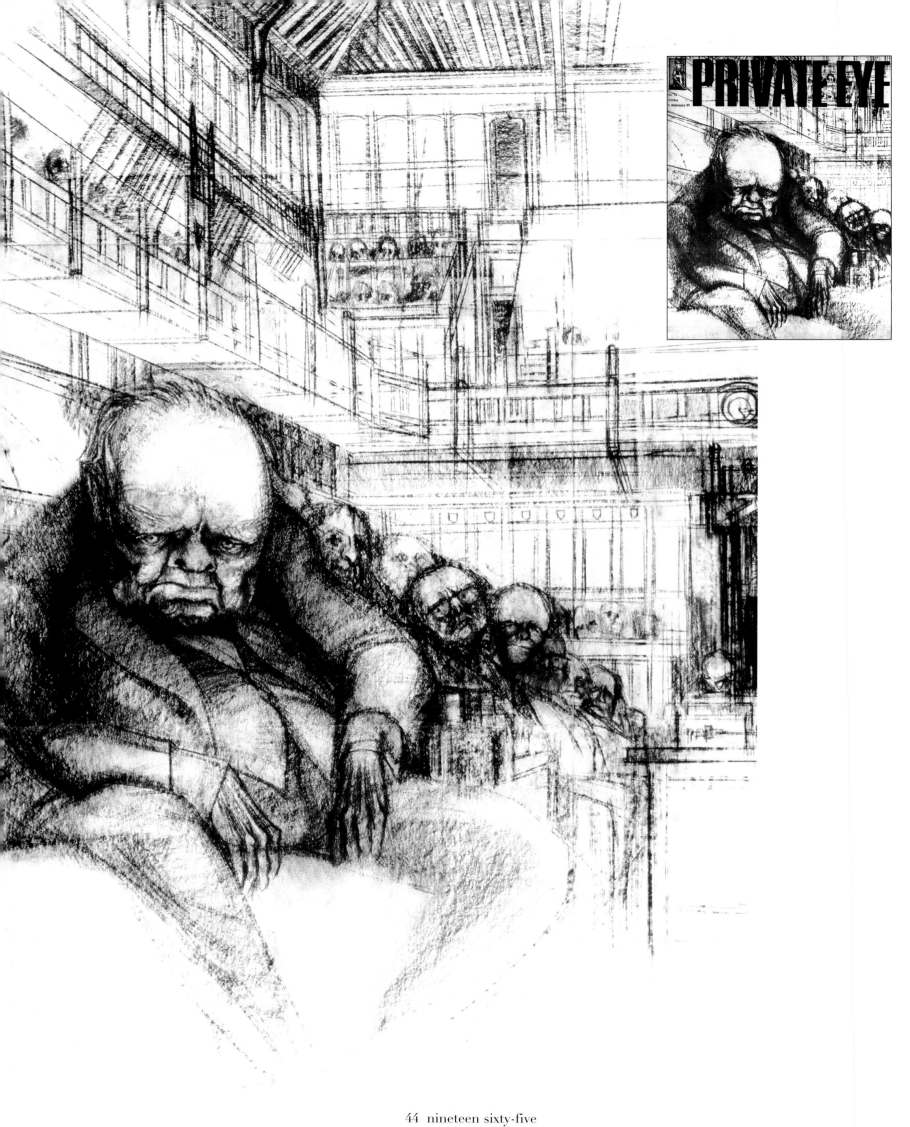

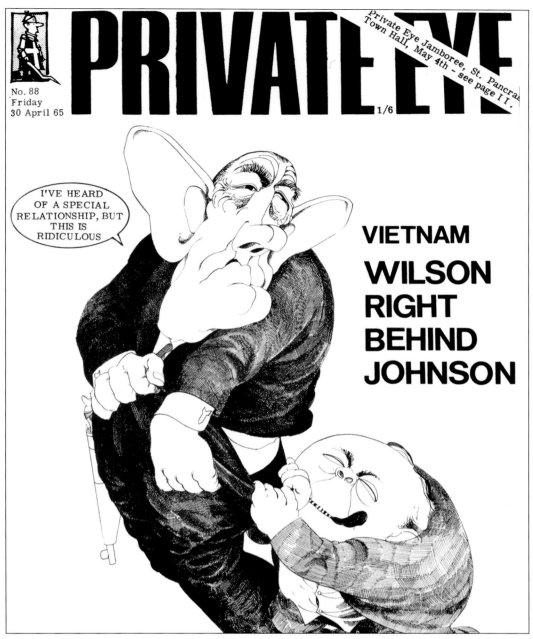

PRIVATE EYE

No. 88
Friday
30 April 65

Private Eye Jamboree, St. Pancras Town Hall, May 4th – see page 11.

1/6

I'VE HEARD OF A SPECIAL RELATIONSHIP, BUT THIS IS RIDICULOUS

VIETNAM
**WILSON
RIGHT
BEHIND
JOHNSON**

This originally had Harold Wilson's tongue up Lyndon Johnson's bottom, but *Private Eye* editor Richard Ingrams thought it a bit much. This is the censored version.

Left: *Private Eye* cover, 30 April: Wilson Right Behind Johnson.
Below: Two-faced Harold Wilson: *Twentieth Century* magazine.

This drawing of Churchill, made during his last days in the House of Commons, was commissioned by *The Times*. I sketched from the public gallery, and I was shocked to see how he had deteriorated. We knew only the British bulldog Churchill: cigar clenched between teeth, steely eyes, and the famous two-finger salute. *The Times* refused to print my drawing, saying that Churchill's wife, Clementine, would be upset when the paper dropped through the letter-box in the morning. I complained about this to Peter Cook, who remembered it, and saw that the drawing was used for the cover of *Private Eye* when Churchill died.

Opposite: *Private Eye* cover, 5 February: Winston Churchill.

I was given special permission by the Sergeant-at-Arms in the House of Commons to sketch Parliamentary members from the public gallery. I have forgotten the names of some. Left-hand side: second row includes, left to right, Christopher Soames, Julian Amery, Ernest Marples, Enoch Powell, Jo Grimond, Jeremy Thorpe, Eldon Griffiths, Christopher Chataway; first row, left to right, Duncan Sandys, Peter Thorneycroft, John Boyd-Carpenter, ?, Iain Macleod, Quintin Hogg, Reginald Maudling, Edward Heath, Alec Douglas-Home, Selwyn Lloyd; standing centre, William Whitelaw. Right-hand side: second row, right to left, Ray Gunter, Frank Cousins, ?, Christopher Mayhew; first row, right to left, Richard Crossman, Michael Stewart, Roy Jenkins, Kenneth Robinson, Frank Soskice, James Callaghan, Denis Healey, Harold Wilson, George Brown at the dispatch box, Herbert Bowden, Michael Foot. Back benches left: Ian Gilmour, Peter Walker.

Following page: House of Commons in session, 27 June.

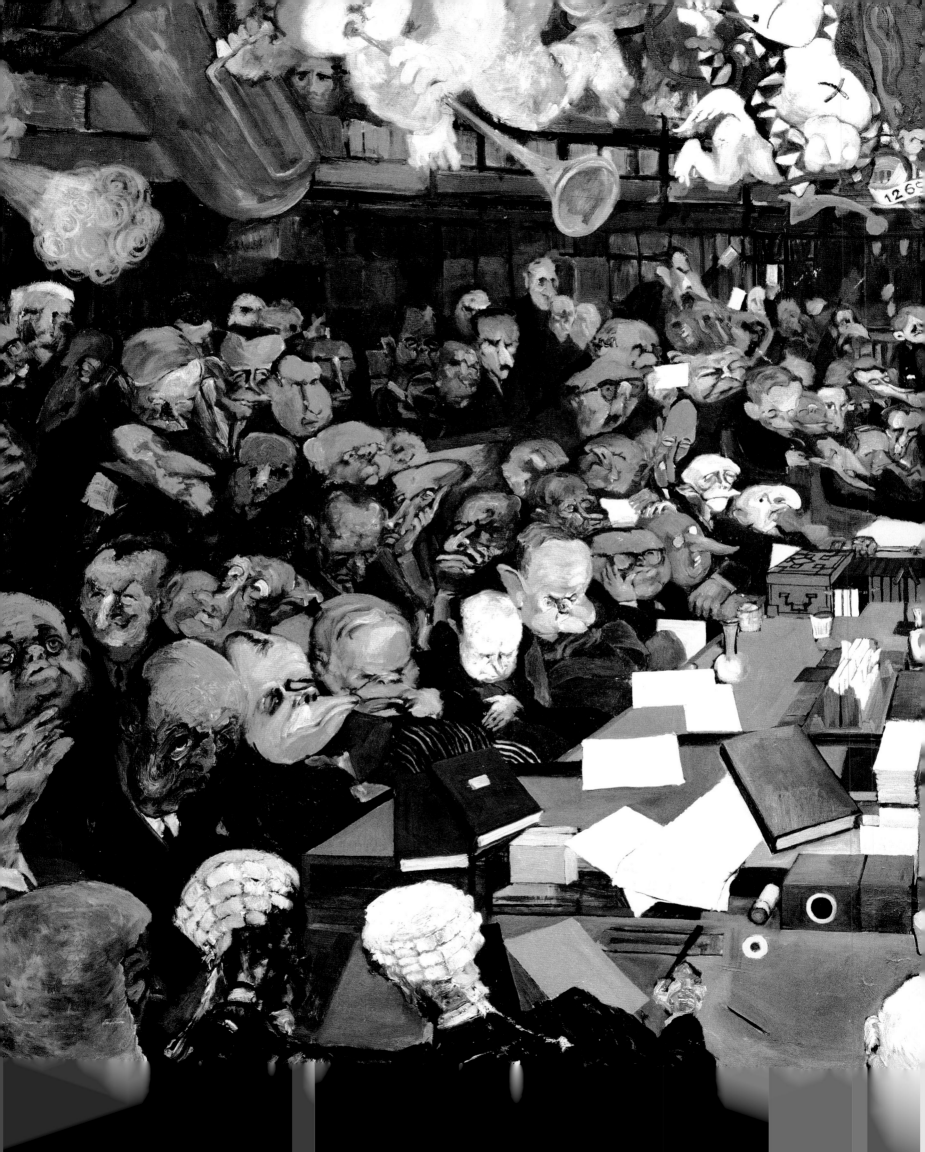

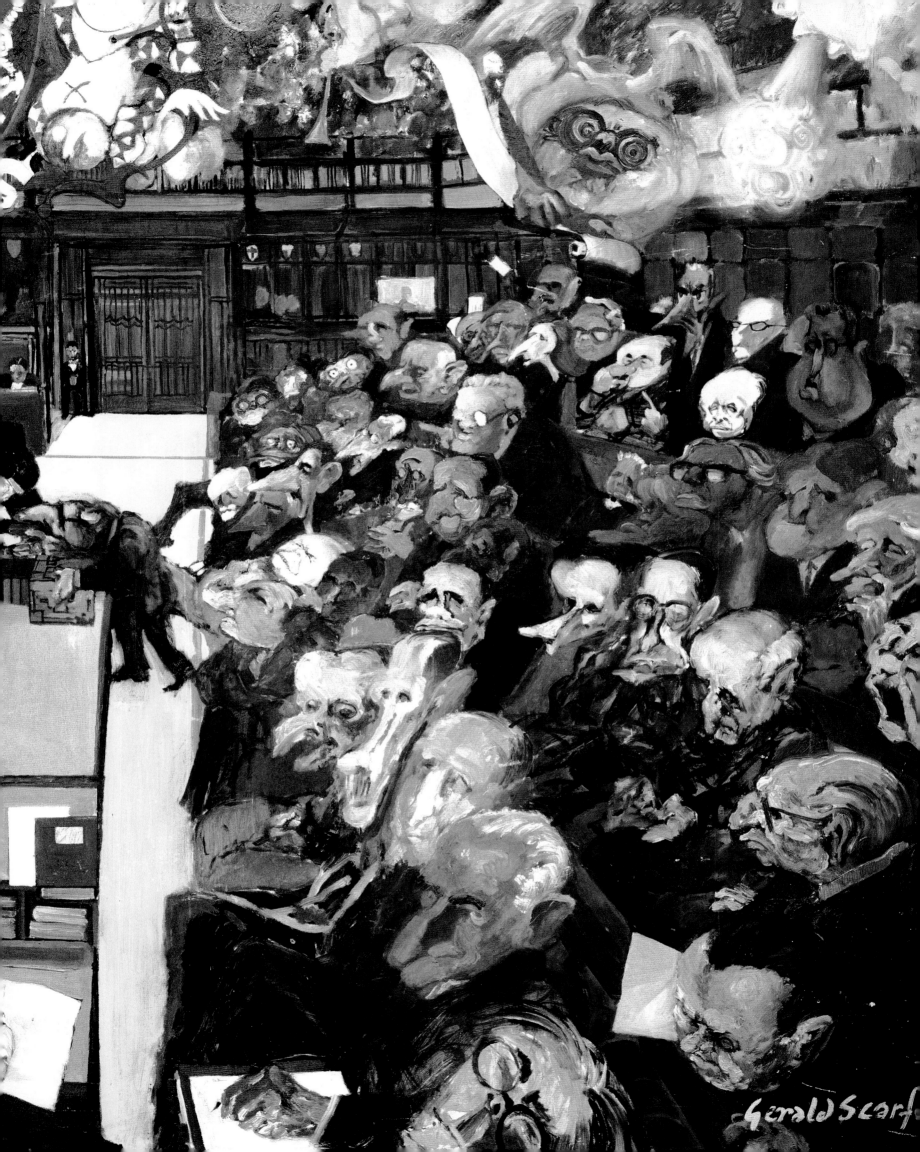

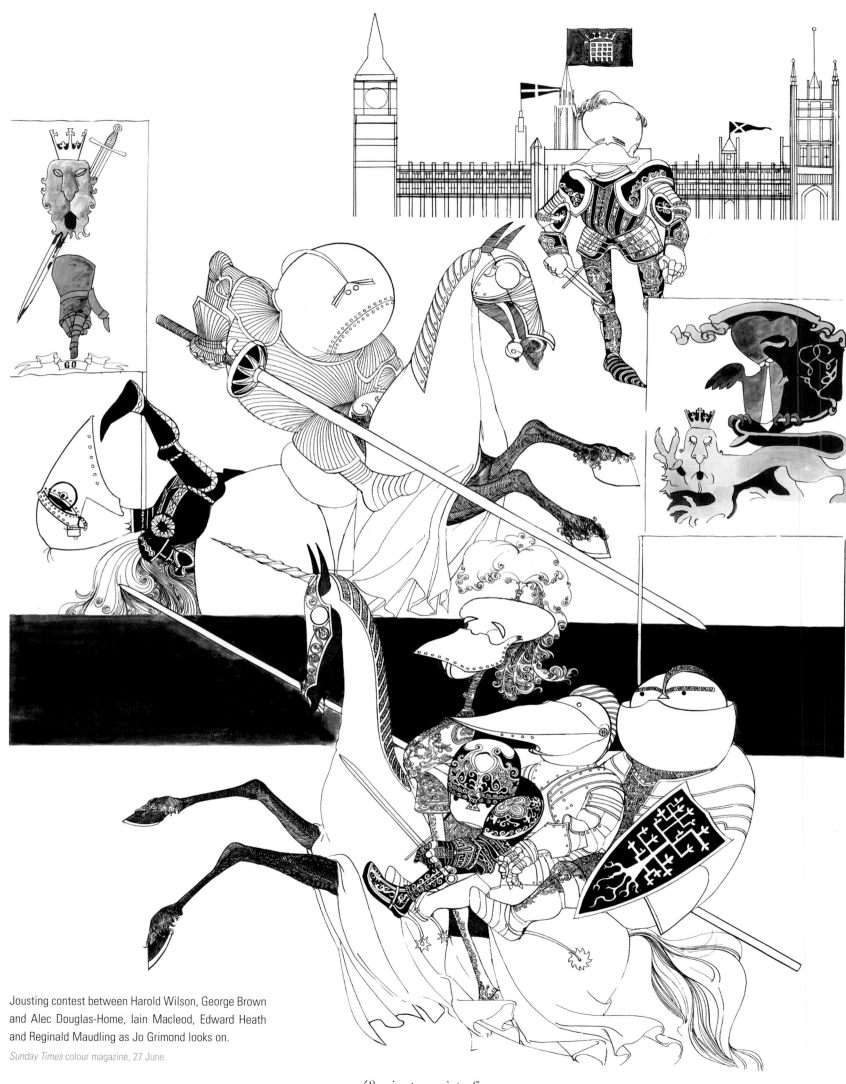

Jousting contest between Harold Wilson, George Brown
and Alec Douglas-Home, Iain Macleod, Edward Heath
and Reginald Maudling as Jo Grimond looks on.

Sunday Times colour magazine, 27 June.

introducing

Ghoulish advance of Mr. Scarfe

by JOHN RYDON

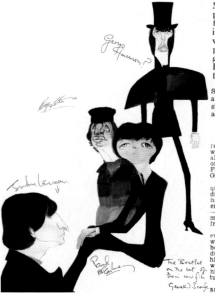

MOVING towards publication now is the first book* of drawings by a young man who is undoubtedly possessed of the most ghoulish line in British cartoonry today.

His name is Gerald Scarfe. He is 28. He lives alone in a Hampstead bed. sit. where he collects spurs as a hobby.

★ ★ ★

And he is producing some remarkable, merciless work which some people are already comparing with that of the fifteenth-century Flemish master macabreist Gerohieronymus Bosch.

Owing to the anatomical quality of a lot of his drawings — nails being hammered into skulls and entrails spilling over floors — one could be forgiven mistaking Scarfe for a frustrated medical student.

Not so. The nearest he ever got to the medical world was being confined to bed with chronic asthma during the greater part of his adolescent life, a period which he maintains afforded him the time and opportunity to draw.

"No, I've never studied anatomy," he told me. "But I wouldn't mind sitting in

VERY PERSONAL summing up of the Beatles At top George Harrison, in centre Ringo Starr and Paul McCartney, in foreground John Lennon.

*"Gerald Scarfe's People," to be published by Peter Owen, Ltd., in March. Price : 65s.

LUDWIG ERHARD, West German Chancellor, by Scarfe. Says he : "I never go out of my way to offend people. I just try to get to the basis of their personality in as short a time as possible."

at a few operations provided I had a sketch book with me. I think I should feel sick otherwise."

Yet this self-effacing chap with a cow lick over one eye and a long horse face manages to make every line burn like a razor slash.

★ ★ ★

His faces are peeled down like oranges to skull structure. His toes and fingers take on the appearance of badly stuffed sausages.

Everywhere rib structures gape like blown-down fences. Noses, teeth, and eyes strain, chatter and glower.

Each fold of flesh, each

wrinkle is magnified to cruellest advantage. Yet in a "straight" drawing the Scarfe line is as delicate as a lace dolly.

"I'm never really conscious of producing a cruel drawing," he says. "I never go out of my way to offend people, whoever they may be. I just try to get to the basis of their personality in as short a time as possible."

In this volume of drawings covering the past three years, and which should establish Scarfe as one of the most significant cartoonists of our time, we shall have the chance of judging for ourselves.

Scarfe's eye view of the president

'My best' said L.B.J.

WHEN President Johnson of the U.S. signed this drawing of himself by Gerald Scarfe he added "My best."

One-time presidential candidate Senator Barry Goldwater signed his with the addition, "Sure, I've got a sense of humour."

What would Wilson, Heath, or any other British politician write on theirs ?

When this article appeared in the *Daily Express* a colleague told me that I'd get offers from the *Express* and its rival, the *Daily Mail*, very soon. Sure enough, I was soon enmeshed in an auction with both newspapers: I was wined, dined and offered money and cars. If this is Fleet Street, I thought, I hope it continues like this. It didn't.

I constantly attacked Ian Smith. A few years later, while visiting Rhodesia, my wife and I were invited to a party at which I was quizzed on my attitude towards Smith and his regime. I said that I thought they had all had a good run and that maybe it was time to call it a day and get out. 'Be careful,' I was told. 'You might find yourself swinging from a tree in the morning.'

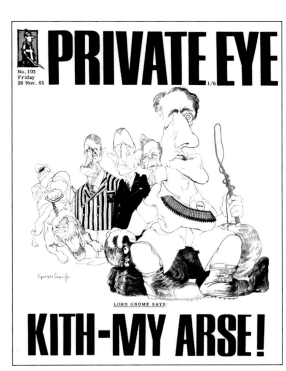

PRIVATE EYE

No. 103 Friday 26 Nov. 65 1/6

LORD GNOME SAYS:

KITH-MY ARSE!

Top: Ghoulish Scarfe, *Daily Express*.
Left: Edward Heath: when he laughed, Heath was known for his cheesy smile and heaving shoulders.
Right: *Private Eye* cover, 26 November: Kith-My Arse – Ian Smith of Rhodesia and friends.

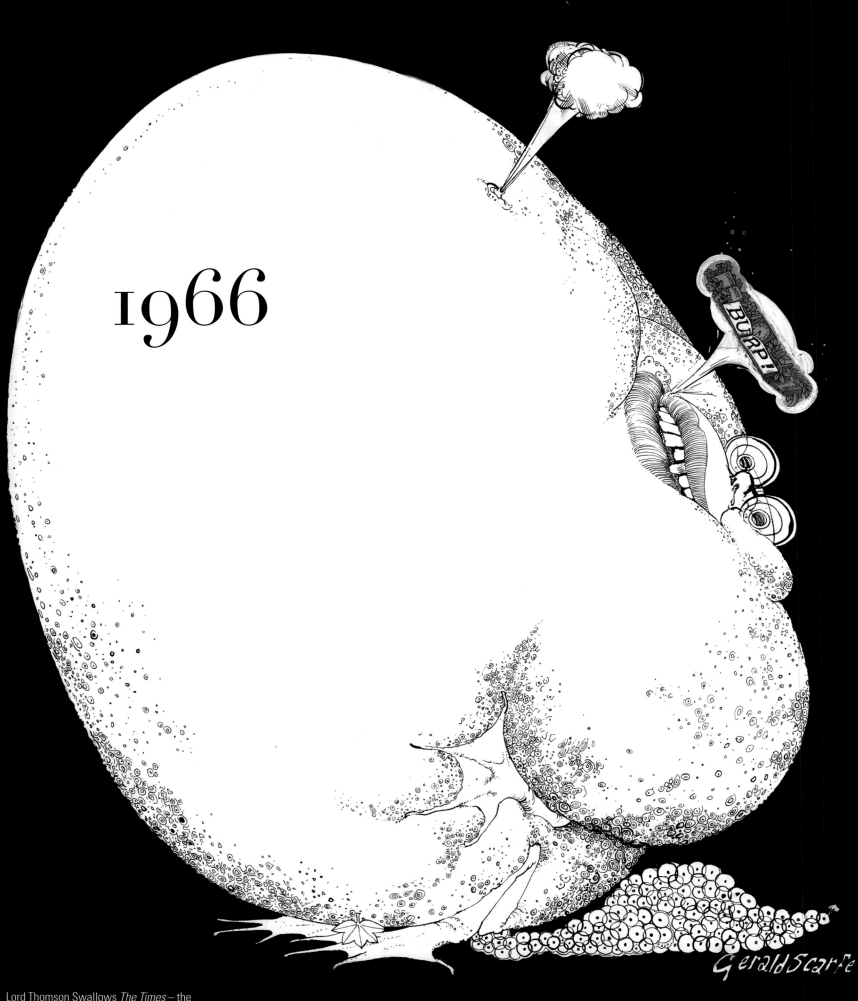

1966

BURP!

GeraldScarfe

Lord Thomson Swallows *The Times* – the
Canadian Lord Thomson buys *The Times*.
Private Eye cover, 14 October.

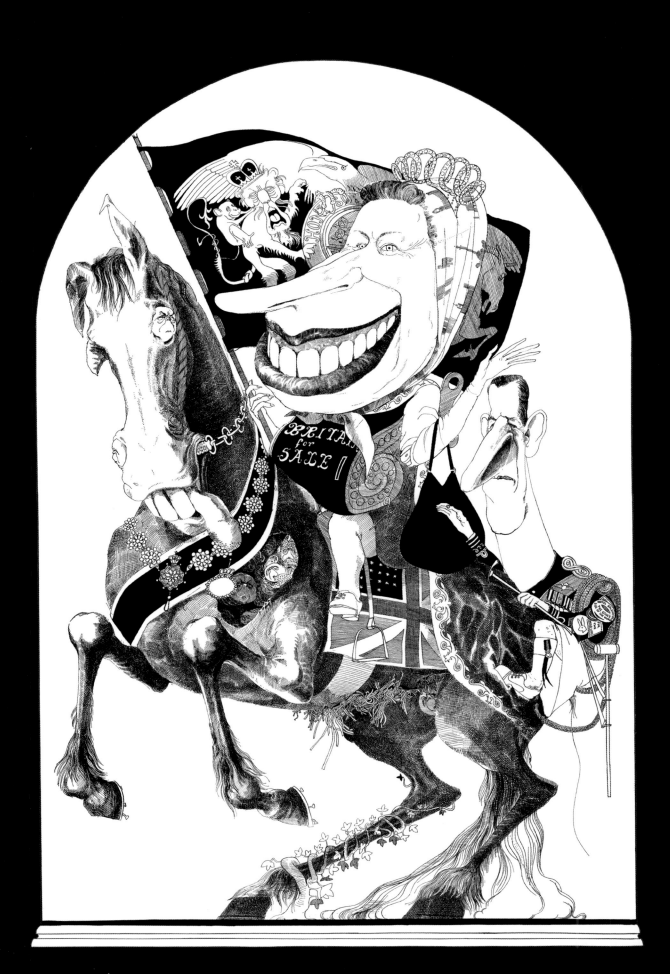

This was the year in which I won the *What the Papers Say* award and joined Fleet Street and the world of mass-circulation newspapers. At the time of the auction between the *Express* and the *Mail*, the owner of the *Mail*, Vere Harmsworth, later Lord Rothermere, asked me and Mike Randall, then the editor, to lunch at Le Caprice. 'What type of car are you giving Gerald?' Vere asked. 'We thought £5000 a year and a Rover,' said Mike. 'Oh, give him £6000 a year and an E-type Jaguar,' replied Harmsworth. 'Let him have a short life and a merry one.'

Well, it wasn't a merry one. I loathed my time at the *Mail*. After *Private Eye* I felt restricted on subject matter. From the *Mail*'s point of view, they didn't know what to do with me. The drawings I had been given the freedom to do for *Private Eye* were not possible at a 'family newspaper'.

As the *Mail* wouldn't print the type of explicit drawings I'd been doing for *Private Eye* they decided to send me to Vietnam to solve an awkward problem. The *Mail* had signed me up because of my notoriety in *Private Eye*, but, as someone said, when the readers opened their cosy *Daily Mail* in the morning and saw a Scarfe, it was as though the family dog had just shat on the breakfast table.

MONDAY, FEBRUARY 21, 1966

Mail

ronicle

The Cartoonist of the Year

GERALD SCARFE

joins the Newspaper of the Year

to start a major week in the Mail

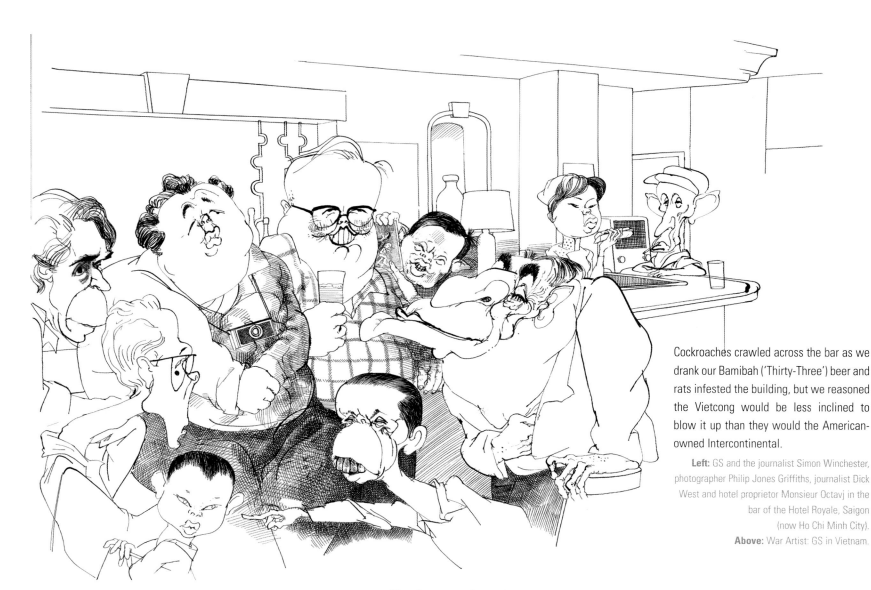

Cockroaches crawled across the bar as we drank our Bamibah ('Thirty-Three') beer and rats infested the building, but we reasoned the Vietcong would be less inclined to blow it up than they would the American-owned Intercontinental.

Left: GS and the journalist Simon Winchester, photographer Philip Jones Griffiths, journalist Dick West and hotel proprietor Monsieur Octavj in the bar of the Hotel Royale, Saigon (now Ho Chi Minh City).
Above: War Artist: GS in Vietnam.

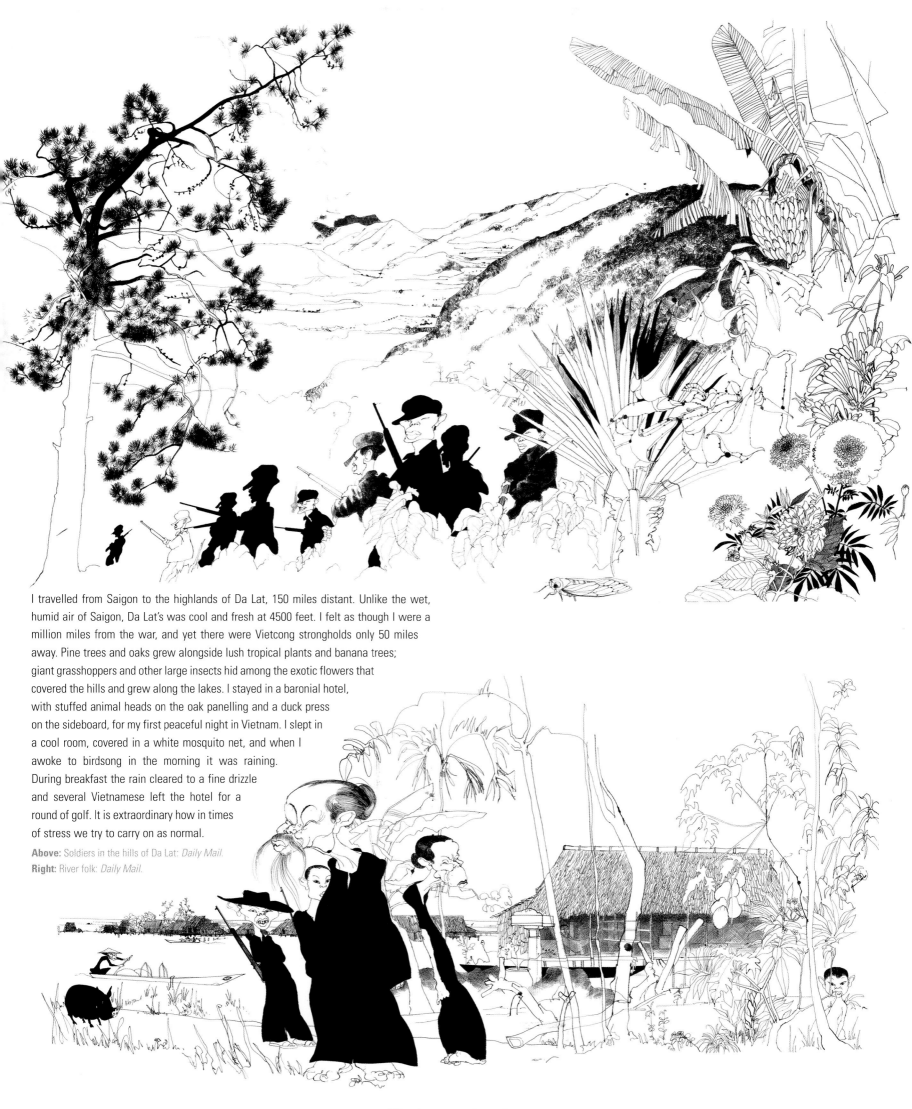

I travelled from Saigon to the highlands of Da Lat, 150 miles distant. Unlike the wet, humid air of Saigon, Da Lat's was cool and fresh at 4500 feet. I felt as though I were a million miles from the war, and yet there were Vietcong strongholds only 50 miles away. Pine trees and oaks grew alongside lush tropical plants and banana trees; giant grasshoppers and other large insects hid among the exotic flowers that covered the hills and grew along the lakes. I stayed in a baronial hotel, with stuffed animal heads on the oak panelling and a duck press on the sideboard, for my first peaceful night in Vietnam. I slept in a cool room, covered in a white mosquito net, and when I awoke to birdsong in the morning it was raining. During breakfast the rain cleared to a fine drizzle and several Vietnamese left the hotel for a round of golf. It is extraordinary how in times of stress we try to carry on as normal.

Above: Soldiers in the hills of Da Lat: *Daily Mail.*
Right: River folk: *Daily Mail.*

Flying in Vietnam was not a pleasant experience. I found myself either in a flimsy plane being thrown around the cloudy sky, or shut in a windowless, monstrous transport plane, which was like flying blind in the Albert Hall. This drawing was made as I was travelling with a dejected platoon to some God-forsaken spot in the jungle.

Left: Soldiers in a troop carrier: *Daily Mail.*

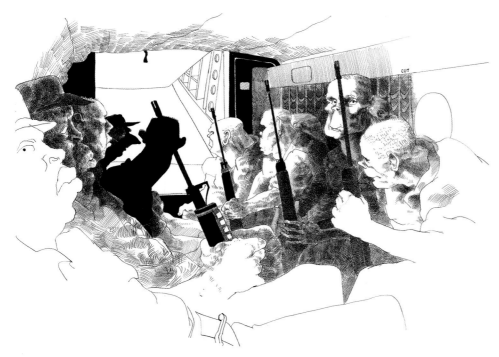

One evening Monsieur Octavj, the proprietor of the hotel, took me to an opium den, a small room in a back street in Saigon. Several figures sat or lay blissfully around a bare room, while the pipe was lit by an emaciated man with greying hair. He handed me the pipe, and – not a smoker – I inhaled tentatively. I can't remember how long I was there, but that night when I returned to the Hotel Royale, I made a very careful drawing from memory. I worked for hours on it, drawing each line very, very slowly. It seemed wonderful at the time, and it was only when I looked at it later that I saw it was rubbish.

Opposite, top left: Opium Den.

A portrait of a young soldier whose platoon had been surrounded by the enemy on a sortie into the jungle. They radioed for US strike aircraft to napalm outside the area where they were pinned down. The planes arrived and napalmed inside the area, wiping out most of his buddies. The boots of his dead friend are beside him.

Below: Friendly Fire: *Daily Mail.*

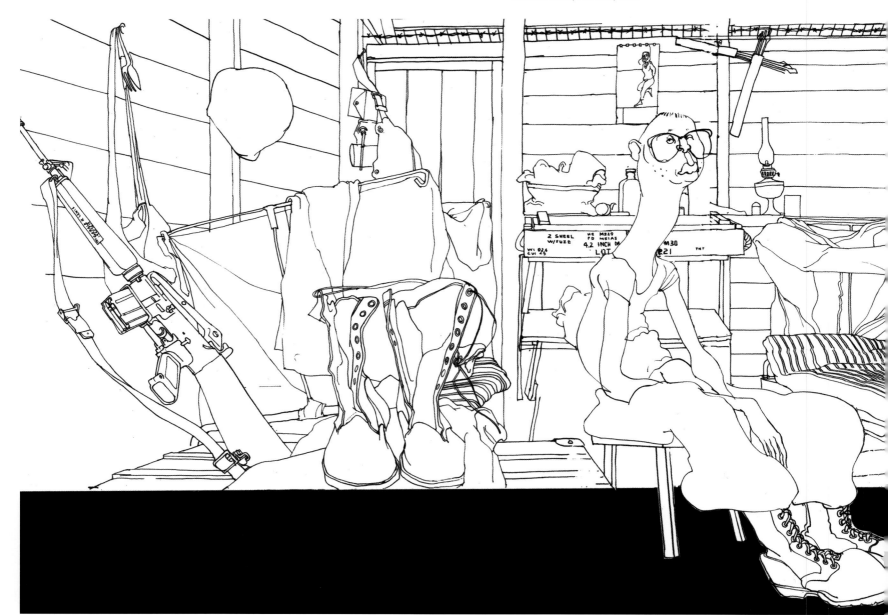

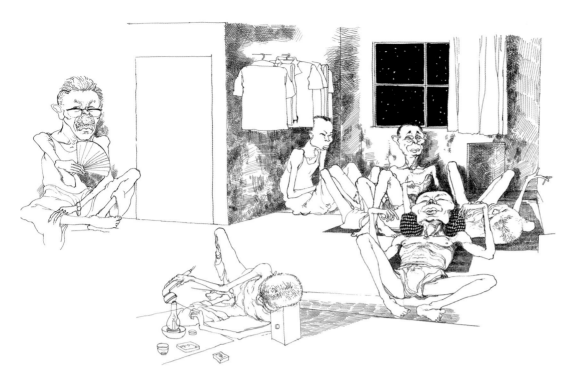

I prided myself that I could draw anything, and I applied to sketch inside the American morgue in a hangar at Tan Son Nhut Airport, Saigon, in order to get a fuller picture of life and death in Vietnam. The sergeant who met me outside said, 'You sure you wanna do this?' 'Sure,' I said – unsurely . . . And when he opened the door, I nearly fainted. On slabs in front of me lay the remains of a platoon: mutilated bodies, bits of bodies – no heads, no limbs – disembowelled half figures. Lumps of meat. They were being cleaned up before their return to the States by a group of cheerful young medics in white coats. I noticed several were whistling. What a job. The floor was awash with blood and bits: it was hell. 'I'm sorry,' I mumbled. 'I can't draw this.' I found myself clutching my armpits and sweating. 'Thought not,' said the sergeant, and took me back into the fresh air.

I drew this man having his fingers amputated in a makeshift 'operating theatre'. 'Yes,' said the French surgeon. 'I studied at the Conservatoire des Beaux Arts in Paris.' Snip, snip. 'Keep still!' shouted the people outside the window. 'There's an artist trying to draw you.' Snip, snip.

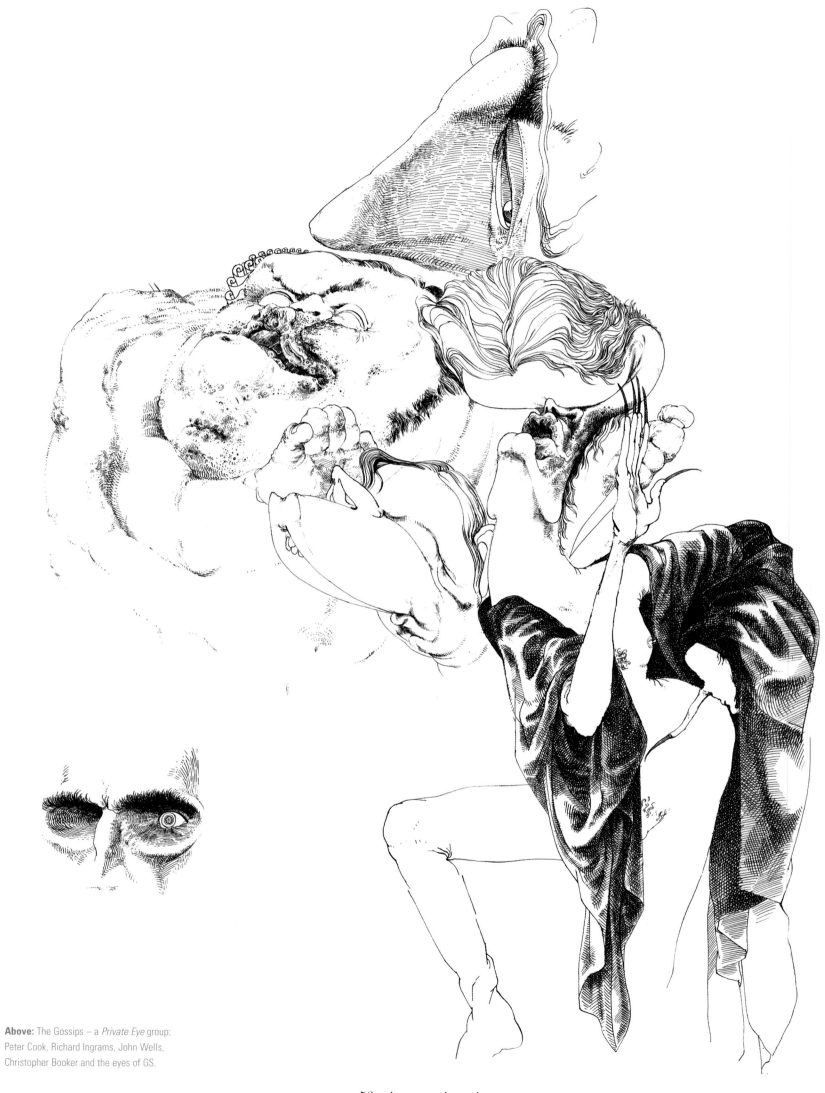

Above: The Gossips – a *Private Eye* group:
Peter Cook, Richard Ingrams, John Wells,
Christopher Booker and the eyes of GS.

Phoenix Theatre programme for *The Rustle of Spring*, a show to raise money to pay libel damages. When asked if I regret any of my drawings, this is one that comes to mind: I regret the implication that Moore was a mere puppet.

Right: Peter Cook and Dudley Moore.

Far right: *Private Eye* photo: left to right, Christopher Logue, Peter Cook, Christopher Booker, John Wells, Claude Cockburn (centre), Richard Ingrams; bottom left, GS and Tony Rushton.
Below: Frost's Breakfast at the Connaught Hotel: *Private Eye*, 1966. David Frost had the habit of inviting important people to breakfast: left to right, Lord Longford, Cecil King, Harold Wilson, Donald Baverstock, a tiny David Frost and the Bishop of Woolwich. (National Portrait Gallery, London)

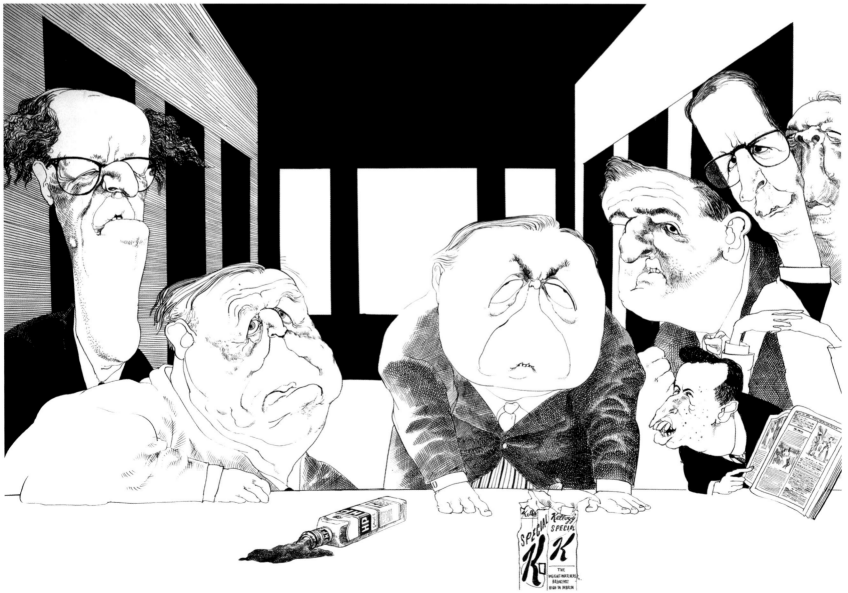

Mel Lasky, the editor of *Encounter*, invited me to go to New York, to make portraits of American intellectuals. Stephen Spender wrote letters of introduction for me to, among others, Aaron Copland, Robert Lowell, Leonard Bernstein, Stravinsky, Robert Oppenheimer (the man who helped create the atom bomb. 'He looks as though he's wondering what he's done,' said Mel), and Arthur Miller. I also drew Mark Rothko, who absolutely loathed my portrait of him.

This page and opposite: Drawings of American intellectuals made from life: *Encounter* magazine.
(Stravinsky drawing: property of Mrs Stephen Spender)

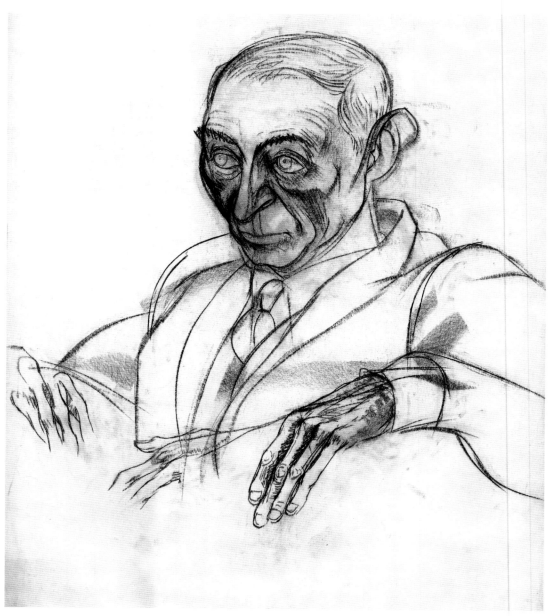

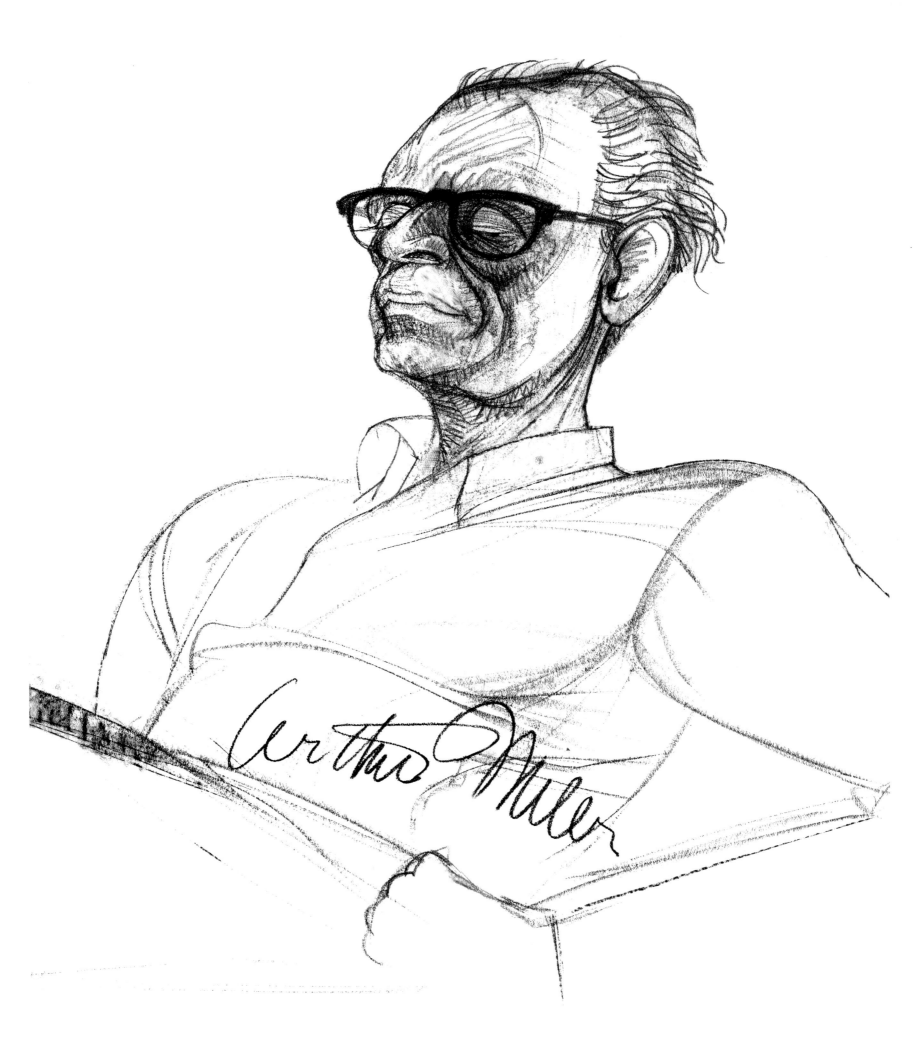

1967

I'd had an unhappy year at the *Daily Mail*, despite my E-type and free petrol. I felt as though my audience had changed, and I didn't take to going into the office every day. When the radical editor Harold Evans invited me to join the *Sunday Times*, I jumped at the chance. However, Harry also had difficulty placing me, and at first sent me on many reportage commissions – from an oil spill in Cornwall to the Six Day War in the Middle East. Reportage is a slightly outmoded form of journalism for an artist: before the advent of photography, artists were sent to make on-the-spot sketches of, for instance, the Boer War. These sketches were carried back to London and worked up into dramatic pictures for the *Illustrated London News* – completed by artists who had never seen the event they were depicting. The advantage of reportage for the artist is that one can amalgamate a number of incidents into one picture. I always felt slightly out of date and exposed as I sketched away in troubled areas like the Middle East, Vietnam and Northern Ireland. While photographers can click and run, I was left sharpening my pencils as the bullets flew.

Also at this time, I found an outlet for my more extreme work in the *New Statesman* under its editor Paul Johnson and literary editor Nick Tomalin.

In a scene from his autobiography, *Point of Departure*, James Cameron dines with Lord Beaverbrook and his guests Winston Churchill and Aristotle Onassis. Churchill slept through the meal, coming to only to receive a cigar between his lips and to make the V-sign; the other two talked about money all evening.

Opposite: Dinner with writer and journalist James Cameron: *New Statesman*, 21 July.
Above: Josef Stalin: *Sunday Times*, 1 October.
Left: Black Power and race riots in America: *Sunday Times*, July 30.

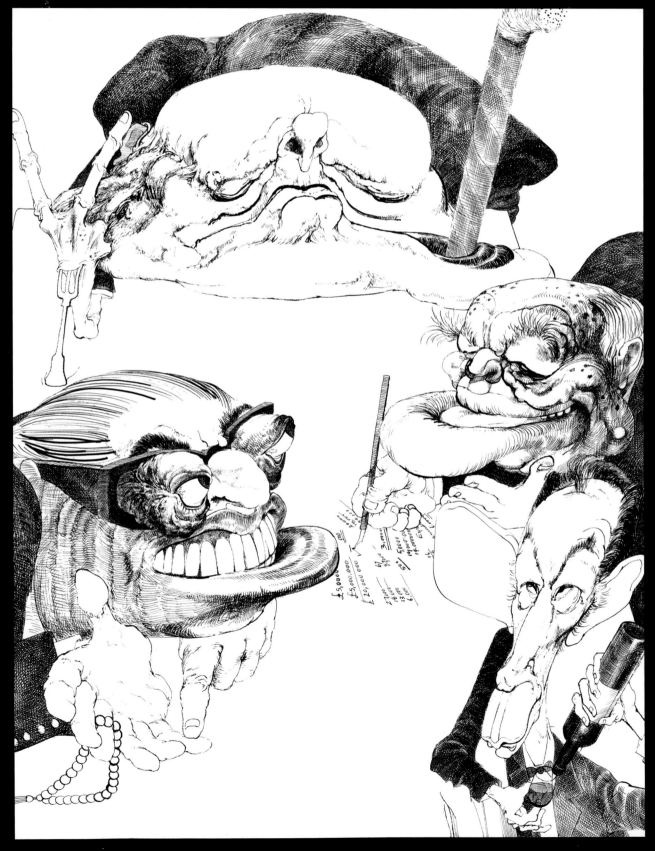

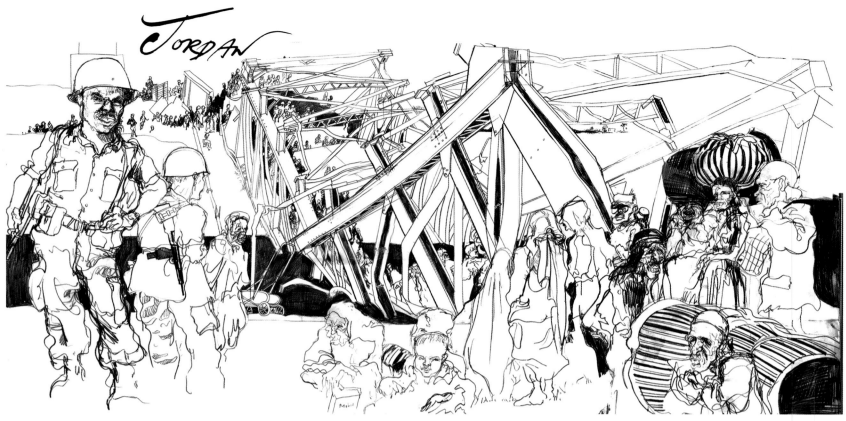

JORDAN

The Israeli tank drove straight at us, flattening a Mercedes and a Buick on the way. My taxi driver swerved into a field, his gun swinging on the door handle. I was on my way from Jerusalem to Jordan while making drawings of the Six Day War. This is a drawing made on the spot, by the destroyed Allenby Bridge.

Above: Six Day War – refugees crossing the Allenby Bridge, Jericho: *Sunday Times*, 18 June.

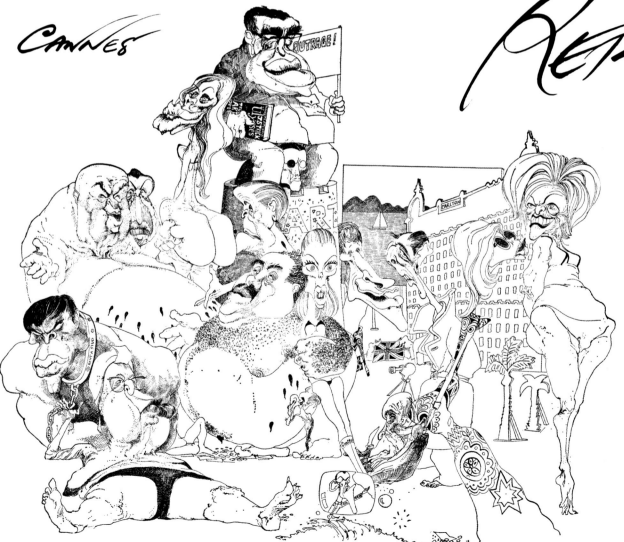

CANNES REPORTAGE

The paper sent me to the Cannes Film Festival and I made a number of sketches that I put together for this final piece. Among others we see (top) Joseph Strick and his notorious film of *Ulysses*, the producer and actor Paul Jones and Eric Sykes, plus a topless Cannes beauty and an anonymous ageing rich lady with a stud on a leash.

Left: Cannes Film Festival: *Sunday Times*.

Right: Mosley Common Colliery, three miles under Lancashire: *Sunday Times*, 23 July.
Below: Racing types at Aintree racecourse: *Sunday Times*.

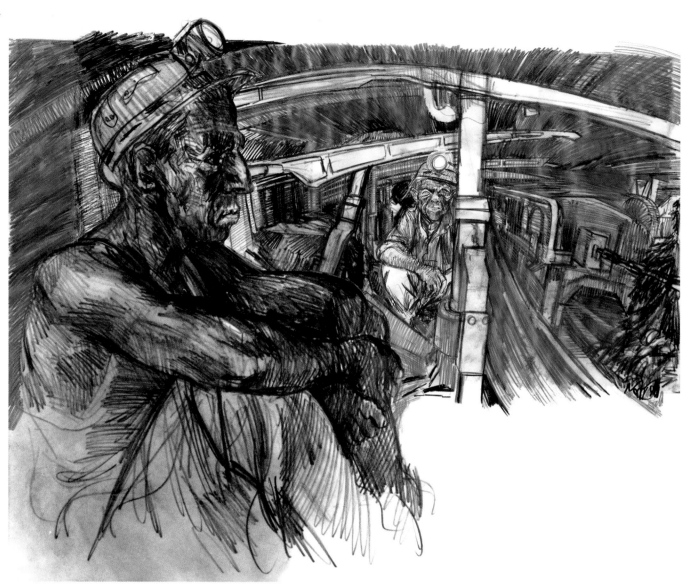

Lancashire

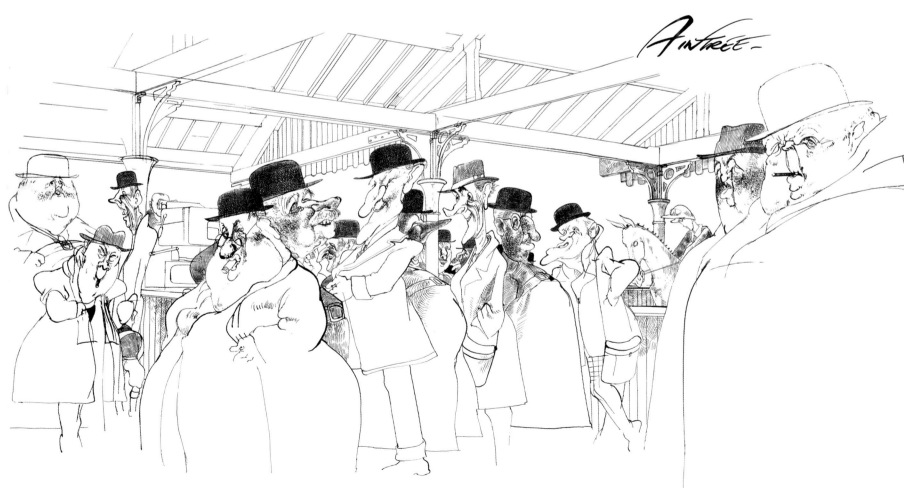

Aintree

I took the characteristics of Beardsley's drawings and caricatured them to the extreme. The *New Statesman* printed a censored version.

Aubrey Beardsley: *New Statesman*, 4 August.

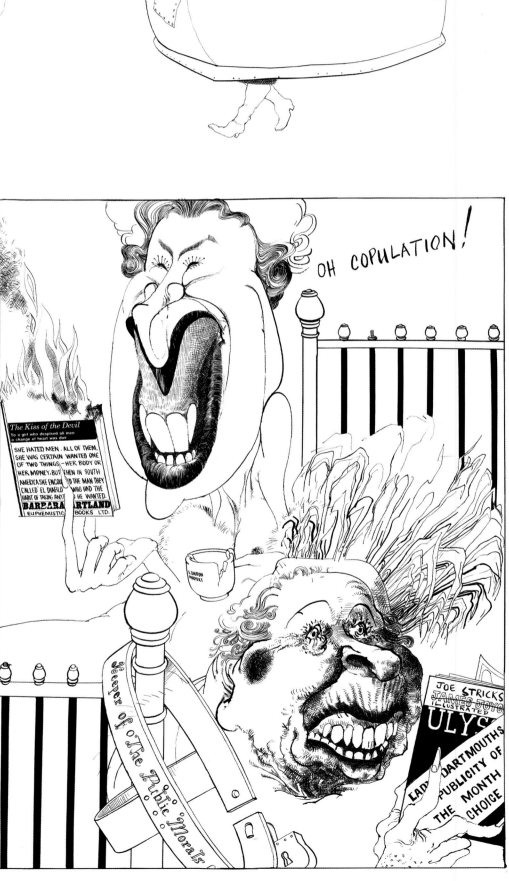

Lady Dartmouth (top), in a spate of righteous indignation, takes on the mantle of the keeper of the country's morals as she objects to Joseph Strick's film of James Joyce's *Ulysses*. Her mother, Barbara Cartland (bottom), wrote mildly titillating romantic novels, one of which her daughter is shown burning. Lady Dartmouth had also complained about the cracked and dirty state of British Rail teacups

Right: Storm in a Teacup – Oh Copulation!: *New Statesman*.

Top left: Sir Francis Chichester crosses the Atlantic, protesting that he wants to be left alone.

Top right: Orson Welles: *New Statesman*, 31 March. A swaggering Falstaff in his film *Chimes at Midnight* – and the spitting image of Père Ubu, the foul-mouthed 'hero' of Alfred Jarry's play *Ubu Roi*.

After printing the Beardsley and Johnson shitting bombs, the *New Statesman* editor, Paul Johnson, was incandescent when he thought I was trying slyly to slip a penis into the magazine. To this day I protest my innocence.

Left: The German statesman Konrad Adenauer.

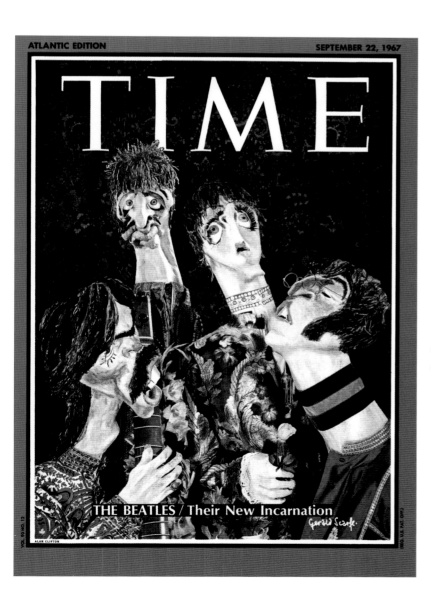

ATLANTIC EDITION

SEPTEMBER 22, 1967

TIME

THE BEATLES / Their New Incarnation

I followed the Beatles around for a week. I sketched them when they were filming *Help!* at Twickenham Studios and then visited their homes for more sketching. Ringo asked me to draw a caricature of him on his living-room wall. Paul explained the meaning of life, using a rose as illustration – I've forgotten how it goes now. And John told me, 'You're a cynic, Gerald, like me.' I decided to sculpt the Beatles in papier mâché, dipping small pieces of torn-up newspaper into a flour-and-water paste and applying them in layer after layer onto a wire armature. Many years later the sculptures made a dream home for the biscuit beetle. Ironically, the fate of my Beatles was to be eaten by beetles.

This page: *Time* magazine cover, 22 September: the sketches of John, Paul, George and Ringo were made on the set of *Help!* at Twickenham Studios.

Ubu Roi

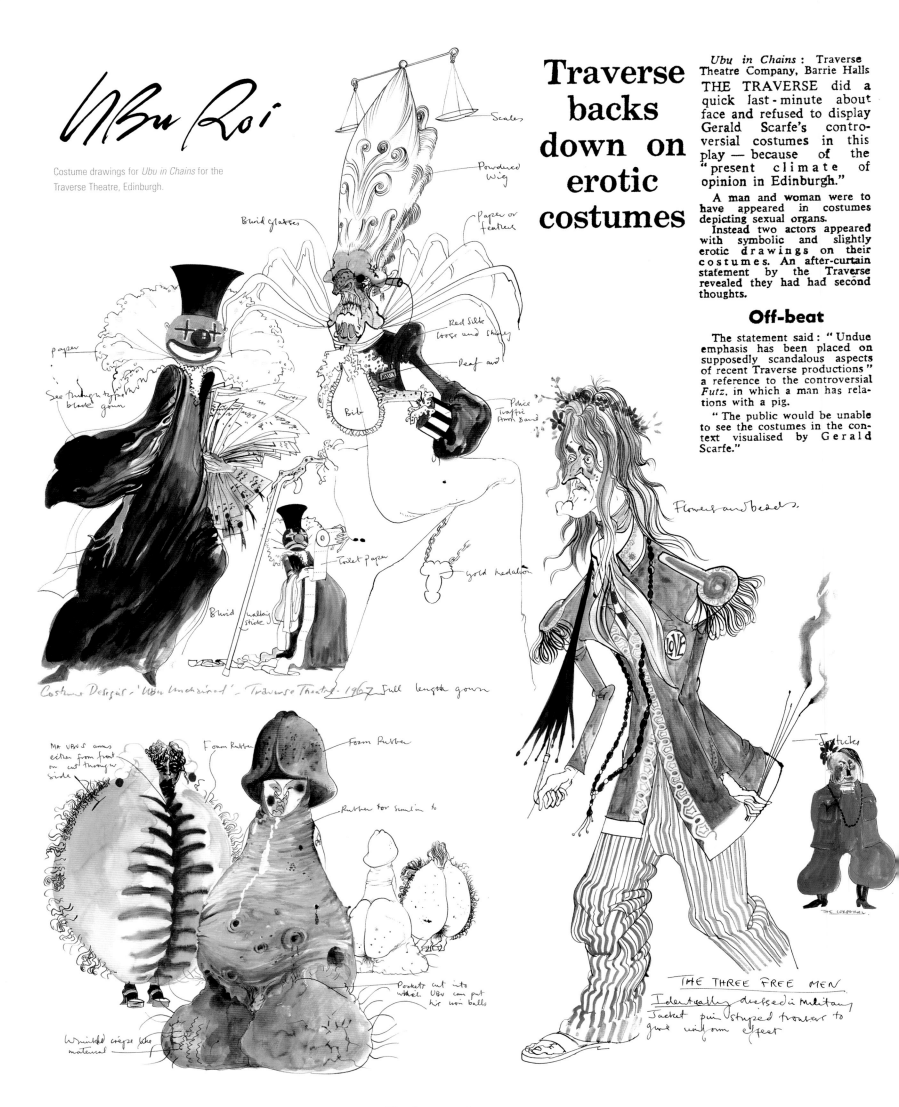

Costume drawings for *Ubu in Chains* for the Traverse Theatre, Edinburgh.

Scales

Powdered Wig

Paper or feathers

Braid glasses

Red Silk loose and shiny

Deaf aid

Bib

Police Traffic Arm Band

See through top to black gown

paper

Gold Medalion

Toilet Paper

Braid walking stick

Costume Design – 'Ubu Unchained' – Traverse Theatre. 1967 Full length gown

Flowers and beads.

MA UBUS arms seen from front on cut through side

Foam Rubber

Foam Rubber

Rubber for semi in to

Pockets cut into which UBU can put his iron balls

Wrinkled crepe like material

Testicles

THE CORPORAL

THE THREE FREE MEN

Identically dressed in military Jacket pin striped trouser to give uniform effect

Traverse backs down on erotic costumes

Ubu in Chains: Traverse Theatre Company, Barrie Halls

THE TRAVERSE did a quick last-minute about face and refused to display Gerald Scarfe's controversial costumes in this play — because of the "present climate of opinion in Edinburgh."

A man and woman were to have appeared in costumes depicting sexual organs.

Instead two actors appeared with symbolic and slightly erotic drawings on their costumes. An after-curtain statement by the Traverse revealed they had had second thoughts.

Off-beat

The statement said: "Undue emphasis has been placed on supposedly scandalous aspects of recent Traverse productions" a reference to the controversial *Futz*. in which a man has relations with a pig.

"The public would be unable to see the costumes in the context visualised by Gerald Scarfe."

Heart Transplants

Christian Barnard and heart transplants: *Private Eye*.

Above: LBJ defecating bombs over Vietnam: *New Statesman.*
Opposite: Bob Dylan: *New Statesman.*

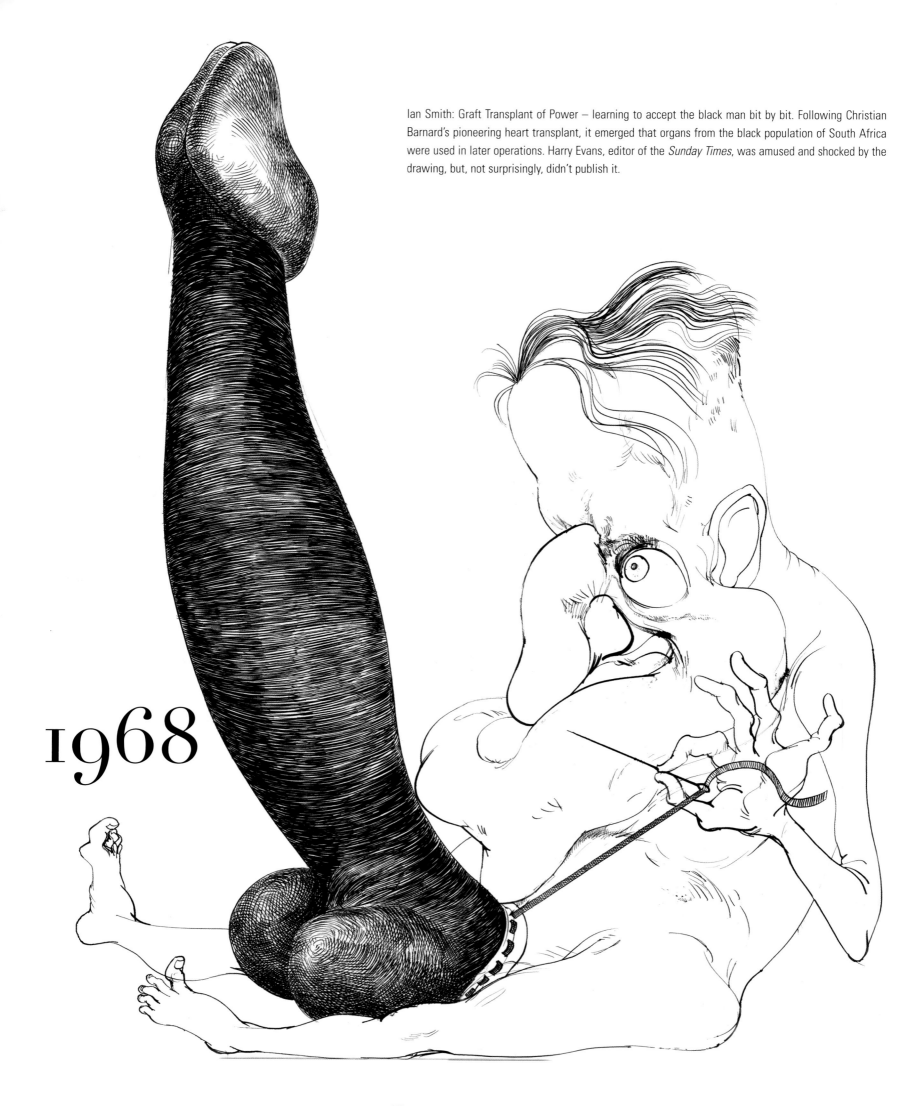

Ian Smith: Graft Transplant of Power – learning to accept the black man bit by bit. Following Christian Barnard's pioneering heart transplant, it emerged that organs from the black population of South Africa were used in later operations. Harry Evans, editor of the *Sunday Times*, was amused and shocked by the drawing, but, not surprisingly, didn't publish it.

1968

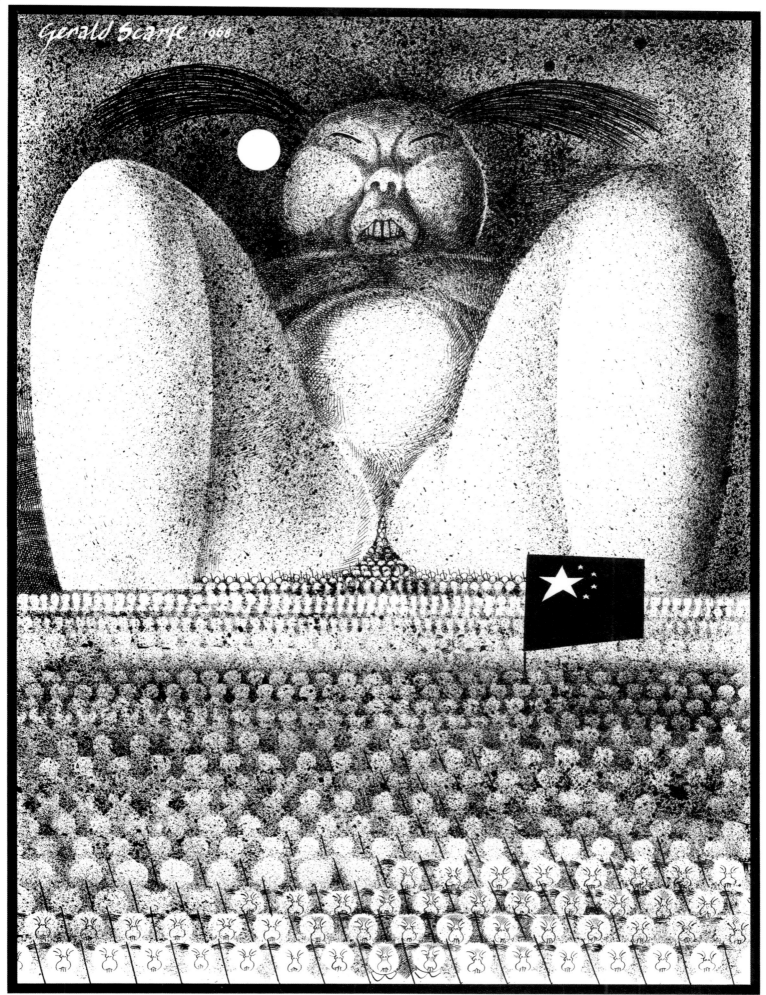

Gerald Scarfe 1968

Chairman Mao

Chairman Mao Gives Birth to the Chinese Millions: *Daily Mirror*, 6 March.

73 nineteen sixty-eight

The journalist and radio and television personality Malcolm Muggeridge was extremely kind and encouraging to me in my early career.

The Avenging Angel: *Sunday Times* magazine, 3 March.

I Think I See Violence All Around Me

I Think I See Violence All Around Me was my first live-action film, which I co-directed with John Irvin. It was one of a series of BBC films called *One Pair of Eyes*, in which personalities explored their own ideas, and I took as my theme what I saw as the violent state of the world. I interspersed animation amid the live action, which I drew under a rostrum camera — as I would draw the titles for *Yes Minister*.

Above: Animation – a flower grows and plunges through the eyes of a threatening monster.
Right: A violent and pugnacious gremlin.
Far right: GS filmed in an abattoir for the BBC film *I Think I See Violence All Around Me*.

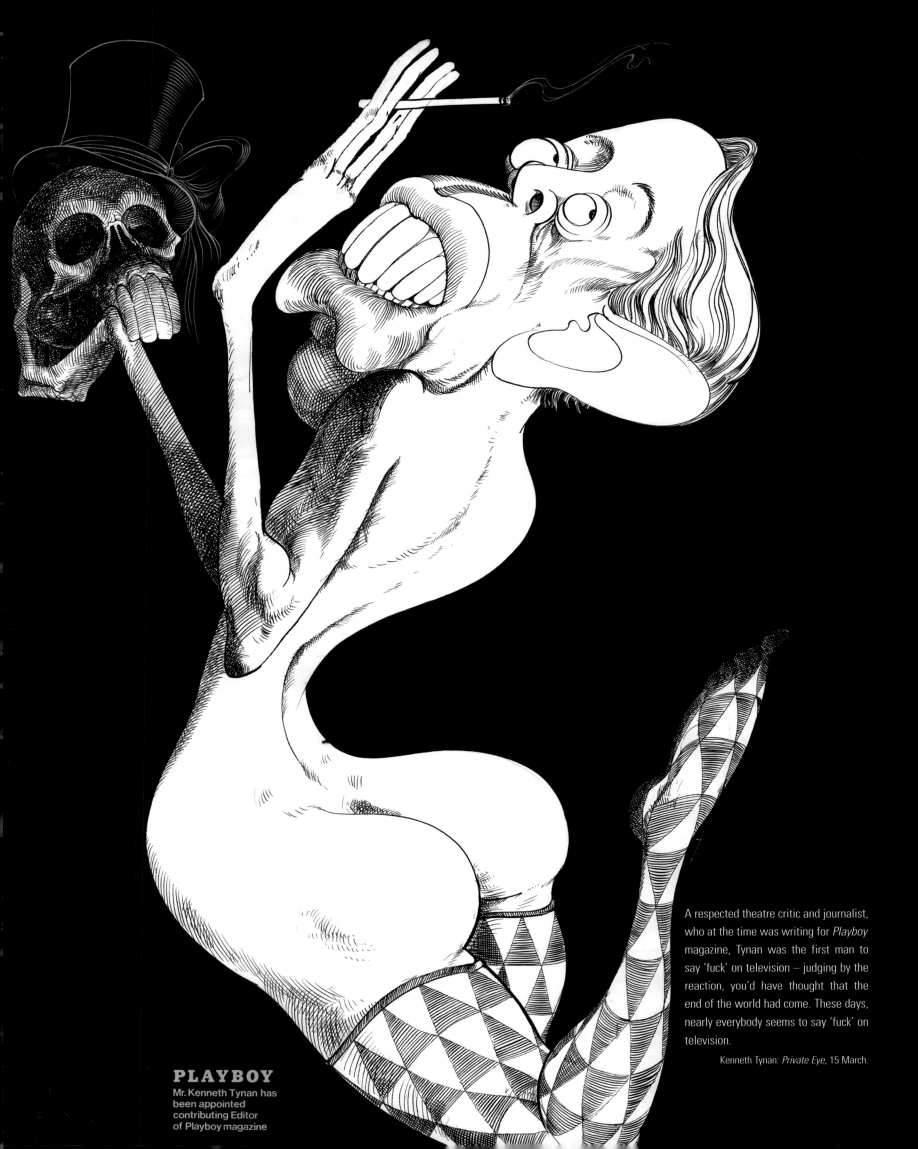

PLAYBOY
Mr. Kenneth Tynan has been appointed contributing Editor of Playboy magazine

A respected theatre critic and journalist, who at the time was writing for *Playboy* magazine, Tynan was the first man to say 'fuck' on television — judging by the reaction, you'd have thought that the end of the world had come. These days, nearly everybody seems to say 'fuck' on television.

Kenneth Tynan: *Private Eye*, 15 March.

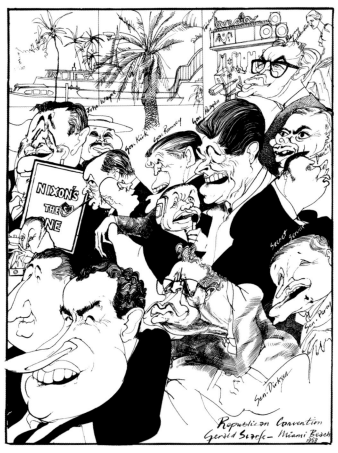

U.S. Elections

Far left: GS sketching at the Republican
Convention in Miami.
Left: John Wayne, Ronald Reagan and Spiro
Agnew among others, Miami Beach:
Time magazine.
Below: The Primaries – Robert Kennedy and
Freckles the dog, Eugene McCarthy, Richard
Nixon and Ronald Reagan electioneering in Los
Angeles, California: *Sunday Times*, 4 August.

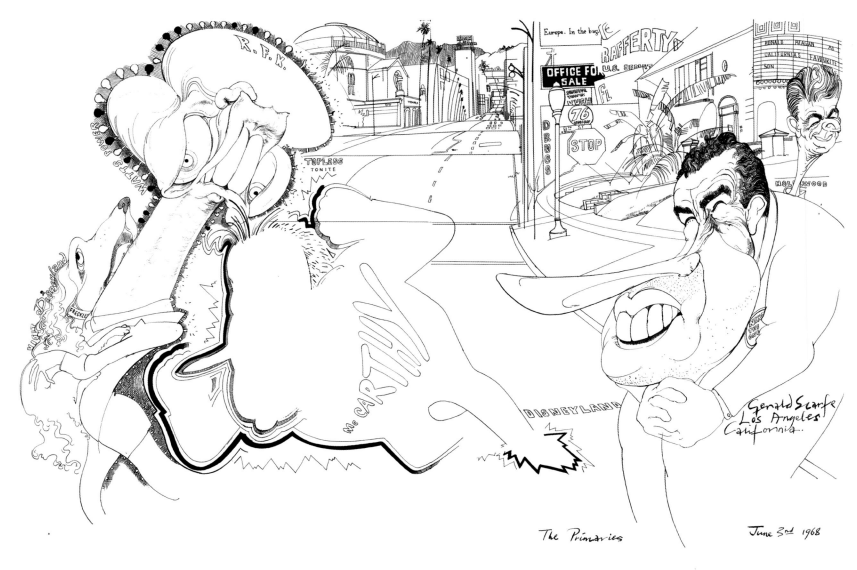

The Primaries June 3rd 1968

I flew with Kennedy in his private jet, following him for *Fortune* magazine. He was extremely charismatic, and everywhere he landed on his electioneering tour there was a clutch of eager, screaming females, many of whom he invited onto the jet for the thrill of a lifetime.

Above: Drawing made of Robert Kennedy shortly before his untimely death. I was in Los Angeles when he was assassinated.

My first attempt at a *Time* cover depicting American TV commercials was rejected because it was thought to be 'too English'. There is a successful sculpted *Time* cover overleaf.

Above: The rejected *Time* cover.

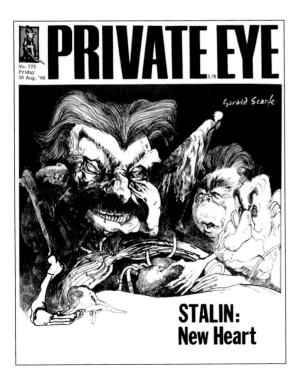

Left: *Private Eye* cover, 30 August: the late Josef Stalin, General Secretary Brezhnev and Premier Kosygin. The invasion of Czechoslovakia.

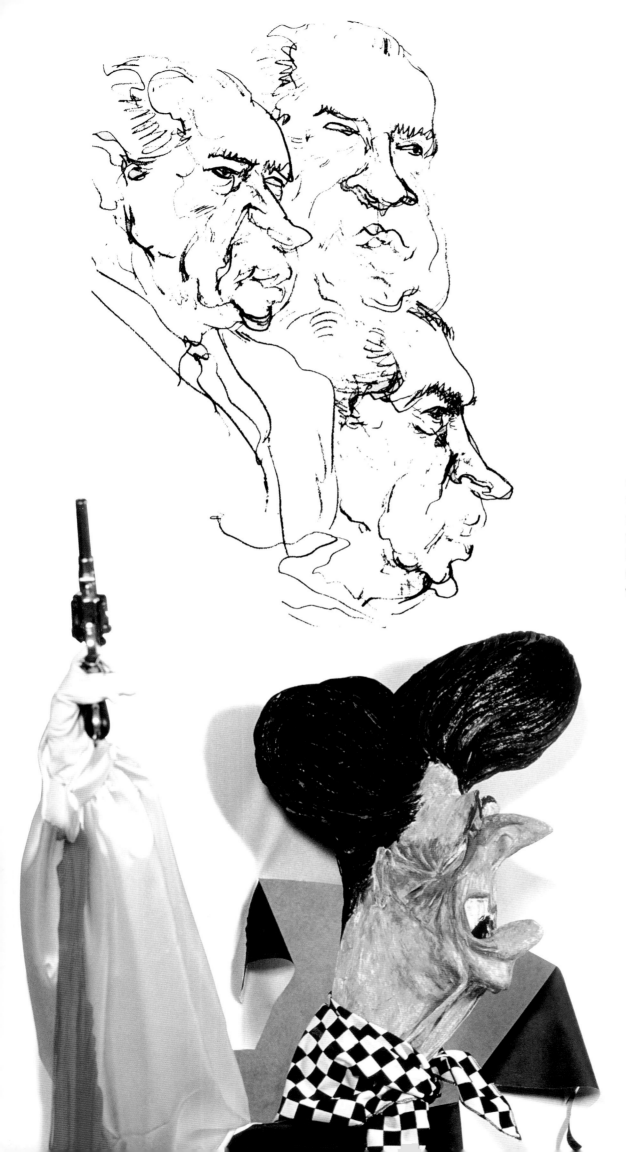

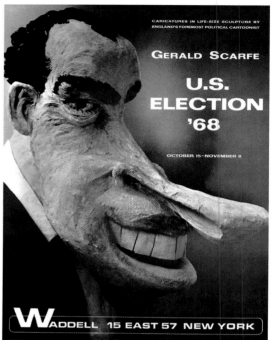

GERALD SCARFE

U.S.
ELECTION
'68

OCTOBER 15—NOVEMBER 9

WADDELL 15 EAST 57 NEW YORK

Time sent me on the campaign trail with Richard Nixon, the eventual victor in the 1968 American election. I was told that although he didn't know who I was, they'd researched the type of drawings I did and had tried to exclude me from travelling with him on the campaign plane. However *Time*, being omnipotent, said I was bloody well going. He hated my drawing him but tried to make friends. 'Hi, Gerry,' he would say. 'Are your pencils sharp today?'

Above left: Drawings made from life of Richard Nixon in Cheyenne, Wyoming.
Above: The resulting papier mâché model of eventual Republican presidential candidate Nixon, made for a *Time* cover. It was rejected.
Below left: Papier mâché model of the Republican Governor of California Ronald Reagan gunning for office: for my show 'US Election 68' at the Waddell Gallery in New York.

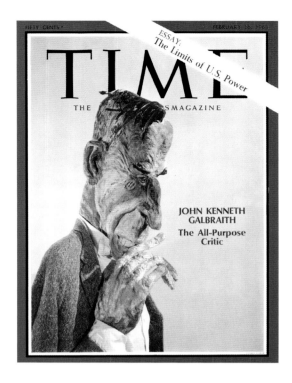

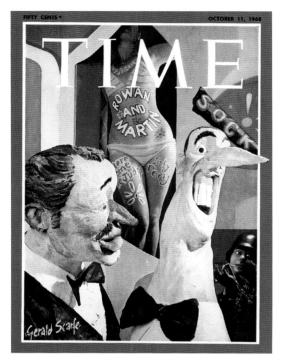

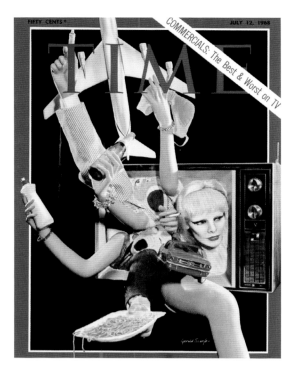

I made the sculptures of Galbraith and Richard Nixon in my rooms at the Algonquin Hotel in New York. The maids were in despair at the crazy Englishman who spent all day and night in his room tearing up copies of the *New York Times* into tiny pieces, and sticking them, soggy and smelly, onto grotesque figures. I obviously wasn't one of the Algonquin's intellectuals. They tried as best they could to clean the room while I was out buying a sandwich. Eventually, the management asked me if I would mind moving, as I was in Ella Fitzgerald's suite and she was coming back to town.

Top left: *Time* cover, 16 February: John Kenneth Galbraith (papier mâché). I flew to Boston to sketch the Canadian-born economist at home.

Top centre: *Time* cover, 11 October: the popular *Laugh-In* comedians Dan Rowan and Dick Martin (papier mâché and wood). I sketched Rowan as we sailed around the Pacific on his yacht. I am in the window, bottom right.

Top right: *Time* cover, 12 July: American TV commercials. A sculpture made of found objects.

Right: The assembled combatants (clockwise): Richard Nixon, Eugene McCarthy, George Wallace, Hubert Humphrey, Ronald Reagan, Nelson Rockefeller and Lyndon Baines Johnson. All for 'US Election 68' at the Waddell Gallery. Governor Wallace of Alabama was the presidential candidate of the American Independent Party, which he had formed, and he accompanied me onto *The Johnny Carson Show*.

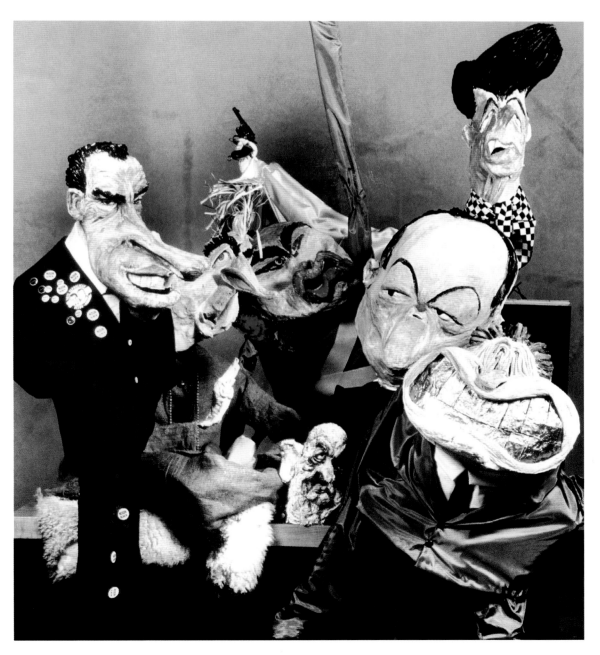

Nelson Rockefeller later bought his sculpture for his mansion. I'm told that it stood at the top of his stairs.

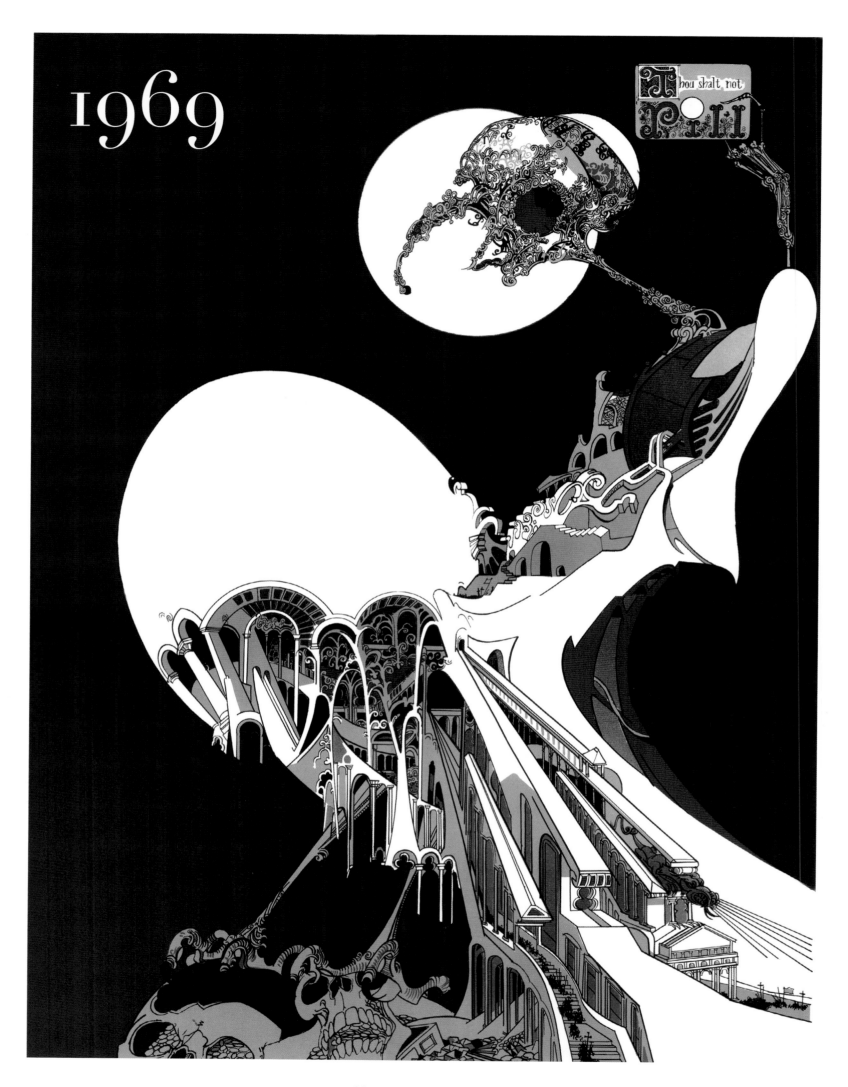

1969

Thou shalt not Pill

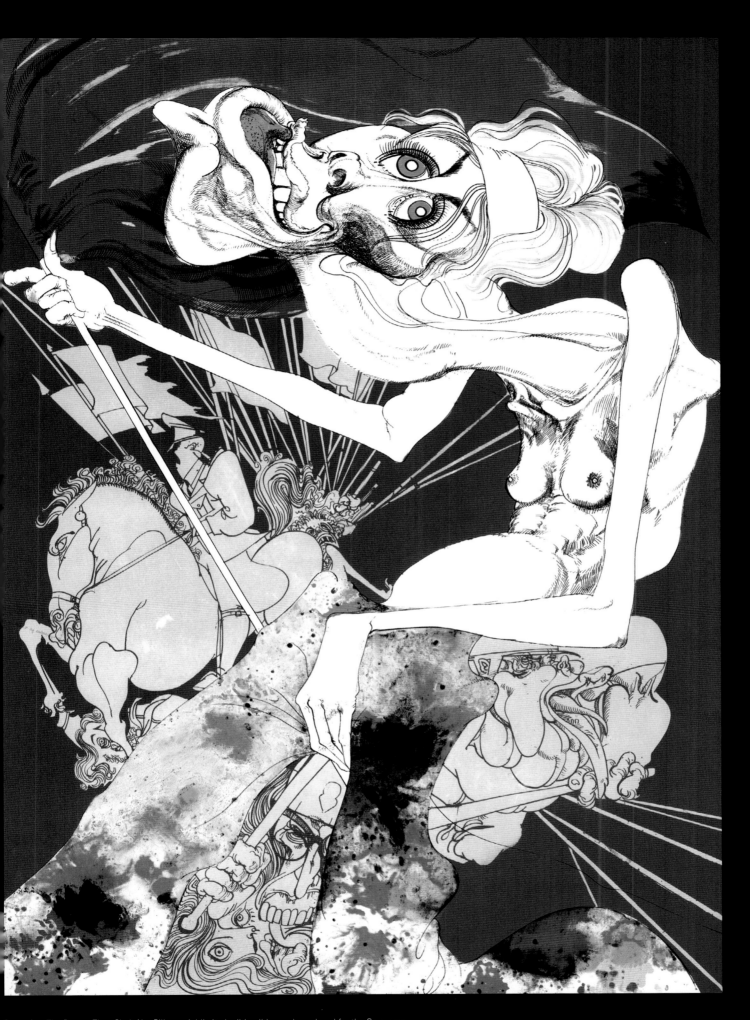

Opposite: The Pope – Thou Shalt Not Pill: special limited edition lithograph produced for the Grosvenor Gallery. Now it's Thou Shalt Not Condom to Aids-Ridden Africa.
Above: Grosvenor Square riots: special limited edition lithograph produced for the Grosvenor Gallery. Actor and activist Vanessa Redgrave feeling herself up with excitement at the thrill of the anti-Vietnam War riots.

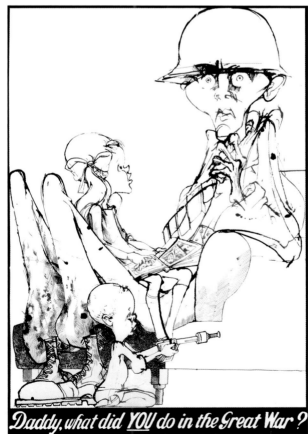

Opposite: Lithograph of Ian Fleming as James Bond (collection of Tate Britain).

Above: Ian Fleming as James Bond – the jokey, cavalier attitude of James Bond films coupled with the very real violence of Vietnam: limited edition lithograph. What's funny about violence?

Right: Daddy, What Did You Do in the Great War? – atrocities in Vietnam: *Sunday Times*, 30 November.

Magnis De Gaulle

Above: After the assassination of his brothers, Ted Kennedy is left to run with the ball.

Above: Landscape USA.

De Gaulle was arrogant and pompous – all questions had to be prepared, all answers were scripted. This lithograph was based on drawings I made from life at the Élysée Palace

Opposite: President de Gaulle: limited edition lithograph.

I enjoyed many drinks with Peter Langan at the bar of Langan's Brasserie. When the restaurant caught fire, Peter ordered a 'table and a bottle of champagne' to be taken across the road so that he could watch it burn to the ground – style!

Right: Mine Jovial Host: Sunday Times.

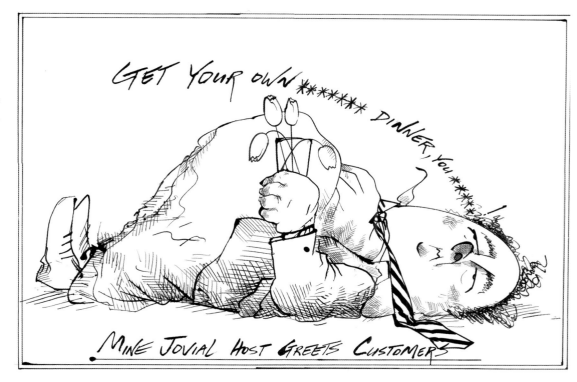

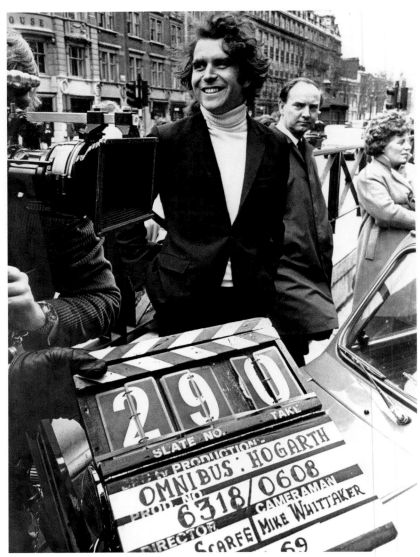

FILMING HOGARTH

I was asked to make a BBC film about the eighteenth-century artist William Hogarth. In it, I asked the question: What would Hogarth be if he were alive today? Cartoonist? Photographer? Journalist or what?

Above: Eighteenth-century Hogarthians looning about.
Left: GS gets a Bunny Girl in the right position.
Right: GS on location.

Right and left: David Bailey by me, me by Bailey: from his book, *Goodbye Baby* and *Amen*, published in 1969.

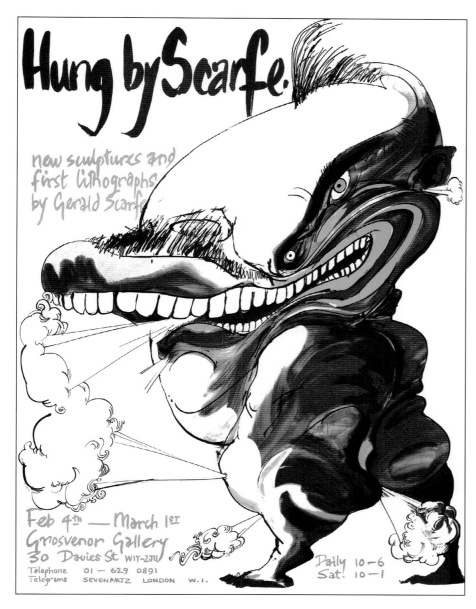

Hung by Scarfe.

new sculptures and
first lithographs
by Gerald Scarfe

Feb 4th — March 1st
Grosvenor Gallery
30 Davies St WIY-2JU
Telephone 01 — 629 0891
Telegrams SEVENARTZ LONDON W.I.

Daily 10—6
Sat! 10—1

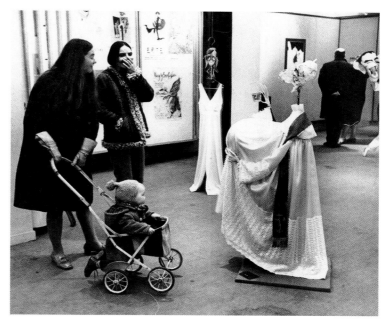

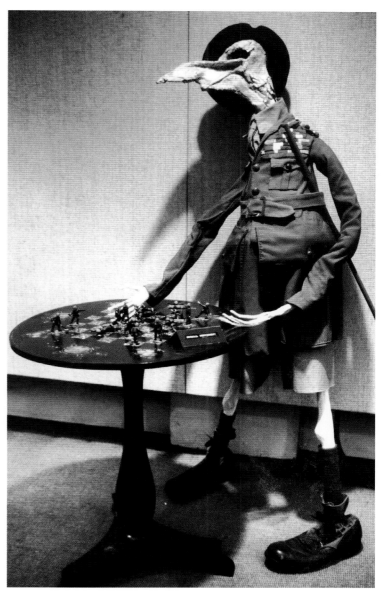

At the Grosvenor Gallery, Gerald Scarfe has clothed his scabrously pointed cartoons with plaster, chicken wire and yards of material and also produced a series of screenprints. Gerald Scarfe's cartoons are too familiar to need much elaboration. They are, I suppose, the embodiment of Swiftian venom in pen and ink, with the same obsessive relish for every human orifice as a potential sink of corruption. Behind each puckered or bulbous lip lies a writhing mass of lies waiting to spew forth, each hand stretched in benediction is really a grasping claw. His targets in the present exhibition, the first public display of a most secretive artist, are not new and the figures he has created are such vulnerable Aunt Sallys as Onassis, Ian Paisley and Enoch Powell. But his big treatment of them would draw a last rictus of pleasure from Gillray's gaping jaw. All the figures are larger than life, except for Field-Marshal Montgomery and the Pope, who have both shrunk to less than human stature and rattle around in their clothes alarmingly. The Pope, precariously held together by chicken wire, clutches the Pill as if it were the rock which occasioned the text 'Tu es Petrus'. Montgomery, the most successful figure in the show, hovers ghoulishly over a chessboard, on the point of moving a tin soldier to swift extinction, with his vulpine face eagerly watching the camera. For the men we love to hate Scarfe pulls out all the stops. The Rev Ian Paisley leans from the cross as if it were a soap box, and Enoch Powell, as a Janus-headed blackbird, bends like a contortionist to a battery of microphones. Onassis becomes an enormous octopus with gobstopper eyes and a filmy nightdress in one tentacle, while Prince Charles, elaborately hosed and gartered for his inauguration, is hardly visible beneath the kind of ears elephants fly with in nursery picture books. They will all give enormous offence in some quarters and hours of pleasure in others

STUFFED DUMMIES BY PAUL GRINKE – 14 FEBRUARY 1969.

IN 1963 Eric Estorick and his wife Sal opened in the Grosvenor Gallery the largest and most splendidly equipped public gallery in London and perhaps in Europe. It had 5,800 square feet of floor space facing Davies Street with a window as wide as the gallery. At the time of the notorious "Hung by Scarfe" sculpture exhibition, 1969, crowds of people gazing in stopped the traffic and an outraged visitor said: "I hope someone throws a brick through your window." Sal said: "We want people to see that an art gallery is no longer a holy of holies." It was an "internationally minded art emporium" called by Arthur Moyse in the *Anarchist Weekly* "this supermarket of the creative mind".

Top left: Poster for the Hung by Scarfe exhibition at the Grosvenor Gallery, London.
Top right: Sculpture in wire and cloth of Pope Paul VI on display at the Grosvenor Gallery, London. Twiggy hangs in the background, made from a wig, a mirror and a coat-hanger with a sixties dress. Encouraged by the success of my papier mâché sculptures, I began to experiment with other materials: wood, wire, cloth – anything.
Above: Alamein Pawns – General Montgomery playing with soldiers on a chessboard. A sculpture in wire and cloth for the Hung by Scarfe exhibition at the Grosvenor Gallery, London.

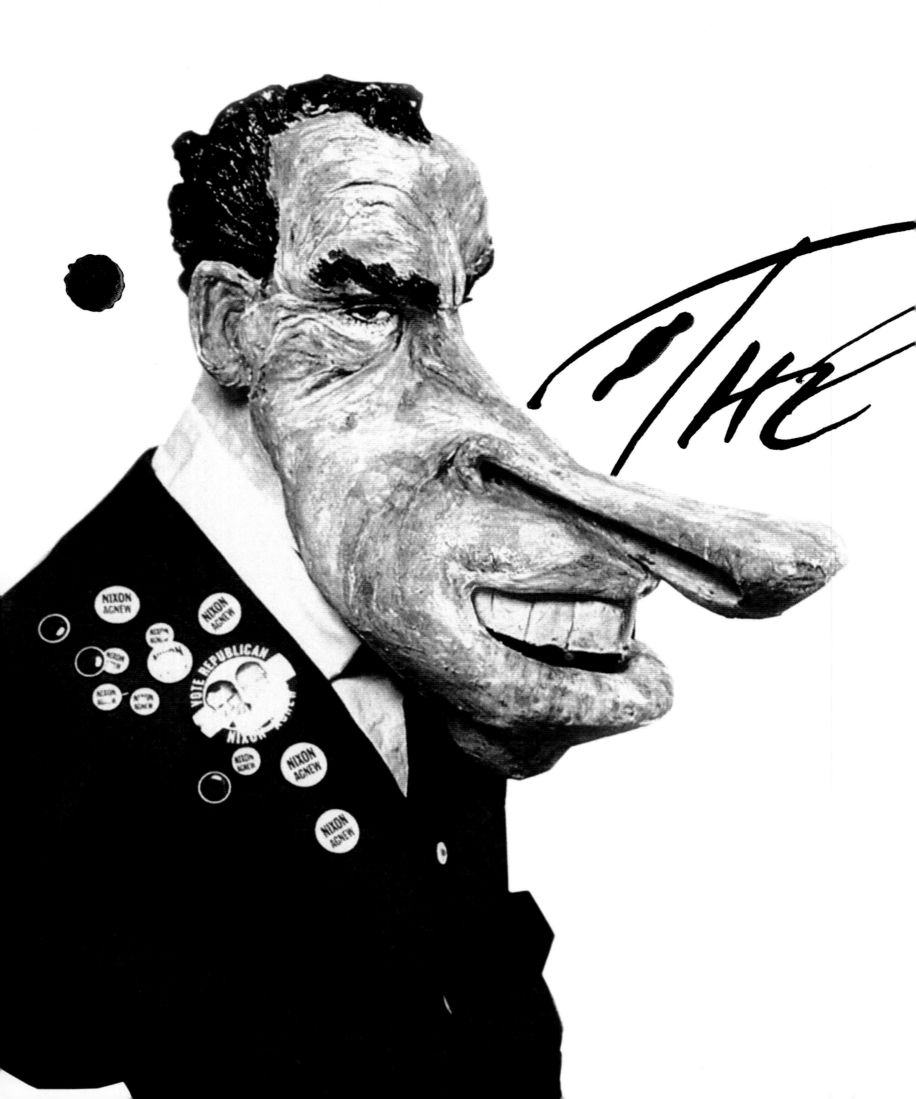

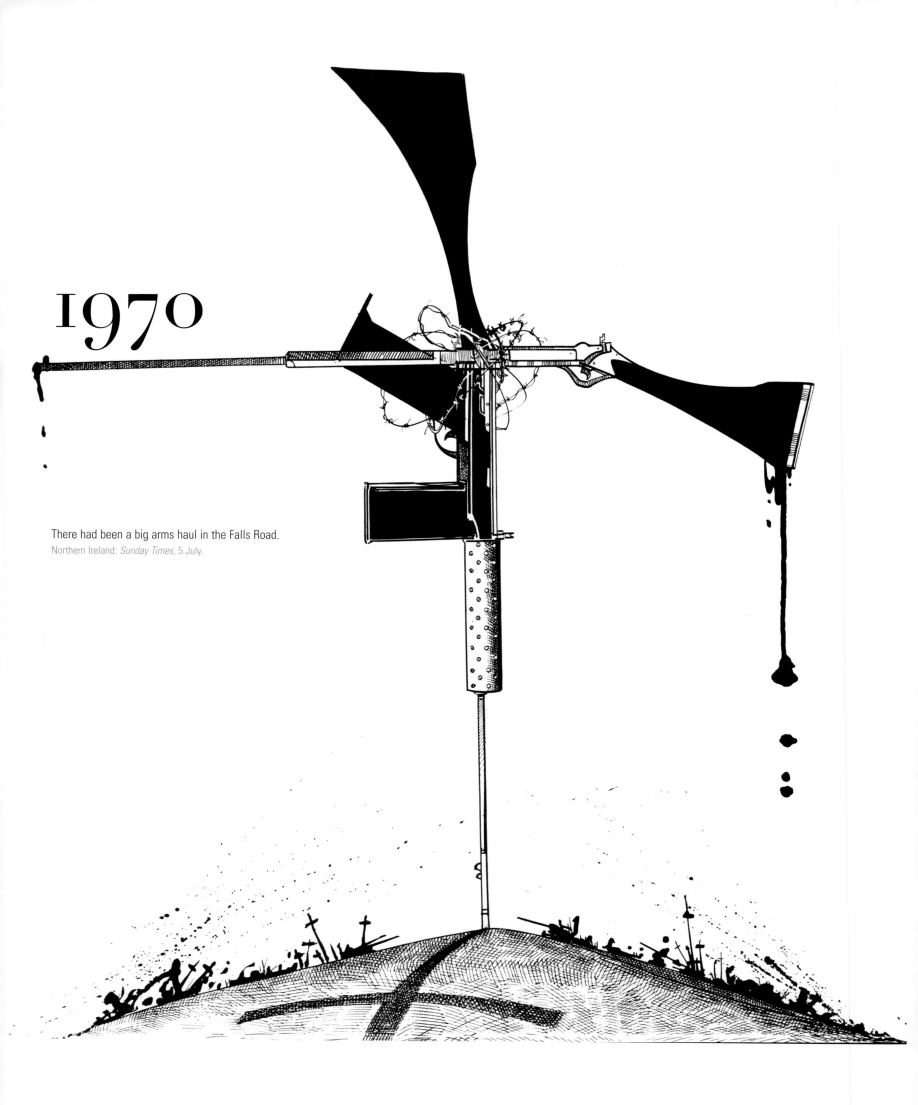

1970

There had been a big arms haul in the Falls Road.

Northern Ireland: *Sunday Times*, 5 July.

It's a living

BUY ME AND STOP ONE

The Arms Salesman

I remember the editor, Harry Evans, looking mystified by this drawing. He still printed it.

The Arms Salesman – Alec Douglas-Home, Foreign Secretary, as an arms salesman: *Sunday Times*, 12 May.

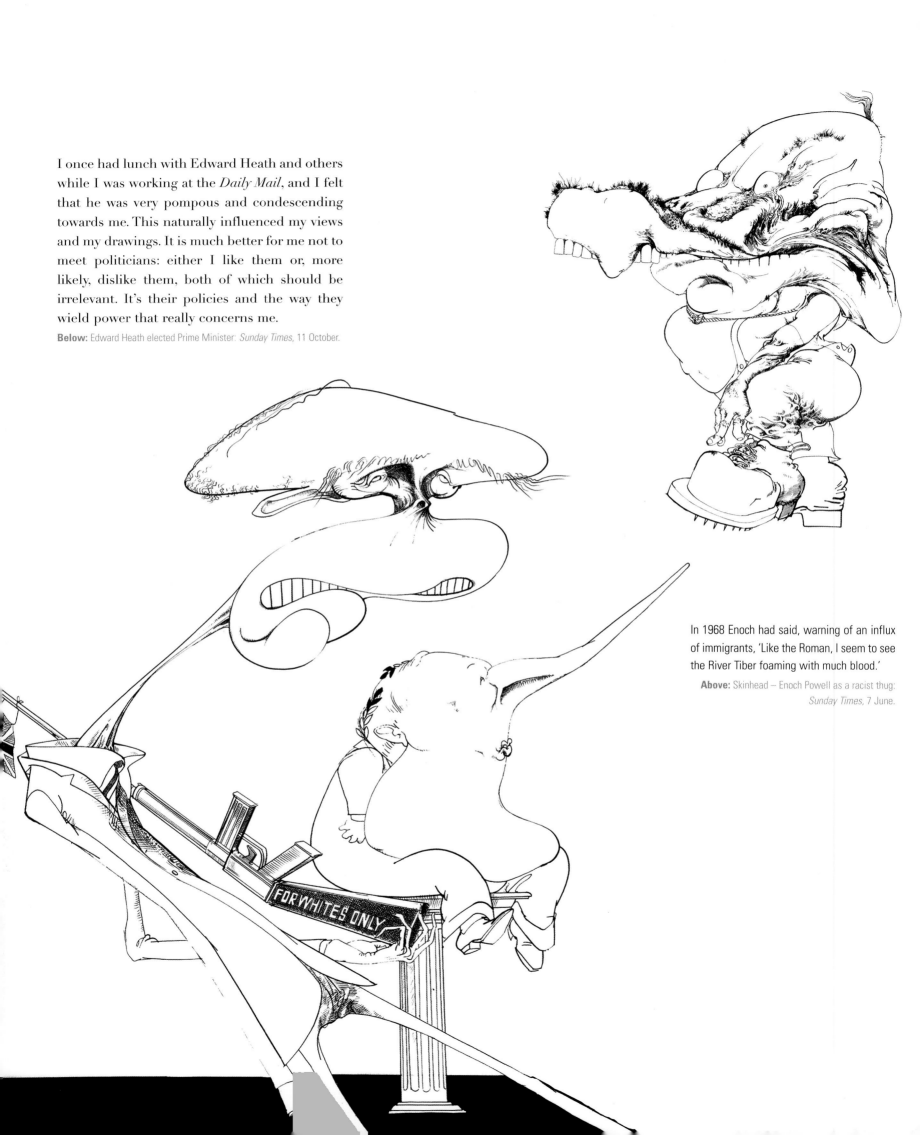

I once had lunch with Edward Heath and others while I was working at the *Daily Mail*, and I felt that he was very pompous and condescending towards me. This naturally influenced my views and my drawings. It is much better for me not to meet politicians: either I like them or, more likely, dislike them, both of which should be irrelevant. It's their policies and the way they wield power that really concerns me.

Below: Edward Heath elected Prime Minister: *Sunday Times*, 11 October.

In 1968 Enoch had said, warning of an influx of immigrants, 'Like the Roman, I seem to see the River Tiber foaming with much blood.'

Above: Skinhead – Enoch Powell as a racist thug: *Sunday Times*, 7 June.

FOR WHITES ONLY

A

CHILDREN'S PROBLEM

JOIN A TO B
(Baffles World Leaders)

B

Simple cartoon, simple message: join the child to the food. We still can't do it. I feel that – where possible in a newspaper – I should reduce a drawing to the bare essentials in order to make it immediately understandable. I am vying for attention among screaming headlines and skilfully designed advertisements, so – the simpler the better.

Join A to B – Famine in Biafra: *Sunday Times*, 25 June.

By RICHARD STOTT

ANNIGONI may be un-veiling his long-awaited portrait of the Queen next week.

But he has been beaten to the draw by cartoonist Gerald Scarfe with this lithograph, one of a series going on sale next week.

An uncommissioned image of Her Majesty . . . stripped of her majesty.

And if Annigoni's portrait is expected to arouse controversy, Scarfe's cari-cature—called " The Mas-querade is Over "—will, no doubt, stir up as great a storm with the inevitable accusations of bad taste.

Alone

Scarfe pictures the Queen as a sort of travel-ling saleslady—much the same role as when he last drew her four years ago.

Then she was seated on a moth-eaten charger with the words " Britain for Sale " across her breast and Prince Philip clinging grimly to the back of the horse.

Now Scarfe has put her alone in a corner with the suggestion of a tear on her cheek.

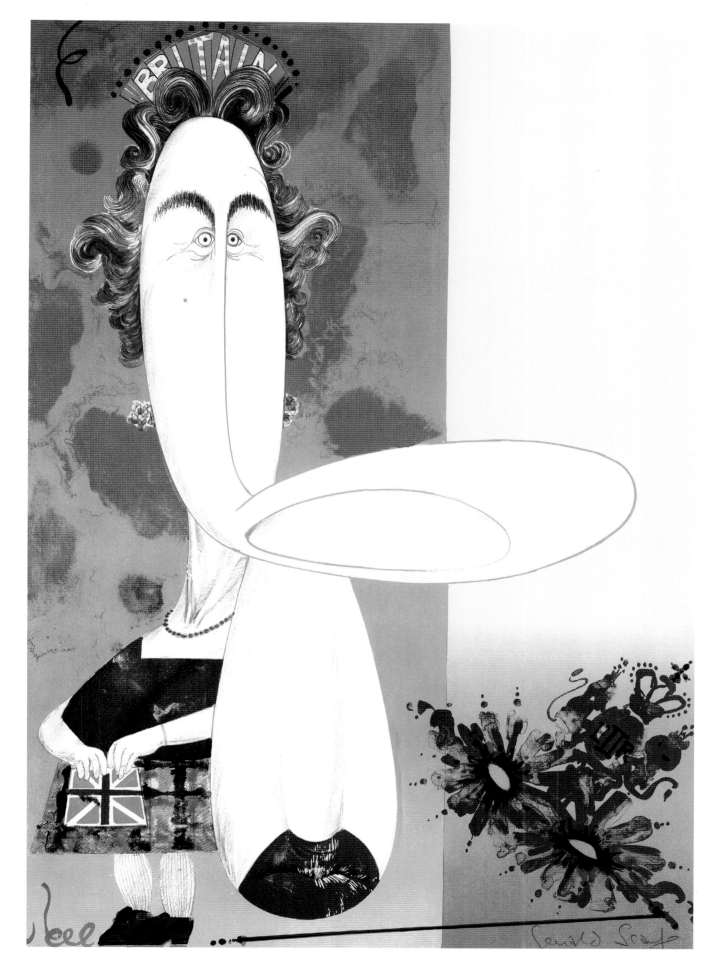

This marked my departure from detailed drawings and the start of a simpler form of caricature using broader shapes.

The Masquerade is Over – the Queen: lithograph (also *Daily Mirror*, 20 February).

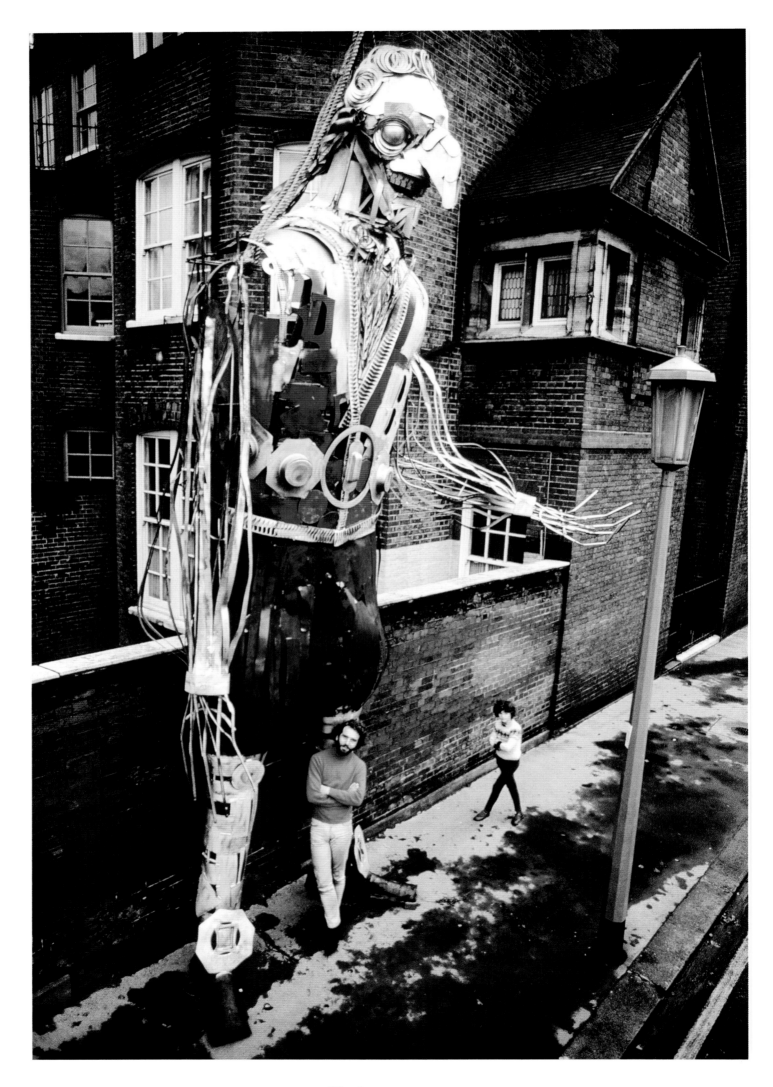

I built this sculpture of Gulliver out of scrap metal in my backyard in Chelsea, for Expo 70, an international showcase of British talent held in Osaka. The Central Office of Information commissioned a series of characters from British literary history, including Sherlock Holmes, Lewis Carroll's Alice, Mr Pickwick and Jonathan Swift's Gulliver.

Above: GS sculpting a model of Mr Pickwick from Charles Dickens's *Pickwick Papers* for Expo 70. In the background, *Alice Through the Looking Glass*. **Opposite:** Gulliver for Expo 70, Osaka

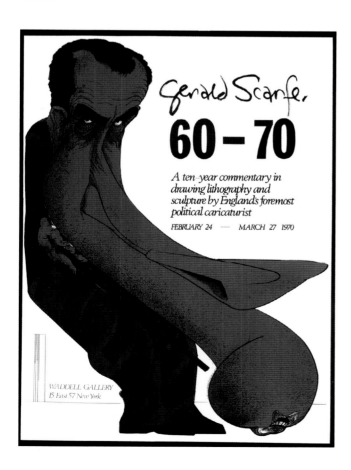

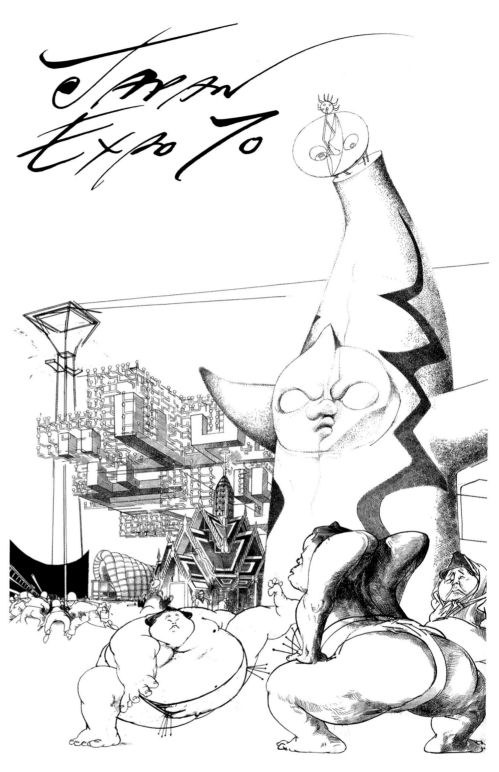

Above: Expo 70, Osaka – Sumo wrestlers set against the Expo site and buildings: *Sunday Times*, 15 March.
Left: 60–70 Poster for show at the Waddell Gallery in New York.

1971

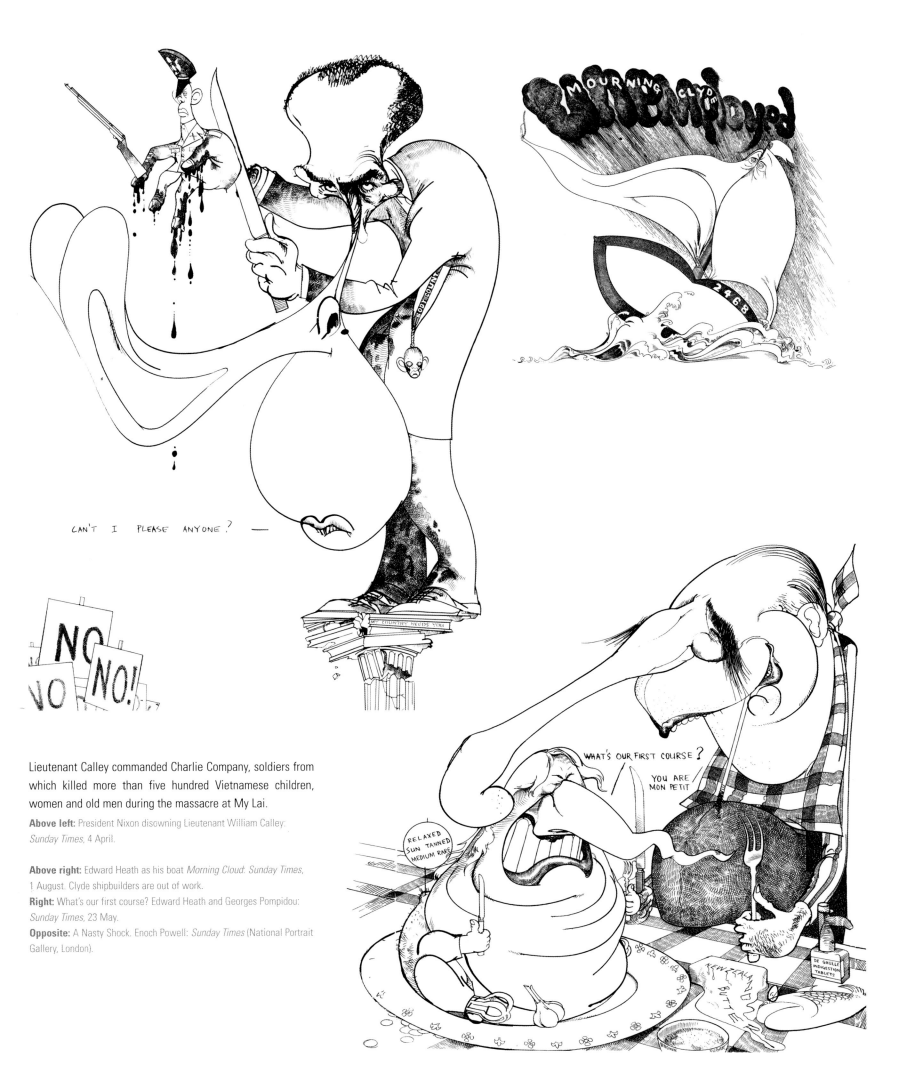

CAN'T I PLEASE ANYONE? —

NO NO NO!

Lieutenant Calley commanded Charlie Company, soldiers from which killed more than five hundred Vietnamese children, women and old men during the massacre at My Lai.

Above left: President Nixon disowning Lieutenant William Calley: *Sunday Times*, 4 April.

Above right: Edward Heath as his boat *Morning Cloud: Sunday Times*, 1 August. Clyde shipbuilders are out of work.

Right: What's our first course? Edward Heath and Georges Pompidou: *Sunday Times*, 23 May.

Opposite: A Nasty Shock. Enoch Powell: *Sunday Times* (National Portrait Gallery, London).

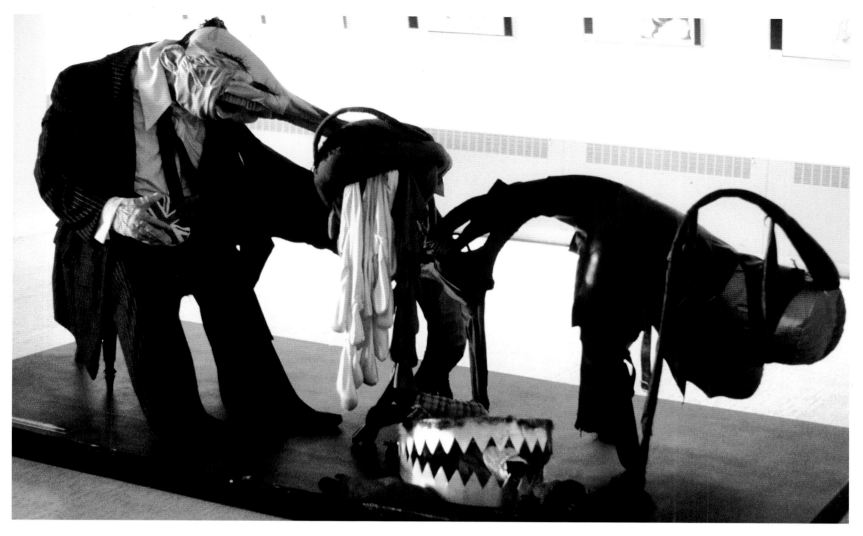

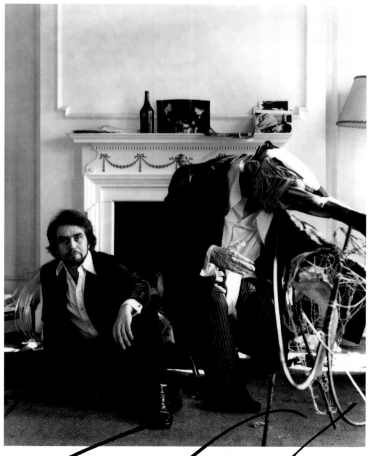

Chairman Mao – expensive pun. Shown in the Snap! exhibition at the National Portrait Gallery, London, 18 March–18 April 1971, that featured work by GS, David Bailey and David Hockney. This exhibition then went on tour, and met a sticky end when it arrived in Newport – see p.104.

Enoch Powell – showing the transformation from vulpine Powell into rabid dog and finally into steel trap with golliwog in its jaws.

Opposite: Chairman Mao (sculpture in wood and leather), from the Snap! exhibition.
Top: Enoch Powell (sculpture in cloth and metal), another Snap! exhibit.
Above left: Nixon in Wood, from Snap!.
Above right: Ted Heath as a runny cracked egg (moulded plastic sculpture), from Snap!.
Right: Scarfe by Bailey, during the construction of Enoch Powell for Snap!.

Snap!

MRS. MARY RIGHTEOUS EXPLAINS HER POSITION TO THE POPE

Mary Whitehouse styled herself an ordinary housewife, but also keeper of public morals. She often complained about what she had seen on television or read in the press, and she started a Clean Up TV campaign, which later became the National Viewers' and Listeners' Association. Her complaints were usually about sex. At one point, she went to Rome to see the Pope about the lax state of morals in Britain. I made this drawing for the cover of *Ink* magazine and, apparently, she wasn't too pleased — she sued me. I received a hilarious letter from her lawyers, couched in legal language, complaining that it suggested that their client was prepared to disport herself before the Pope. I forget how it ended, but I think that *Ink* magazine stumped up a couple of hundred and it all quietened down. Thank goodness she didn't see the uncensored version.

Mrs Mary Whitehouse Explains Her Position to the Pope: *Ink* magazine, 1 September 1971.

Obscenity!

As an artist, I feel I should comment on the whole of life, and, of course, that includes – most importantly – sex. The attitude today is much more laissez faire, but in the 70s, and despite the swinging 60s, there were those who publicly declared the whole thing rather disgusting and unnecessary and objected to any depiction of it by artists or writers. This obsession with sex seemed rather small beer while the world goes to hell on famine and war.

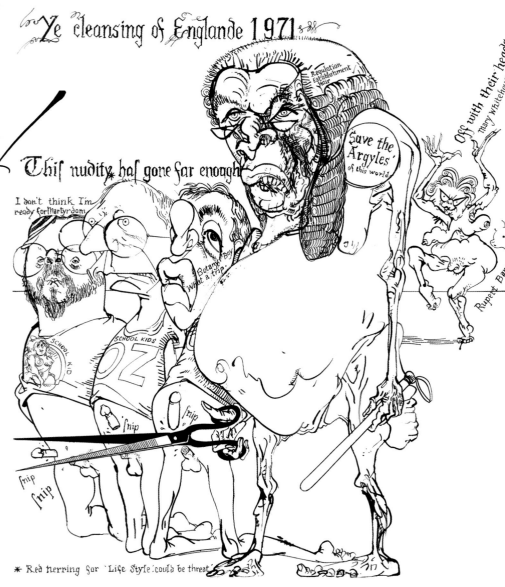

Ye cleansing of Englande 1971

This nudity has gone far enough

I don't think I'm ready for Martyrdom

Save the Argyles of this world

Off with their heads — mary whitehouse

Rupert Bare

* Red herring for 'Life Style' could be threat

The *Oz* editors, Richard Neville, Jim Anderson and Felix Dennis, are prosecuted for the 'school-kids' issue of the magazine. All three were sentenced to jail by Judge Argyle, Neville for sixteen months. The sentences were quashed on appeal.

Above: Ye Cleansing of Englande: *Sunday Times*, 8 August.

Lord Longford was an eccentric old bird, who decided, under the influence of Mary Whitehouse, to examine the morals of Britain, and felt it part of his duty to spend time with, and question, prostitutes about their way of life. He aimed to outlaw pornography but was seen by some as a prurient reactionary and a shameless hypocrite who toured the sex clubs that he wanted to close down.

Below: Close Your Eyes and Think of England: *Sunday Times*, 29 August.

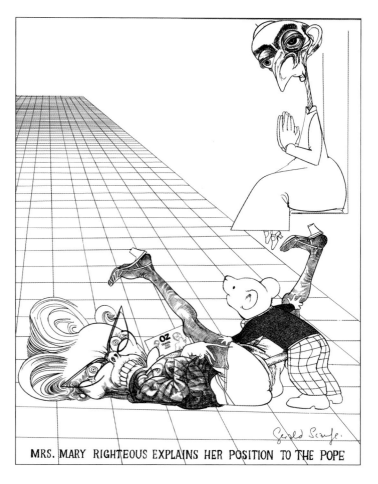

MRS. MARY RIGHTEOUS EXPLAINS HER POSITION TO THE POPE

Our attitude at this stage is that we had no intention of imputing sexual immorality to her or alleging that she was a hypocrite. It would be helpful to you therefore if at this early stage we made that clear in correspondence to Mrs. Whitehouse's solicitors.

As you know and as I have indicated to you on several occasions it is important that these matters are dealt with before they escalate. Once they do escalate you become heavily involved in costs which you are anxious to avoid. I look forward to hearing from you but in accordance with your instructions will do nothing at this stage.

Yours sincerely,

T. Moynihan

T. MOYNIHAN

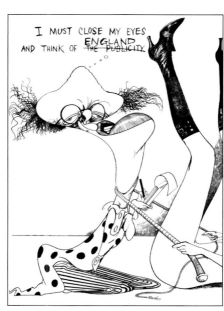

I MUST CLOSE MY EYES AND THINK OF ENGLAND ~~THE PUBLICITY~~

Above left: The unpublished Mary Whitehouse drawing.
Left: A letter from my lawyer.

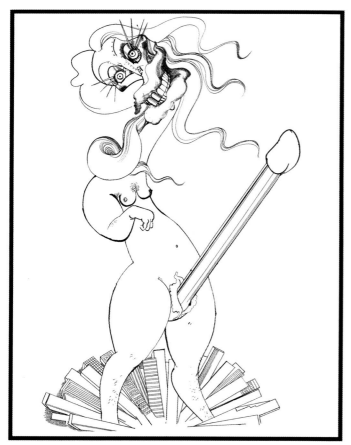

Womens Liberation Front — or — Venus Rises

Pausing only to buy a screwdriver at Woolworths, I made my way to Newport Art Gallery. I strode into the gallery and started unscrewing pictures from the wall. The director of the gallery was appalled. He ran around flapping his arms. He told me to stop or he would call the police. I told him to go ahead. After I had taken down about ten pictures, the police arrived and the director pointed me out in excited fury. I thought he would explode. 'Now then, sir,' said the inspector. 'What's all this about, then?'

I explained that my exhibition from the National Portrait Gallery was to be shown at Newport but a councillor and the committee had objected to three of my drawings, calling them 'Lavatory Wall Artistry', and wanted to take them out of the exhibition. On hearing this I had told the Arts Council, who ran the exhibition, that it was understandable if they didn't want to show them but they must remove the whole of my work or none of it. I had taken great trouble to pick a balanced, representative selection; the drawings they wanted to remove were sexual in content, but as an artist I felt there was no part of human activity that I should not show in my work, and indeed I was known for the use of human sexual activity as a vehicle in my drawing. Therefore it would be an incomplete collection if they were not included.

What had spurred me to take this action was that the committee had gone ahead with the exhibition without the three controversial drawings against my will.

'Well, Mr Scarfe,' said the inspector, ' you are completely within your rights to remove your property.'

I did.

The exhibition closed and the gallery director exploded.

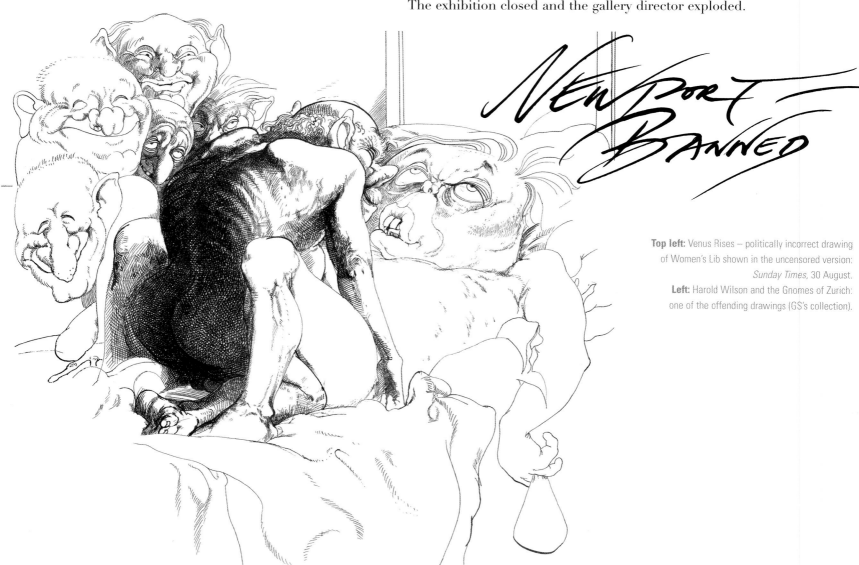

Newport Banned

Top left: Venus Rises – politically incorrect drawing of Women's Lib shown in the uncensored version: *Sunday Times*, 30 August.
Left: Harold Wilson and the Gnomes of Zurich: one of the offending drawings (GS's collection).

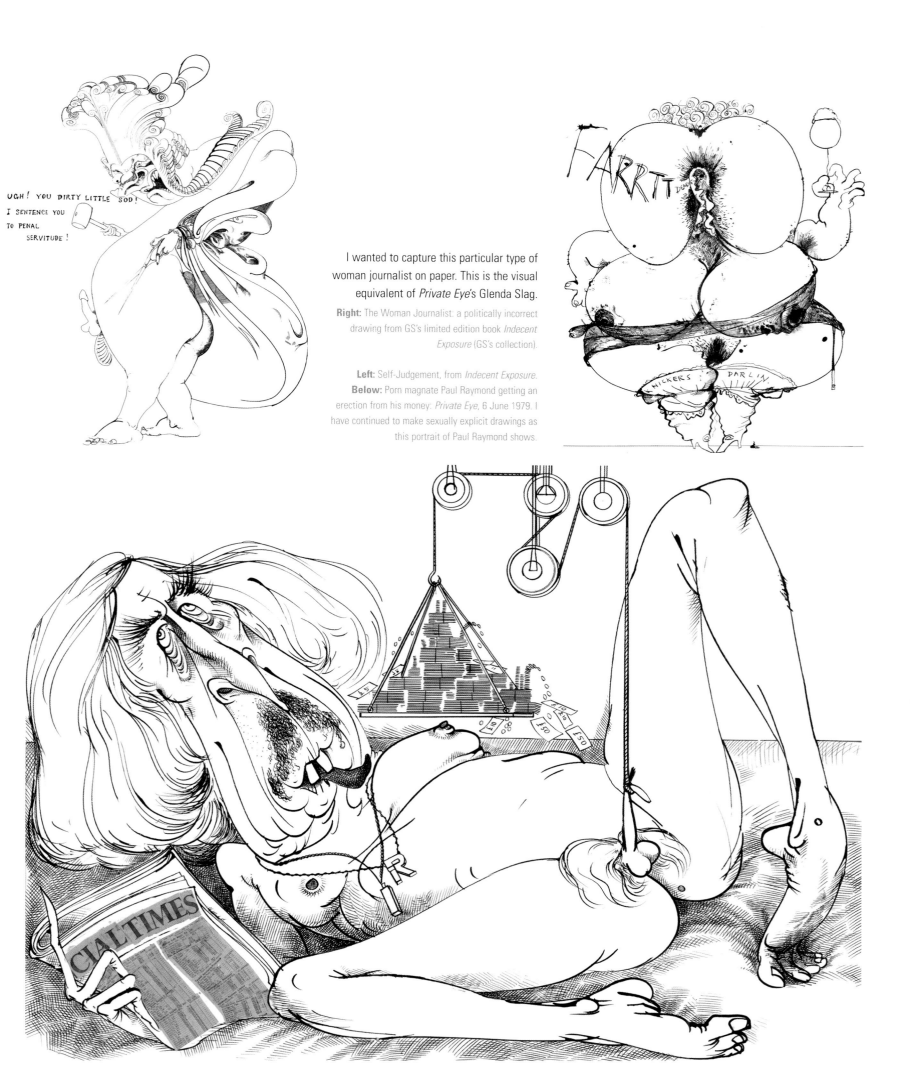

UGH! YOU DIRTY LITTLE SOD!
I SENTENCE YOU
TO PENAL
SERVITUDE!

I wanted to capture this particular type of woman journalist on paper. This is the visual equivalent of *Private Eye*'s Glenda Slag.

Right: The Woman Journalist: a politically incorrect drawing from GS's limited edition book *Indecent Exposure* (GS's collection).

Left: Self-Judgement, from *Indecent Exposure*.
Below: Porn magnate Paul Raymond getting an erection from his money: *Private Eye*, 6 June 1979. I have continued to make sexually explicit drawings as this portrait of Paul Raymond shows.

FARRTT

NICKERS DARLIN

CIALTIMES

THE Real Obscenity

The Real Obscenity — war in Pakistan: *Sunday Times*, 9 May.

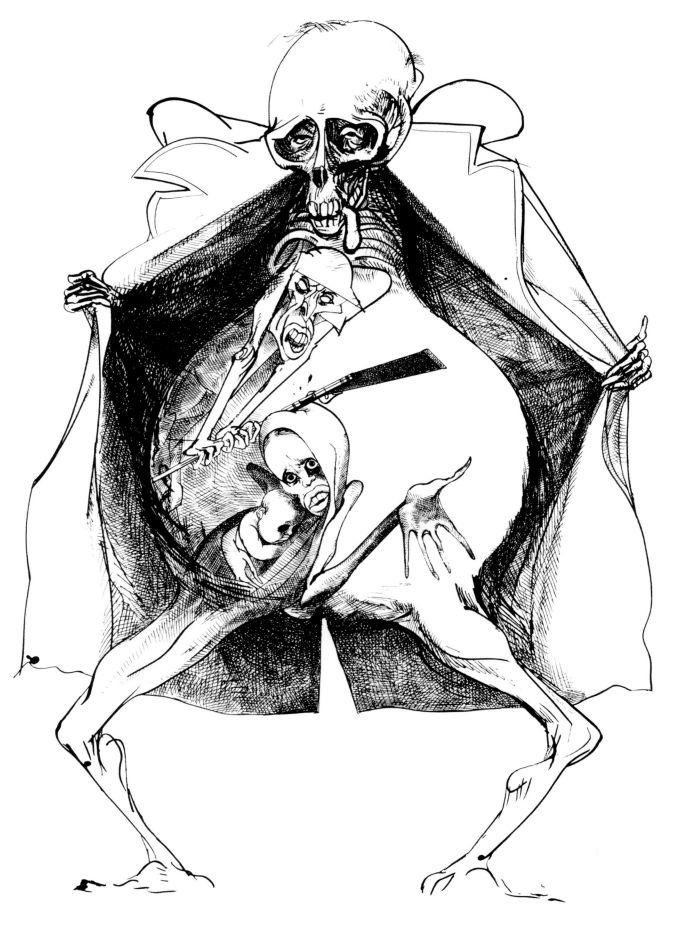

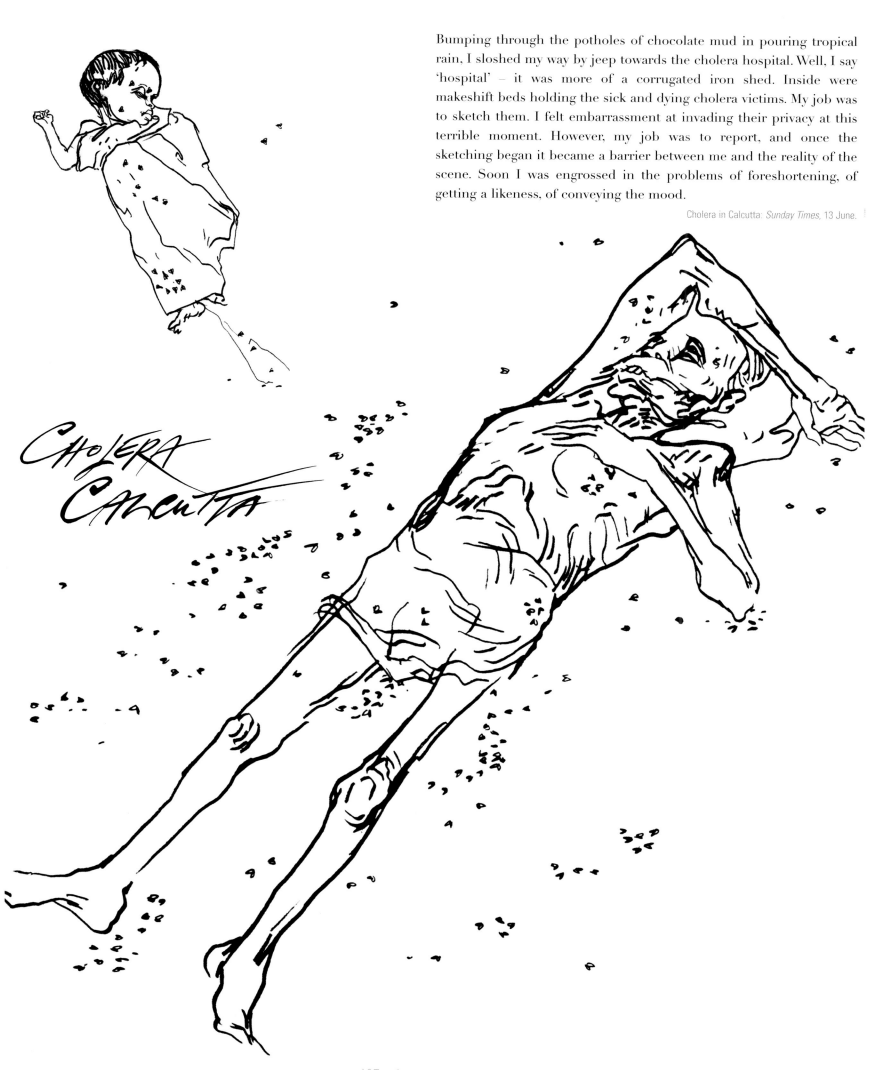

Bumping through the potholes of chocolate mud in pouring tropical rain, I sloshed my way by jeep towards the cholera hospital. Well, I say 'hospital' – it was more of a corrugated iron shed. Inside were makeshift beds holding the sick and dying cholera victims. My job was to sketch them. I felt embarrassment at invading their privacy at this terrible moment. However, my job was to report, and once the sketching began it became a barrier between me and the reality of the scene. Soon I was engrossed in the problems of foreshortening, of getting a likeness, of conveying the mood.

Cholera in Calcutta: *Sunday Times*, 13 June.

CHOLERA
CALCUTTA

1972

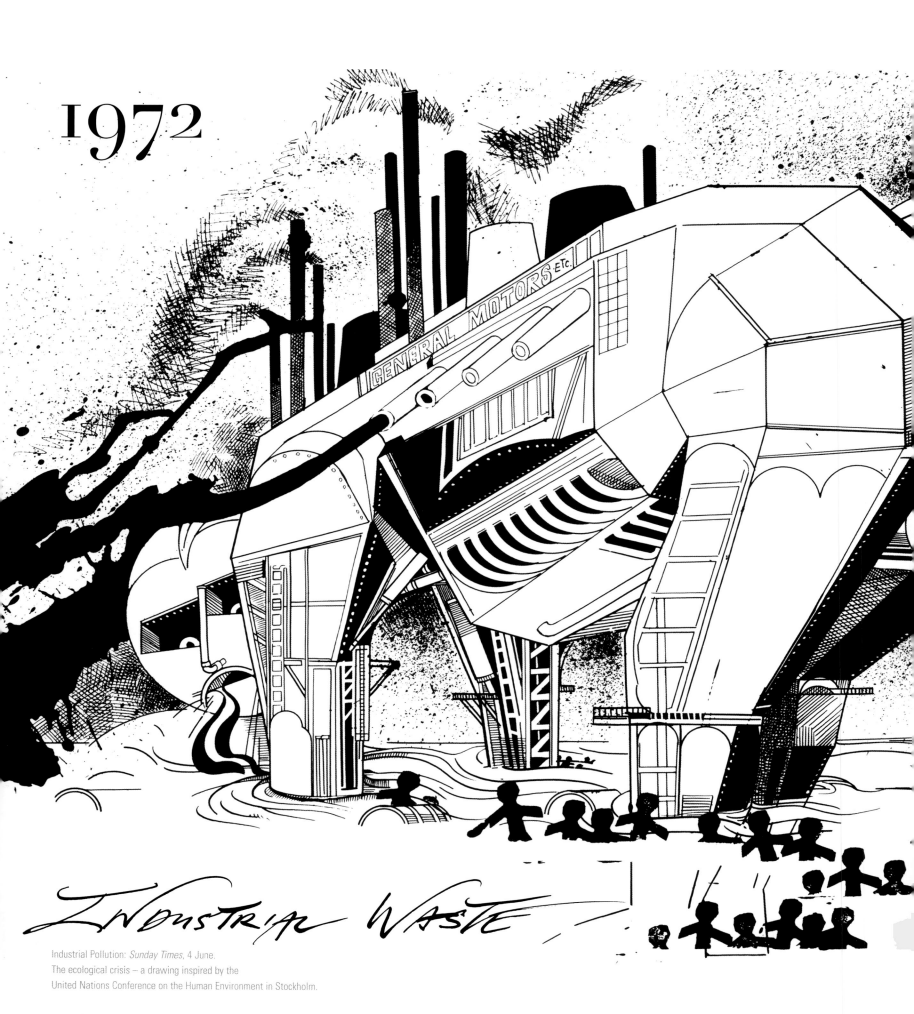

Industrial Waste

Industrial Pollution: *Sunday Times*, 4 June.
The ecological crisis – a drawing inspired by the
United Nations Conference on the Human Environment in Stockholm.

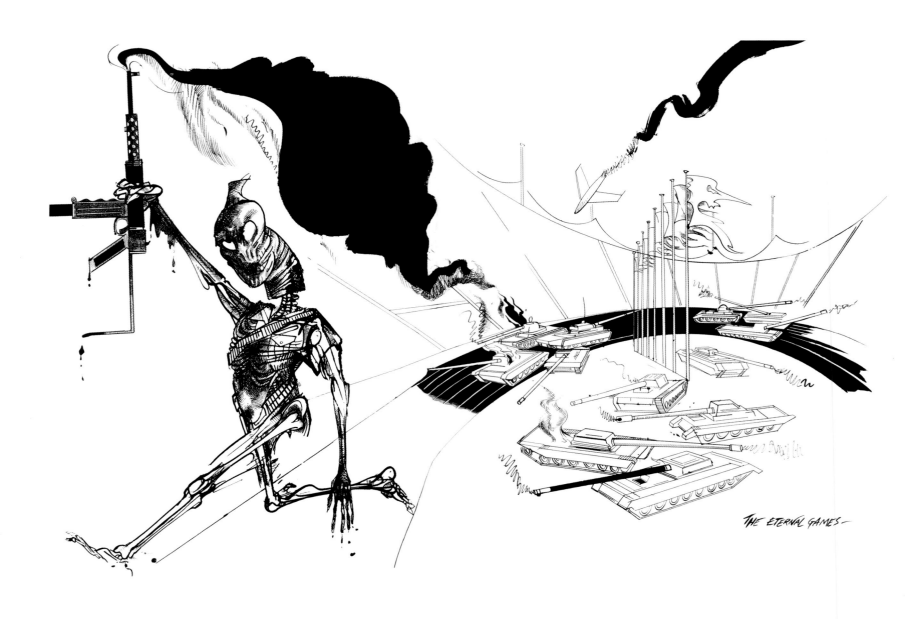

THE ETERNAL GAMES

Above: The Eternal Games – eleven Israelis are kidnapped and murdered by the Black September group at the Munich Olympics: *Sunday Times*, 10 September.

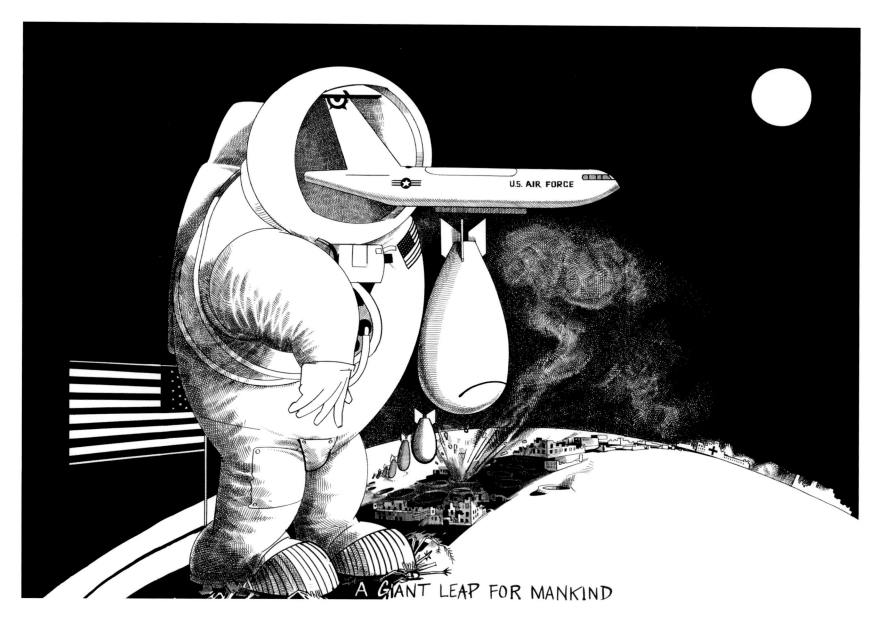

A GIANT LEAP FOR MANKIND

Bombs for Christmas. Nixon continued to carpet bomb Vietnam at Christmas time. He ordered the most pulverising saturation bombing of the wretched Vietnamese people. He appeared to think that bombs were nothing more than strategic counters in a political game.

Above: A Giant Leap for Mankind: *Sunday Times*, 24 December.

Hi JACKED

Unwisely, I drove my hired Cortina into the Catholic Bogside district of Derry in Northern Ireland. I had to go around several barricades of burnt-out cars. Once inside the deserted area, I stopped and moved into the passenger seat in order to have room to rest my drawing board on my knee, and began sketching one of the barricades and the Ross Hill Flats. After about half an hour, I was startled when a young man rapped on the window and asked me what I was doing. I explained that I was making a drawing for the *Sunday Times* in London. 'Well,' he said, 'we might need your car.' I explained that I was uninsured: Avis had refused to cover me because I was going into a dangerous area. He seemed satisfied with this and went away. I discussed with my wife, Jane, who was reading in the back of the car, whether it would be better to run for it, or to continue sketching as though

I had a perfect right to. Before we could decide, a Zephyr pulled across the front of our car and three men leaped out. An unshaven man, with long, lank hair got into the driver's seat. The other two got into the rear seats and stuck automatic pistols in our ribs. 'This is official,' they announced. 'We're going to drive you somewhere.' We were driven for about half a mile and then told to get out. As we did, one of the men asked if we had anything in the boot we needed to take. I retrieved my drawing things, and, prickles running down our spines, we walked away. I later heard that the IRA was very fond of Cortinas: they had large boots and could hold plenty of gelignite. Later that day, they blew up the post office.

Opposite: Hijacked by the IRA.

1973

Long Drawn-Out Trip

Long Drawn-Out Trip was my first attempt at animation. The BBC sent me to Los Angeles to work on a twenty-minute film about all things American — a psychedelic stream of consciousness featuring Mickey Mouse, Black Power, *Playboy* magazine, the Statue of Liberty, Nixon and John Wayne. This was my first experience of full animation. Having been a Disney fan as a child, the magic of animation had always fascinated me, but I found that in practice it was a rather tedious business. There were exhilarating moments, when the character I had drawn 'took over' and developed a life of its own, suggesting and dictating to me the direction it would be taking in the next frame. I drew every frame myself directly onto 70mm film, in a frame area of 2" x 3" as shown in the photograph. The first frame I drew would be projected underneath the next empty frame so that I could trace and slightly alter the image. That would in turn be projected under the next empty frame, and so on.

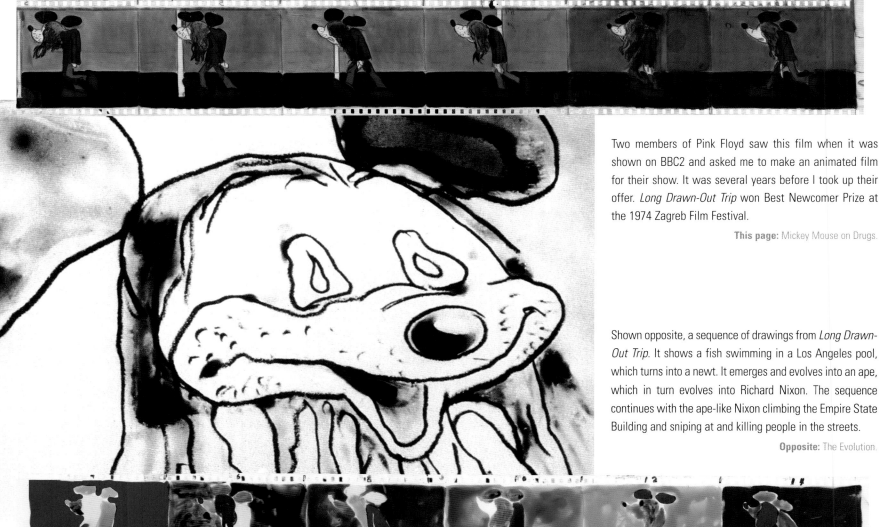

Two members of Pink Floyd saw this film when it was shown on BBC2 and asked me to make an animated film for their show. It was several years before I took up their offer. *Long Drawn-Out Trip* won Best Newcomer Prize at the 1974 Zagreb Film Festival.

This page: Mickey Mouse on Drugs.

Shown opposite, a sequence of drawings from *Long Drawn-Out Trip*. It shows a fish swimming in a Los Angeles pool, which turns into a newt. It emerges and evolves into an ape, which in turn evolves into Richard Nixon. The sequence continues with the ape-like Nixon climbing the Empire State Building and sniping at and killing people in the streets.

Opposite: The Evolution.

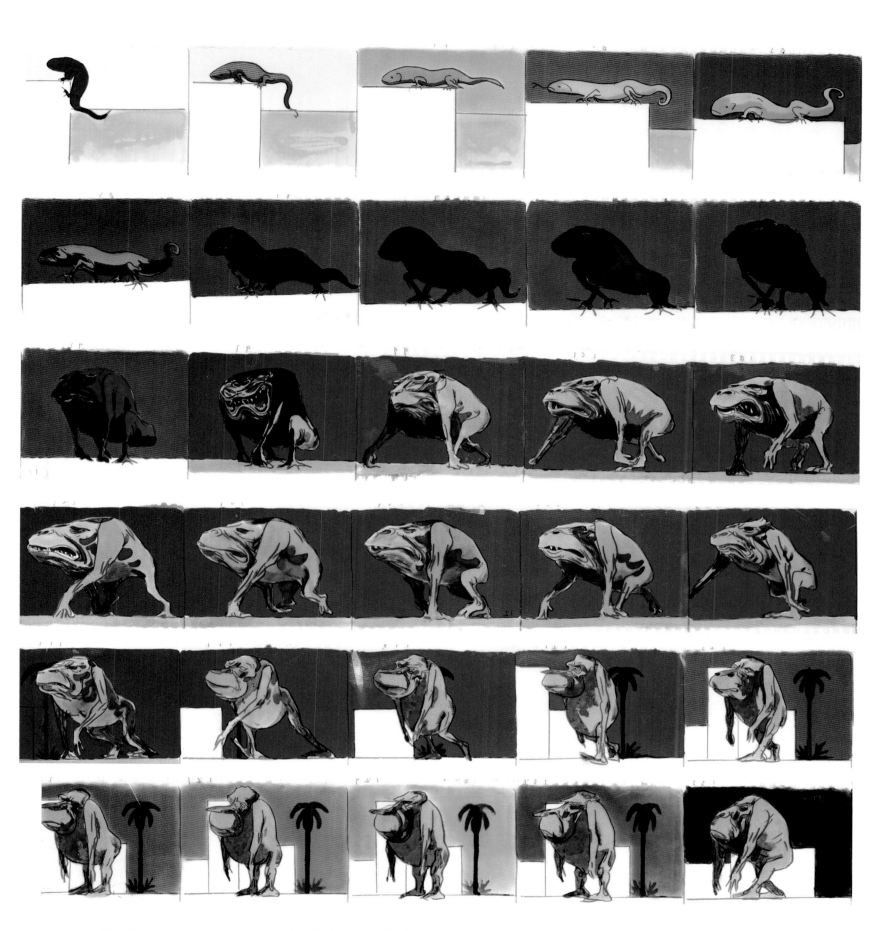

The most powerful and the most penetrating and unquestionably the outstanding film of the festival was also British, The Long Drawn-Out Trip by political cartoonist Gerald Scarfe. Scarfe, of course, is already an established artist of international reputation but this is his first animated film. He drew it for BBCTV during a six-week stay in California, using a new animation technique which allowed him to put down his ideas while they were still fresh. Its theme is the souring of the American Dream and its tone is vitriolic humour. John Wayne's voice lectures us on American ideals while his cartoon counterpart shoots Indians. Mickey Mouse degenerates into a drug-addicted hippie, as his face evolved at one point into Richard Nixon. Violence, smog, television and other aspects of US life today are viewed through an unflattering distorting mirror. Scarfe combines his inventive images and caricatures with an equally inventive soundtrack of song, speeches and real (instead of cartoon) noises. The satire is savage and close in spirit to Swift; deft and devastating. After Scarfe, most of the other films at Zagreb seemed irrelevant.

ZAGREB '74: *FILMS & FILMING*, KEN WLASCHIN.

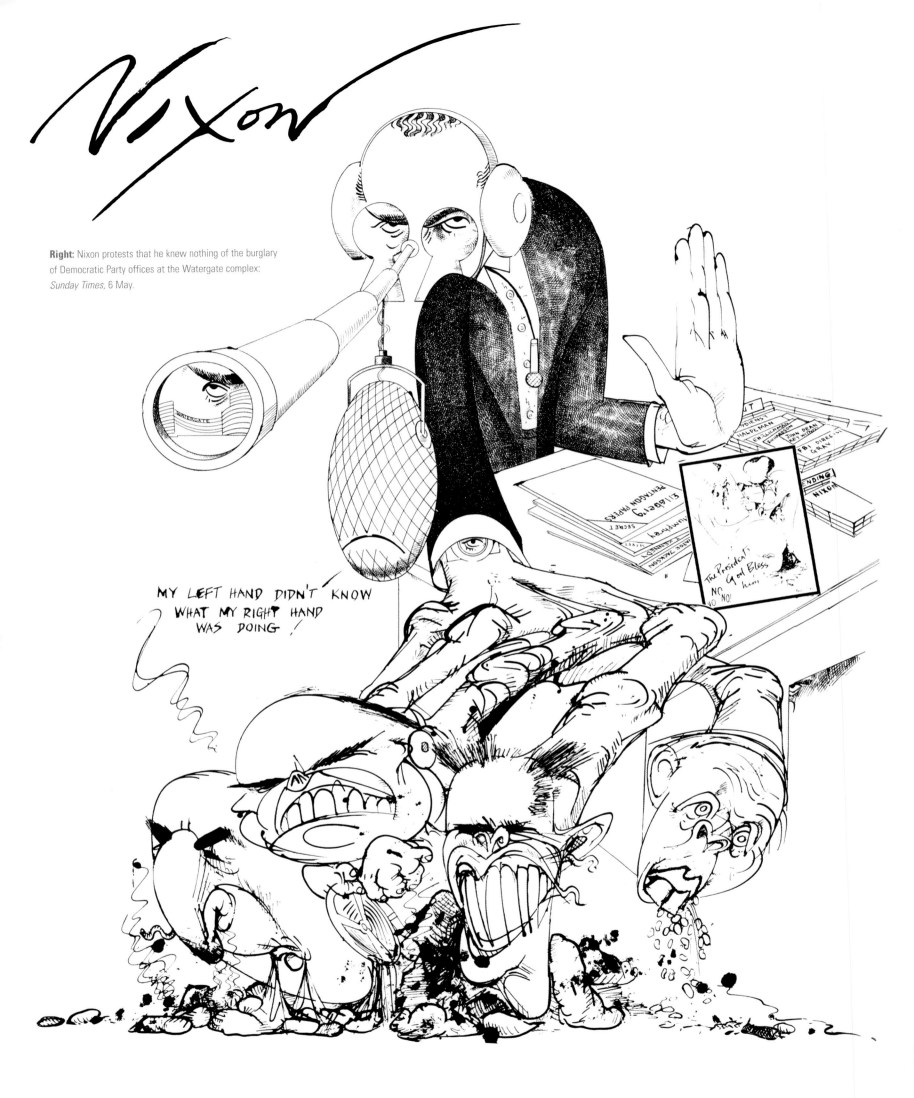

Nixon

Right: Nixon protests that he knew nothing of the burglary of Democratic Party offices at the Watergate complex: *Sunday Times,* 6 May.

MY LEFT HAND DIDN'T KNOW
WHAT MY RIGHT HAND
WAS DOING!

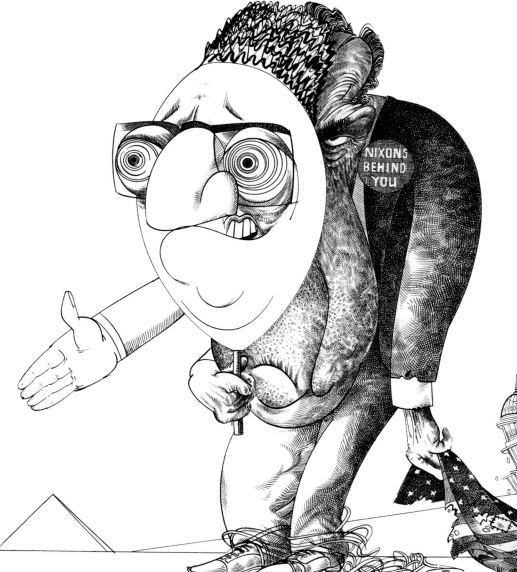

Right: Nixon's Behind You: *Sunday Times*, 11 November. Henry Kissinger was Nixon's National Security Adviser and front man.

I remember when Nixon was finally forced to bring the troops home in 1973, a mother confronted him on TV. She said, 'My son died out there, Mr President. What for? What for? WHAT FOR?'

Below: Perhaps He'll Get the Right Man This Time – Nixon has blamed and sacked everyone but himself: *Sunday Times*, 4 November.

Below right: Nixon wronged – cutting.

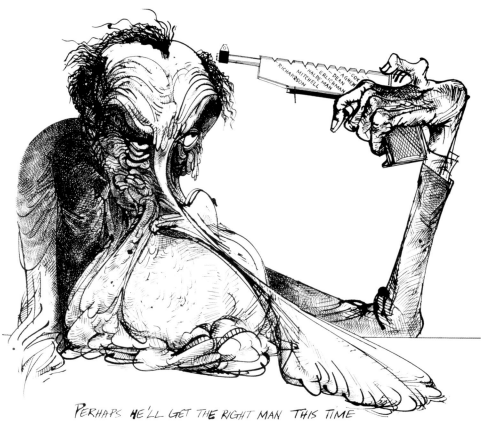

PERHAPS HE'LL GET THE RIGHT MAN THIS TIME

Nixon wronged

I AM disgusted that you saw fit to publish Gerald Scarfe's anti-President Nixon cartoon (Leader page, last week).

The world may sleep sounder because of the alertness of President Nixon, but the media—which the President so correctly put in its place during his Press conference—is obsessed so very much with Watergate that it sees fit to attack him even when he takes action to protect the whole of the free world. And that includes the free Press.

You must indeed be asleep if you really think the Russians can be **trusted**, and it was only natural that they, too, would speak out against President Nixon's action. What he did was to show them that, in spite of all his troubles at home, he is all too alive and aware of the **real** evils which exist in the world.—John D Smith. Gosport.

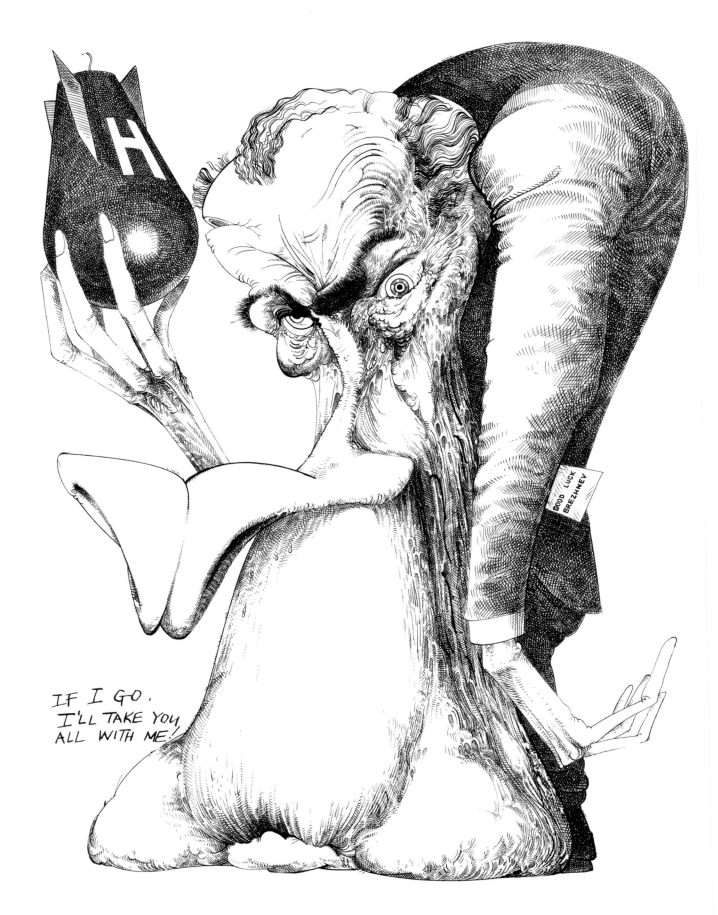

Text within illustration: IF I GO, I'LL TAKE YOU ALL WITH ME!

Text on label: GOOD LUCK BREZHNEV

Nixon refuses to go. At his delayed press conference, the President tried to pass off Watergate as an irrelevance. He claimed that he and Brezhnev, who visited America in June, were 'bringing peace to the world'. He then ordered a nuclear alert over Russia and the Middle East and it was suggested he might be playing nuclear games to save his own skin. Impeachment became a serious possibility. The more I drew Nixon, the more his face collapsed and his jowls continued to sag until they spilled onto the floor.

If I Go, I'll Take You All with Me: *Sunday Times*, 28 October.

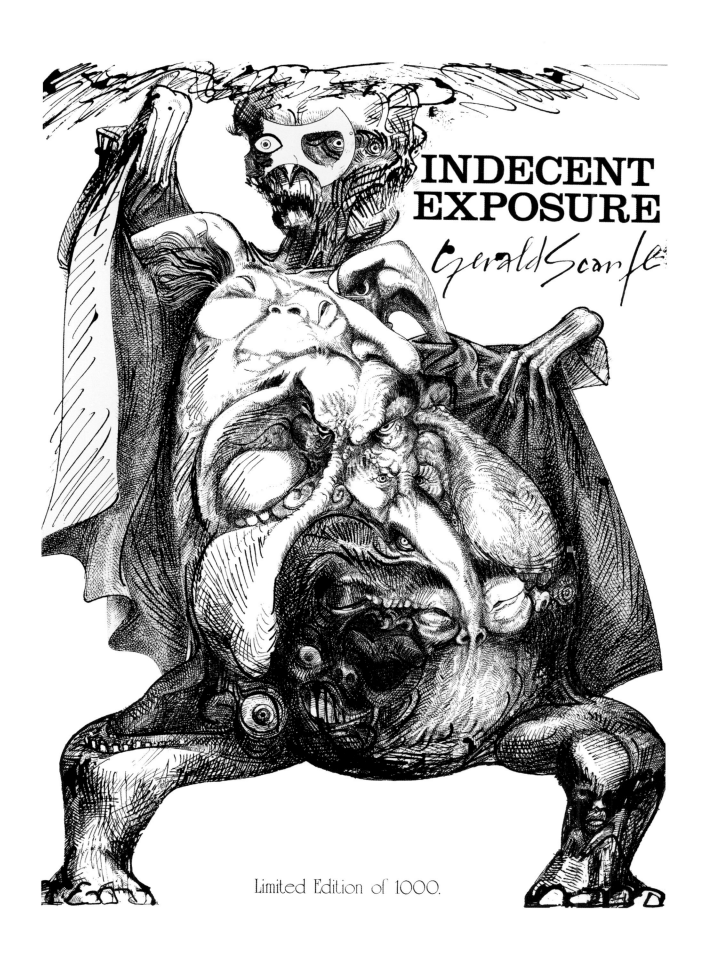

INDECENT
EXPOSURE

Gerald Scarfe

Limited Edition of 1000.

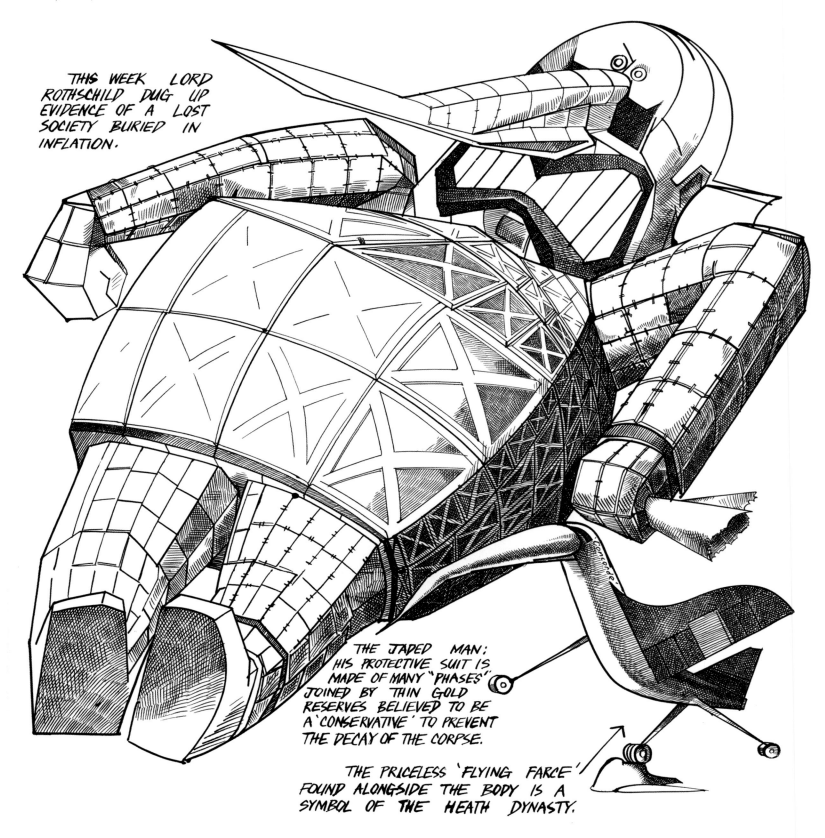

The Amazing Jaded Man – from the Chinese exhibition at the Royal Academy: *Sunday Times*, 30 September (The National Portrait Gallery, London).

THIS WEEK LORD ROTHSCHILD DUG UP EVIDENCE OF A LOST SOCIETY BURIED IN INFLATION.

THE JADED MAN: HIS PROTECTIVE SUIT IS MADE OF MANY "PHASES" JOINED BY THIN GOLD RESERVES BELIEVED TO BE A 'CONSERVATIVE' TO PREVENT THE DECAY OF THE CORPSE.

THE PRICELESS 'FLYING FARCE' FOUND ALONGSIDE THE BODY IS A SYMBOL OF THE HEATH DYNASTY.

The New Year – nothing changes. On and on it goes:
Sunday Times, 30 December.

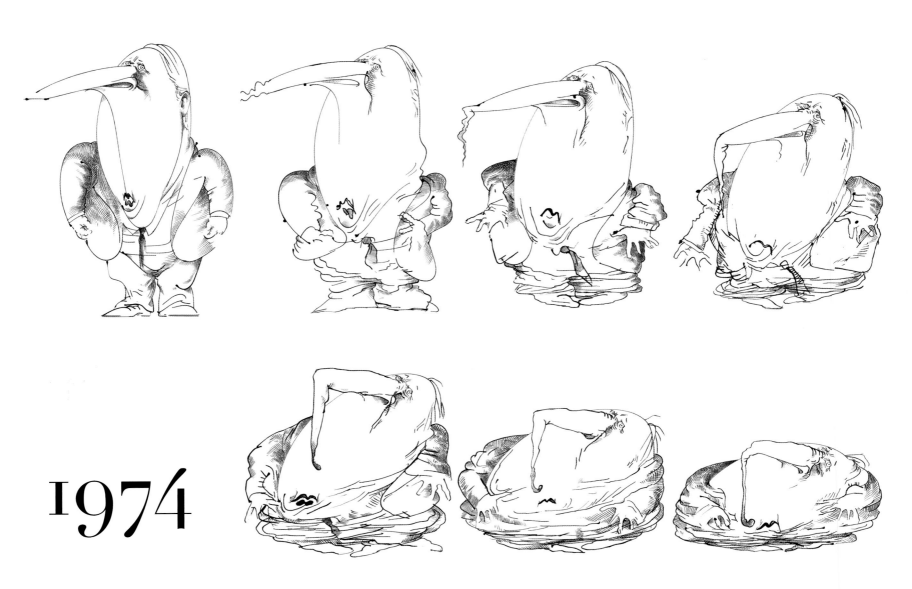

1974

The Prime Minister, Harold Wilson, called the second General Election within a year. The Tories lost again.

Above: Deflation of pompous Heath: *Sunday Times*, 13 October.
Below: Heath Wrecked: Edward Heath as his boat *Morning Cloud* again (GS's collection).

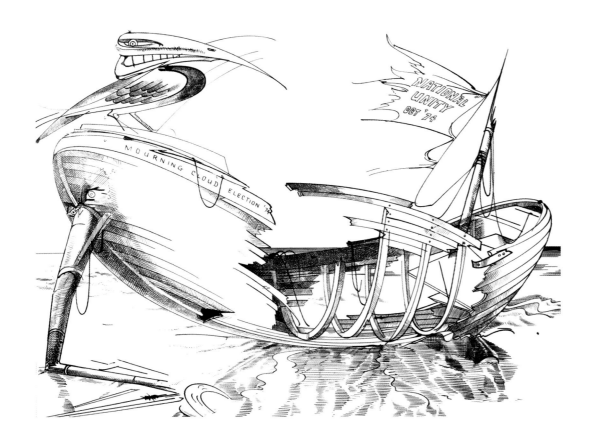

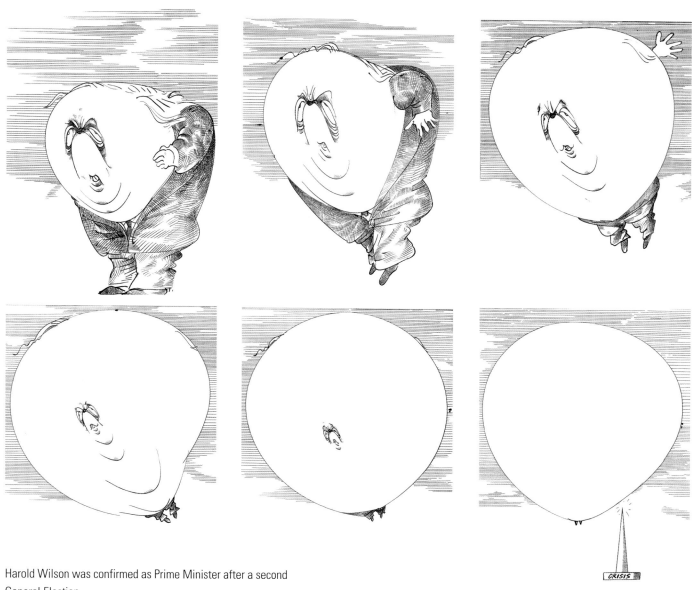

Harold Wilson was confirmed as Prime Minister after a second General Election.

Above: Inflation of Wilson: *Sunday Times*, 13 October.
Below right: Two-faced Wilson – this way, that way, which way, all ways: *Sunday Times*, 17 February. Election fever for the first time in 1974.

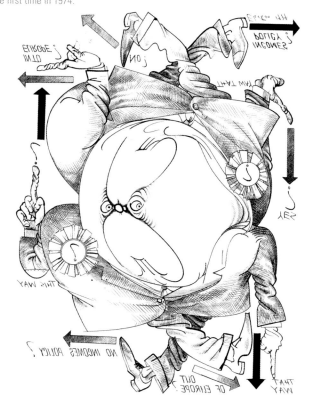

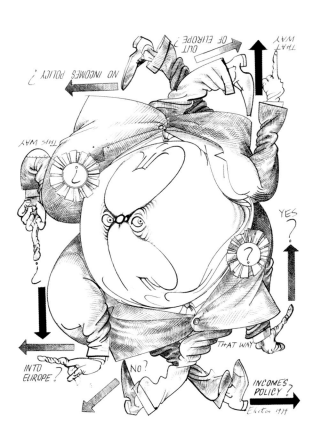

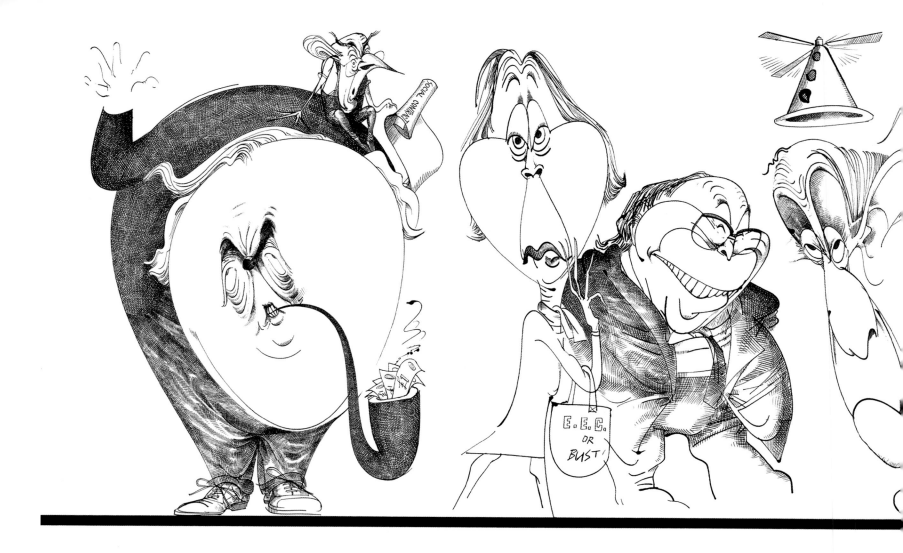

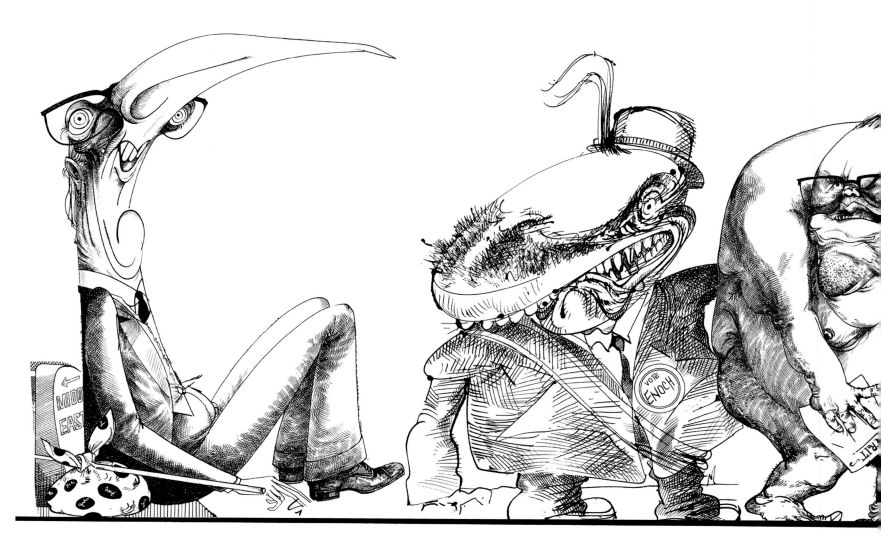

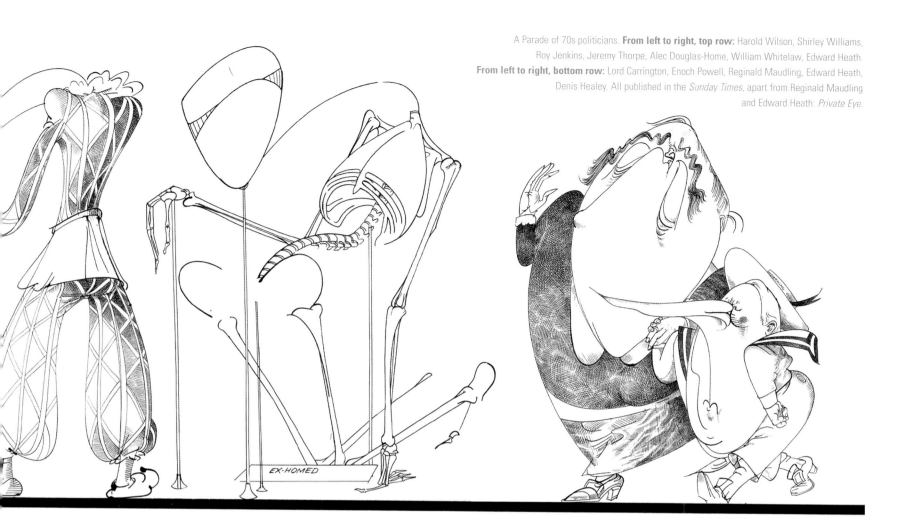

A Parade of 70s politicians. **From left to right, top row:** Harold Wilson, Shirley Williams, Roy Jenkins, Jeremy Thorpe, Alec Douglas-Home, William Whitelaw, Edward Heath. **From left to right, bottom row:** Lord Carrington, Enoch Powell, Reginald Maudling, Edward Heath, Denis Healey. All published in the *Sunday Times*, apart from Reginald Maudling and Edward Heath: *Private Eye*.

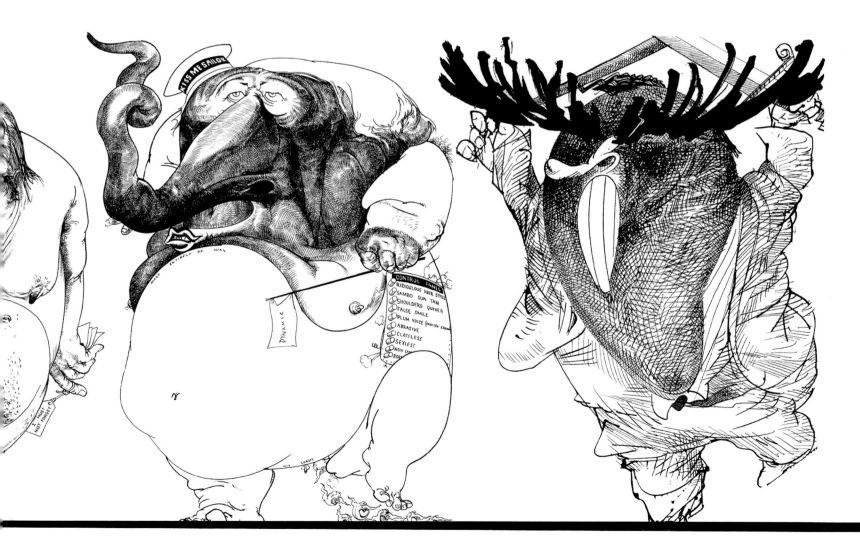

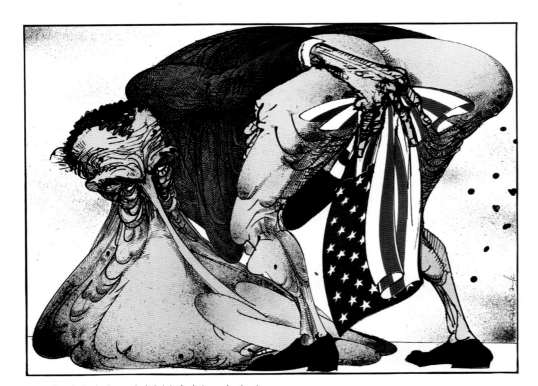

A second limited edition privately printed book, all about Nixon and his downfall. The phrase 'expletive deleted' was used extensively in the transcriptions of the Watergate tapes – recordings made in the White House of Nixon and his staff. It was clear that Nixon had sworn unremittingly, and these expletives had been deleted.

Left: Nixon and the Flag: limited edition print issued with *Expletive Deleted.*

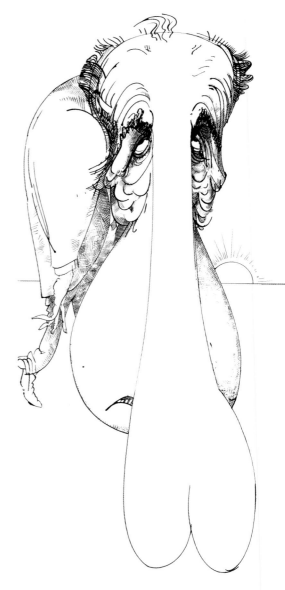

A Cartoonist's Lament

Though Nixon made me sick
I'll miss his every trick
His used car style
and sweaty smile
made him a perfect (expletive deleted)

Above: Cartoonist's lament. When Nixon finally went, I almost missed him. *Sunday Times.*
Left: The old Republican elephant in the elephant's graveyard, dying from the heat of the Watergate sun: *Sunday Times*, 28 July.

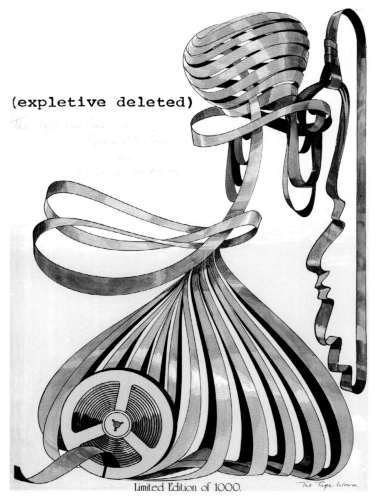

(expletive deleted)

Limited Edition of 1000. The Tape Worm

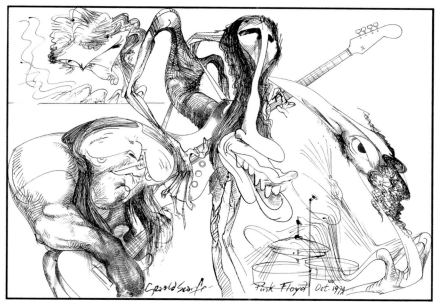

Gerald Scarfe Pink Floyd Oct. 1974

Top: The ever-growing world population: *Sunday Times*, 7 April.
Left: The cover of GS's limited edition book, *Expletive Deleted*.
Above: Drawing made for Pink Floyd fanzine.
Left to right: Rick Wright, Dave Gilmour, Roger Waters, Nick Mason.

125 nineteen seventy-four

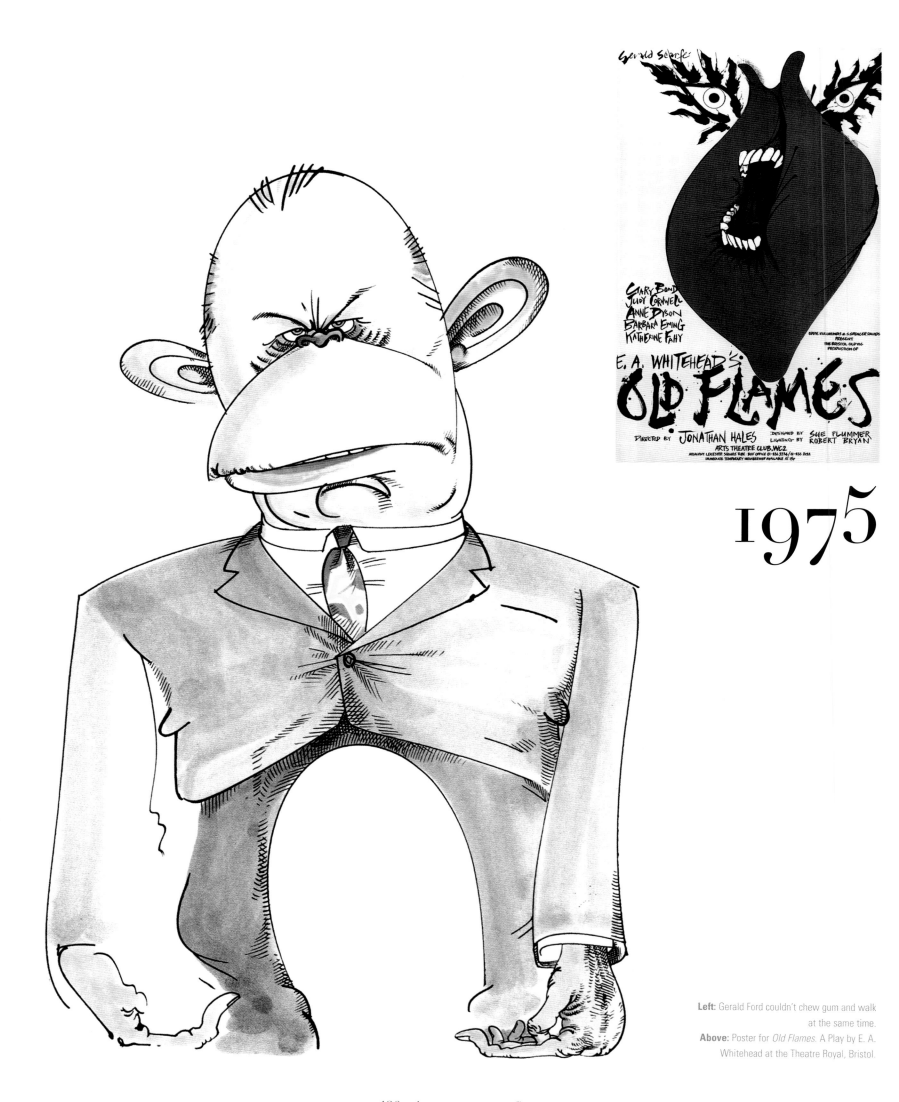

Gerald Scarfe

GARY BOND
JUDY CORNWELL
ANNE DYSON
BARBARA EWING
KATHERINE FAHY

EDDIE KULUKUNDIS & S.SPENCER DAVIES
PRESENT
THE BRISTOL OLD VIC
PRODUCTION OF

E. A. WHITEHEAD'S

OLD FLAMES

DIRECTED BY JONATHAN HALES
ARTS THEATRE CLUB.WC2

DESIGNED BY SUE PLUMMER
LIGHTING BY ROBERT BRYAN

REGENT LEICESTER SQUARE TUBE · BOX OFFICE 01-836 3334 / 01-836 2132
IMMEDIATE TEMPORARY MEMBERSHIP AVAILABLE AT 15p

1975

Left: Gerald Ford couldn't chew gum and walk
at the same time.
Above: Poster for *Old Flames*. A Play by E. A.
Whitehead at the Theatre Royal, Bristol

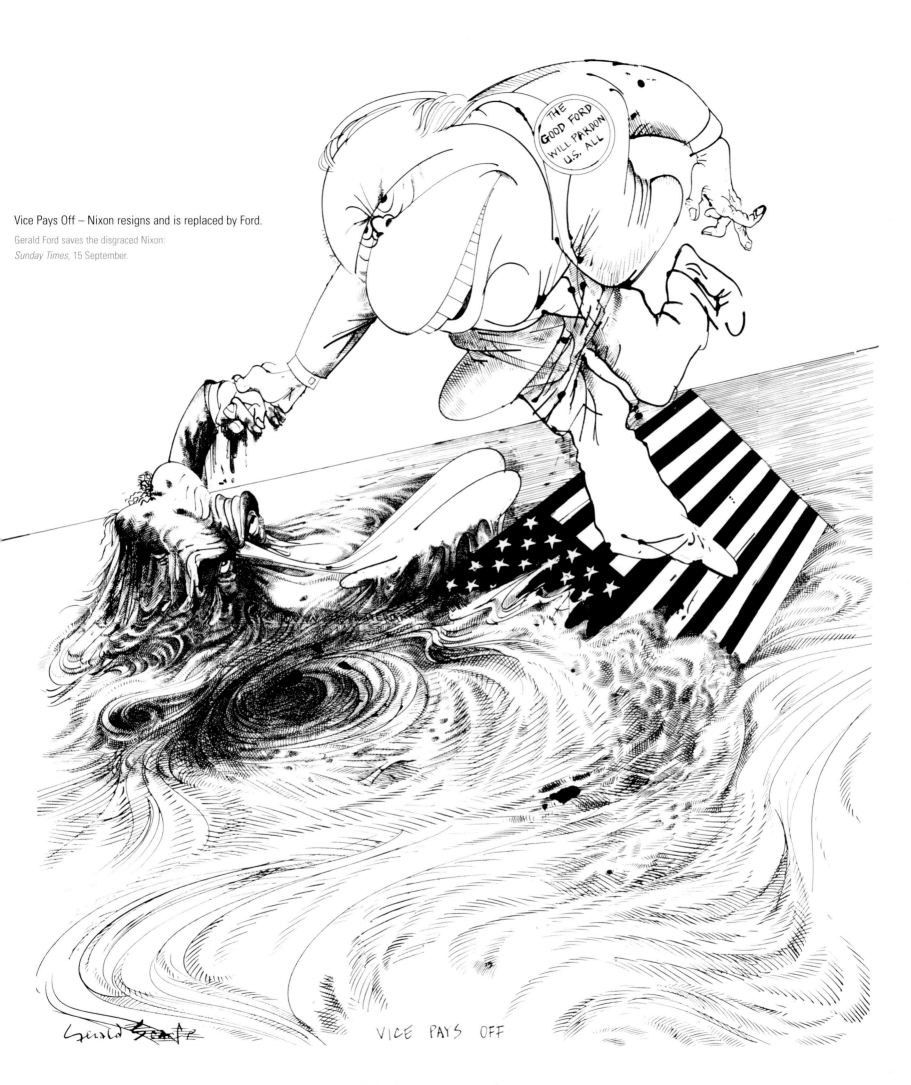

Vice Pays Off – Nixon resigns and is replaced by Ford.

Gerald Ford saves the disgraced Nixon:
Sunday Times, 15 September.

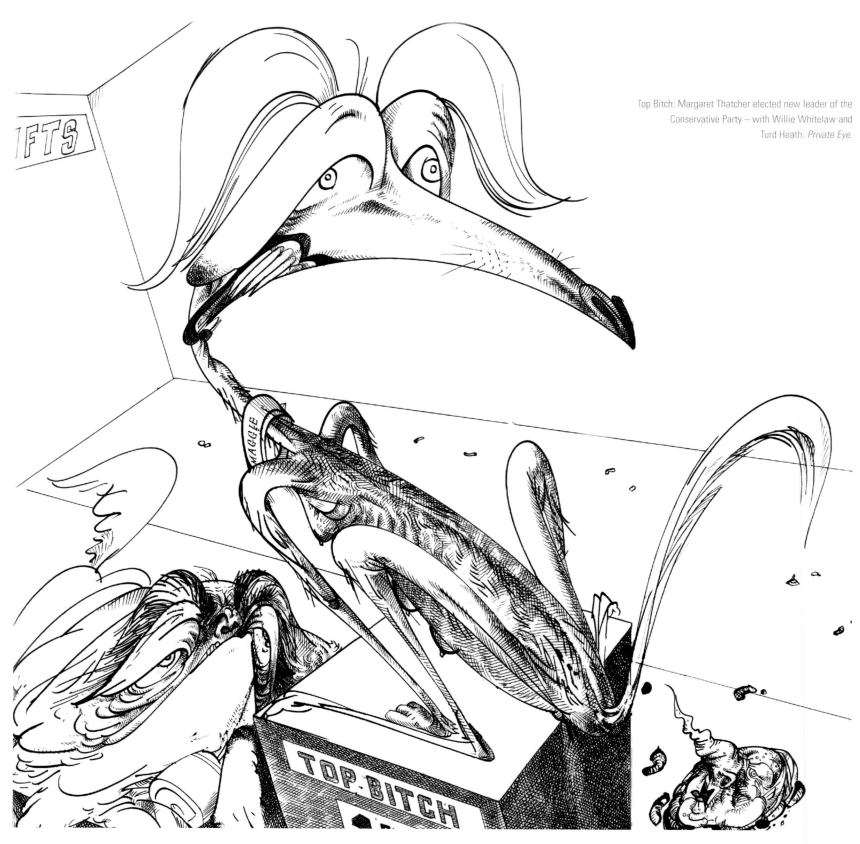

TOP BITCH

THE JUDGES were unanimous. "Thatcher", the bright-eyed, shrill-yelping little number from Grantham, Lincs, was voted outright winner of this year's Crusts with the biggest roar of acclamation ever. Owned by proud, quiet-spoken Mr and Mrs Airey Knees, "Thatcher" delighted the judges and a thousand "fanciers" with her clever tricks, which included sitting up and begging, rolling over on her back for the cameras, and leading the blind. Top marks were also awarded for her freshly shampooed coat and well-turned-out appearance. Second place was won by "Willie", a flea-infested, malodorous elderly Old English Vicar Dog. Said his owner Mrs Whitelaw from London: "I had high hopes for my Willie, many of the judges fancied his chances. But he has a nasty habit of falling over when asked to perform."

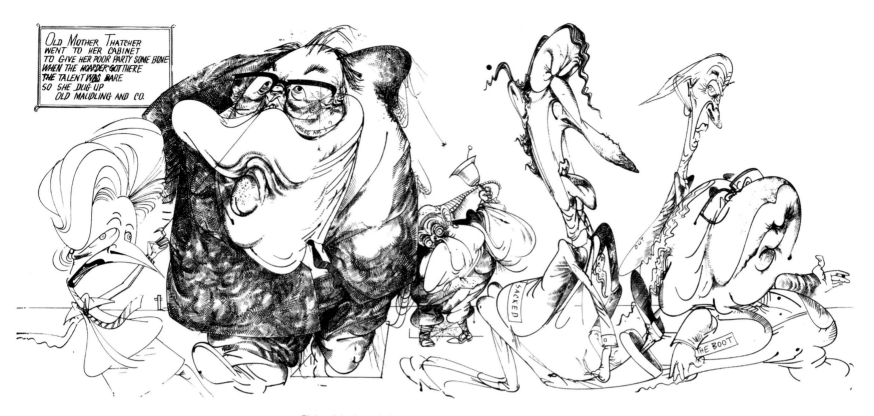

OLD MOTHER THATCHER
WENT TO HER CABINET
TO GIVE HER POOR PARTY SOME BONE
WHEN THE HOARDER GOT THERE
THE TALENT WAS BARE
SO SHE DUG UP
OLD MAUDLING AND CO.

Eight o'clock at night, a furious Harry Evans rang me at home. What did I think I was trying on – slipping a penis into the *Sunday Times*! I had no idea what he was on about, until I looked at Maudling's chin. He was right – it did look like that. Completely unintentional. Déjà vu . . .

Above: Mrs Thatcher defeats Ted Heath to become the new leader of the Conservative Party and picks her shadow cabinet. In come Reginald Maudling and Lord Hailsham, out go Peter Walker, Robert Carr and Geoffrey Rippon: *Sunday Times*, 23 February.

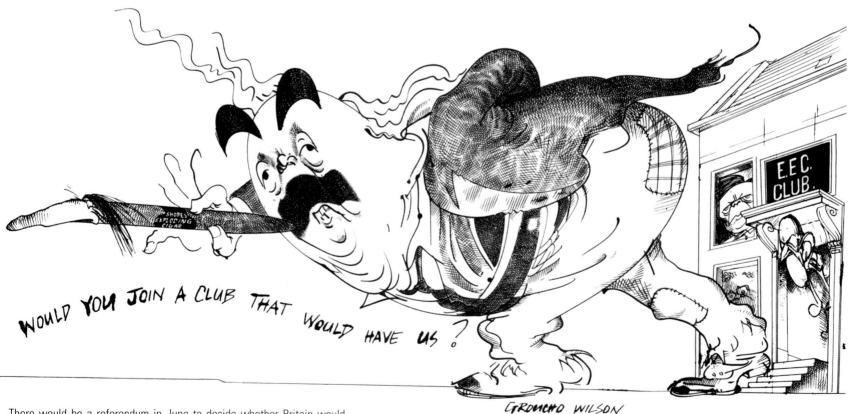

WOULD YOU JOIN A CLUB THAT WOULD HAVE US?

GROUCHO WILSON

There would be a referendum in June to decide whether Britain would stay in Europe or not – Wilson was for; Shore was against.

Above: Groucho. Prime Minister Harold Wilson as Groucho Marx and Secretary of State for Trade Peter Shore as his cigar: *Sunday Times*, 26 January.

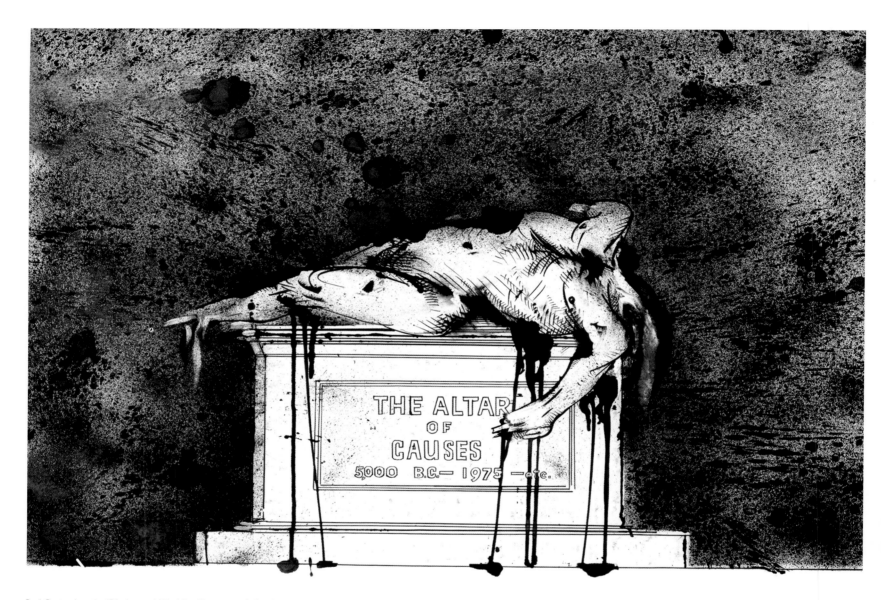

On 1 September, the IRA shot and killed five Protestants in South Armagh. Altar of Causes: *Sunday Times*, 7 September.

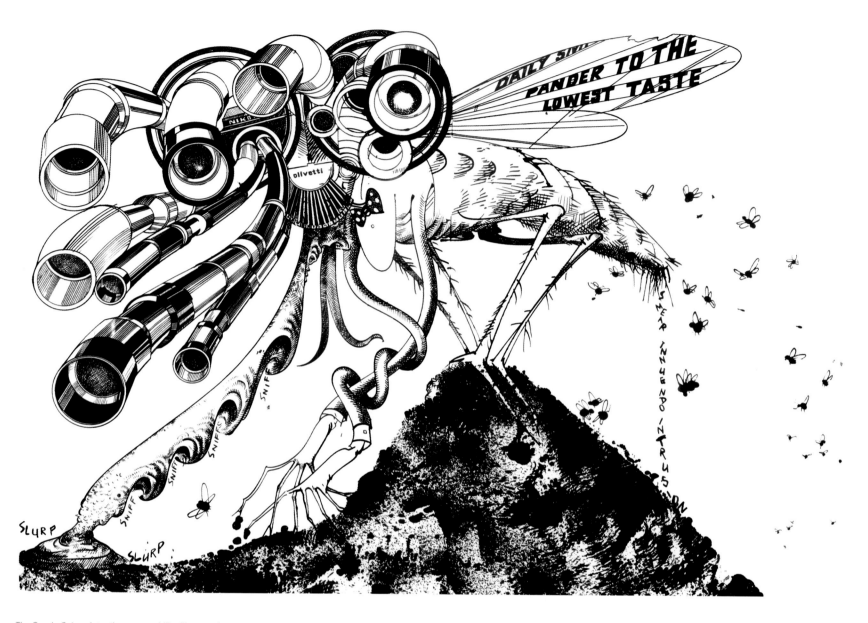

The Gossip Columnist – the paparazzi like flies round a
sore: *Sunday Times*, 3 August.

Animation

Animation is magic. To make a static drawing come to life is an artist's dream, yet it has never been fully explored as an art form. Disney, marvellous though it is, has had such a strong and far-reaching effect on the industry: imagine what Matisse or Picasso would have done with it. There's no reason why they have to be cute little animals. European animators have tried to use their craft for social comment, but there's only so much you can take of butterflies symbolising freedom. Pink Floyd had enthused about my *Long Drawn-Out Trip*, and in 1971 had asked me to make animated films to be projected behind their live concerts. I didn't take up their offer until 1974: it seemed like a lot of work and I feared it might stop the flow of my other work. It did. Directing animation is a full-time job. I ended up with a studio of about forty animators whom I tried to wean away from the Disney system in which most are trained.

The first animations I made for Pink Floyd were for their performance of *Wish You Were Here*. These were projected onto a circular screen at the back of the stage, behind the band. I drew a man who walked slowly towards the camera, stopped and was eroded like sand, by the blowing wind. A metal monster that stomped across the landscape for the song 'Welcome to the Machine', a sea of blood that appeared over the horizon, raced towards us and engulfed two shining, circular, metal towers. The blood turned to groping hands, which prayed to the metal monoliths. A leaf tumbled through the sky and slowly turned into a naked man, who, still tumbling, smashed through the sky, as though it were made of glass.

Wish You Were Here

Right: The Metal Monster, which illustrated the song 'Welcome to the Machine'.
Below: Dog Man from *Wish You Were Here*.
Opposite: The Leaf Man: animation cells for projection during live concerts of Pink Floyd's *Wish You Were Here*.

THE SUNDAY TIMES

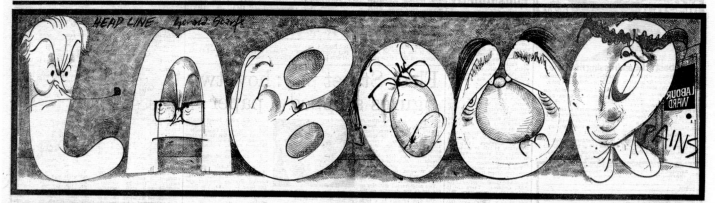

HEAD LINE — Gerald Scarfe

LABOUR PAINS

THE MAKING OF A PRIME MINISTER
- Wilson: an exclusive interview
- Profiles of the six contenders
- Opinion poll: full details
5-PAGE SPECIAL BEGINS ON PAGE 14

NEWS DIGEST
MARCH 21 1976

Glass chief in line for top rail job

PETER PARKER, 52-year-old chief of the Rockware Group, is in the front rank of choices for the controversial job as chairman of British Rail.

He is likely to leave his £65,000-a-year post as chief executive of the giant glass bottle firm—which expects to announce a hefty profit this week—for the £22,750 rail job which will become vacant when Sir Richard Marsh leaves in September.

This will be the second time Mr Parker has been offered the British Rail job; he turned it down in 1967 because he felt that nationalised industry chairmen should be paid salaries in line with private industry. He is said to combine capitalist instincts with socialist philosophy.

Vorster troops to quit Angola

SOUTH AFRICA is to withdraw its last troops from Angola within the next seven days. According to a statement being made today by Mr Vorster, the South African Prime Minister, assurances have been received through " a third party " that Angola will safeguard the Calueque dam near the frontier with Namibia. South

Foot leads but voters want Jim Callaghan

By our political staff

MICHAEL FOOT is ahead among Labour MPs in the race for No 10 but James Callaghan is the most popular man among Labour voters in the country. He comes top as a party unifier and handler of the present economic situation, while Foot comes fifth out of the six candidates on almost all points.

The Sunday Times conducted two polls last week: one of Labour voters by Robert Worcester of Market & Opinion Research International (MORI), and another of 265 Labour MPs. A large body of MPs still appears uncommitted, perhaps as many as 20 per cent. The remarkable feature of those who would tell us their intentions is that support for Mr Callaghan on the first ballot seems to have ebbed, to make Mr Foot the likely leader of the six.

Among the 265 MPs asked, almost all reached direct by telephone, we found 181 firm pledges Thirty-three MPs told us they were still

OUR FIRST BALLOT PROJECTIONS

Foot	90—110	Benn	20—30
Callaghan	70—90	Healey	20—30
Jenkins	50—65	Crosland	20—30

Adding these together, and allowing both for sampling error and the doubts among the don't knows, we arrived at the projections shown in the table. While naturally approximate, these assessments are more soundly based than any yet published.

The MORI poll of Labour voters (details, page 14) puts Mr Callaghan far ahead as the preferred leader, with Mr Benn second.

Mr Callaghan is also well ahead in personal assessments. He is found honest, capable, strong and likeable by many more people than any other candidate. As many as 53 per cent of Labour voters

Only on "dealing with the unions," does Mr Foot come out ahead—25 per cent rate him best, against 24 per cent Mr Callaghan, 13 per cent Mr Benn, 8 per cent Mr Jenkins.

Mr Jenkins makes his most notable showing on the question of who would make the best Prime Minister. Although Mr Callaghan is here, again, the clear leader, with 50 per cent support, Mr Jenkins is second with 18 per cent, followed by Mr Benn and Mr Healey with 10 each, Mr Foot with 7, and Mr Crosland with no measurable backing.

Mr Benn's most notable score,

dustrial democracy in action. That is what we need again today."

Mr Foot's nomination paper carried the names of 27 Labour MPs. They include three Cabinet Ministers: Mrs Barbara Castle, Mr Peter Shore and Mr John Silkin, together with several junior ministers: Mr Gerry Fowler, Mr John Fraser, Mr Frank Judd, Miss Margaret Jackson, Mr Stanley Orme and Mr Brian O'Malley.

Mr Rees's speech contained a clear presumption of a Callaghan victory—" The personal relations between the supporters of those seeking to be leader of the Party and the next Prime Minister are good natured and friendly." He referred to the difficult task ahead. "The next Prime Minister will lead us towards the 1980s. This will not be an easy task. 1977, 1978 and 1979 are the years in which it is essential that we climb out of our economic difficulties and be in a strong position to surge ahead in the 1980s. This will require hard decisions and no-one should be under any delusion. If we are to succeed, we must have a united country with a united Labour movement to lead it."

Mr Benn, who has been conducting a vigorous public campaign yesterday set out new ideas for deciding policy in public

Benn statement, page 2

Here Mr Callaghan gets 39 per cent, but Mr Benn is next with 14. Once again, Mr Crosland scores a zero.

Mr Callaghan and Mr Foot yesterday issued manifestos of their policies, which significantly balance each other.

Mr Callaghan himself kept silent, but his principal backer and campaign manager, Merlyn Rees, Secretary for Northern Ireland, spelled out his supremacy as the election winner and unifier when he said in a speech at Scarborough: " It is our determination to elect a leader who will win the next general election and carry both the Labour movement and the country with him in the years ahead."

At the same time Mr Foot without mentioning the leadership struggle but clearly emphasising his stronger point, came out vehemently on the supreme need for " the unshakeable alliance between the Labour Government

MAGAZINE
FORTY YEARS OF FASHION
Plus LIFESPAN on
- Gardening - Antiques
Child actors - Banks
Racing tipsters - Soups
ONE MAN'S WEEK 32
John Mortimer and his two vicars ...

THE SUNDAY TIMES

1976

PARIS AFTER DARK
The Thirties photographs of Brassaï

MIDDLE-AGE FITNESS— A SUCCESS STORY
Results of our year-long experiment 28-29
- Preparing for retirement : Magazine

CROSSMAN DIARIES
Devaluation and Jim's fight to the death 33

ssians
shed up
deaths
revolt'

et authorities have kept 1962 uprising in Novo- c in which 70 to 80 ere killed by troops and Alexander Solzhenitsyn the third of his Gulag just published in

rebellion in Novo- t, a city of 168,000 on river in the Ukraine, after a simultaneous in- food prices and a cut

is how Solzhenitsyn the sequence of events: 1, 1962, Khrushchev d national price in- r butter and meat. On day, the electric loco- orks in Novocherkassk d wage cuts of up to 30

. Outraged workers wildcat strike and called g. After subordinates the employees back get the director of the plant, in, entered

are we supposed to live the workers asked. just have to eat jam f meat from now on," l to flee to avoid being pieces

gh the strike spread t the locomotive noon, workers at other refused to go along. of women occupied the ostov railway tracks works. At the same started to rip up tracks barricades. Protest eared all over the city v" and " down with ev" and "Khrushchev the saucem machine

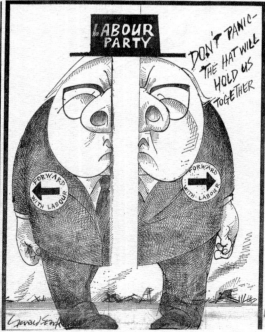
LABOUR PARTY
DON'T PANIC — THE HAT WILL HOLD US TOGETHER
FORWARD WITH LABOUR
FORWARD WITH LABOUR

Gerald Scarfe

Big shake-u urged for nationalise industries

By Keith Richardson, Industrial Editor

A FURIOUS WHITEHALL row is brewing over the McIntosh Report, recommending drastic changes in the way Britain runs its nationalised industries. It is likely to erupt when the report is officially published next week.

The still confidential report, excerpts from which are exclusively published in Business News on page 62, proposes a complete cutting of present links between ministries and the industries for which they are responsible. Instead, it recommends interposing a brand-new policy-making body, designed to interpret and pass on the Government's requirements, and to insulate the executive boards from routine civil service interference.

Concerned by widespread condemnation of state industry efficiency (losses totalled £1,000m in 1974), and the often appalling relationships with Whitehall, the Prime Minister has personally decided to have the report published as quickly as possible.

It was written by a National Economic Development Office team, headed by the NEDO's Director - General, Sir Ronald McIntosh. The work involved 15 months of intensive study, 260

posed loss of status a responsibility for steering own affairs.

- Many civil servants ob losing direct control and i report as challenging th they have been doing up t

- The trades unions will any attempt to give the than the 50 per cent contr are hoping to extract fr Bullock Committee now l at worker democracy.

Over and above these partisan views lies a much degree of scepticism abo practical value of organis changes like this. Who yet another tier of manaş in the system? How c strategic responsibility p be taken away from the who run and know the bus Critics of McIntosh argu his proposals would tal much time and legislative to implement without ge the roots of the problem

Among these roots, th the extraordinary delays government will make on those policy issu

Above: Labour Pains – Anthony Wedgwood Benn, Michael Foot, James Callaghan, Roy Jenkins, Anthony Crosland and Denis Healey. The candidates to replace Harold Wilson, who had resigned, suddenly, as leader of the Labour Party and Prime Minister: *Sunday Times*, 21 March.
Left: Split in the Labour Party – James Callaghan. Callaghan defeated Foot in the final ballot: *Sunday Times*, 14 November.
Opposite: United at Last – the IRA kills ten Protestants in South Armagh: *Sunday Times*, 11 January.

THE SUNDAY TIME

Ulster SAS men arrive in the night

By Chris Ryder and Tony Geraghty

DETACHMENT of 150 men the 600-strong Special Air regiment, ordered to Northern Ireland by Downing began landing late last under cover of darkness at a wartime airfield on the Down coast and was immediately airlifted into County ...

... are this morning beginning week's duty along the ... in South Armagh; others ... ployed in what is known ... murder triangle—an area north of the county which ... been the scene of a large ... of sectarian killings.

... SAS men, attached to 3rd ... headquarters at Lurgan, ... watching suspects and iso-... ouses and farms where ... sidents are considered ... o murder attempts. The ... are also in position along ... ads. Each is equipped ... so-called "bingo book," ... ing lists of wanted men ... hicles and suspect ad-...

... also carry standard army ... hand guns, smoke gren-... d signal pistols. Infra-... t sights and image inten-... or night vision are fitted ... weapons. In addition to ... they carry two sophisti-... technical aids—Iris, an ... d intruder detection sys-... ective over three miles by ... control, and ground sur-... e radar, a three-piece por-... it with a scanning range ... 0 metres.

... ver, there has been some ... muffled indignation ... some SAS soldiers about ... se in a Downing Street ... spotlight. For an out-... h prefers to operate be-... scenes, their exposure ... k is unwelcome.

... SAS is the world's most ... y-shy army. When a ... of the regiment marries, ... ding picture may not be ...

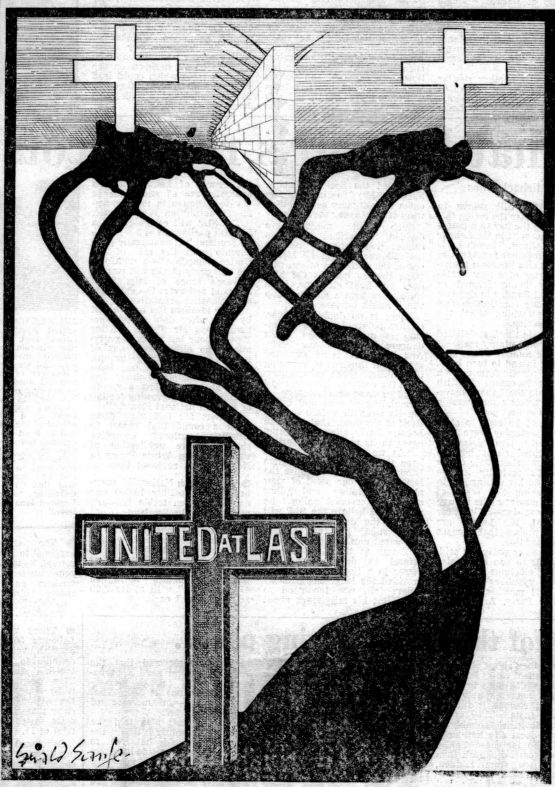

UNITED AT LAST

Gerald Scarfe

Ulster: What can we do?

Four-page major analysis of the options 15

Police up Spa striker tear ga

By Tim Brow...

POLICE FIRED tear gas and baton-charged striking workers in several violent clashes in and around Madrid yesterday as labour unrest appeared to increase despite the ending of the underground strike after five days of traffic jams and confusion in the city. And by last night 19 workers belonging to trade unions and clandestine workers' committees had been arrested.

Tear gas was used to disperse about 5,000 car workers who had started a march from the Chrysler factory near Madrid to a church two miles away, in the working class district of Cara-banchel. Police followed up with baton charges. At the church several thousand Chrysler men and strikers from the Standard Eletric factory, two of the main trouble spots in the capital, were evicted by police.

There were also violent clashes between police and striking engineering workers at Getafe, an industrial town 12 miles from Madrid. Police first cleared strikers from two churches where they were staging protest sit-ins. Clashes followed and there were a number of arrests.

The workers' protest, which has now affected all industries and has brought out about 50,000 workers in Madrid alone, is against a near-freeze of wages declared by the government. The men are also demanding amnesty for political prisoners and re-instatement of workers dismissed for striking.

Behind the unrest is the illegal but powerful Communist-led trade union movement, the ...

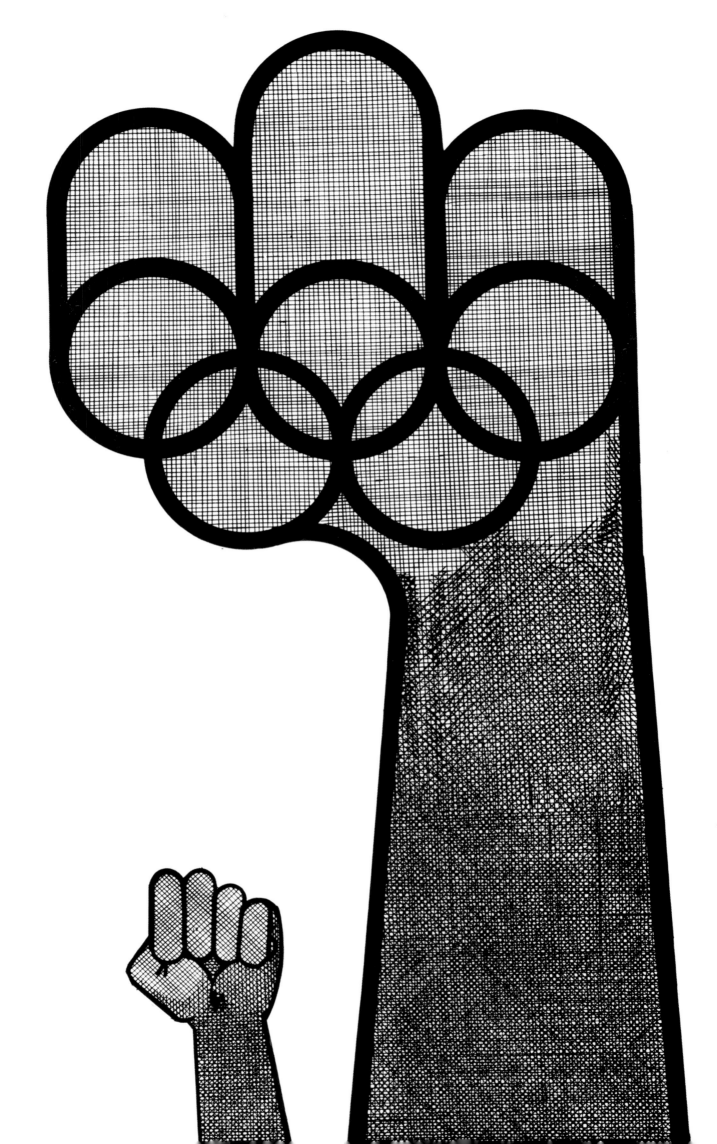

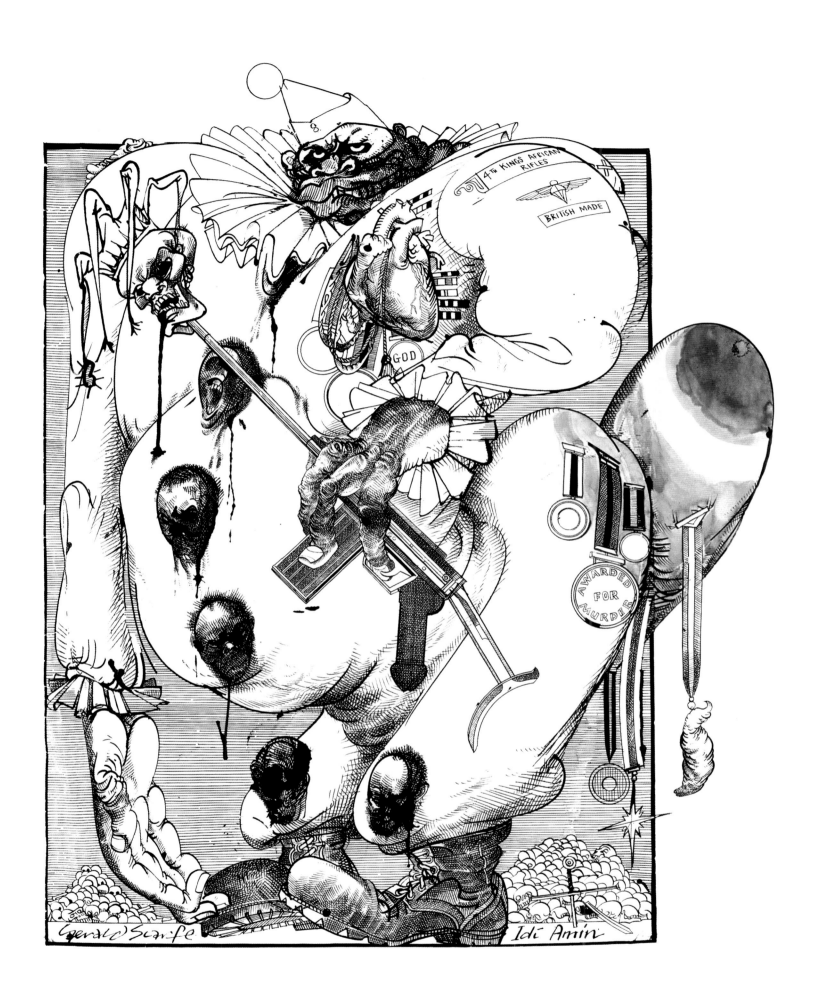

Opposite: Black Power demonstrations at the Montreal Olympics: *Sunday Times*, 25 July.

Above: Increasing evidence was emerging of the horrific murders committed by the Ugandan dictator Idi Amin: *Sunday Times*, 13 June.

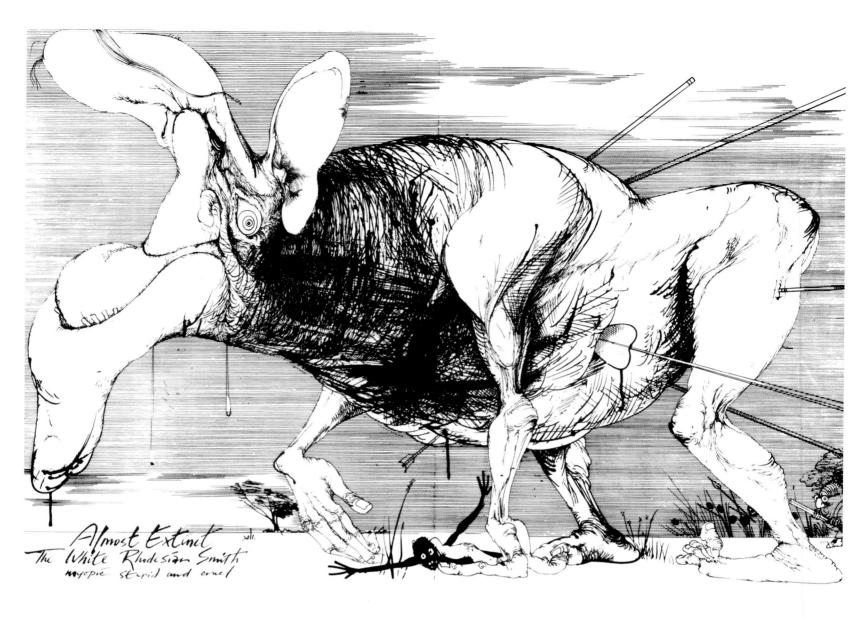

Almost Extinct
The White Rhodesian Smith
myopic stupid and cruel

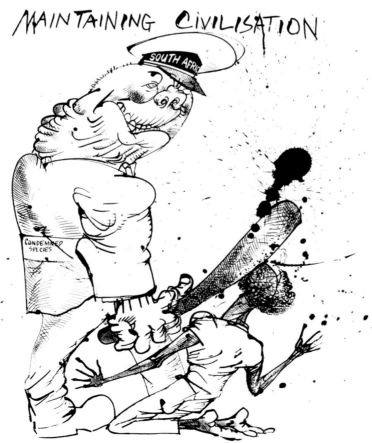

MAINTAINING CIVILISATION

SOUTH AFRICA

CONDEMNED SPECIES

In Rhodesia Prime Minister Ian Smith is forced to face the fact that eventually the white man's domination of Rhodesia will come to an end.

Above: Almost Extinct: *Sunday Times*, 2 May.
Left: Maintaining Civilisation – oppression in South Africa: *Sunday Times*, 15 August.

US Secretary of State Henry Kissinger hands Ian Smith a document saying that Rhodesia agrees to black rule in two years. 'You want me to sign my own suicide note?' asks Smith.

Opposite top: The White Man Got Me: *Sunday Times*, 26 September.
Opposite below: Smith's Last Stand – Ian Smith continues to ignore the tidal wave of black resentment: *Sunday Times*, 22 February.

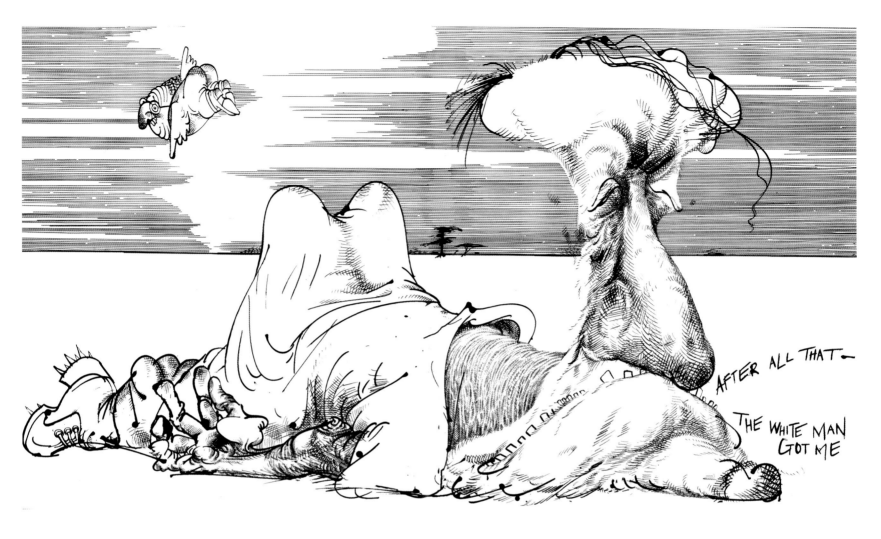

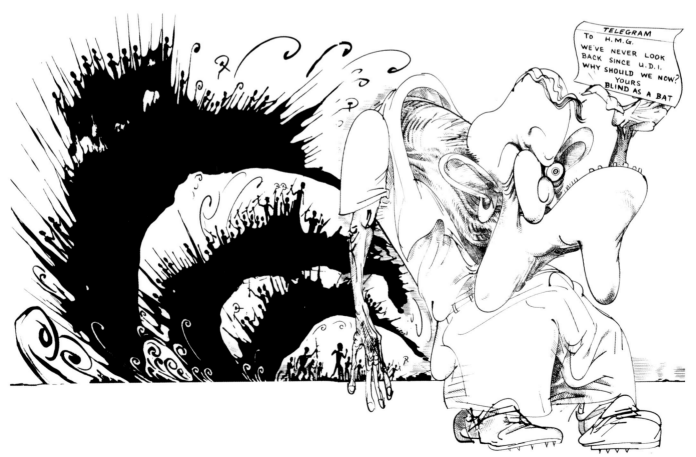

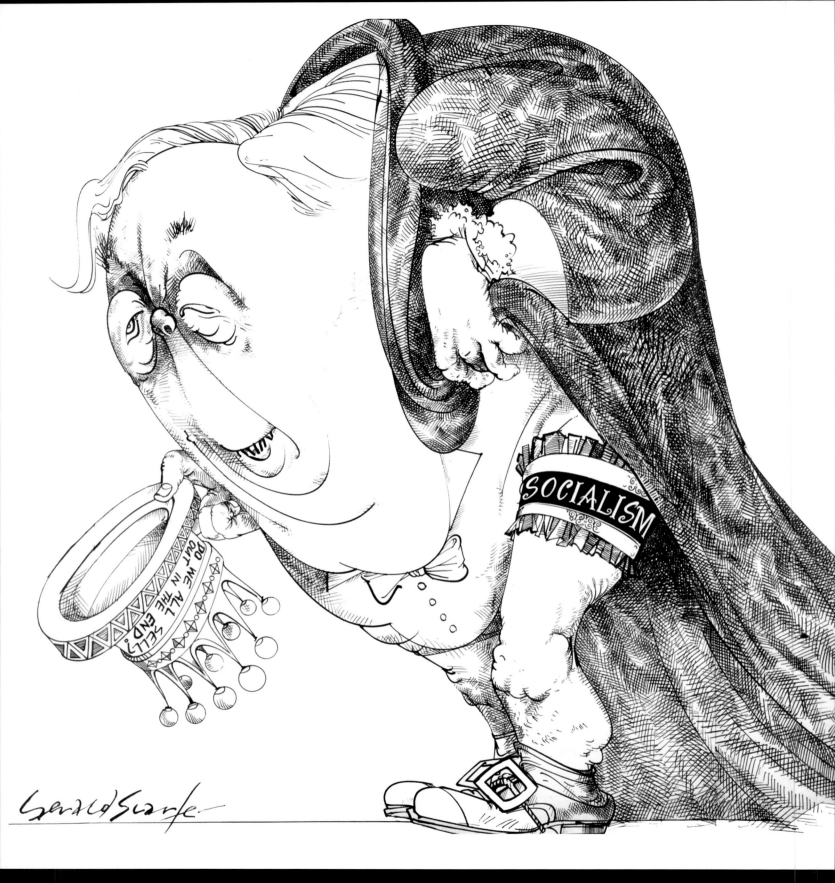

Wilson wanted to remain an MP after resigning and therefore was not
offered the customary peerage, becoming a Knight of the Garter instead.

Do We All Sell Out in the End? – Harold Wilson receives a knighthood:
Sunday Times, 25 April.

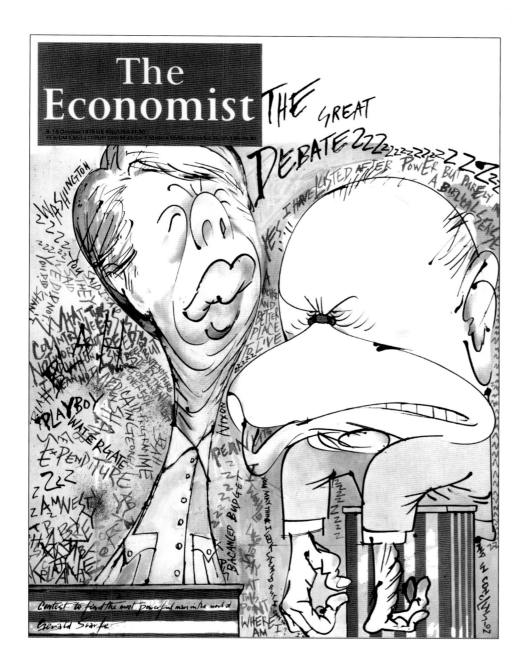

Top left: The Democrat challenger Jimmy Carter and President Ford. The Great Debate: *Economist* cover, 9–15 October.

Top right: Michael Foot, Minister of Employment, finds theory easier than practice. He is replaced in April: *Sunday Times*, 1 February.

Right: 'You've Never Had It So Good' was Macmillan's famous phrase – former Prime Minister Harold Macmillan pronounces on the state of the country: *Sunday Times*, 24 October.

1977

DEVOLUTION:— THE CAUSING OF ANYTHING TO DESCEND OR FALL UPON:— OXFORD ENGLISH DICTIONARY

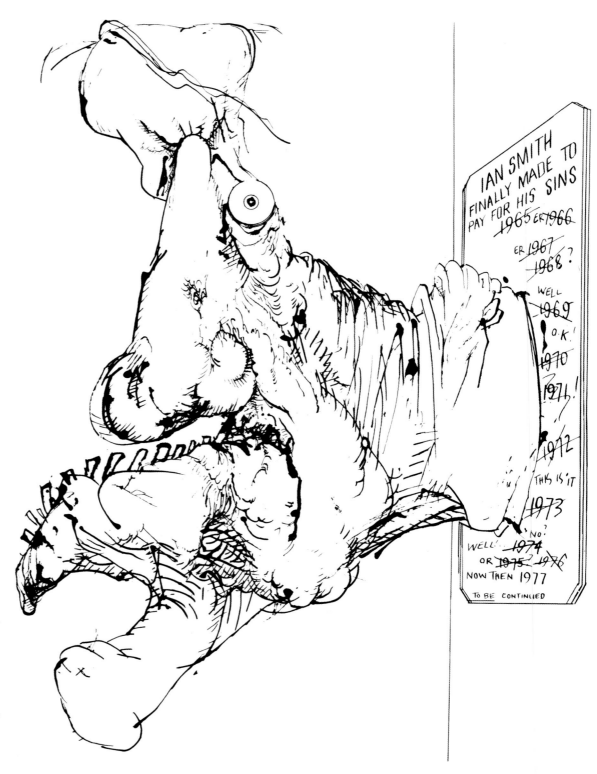

Devolution is dividing the United Kingdom into financially separate parts.

Above left: Devolution: *Sunday Times*, 27 February

Under the Anglo-American plan for Rhodesia, guerrilla forces will form the basis of the new Zimbabwean army to be used during the transition to the new constitution.

Above right: Stuffed – Ian Smith: *Sunday Times*, 4 September.

Idi Amin is still viewed by the world as a clown, but he continues his murdering way. The arrest and sudden death of the Ugandan Archbishop Luwum and two ministers bring cries of atrocity and gross violation of human rights. It is said that Amin keeps severed heads in his fridge. He plans to attend the Queen's jubilee celebrations and Prime Ministers' conference in London in June. There are strong hints he should stay away – he does.

Opposite: Isn't He a Laugh?: *Sunday Times*, 20 February.

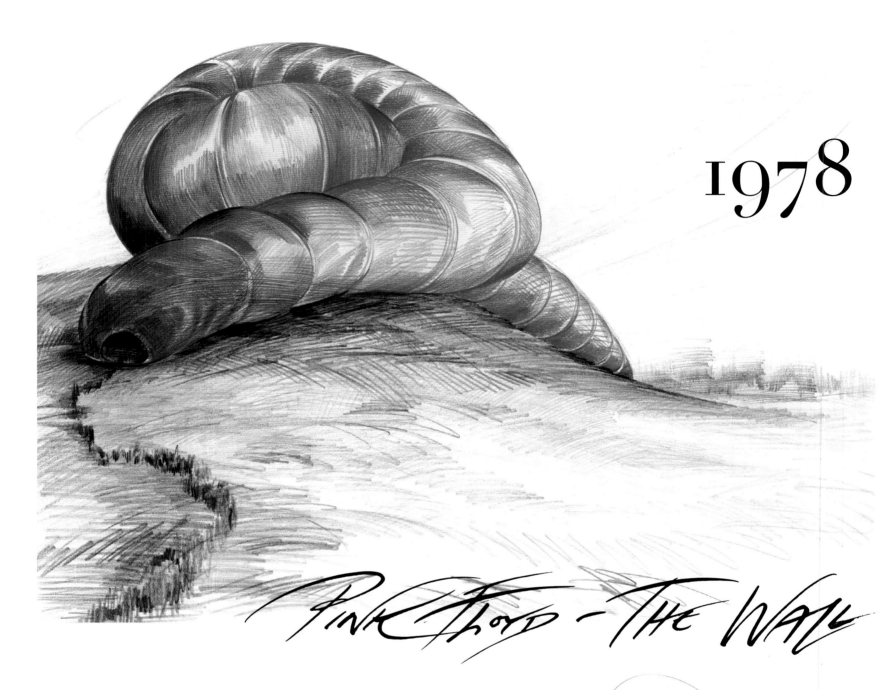

1978

Pink Floyd – The Wall

I met Roger Waters in the spring of this year, when he came to my house with the raw tapes of *The Wall* and played them to me. As I listened to his voice singing to a synthesiser, I had difficulty in imagining what the finished article would sound like. He was very clear at this point that he wanted it to be a record, a show and a film, and that the main characters, Pink and his wife, should be Punch and Judy. I started designing immediately and did many drawings of Punch and Judy until one day Roger reappeared and said, rather shamefacedly, 'I've been thinking about Punch . . . I'm not sure it's a good idea.' So Punch was scrapped and I started redesigning the new Pink. I eventually saw him as a vulnerable pink prawn-like doll.

Roger Waters wanted the road show to be held inside a huge inflatable slug that could be erected on any open space. This is one of the many tent designs I drew for Pink Floyd, but it was never realised.
Above: The Inflatable Slug:

These are the first attempts I made at designing the animated characters to be projected at the concert performances of Pink Floyd's *The Wall*. The Girlfriend, the Doctor, the Teacher, the Wife and a blind worm stand behind an undulating wall, forming a judge's dais. I later simplified the Wife, Teacher and Girlfriend, but the essentials are already here.

Right: early drawing when Punch played the part of Pink.
Opposite top: Early design for the Girlfriend, Doctor, Teacher and Mother.
Opposite below left: First design for the Teacher.
Opposite below right: Punch, the original Pink and Judy, the original Wife.

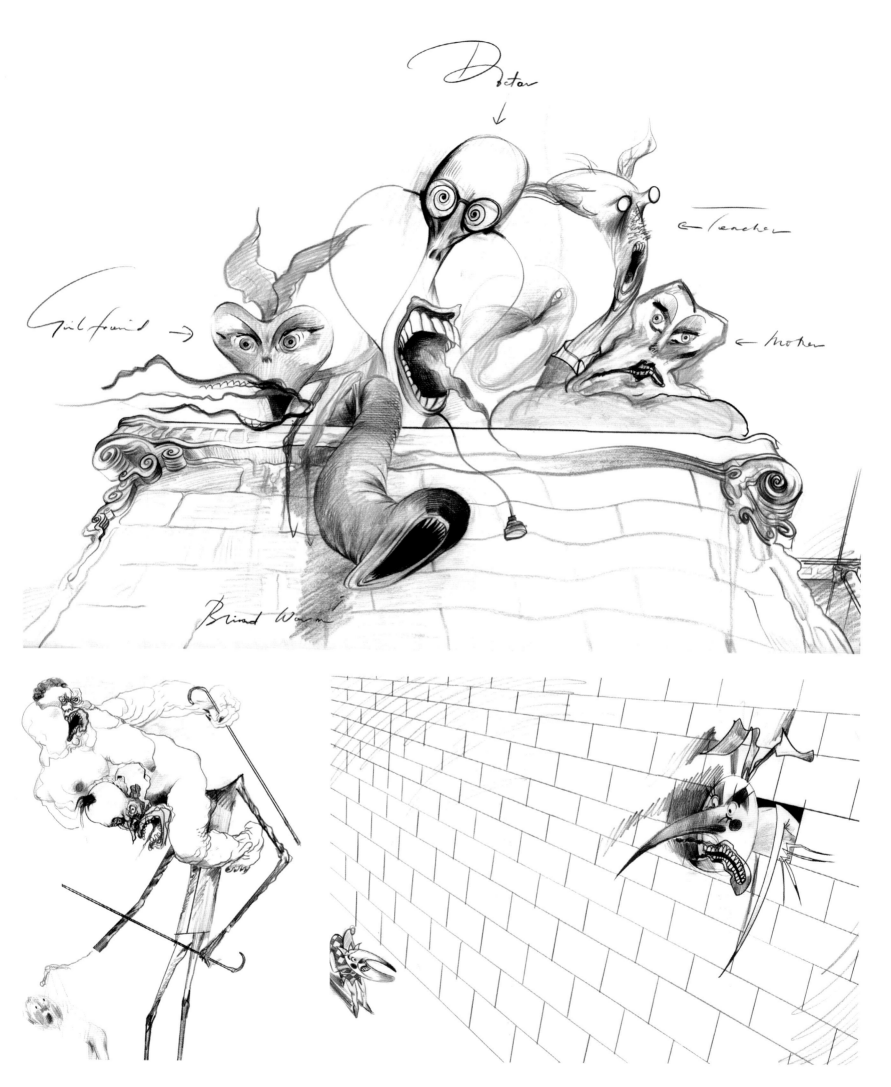

Girlfriend →

← Teacher

← Mother

Doctor ↓

Blind Worm

London 1978

Violence Luvly Violence

After a period of bitter estrangement, Begin and Sadat are ready to talk. Carter offers a separate Israeli–Egyptian deal, divorced from the Palestinian problem. Carter's stock, which is at a low ebb, shoots up.

Right: Peace talks – President Jimmy Carter, Egyptian President Anwar Sadat and Israeli Prime Minister Menachem Begin are to meet at Camp David in Maryland on 5 September: *Sunday Times*, 13 August.

Above: Menachem Begin – Middle East flare-up. Lebanon is torn by conflict and the forces of Syria and Israel are on the alert. The Israelis prevent the Syrians from storming Christian-held East Beirut: *Sunday Times*, 9 July.
Opposite: Middle East terrorists are active in London. Gun and grenade attacks on the El-Al branch office in Mayfair: *Sunday Times*, 27 August.

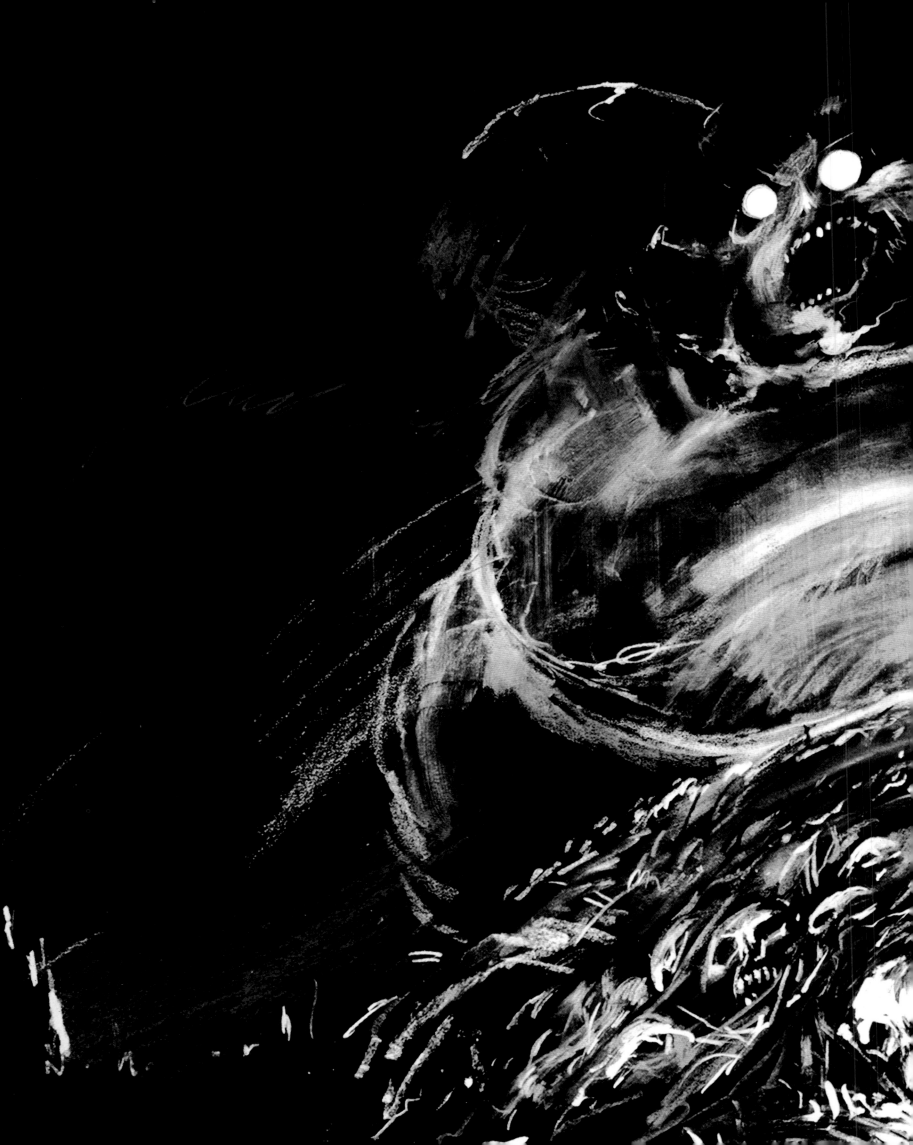

1979

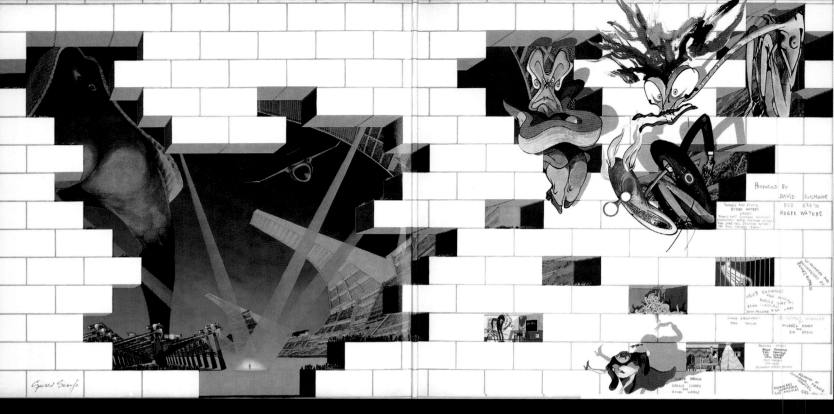

Wall Album

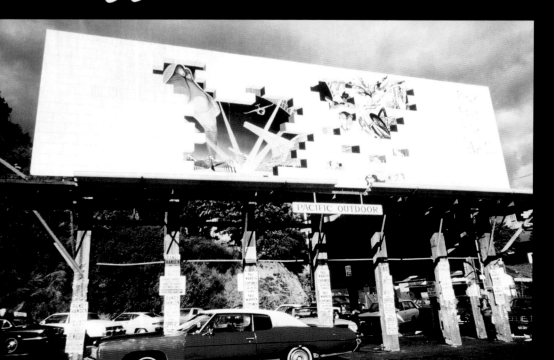

Previous page: Preliminary drawing for the War Lord for *The Wall*.
Above: Album sleeve design for *The Wall*.
Right: Billboard on Sunset Boulevard, Los Angeles, advertising *The Wall*.

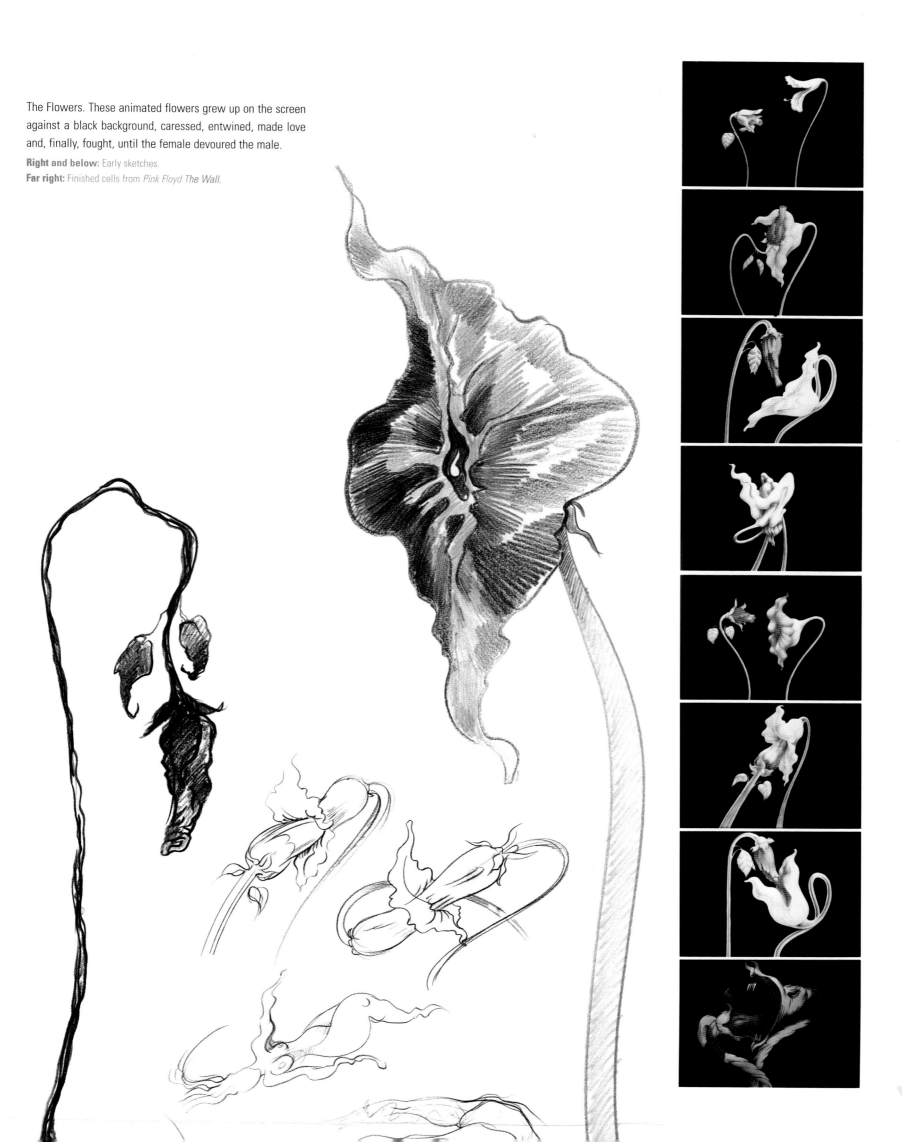

The Flowers. These animated flowers grew up on the screen against a black background, caressed, entwined, made love and, finally, fought, until the female devoured the male.

Right and below: Early sketches.
Far right: Finished cells from *Pink Floyd The Wall*.

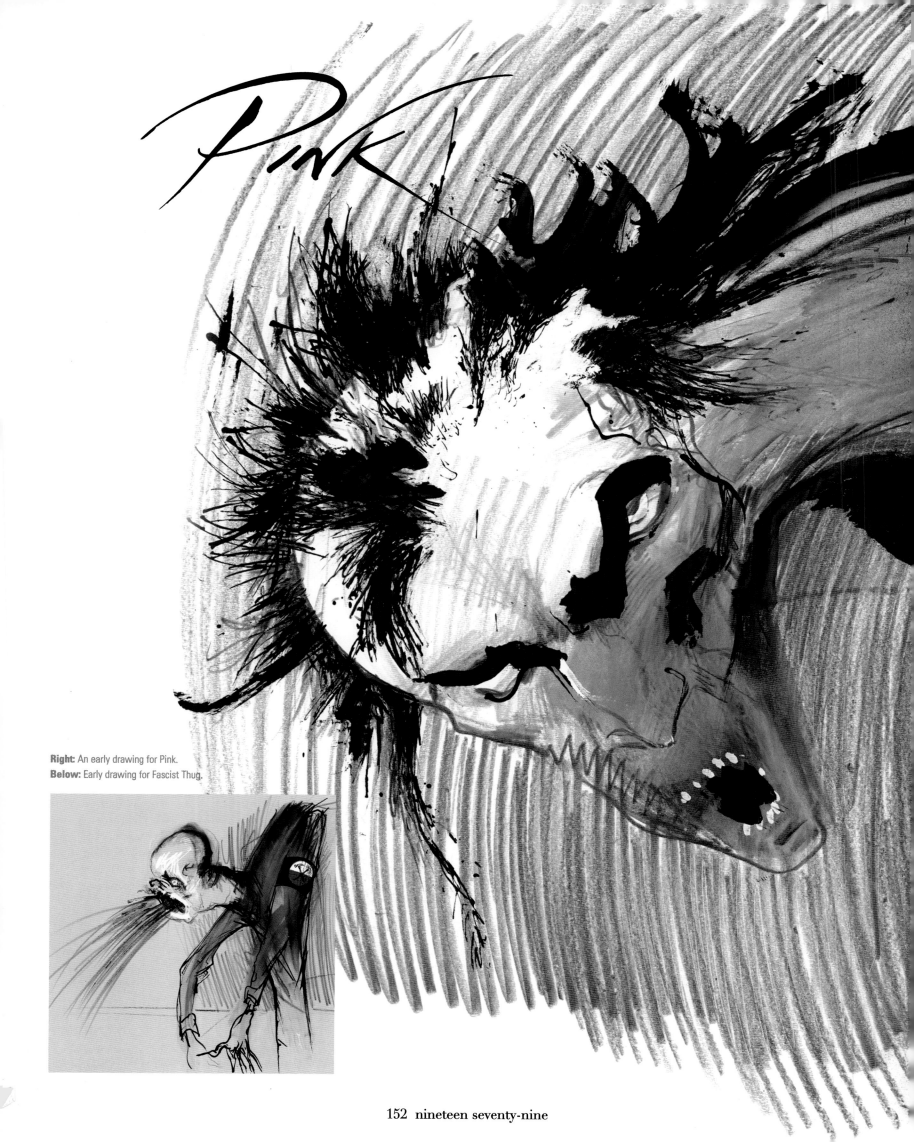

Pink

Right: An early drawing for Pink.
Below: Early drawing for Fascist Thug.

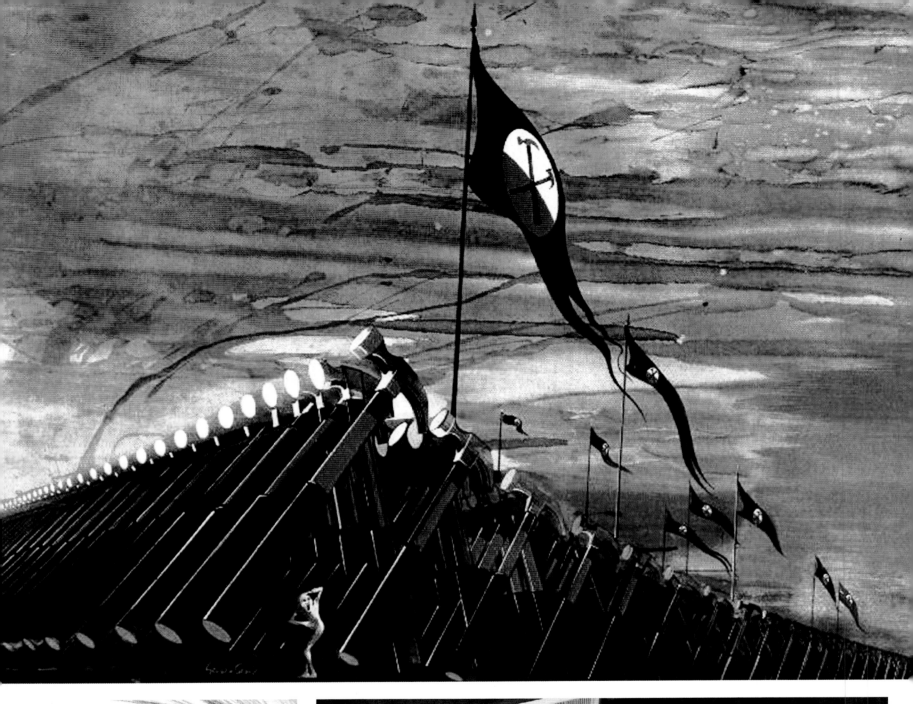

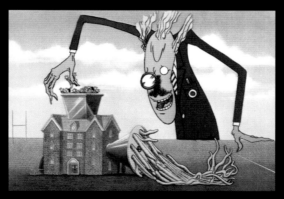

This page:

Above: Finished cell for the Marching Hammers.

Top left: Finished cell for the Wife: a hunched, poisonous praying mantis.

Top right: Finished cell for the Teacher: a bullying tyrant who visits his personal disappointments and troubles on his pupils.

Bottom left: Finished cell for the Judge: a gigantic arse.

Bottom right: Finished cell for the Prosecuting Counsel.

Opposite:

Top: Prototype drawing for the Marching Hammers.

Below left: Early sketch for Marching Hammers.

Below right: Concert programme designed by GS.

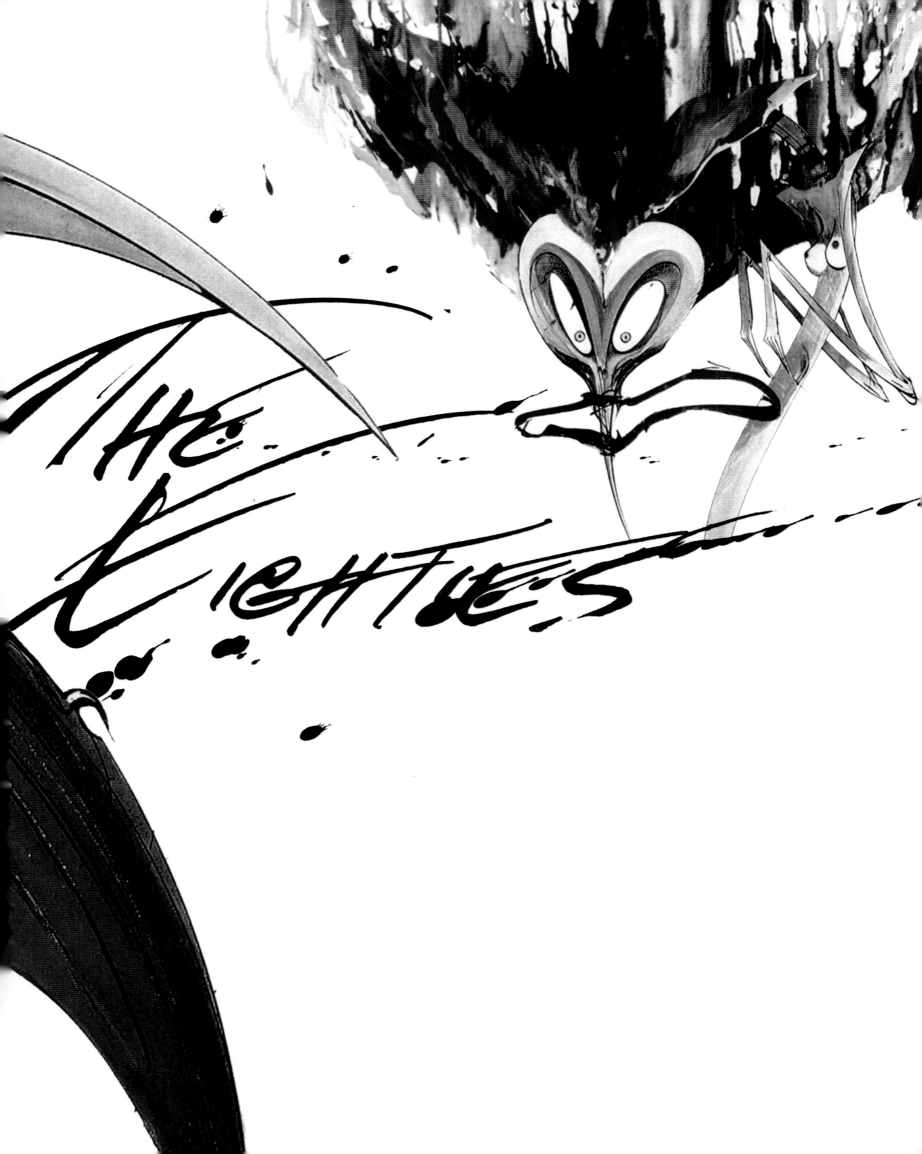

WALL CONCERTS

This is the year Roger Waters and I wrote the storyboards for the film of *The Wall*, and the year of *The Wall* concerts.

1980

Animated images were projected behind the band during the performance. There were three synchronised projectors side by side, throwing the images onto the Wall across the front of the stage.

Above: Projected images.

While the band played, this gigantic Mother figure slowly inflated above their heads. She had symbolic, wall-like arms, which could cradle and stifle Pink at the same time.

Right: GS and designer Mark Fisher testing the thirty-foot-high Mother inflatable at Earl's Court, London.

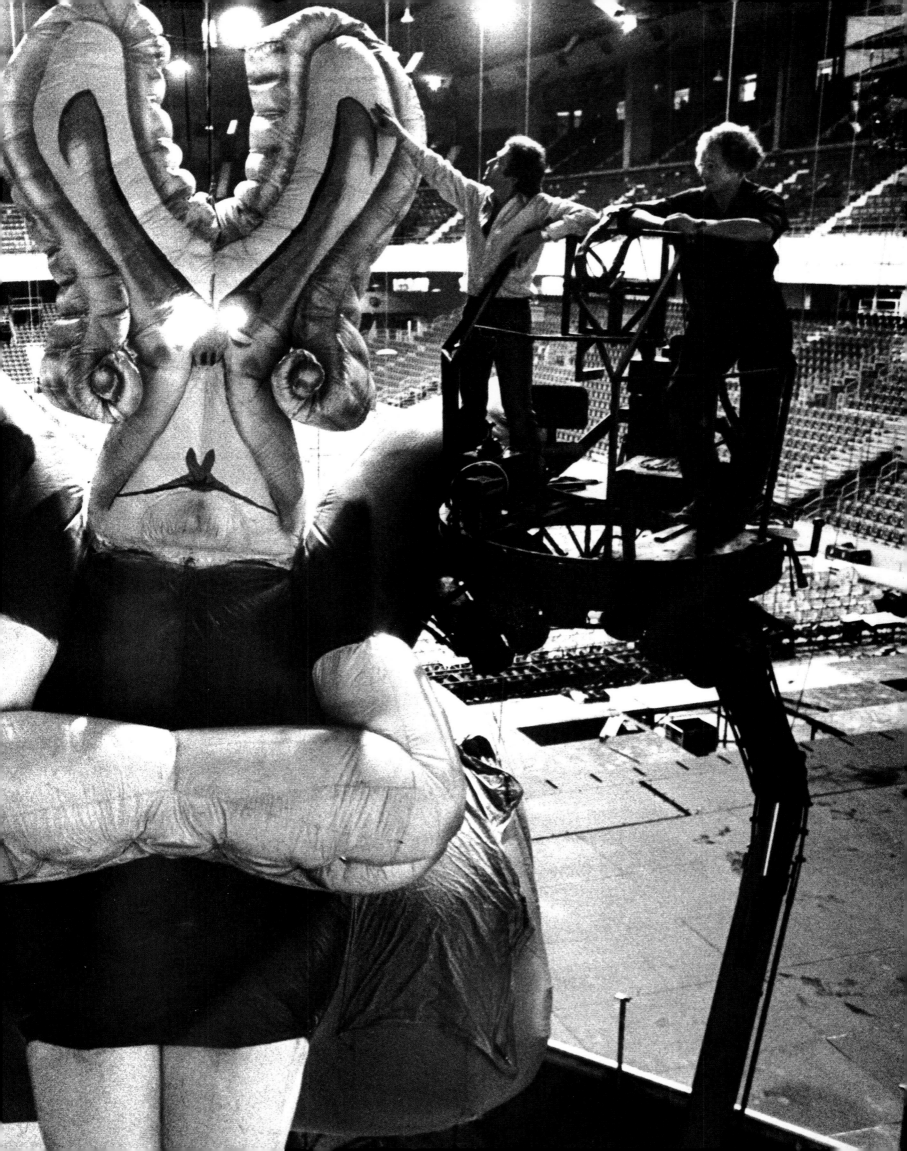

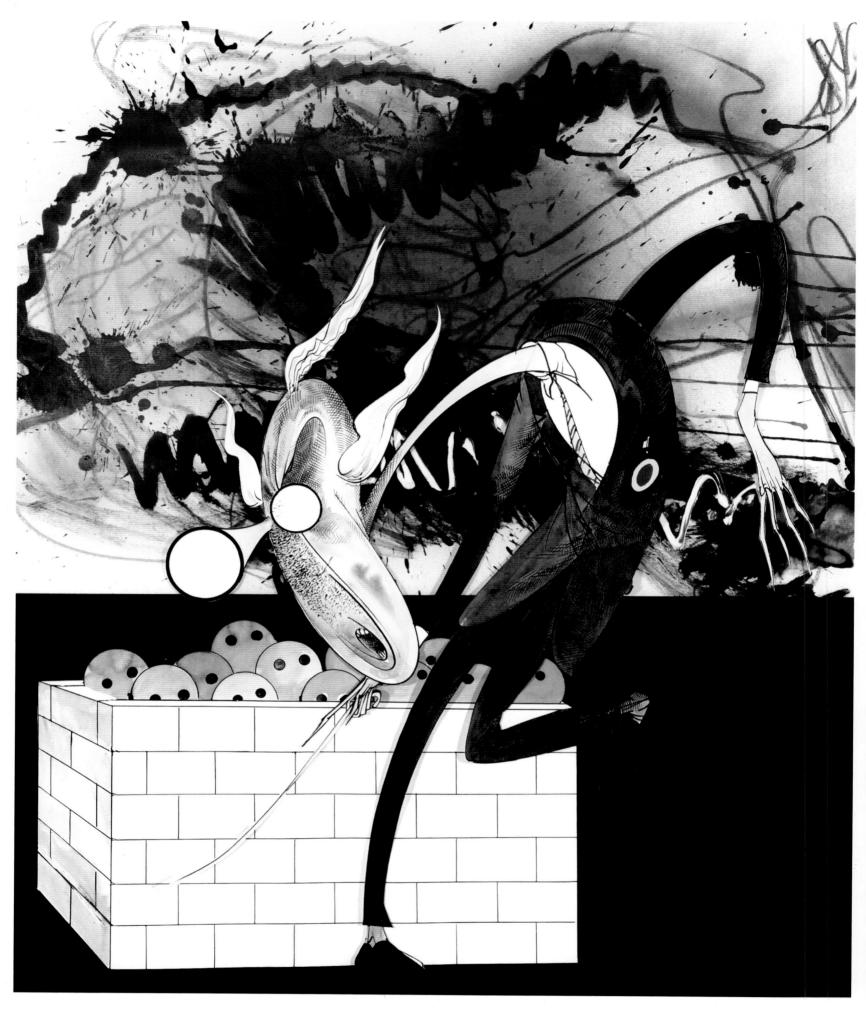

Above: The Teacher. This drawing was projected onto a circular screen behind the band.
Opposite: The inflatable version of the Teacher.

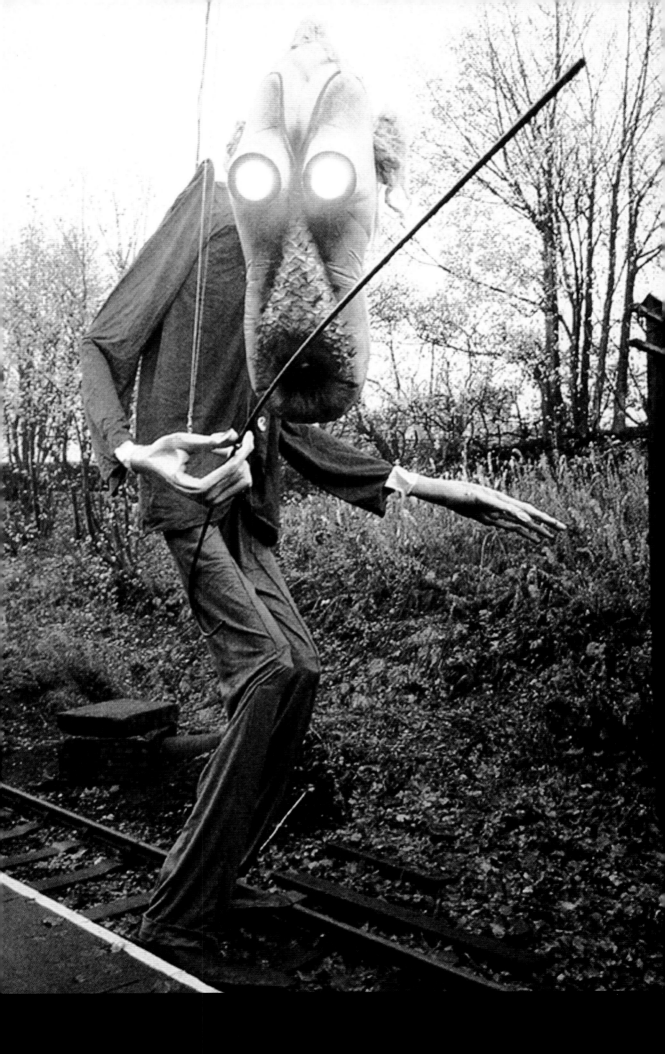

Above: Pink sits slumped in his armchair, watching television in his hotel room. In this illustration and design for the live-action sequences, I've transported him to a surreal, alien landscape.
Below left: The main character, Pink, screaming in his Los Angeles room. Illustration and live-action design for 'One of My Turns'.
Below right: The Backstage Groupie. Illustration and design for live-action scene to accompany the song 'Young Lust'.

In order to convince MGM/United Artists to finance the film of *The Wall*, Roger and I put together this brochure, including the lyrics and my drawings. You will see from the frontispiece that at this point in the development of the film I was co-director with Michael Serinson, and during the year we filmed scenes at live concerts, which were specifically set up not only for the audience but for the filming opportunities. We filmed a sequence of Roger singing 'Is There Anybody Out There?' behind the Wall, and the camera then tracked out and over the wall to show the screaming fans on the other side. We tried this three nights running, irritating the fans because of the heavy lighting necessary for filming. 'You're spoiling a great scene, man!' I remember one fan shouting at me. Alan Parker was producer at this point, and he said he found the shot material unconvincing. There was a palace coup, and Alan became director. I became designer and director of animation, and Michael Serinson left, later to become a cameraman on the *Lord of the Rings* series.

Above: Illustration from the brochure of the Wife's shadow on the Wall. This was a design for a live-action sequence in which the Wife's shadow turns into a menacing monster. Misogynistic? I should say so . . .
Right: Frontispiece of brochure.

SHE COULD LICK ANY MAN IN THE PLACE

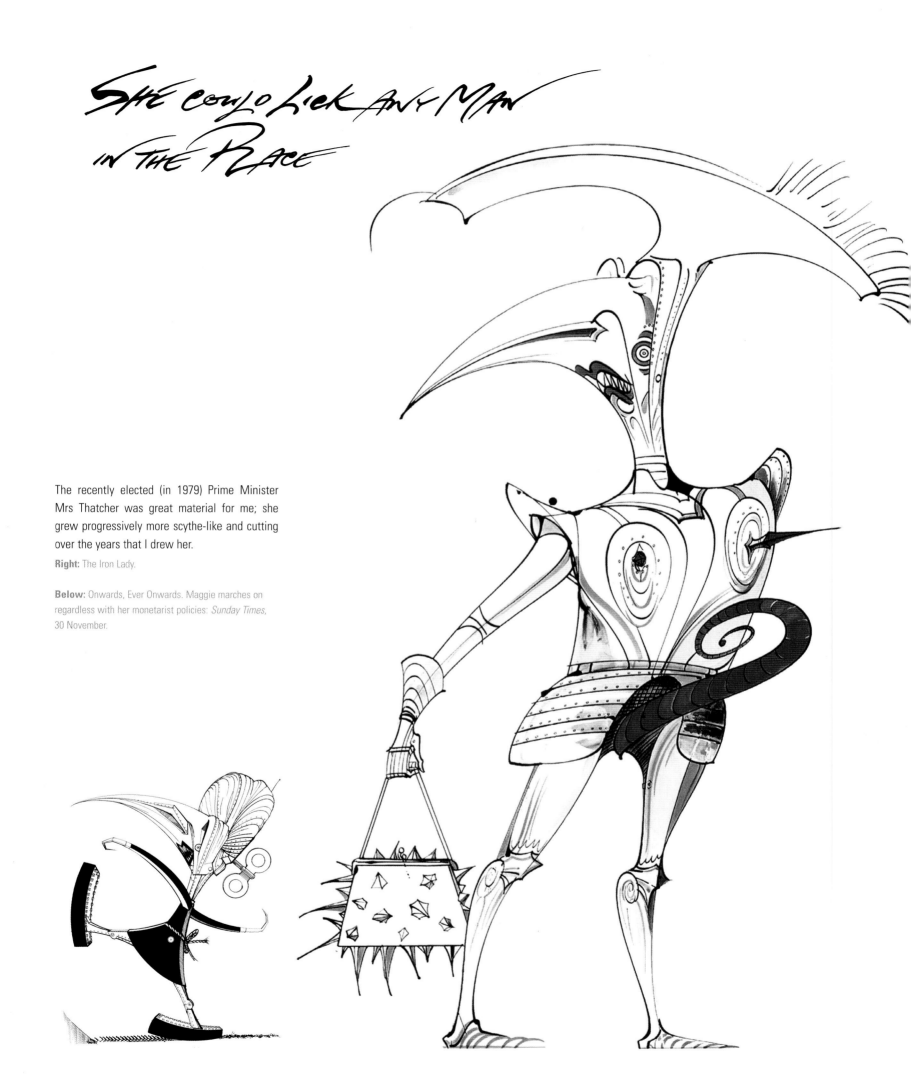

The recently elected (in 1979) Prime Minister Mrs Thatcher was great material for me; she grew progressively more scythe-like and cutting over the years that I drew her.

Right: The Iron Lady.

Below: Onwards, Ever Onwards. Maggie marches on regardless with her monetarist policies: *Sunday Times*, 30 November.

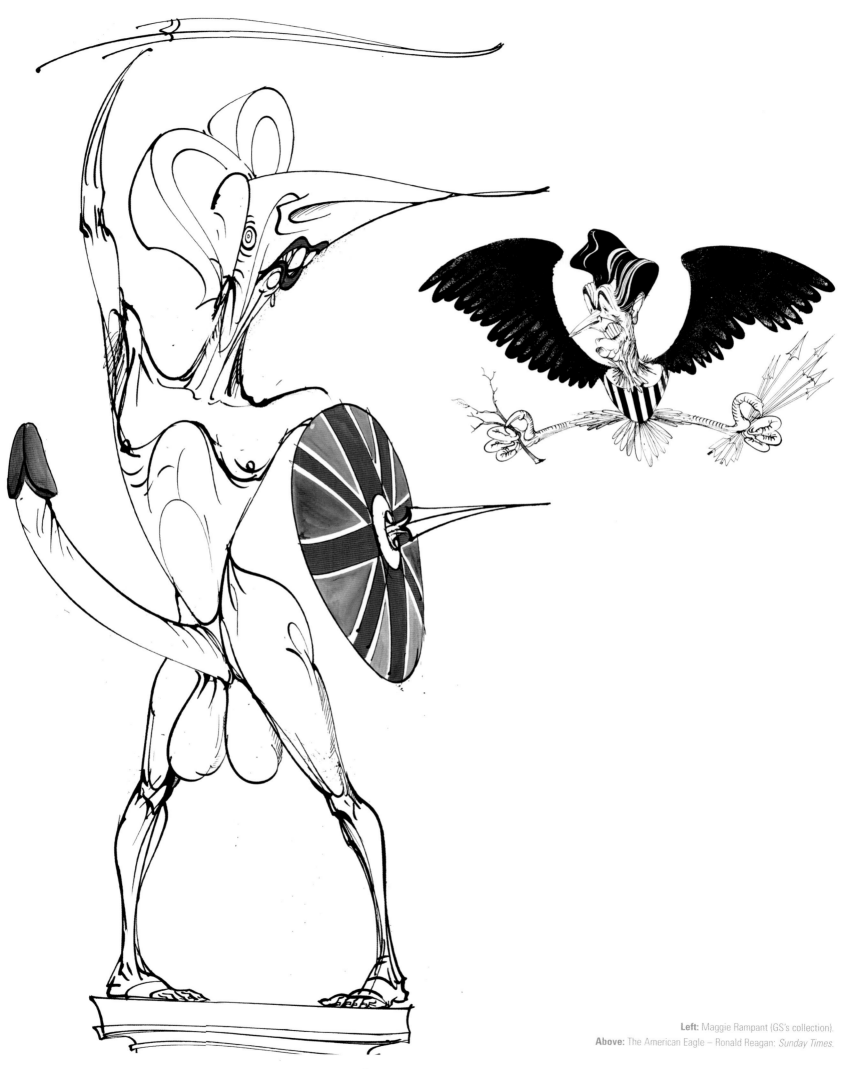

Left: Maggie Rampant (GS's collection).
Above: The American Eagle – Ronald Reagan: *Sunday Times*.

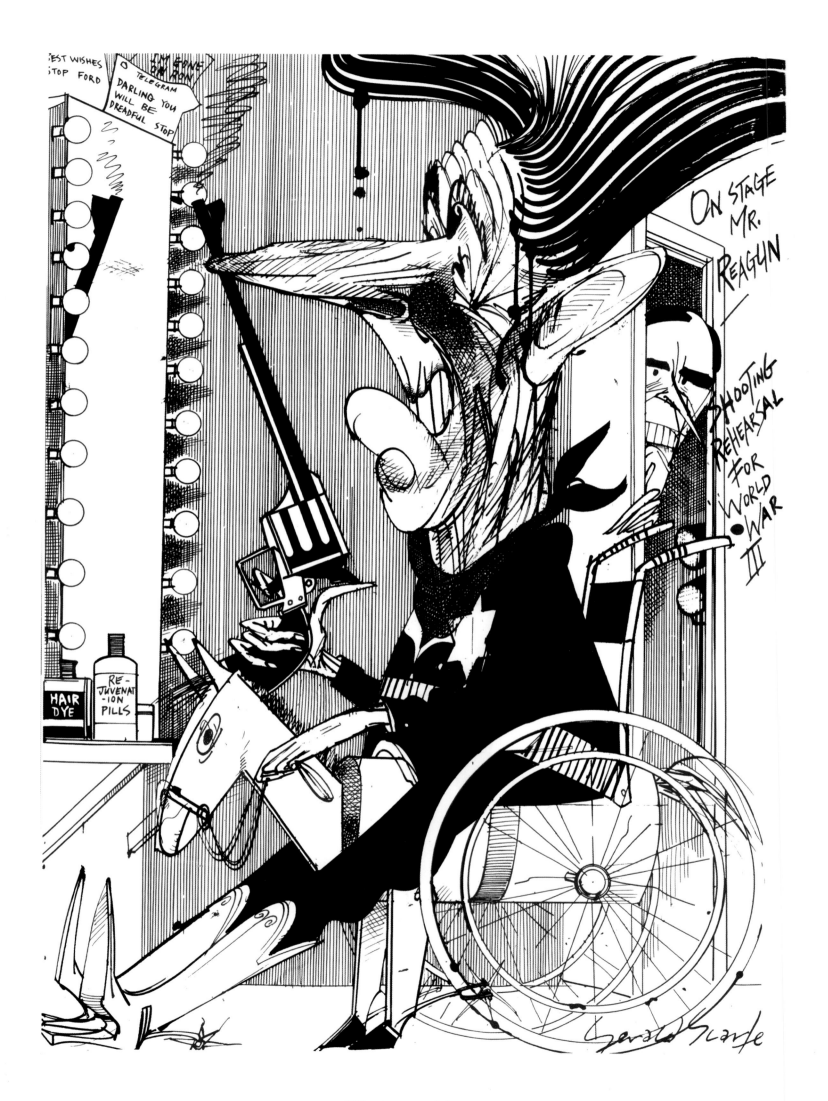

Auberon Waugh's Diary

TUESDAY

THE MORNING is spent sitting for my portrait by Gerald Scarfe, the cartoonist. This may seem a curious thing to do, but I am persuaded that it is one's duty to leave posterity such a memorial, showing warts and all.

Scarfe's problem is one which has confronted all the caricaturists who have ever faced the task of making something ugly or grotesque out of my bland, symmetrical features: there are simply no warts to show. Many have been driven to suicide, and Mark Boxer, sent by the small but resourceful Dame Harold Evans to mock me, had to be led away after quietly inanely, swallowing mothballs for a week.

As I watch Scarfe wrestling with the problem of finding ugliness where there is only refinement, stupidity out of high intelligence, spite out of good humour, affectation out of manliness, a strange transformation comes over him.

First, I notice a wild, frustrated look in his eyes, then his lip begins to curl like a cabbage leaf, ending up as a sort of jam-and-chocolate swiss roll; next his tongue elongates like a snake until it lies ten feet long, red and glistening on my carpet. His eyes pop out on curious antennae and his penis. . . but then, perhaps I had better not say what happens to his penis, as this is a family magazine read by many impressionable young people.

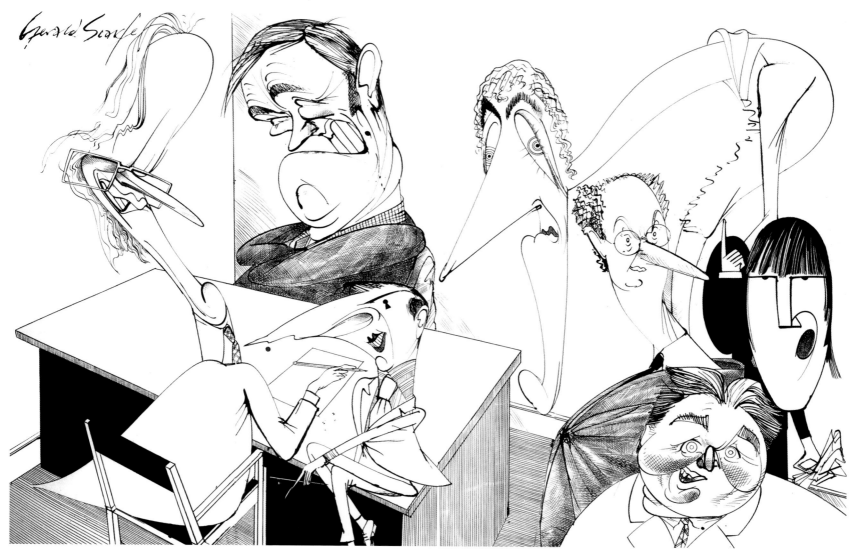

Opposite: Ronald Reagan and his running mate, George Bush, rehearse for the forthcoming US election: *Sunday Times*, 20 July.

Top: Auberon Waugh's column. I went to *Private Eye*'s offices to draw Bron Waugh for a composite portrait. The drawing is by William Rushton.

Above: Portrait of *Private Eye* staff: left to right, Christopher Booker, Richard Ingrams, Nigel Dempster, Peter Cook, Auberon Waugh, Peter McKay and Paul Foot.

Yes Minister. The BBC TV series has become a classic. For the title sequence I used stop-action rostrum filming. I would draw about an inch of line, then take two frames of film, draw another inch of line, then film two more frames. When the film was played at normal speed the character would build up before your very eyes, as if drawn by an invisible hand.

Right: Nigel Hawthorne, Derek Fowlds and Paul Eddington.

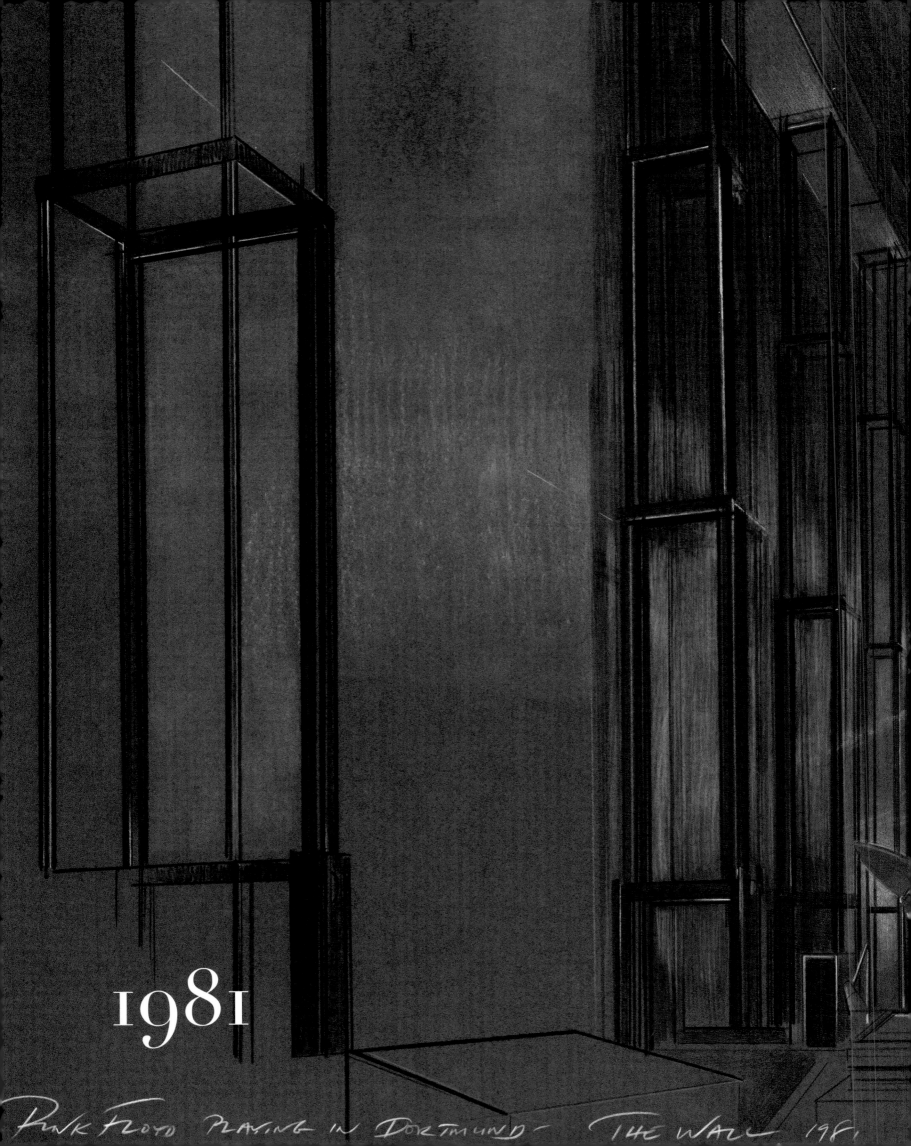

1981

Pink Floyd playing in Dortmund — The Wall 1981

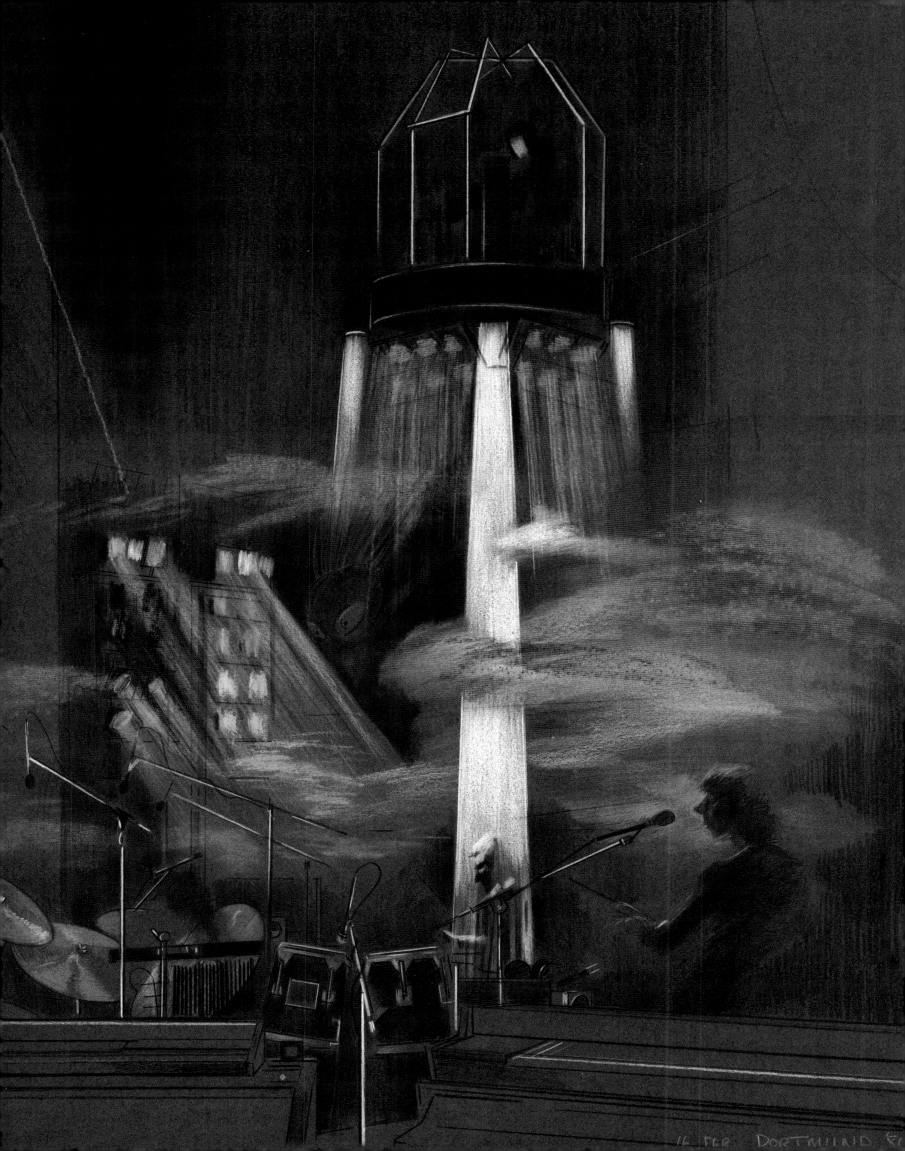

16 FEB DORTMUND 8.

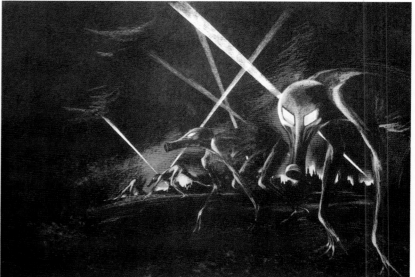

Previous page: Dortmund Concert. I made this drawing behind the wall while the band played.

Top: A preliminary drawing for *The Wall* of the eagle warplane taking off.

Above left: The eagle warplane crashing.

Above right: The Frightened Ones: *The Wall*'s troglodyte-like creatures with gas-mask heads scurry below the searchlights of Second World War England.

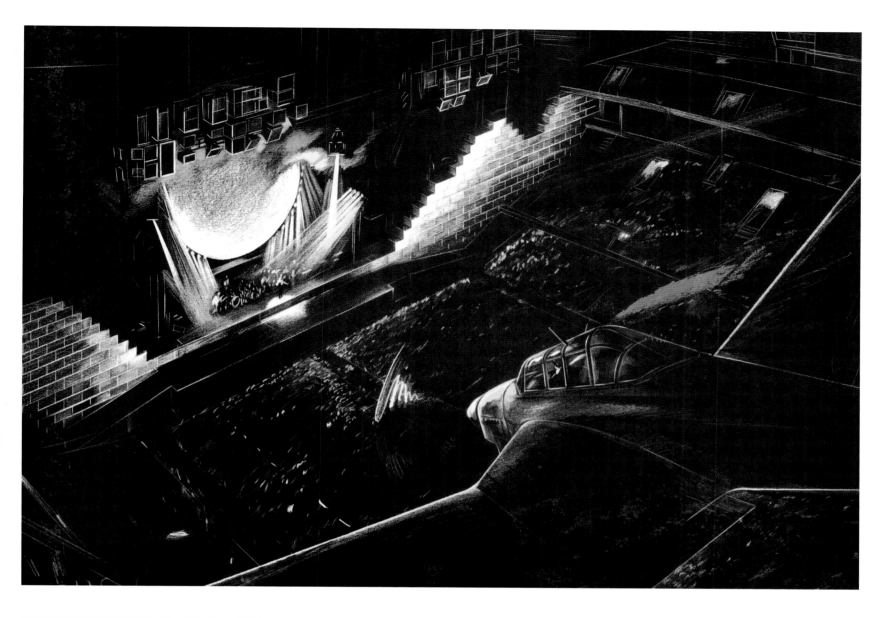

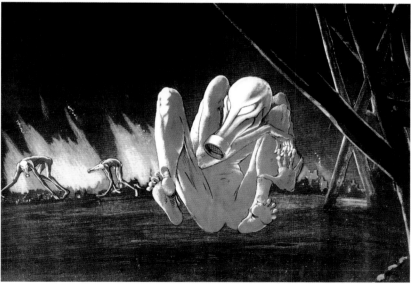

Top: Drawing made during the *Dark Side of the Moon* concert at the
Rainbow, Finsbury Park, London.
Above left: Finished cell for the Frightened Ones.
Above right: The eagle warplane over burning London.

Next page: Pink screams in the back of the limo. Illustration for
live-action sequence.

Opposite: The first drawing for the War Lord from *The Wall*.
Top: Finished cell of the War Lord.
Above: The Metal War Lord from *The Wall*.

As well as designing the animation for *The Wall*, I made drawings and storyboards for the live-action sequences. This was the final year of *The Wall*. By this time relationships were fraught: someone said, 'What do you expect when you put three megalomaniacs in a room together?' I remember driving to Pinewood at 9 a.m. with a bottle of Jack Daniel's on the passenger seat. I needed a slug before I could face it all – incidentally, I'm not a heavy drinker.

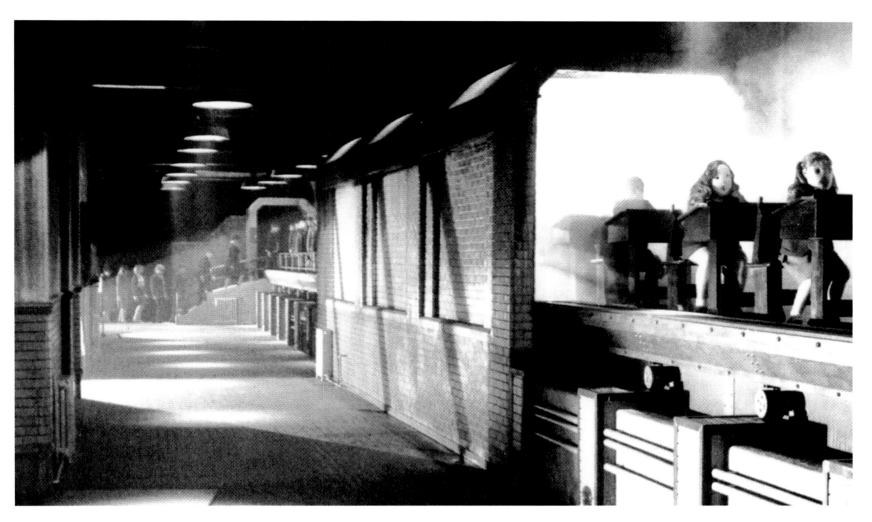

The war room: my storyboards covered the walls. Left to right, the director Alan Parker, GS and production designer Brian Morris.

This page:
Above: The conveyor belt.
Right: The room at Pinewood where *The Wall* was put together.
Below: Storyboard as seen in the photograph above.

Opposite:
Above: Design for the conveyor belt on which the children are processed.
Far left: Live-action shot of the mincing machine.
Left: Design for the Mincer.

 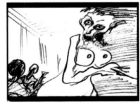 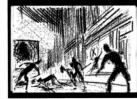 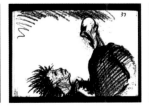

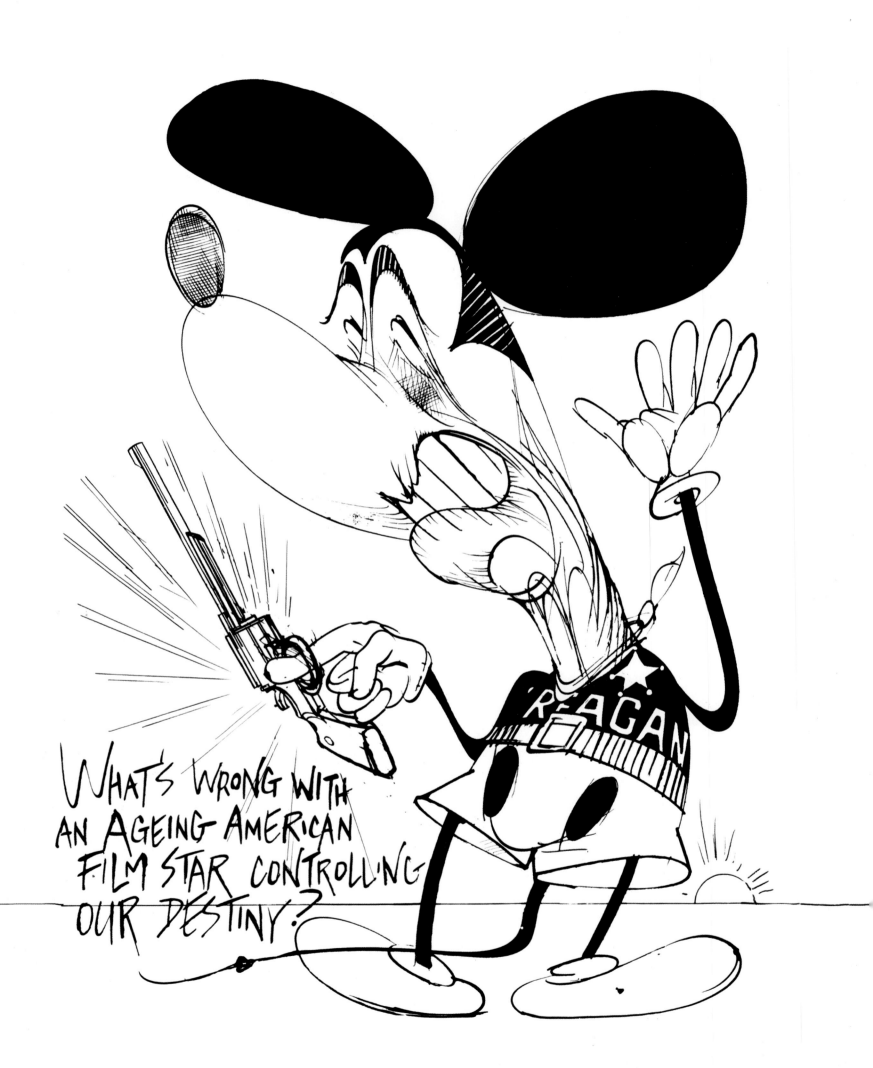

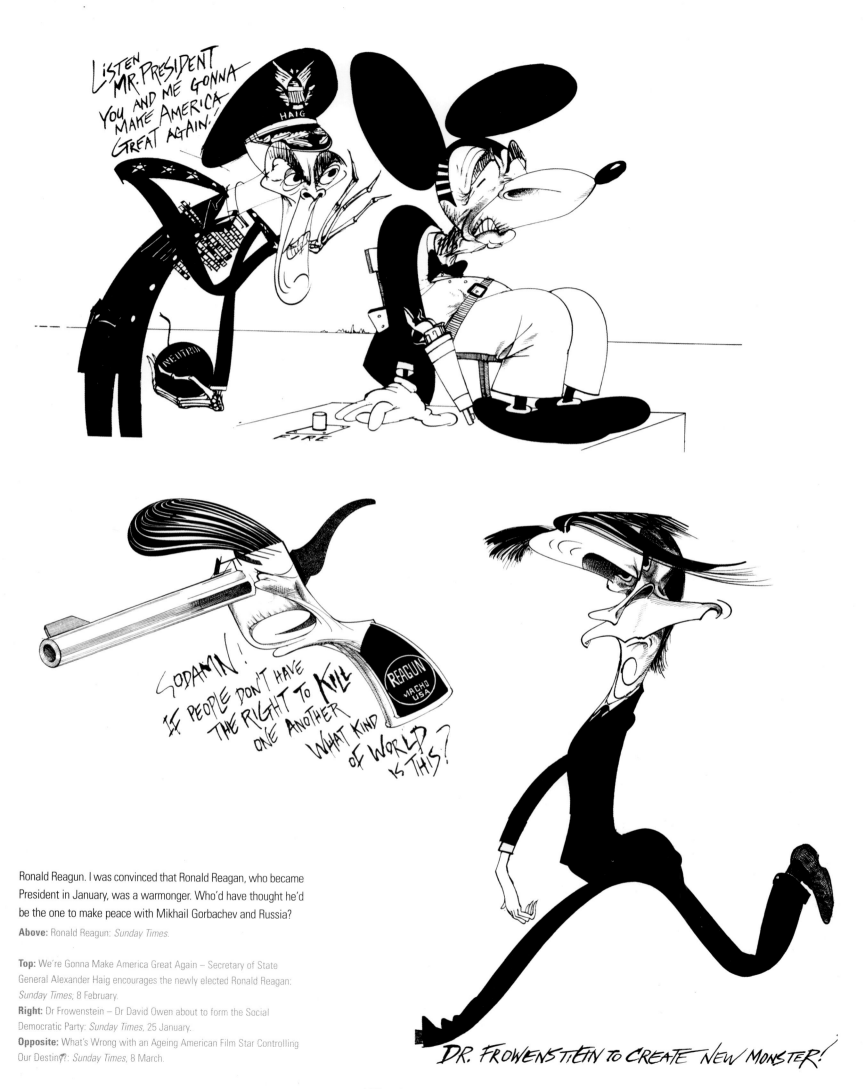

Ronald Reagun. I was convinced that Ronald Reagan, who became President in January, was a warmonger. Who'd have thought he'd be the one to make peace with Mikhail Gorbachev and Russia?

Above: Ronald Reagun: *Sunday Times*.

Top: We're Gonna Make America Great Again – Secretary of State General Alexander Haig encourages the newly elected Ronald Reagan: *Sunday Times*, 8 February.
Right: Dr Frowenstein – Dr David Owen about to form the Social Democratic Party: *Sunday Times*, 25 January.
Opposite: What's Wrong with an Ageing American Film Star Controlling Our Destiny?: *Sunday Times*, 8 March.

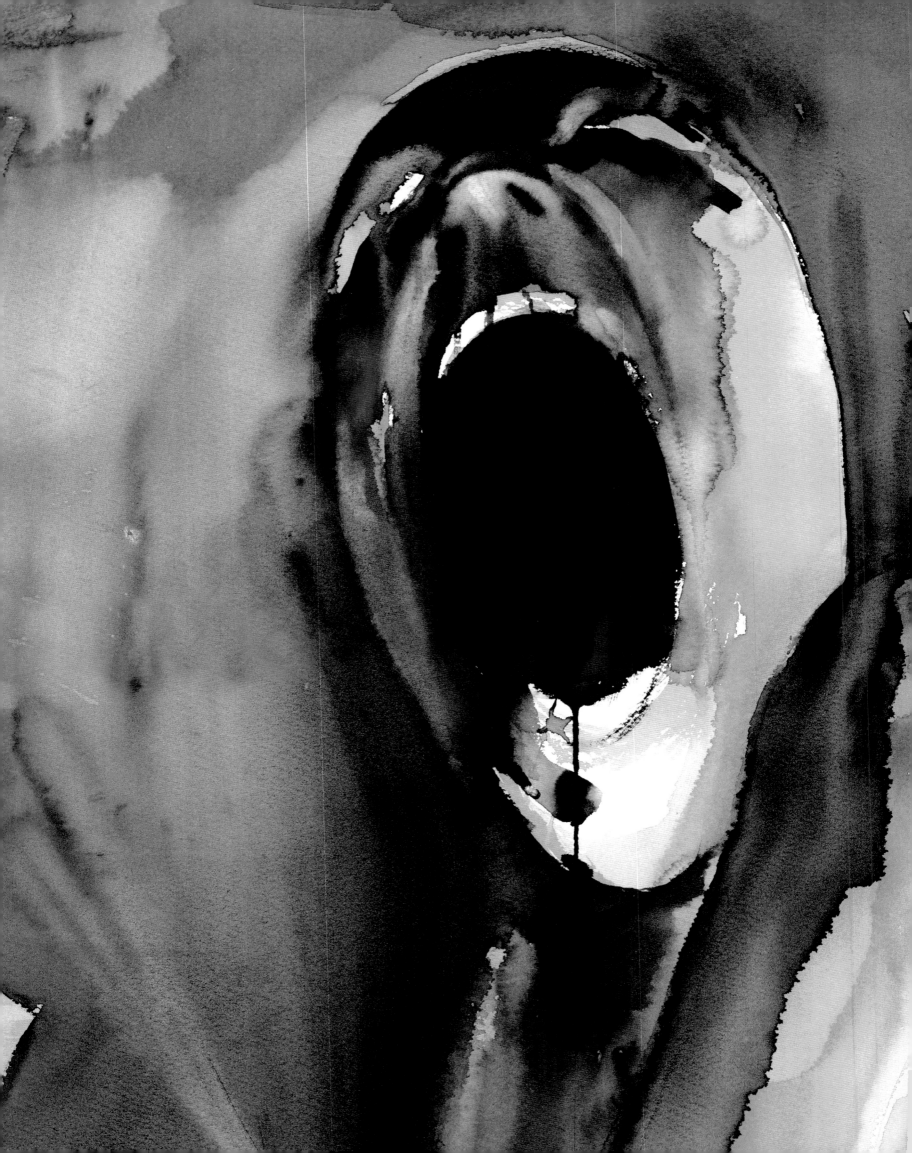

It was in this room in Cheyne Walk that we discussed and planned *The Wall* from the moment Roger Waters brought the raw tapes of his singing to a synthesiser to the final storyboards for the film.

Previous page: GS in his studio surrounded by all his designs for *The Wall*.

THE Wall Premiere

Left: The Screaming Head: watercolour used for publicity material and posters.
Below: On the roof of MGM, Los Angeles: left to right, Pink Floyd's manager Steve O'Rourke, GS, Bob Geldof (who played Pink in *The Wall*), Ginger Gilmour and Dave Gilmour.

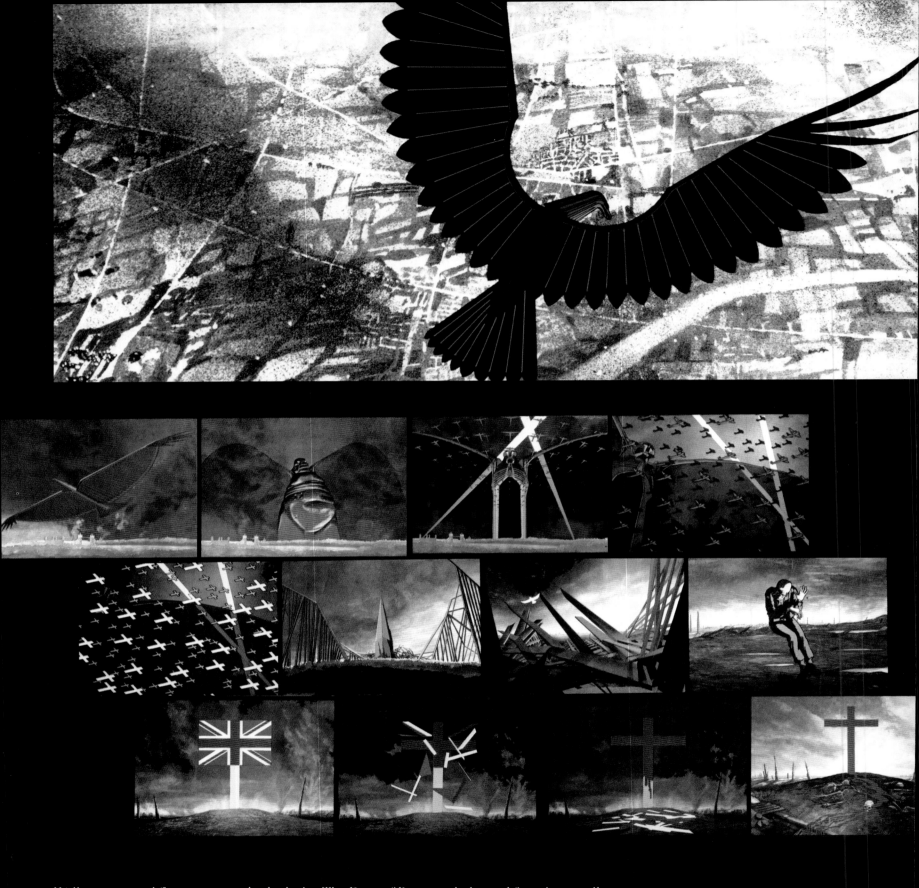

Walls scream and flowers turn to barbed wire. The Dove of Peace explodes and from its entrails a terrible eagle is born. This menacing creature tears great clods from the countryside with its giant talons, destroying whole cities. Swooping low, it gives birth to the War Lord, a gargantuan figure who turns to metal and sends forth bombers. The bombers turn to crosses as the Frightened Ones run to their shelters. The ghosts of soldiers fall and rise again on a hill of bodies. A Union Jack turns to a bloody cross: blood runs down the cross, through the corpses, and pointlessly trickles down the drain.

This page and opposite: Animation stills from the final film.

The Argentine *General Belgrano* was sunk with the loss of more than three hundred lives. The ship was outside the 200-nautical-mile exclusion zone and heading away from the Islands when it was torpedoed.

Opposite: Belgrano Nightmare – Thatcher Wakes Screaming (GS's collection).

Below: Aggression Must Not Be Seen To Pay – General Galtieri of Argentina seizes the British Falkland Islands and Thatcher sets sail: *Sunday Times*, 23 May.

THE FALKLANDS

AGGRESSION MUST NOT BE SEEN TO PAY!

1983

Above: GS with 'Mickey Reagan' – Ronald Reagan as a gun-toting
Mickey Mouse: sculpture for an exhibition at the Royal Festival Hall
in London.

Above right: Poster for the Royal Festival Hall exhibition: GS at the
Festival Hall.

Opposite: Twelve-foot-high sculpture of Maggie intended for a
public place, showing her standing on the tomb of the unemployed.

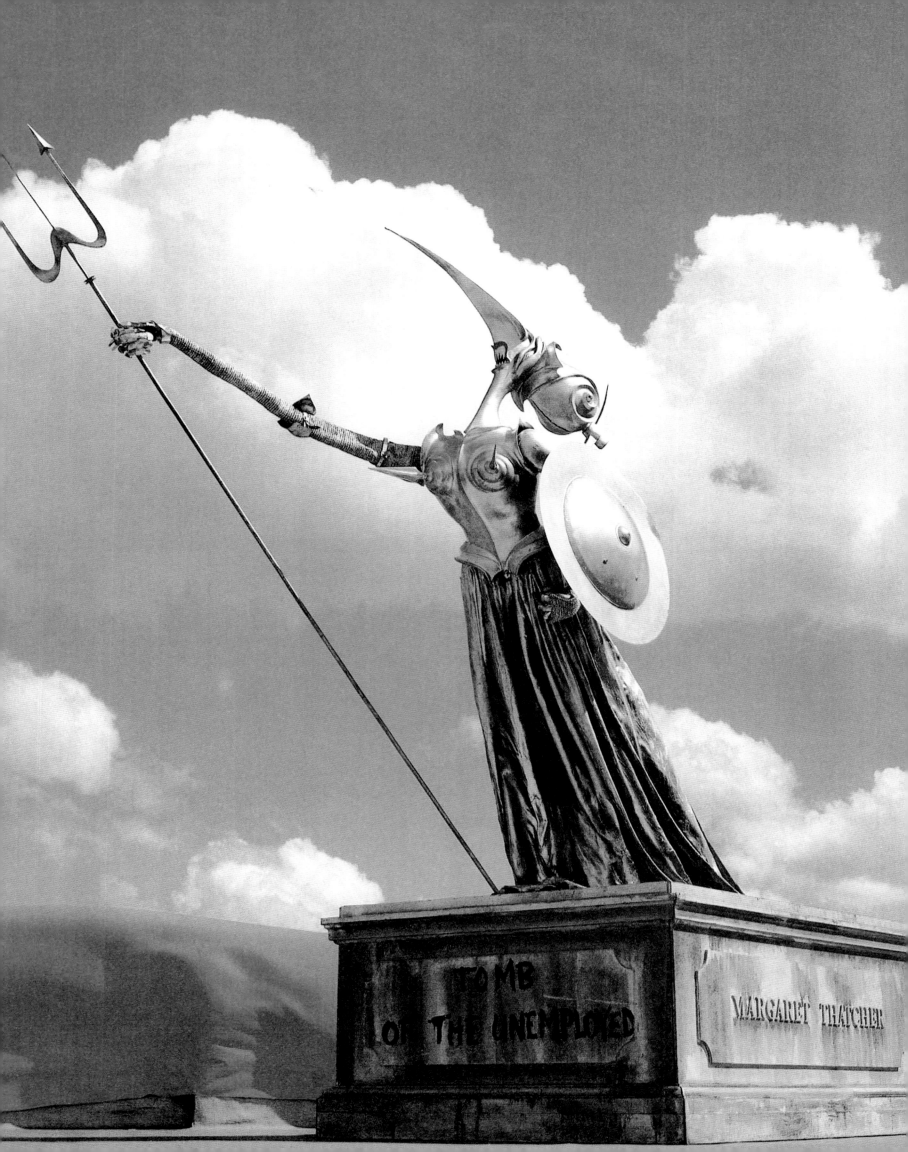

Opposite: Who Won? – nuclear war: *Sunday Times*, 13 March.

Above: Pope John Paul II visits his home country, Soviet-controlled Poland, underlining his stance against Communism: *Sunday Times*, 26 June.

Following page: Backdrop for *The Big One*, a charity show for peace, with various celebrities, staged at the Dominion Theatre in London.

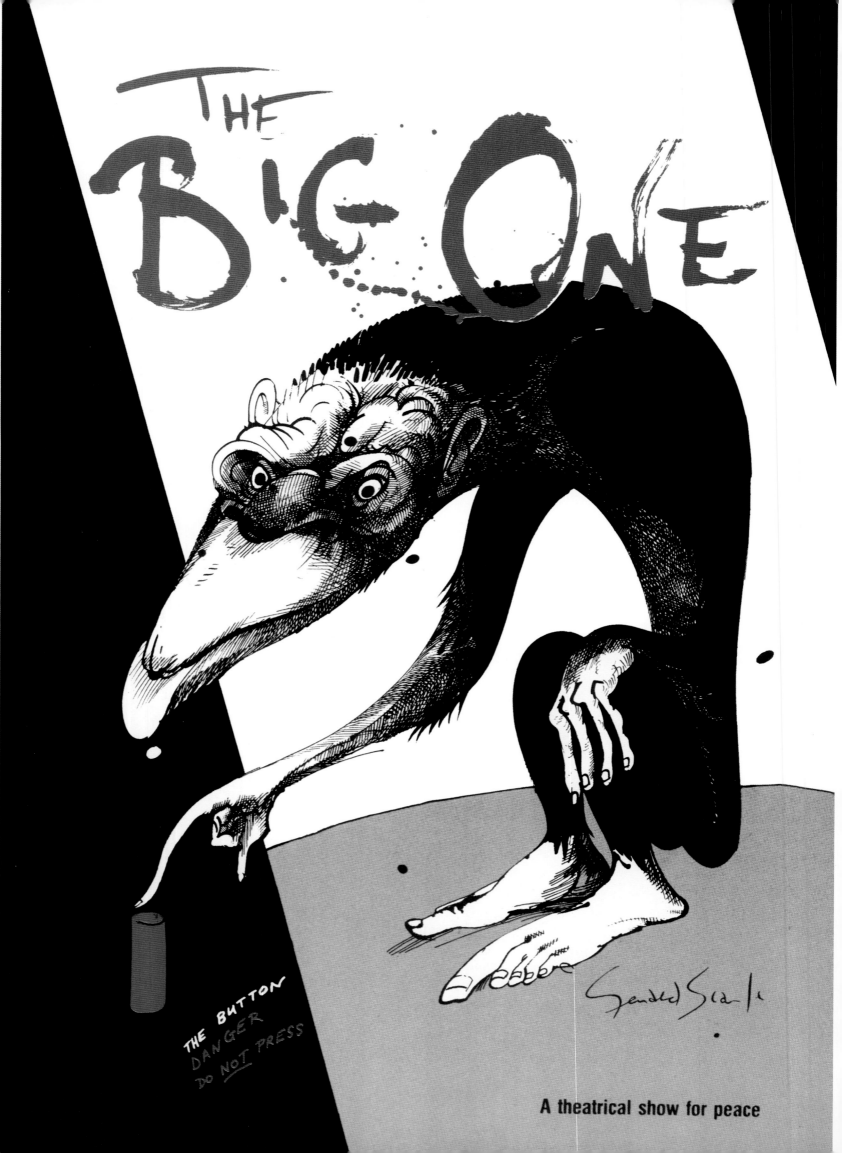

It was this drawing that prompted David Pountney, the Artistic Director of the ENO, to commission me to design Offenbach's *Orpheus in the Underworld* in 1984.

Above: Drawing of the English National Opera production of Wagner's *The Valkyrie* at the Coliseum in London: *Sunday Times*.

Left: David Over-Exposed — David Hockney has a show of his Polaroid pictures at the Hayward Gallery in London: *Sunday Times*, 13 November.
Above: Dalí You're Wonderful — Dalí was found on his sick bed, surrounded by flames: *Sunday Times*.
Opposite: Poster for *The Big One*.

DRAWING IN THE DARK

1984

Enjoyable evenings in the theatre and cinema, courtesy of the *Sunday Times*. Sketching in the dark during the performances and then back to the studio to complete the finished drawing for the *Sunday Times* arts pages. It's very difficult to sketch without irritating the person beside you, or more especially the person directly in front. It was also very difficult to concentrate on the play and sketch at the same time.

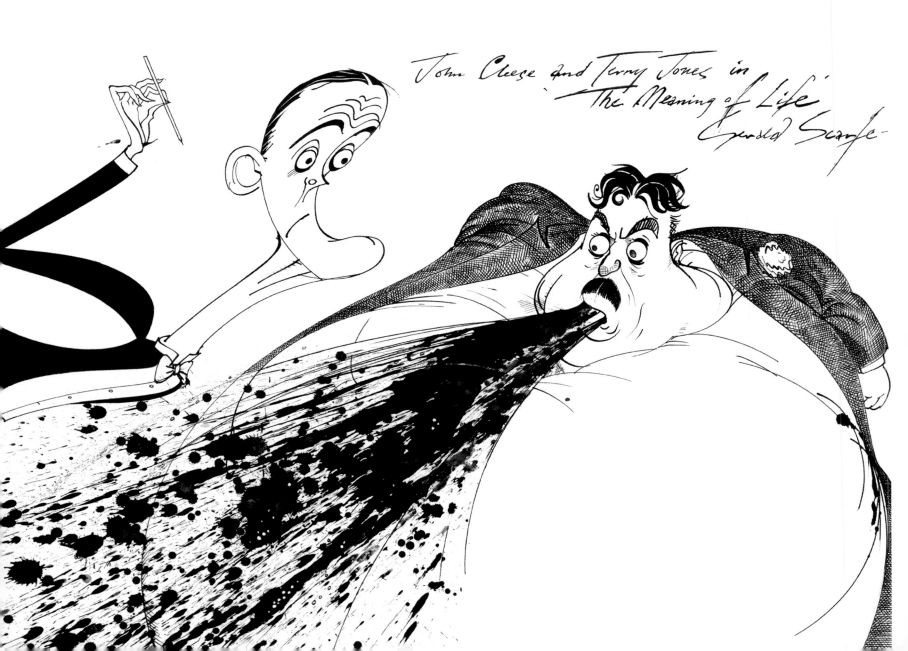

John Cleese and Terry Jones in The Meaning of Life

Gerald Scarfe

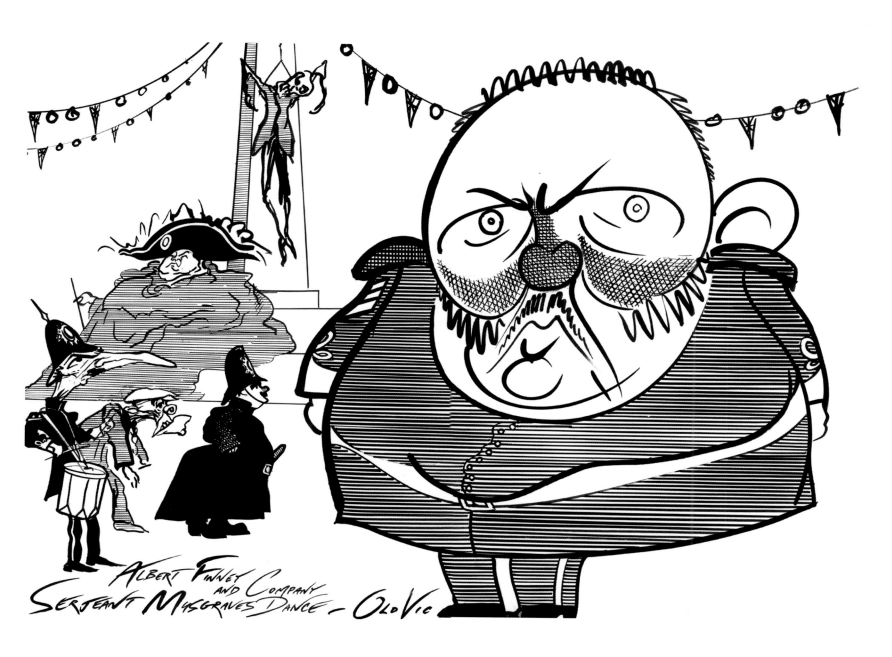

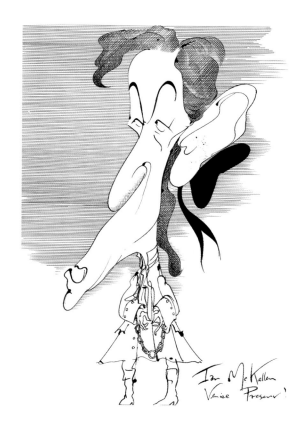

Opposite: Monsieur Creosote from *Monty Python's The Meaning of Life* – John Cleese and Terry Jones: *Sunday Times*.

Above: Albert Finney and company in *Serjeant Musgrave's Dance* by John Arden at the Old Vic: *Sunday Times*.

Right: Sketch of Ian McKellen during a performance of Thomas Otway's *Venice Preserv'd*.

Far right: *Venice Preserv'd* – the final version: *Sunday Times*.

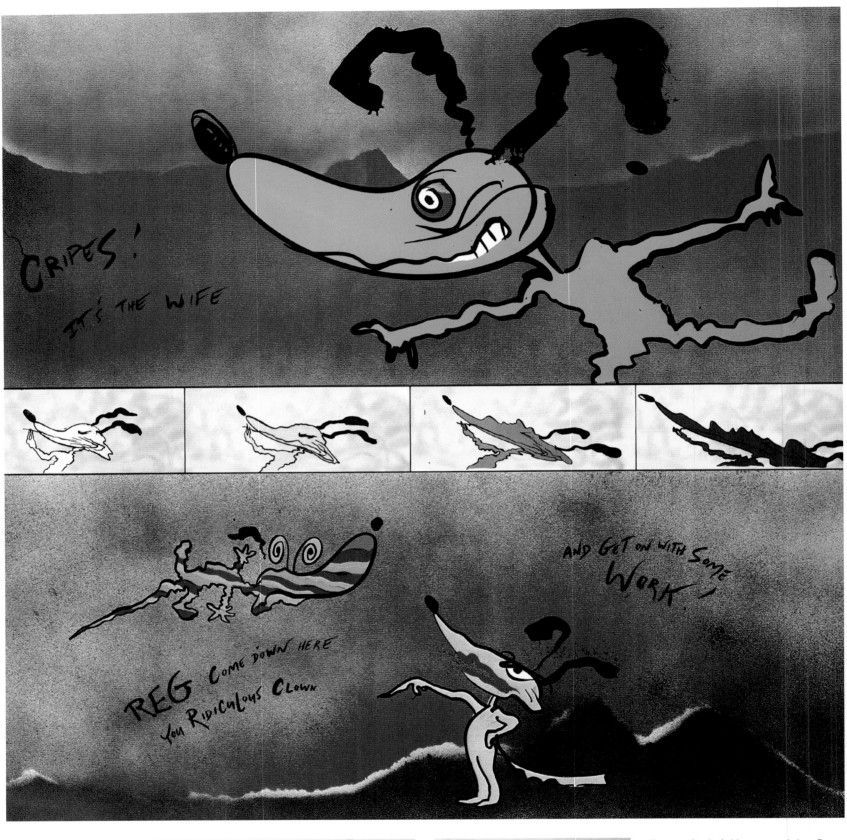

I'm very fond of this wayward dog: Roger pointed out that 'Reg' was a combination of his name – 'Rog' – and the first part of my name backwards. I wish Reg had had a longer life.

Cripes! It's the Wife – drawings of Reg the Lazy Dog, high on drugs. Back projection for Roger Waters' *Pros and Cons of Hitch-hiking* tour and the cover for the album.

CHILLING

Chilling. Frozen embryos — the debate on the moral implications of
and fears about cloning: *Sunday Times*, 22 July.

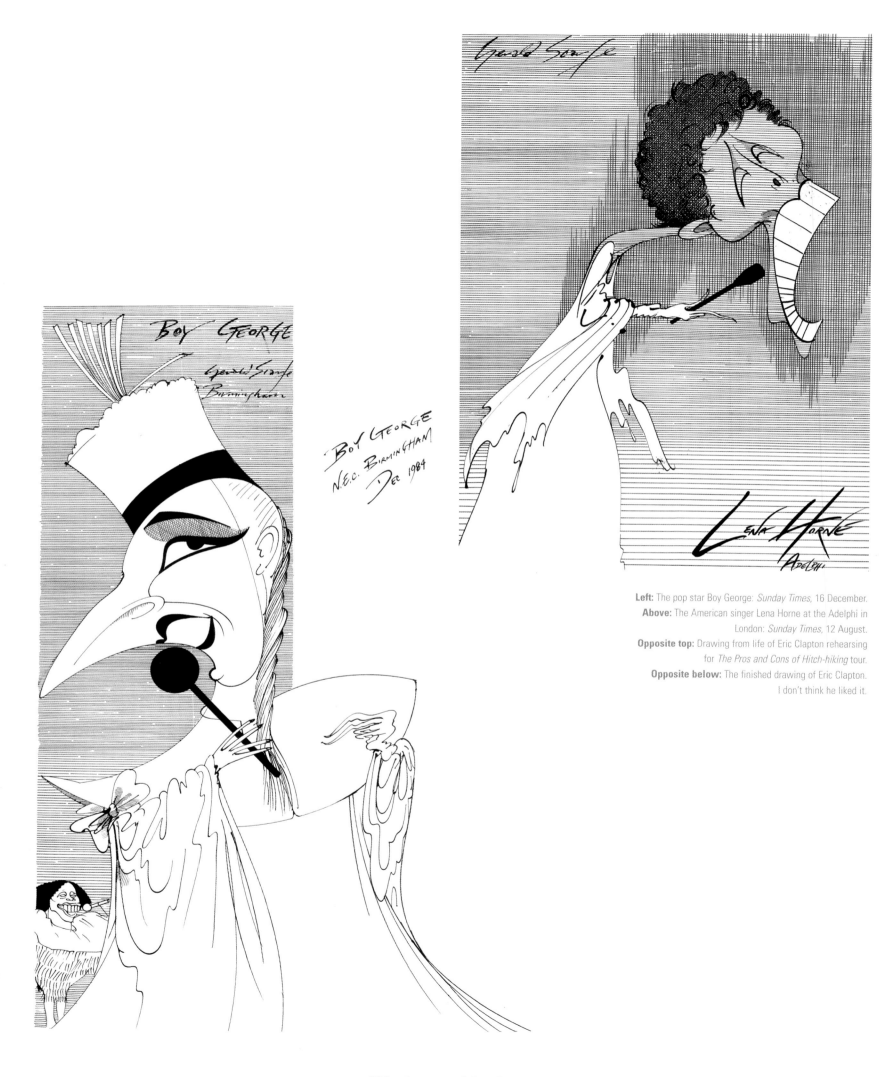

Gerald Scarfe

BOY GEORGE

Gerald Scarfe
Birmingham

BOY GEORGE
N.E.C. BIRMINGHAM
DEC 1984

Lena Horne
Adelphi

Left: The pop star Boy George: *Sunday Times*, 16 December.
Above: The American singer Lena Horne at the Adelphi in
London: *Sunday Times*, 12 August.
Opposite top: Drawing from life of Eric Clapton rehearsing
for *The Pros and Cons of Hitch-hiking* tour.
Opposite below: The finished drawing of Eric Clapton.
I don't think he liked it.

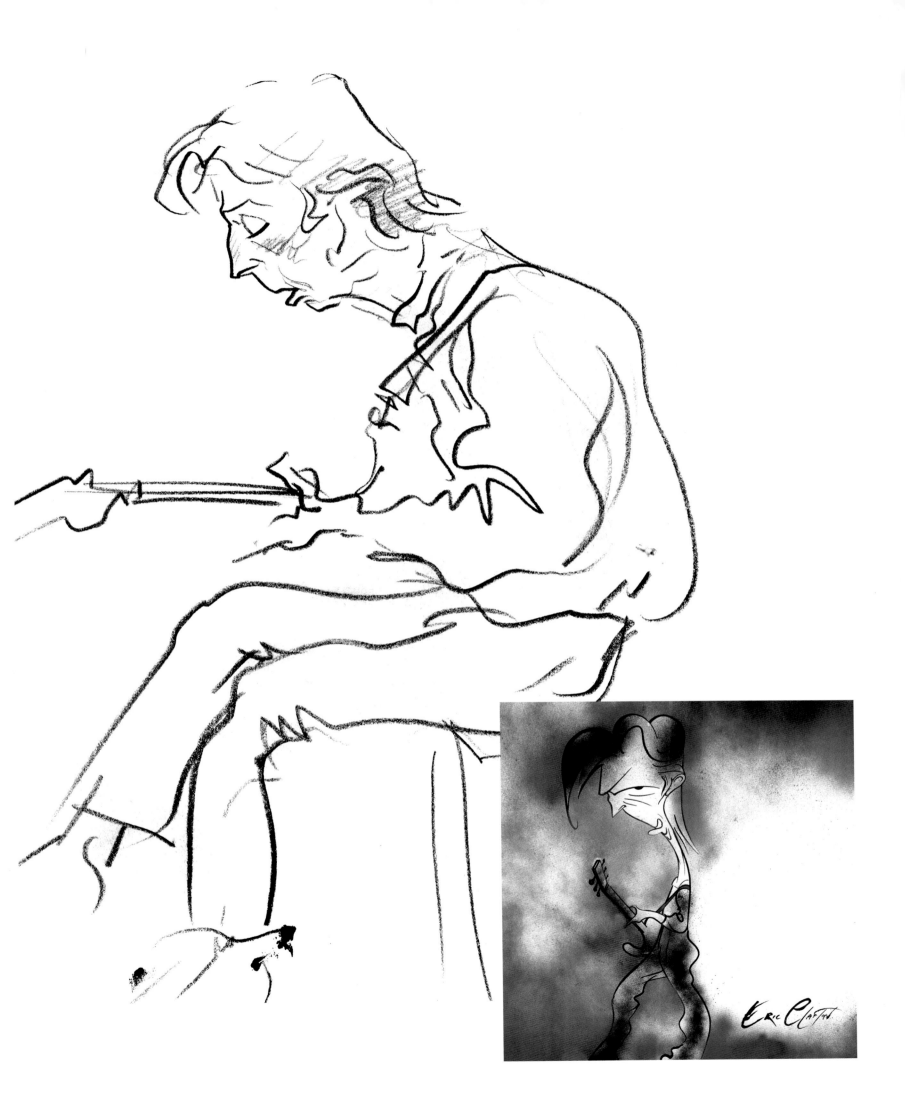

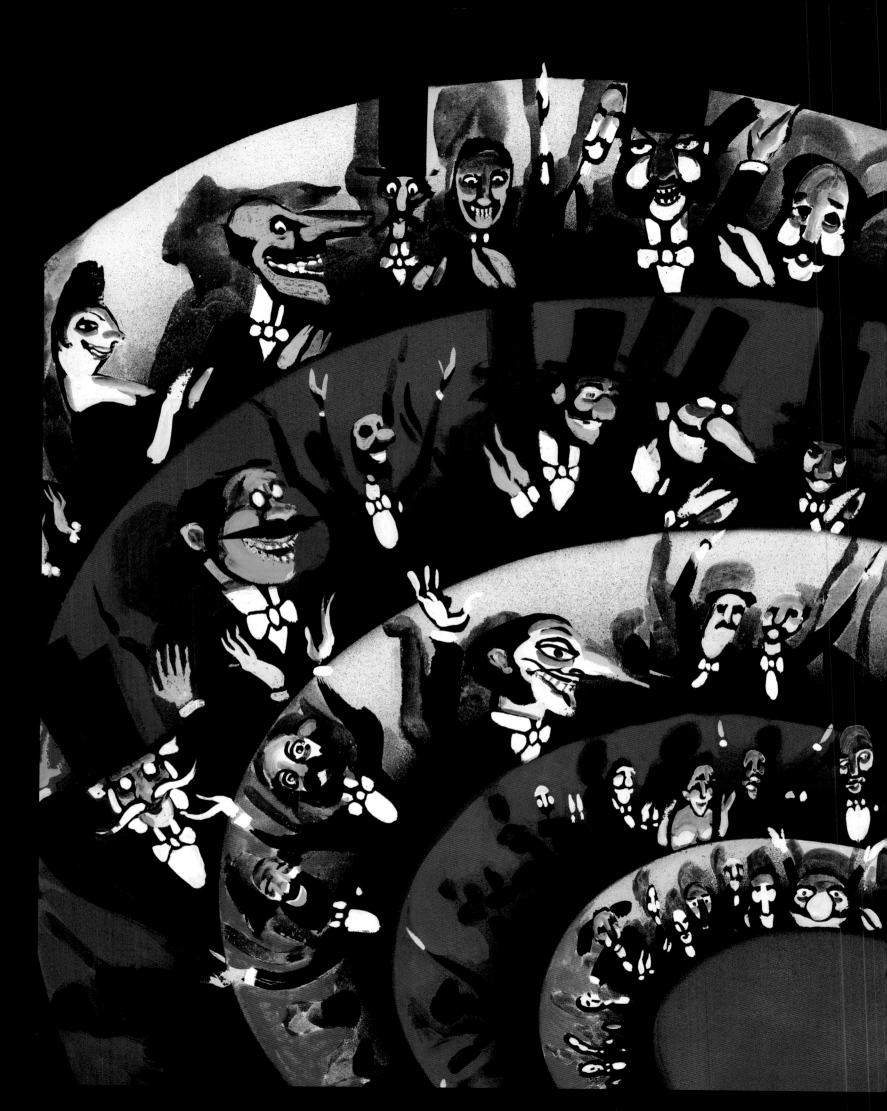

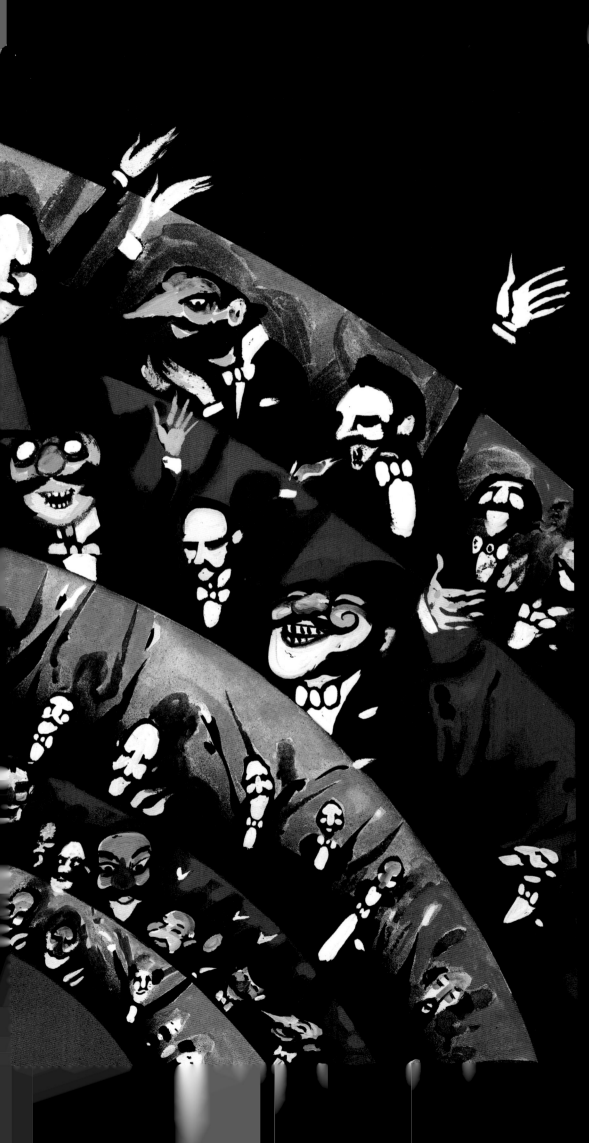

Left: Painting of the cheering audience: front-cloth for the English National Opera's production of *Orpheus in the Underworld*.
Top: *Orpheus*: design for the can-can girls.
Above: GS in front of back-cloth for *Orpheus*.

ORPHEUS IN THE UNDERWORLD

A Royal Gala Performance
in the Presence of
H.R.H. Princess Alexandra

Orpheus in the Underworld

OFFENBACH

Sponsored By
ChemicalBank

7.30 December 2ND 1985

WHAT A HIT!

"...QUITE SIMPLY THE BEST SHOW IN TOWN"
LONDON STANDARD

"...INCESSANT ENTERTAINMENT..."
THE TIMES

"THIS WHIRL OF A PRODUCTION..."
THE TIMES

"...A SPECTACLE THAT SIZZLES AND STUNS"
THE SUNDAY TIMES

"...AN EVENING OF

"FABULOUS BARRME OF VISUAL FANTASIES..."
"...LONDRES WILL NO DOUBT GO TO SEE THIS SHOW"
DAILY TELEGRAPH

UNIQUE CHARITY OCCASION
AT THE LONDON COLISEUM
ST. MARTINS LANE

HELP US BUY A
KURZWEIL READING MACHINE
FOR THE BLIND.
BOOK NOW — TELEPHONE
SHEILA SPAUL 01—798 2768
OR THE BOX OFFICE 01—240 5250
ACCESS/ AMERICAN EXPRESS/ VISA/ DINERS CLUB.

1985

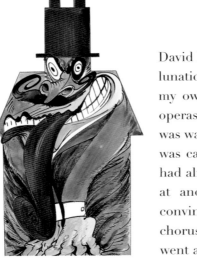

David Pountney wanted *Orpheus in the Underworld* set in a Victorian lunatic asylum. I felt constricted by the idea, and wanted to create my own world. There seems to be a convention of transporting operas to another time. However, it threw me. I didn't know what was wanted. I became confused and the opera ground to a halt and was cancelled. I didn't want to give up on the project, because I had already invested a great deal of time in it, so I kept going, and at another meeting with David some months later, he was convinced when he saw my design for the transformation of the chorus in the bed into the same characters in the bath. So off we went again.

In every other respect too the evening is dominated, quite shamelessly, wholly and completely, by the visual imagination of Gerald Scarfe. There need be no concern that his drawings might not translate well to the operatic stage: they do so uproariously, partly because a very great deal of the décor consists quite simply of cartoons writ large. Even at a time when painted scenery has made a comeback, it is a surprise and a delight to see such a profusion of drops and flies, coloured with the incisive guidelines of a Chinese demonology. Thanks obviously to the inventiveness of the ENO technical staff, Scarfe's ideas have even been brilliantly realised in the masks and costumes. This is one of those productions which silently put critics on trust not to give the game away, but I feel quite safe in describing something of the wardrobe, since no words could possibly undermine this flamboyant underworld. There is Mars, strutting as a metal pterodactyl with a ludicrously enormous crest to his helmet. There is Venus as a cross between de Milo and de Mille. There is Mercury aglitter in silver shorts, Jupiter with his monstrous whiskers of feigned surprise, a chorus line of bellhops with suspenders and nymphet voices, another ballet of black dancers in costumes of ash and flame for the can-can. One could go on. And Scarfe does. **A REVIEW OF *ORPHEUS IN THE UNDERWORLD* BY PAUL GRIFFITHS: *THE TIMES*, 11 SEPTEMBER.**

Opposite: Poster for the Royal Gala performance of *Orpheus*.
Above left: *Orpheus*: costume for John Styx.
Above: Lecherous house from Act I of *Orpheus*.
Below left: Blow-out in Hades: detail from back-cloth design for *Orpheus*.
Below right: Design for Pluto's costume, *Orpheus*.

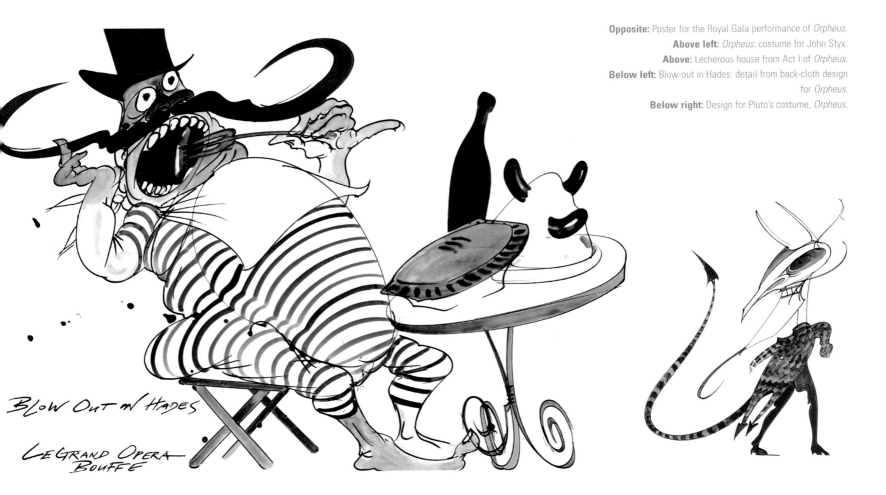

BLOW OUT IN HADES

LE GRAND OPERA BOUFFE

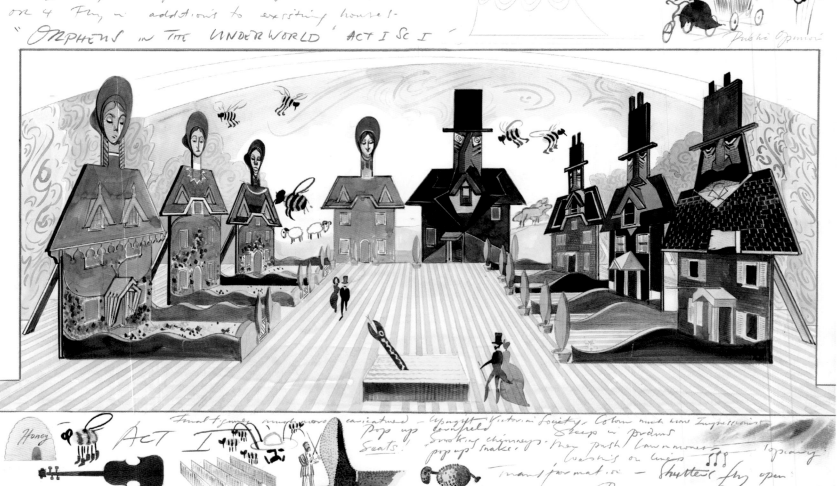

"ORPHEUS IN THE UNDERWORLD" ACT I SC I

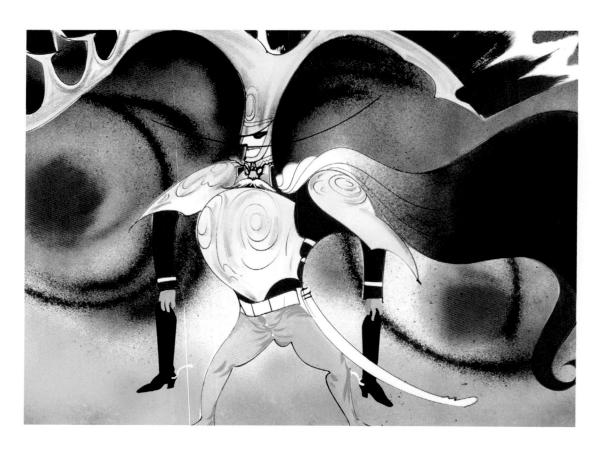

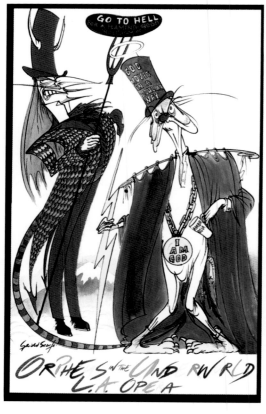

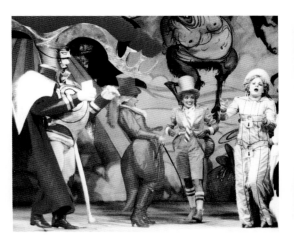
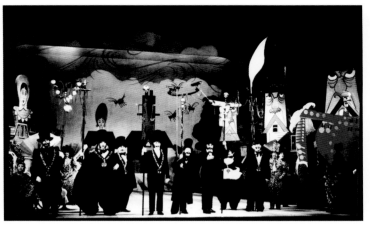

Opposite:
Top: *Orpheus* Act I, scene i: Houses and gardens: design for back-cloth for *Orpheus*.
Below left: *Orpheus*: costume design for Mars, the God of War.
Below right: Poster for the Los Angeles Opera's production of *Orpheus*.

This page:
Top left: Mars, Diana, Cupid and Juno on stage at the London Coliseum.
Top centre: *Orpheus*: the assembled town councillors and Pluto.
Top right: *Orpheus*: Pluto and Eurydice.
Below: *Orpheus*: design for Eurydice's costume.

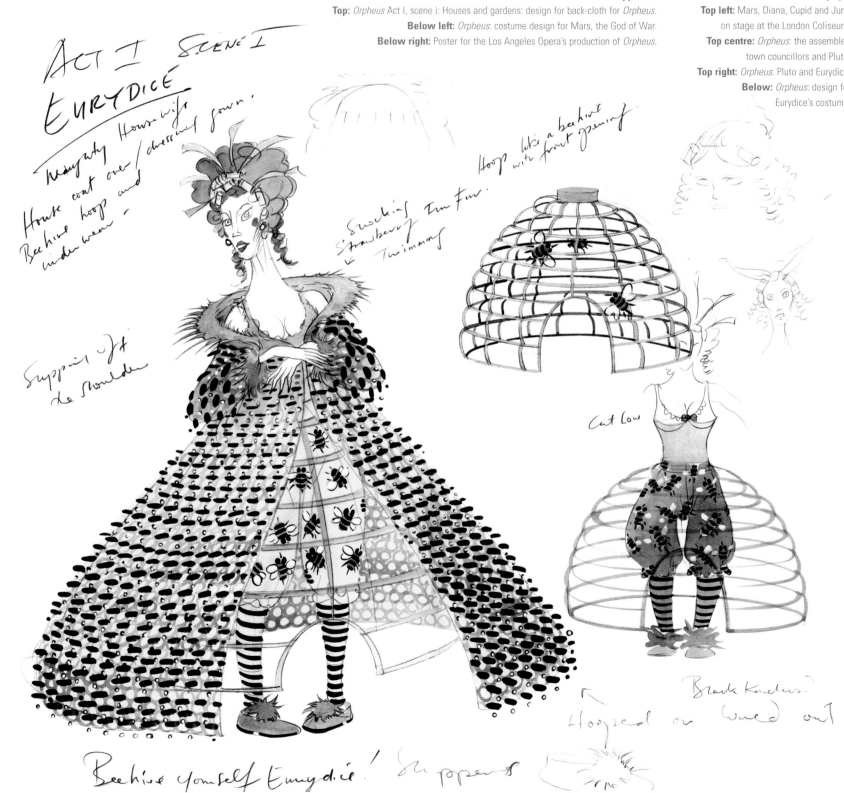

ACT I SCENE I
EURYDICE

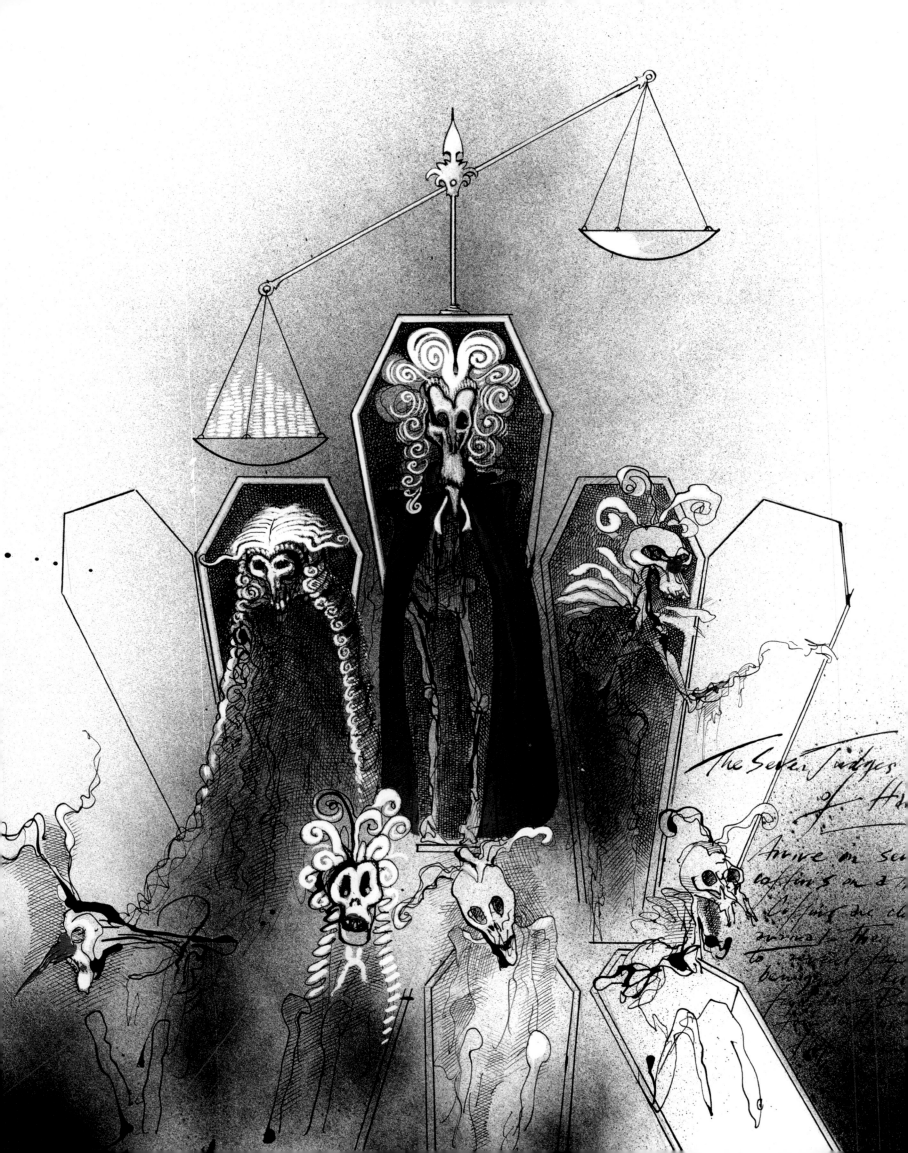

The Seven Judges

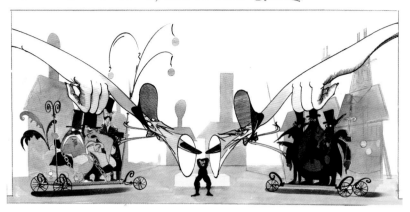

ACT I PUBLIC OPINION + TOWN COUNCIL

ORPHEUS IN THE UNDERWORLD

A REVOLUTIONARY

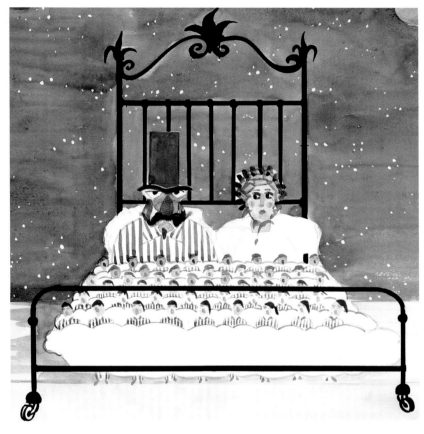

The Royal Exchange THEATRE COMPANY

World premiere of a New Musical

MONEY

WHO'S A LUCKY BOY?

SEX

BY ALAN PRICE
BASED ON AN IDEA BY BRAHAM MURRAY, ALAN PRICE, GERALD SCARFE

DRUGS

DIRECTED BY BRAHAM MURRAY
DESIGNED BY GERALD SCARFE.

9 July - 10 August 1985
(Previews from 4 July)

Box Office 061-833 9833

supported by The Arts Council of Great Britain ● The Greater Manchester Council ● The Manchester City Council

Opposite: *Orpheus*: design for the Seven Judges of Hades.

Top left: *Orpheus*: design for the Accusing Fingers. **Top right:** *Orpheus*: a Revolutionary.

Centre left: *Orpheus*: design for back-cloth of Juno and Jupiter in bed.

Above: *Orpheus*: Juno and Jupiter in bed – stage set.

Above right: Poster for Alan Price's *Who's a Lucky Boy?* I designed costumes
and sets for this musical satire based on Hogarth's *Rakes Progress*.

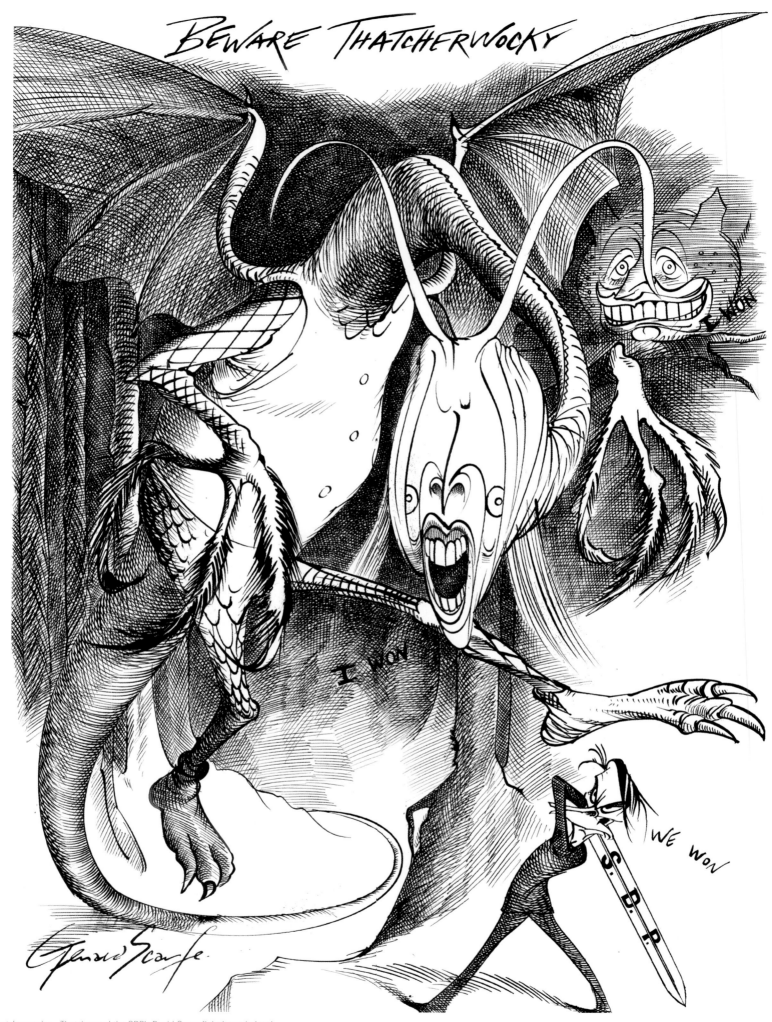

BEWARE THATCHERWOCKY

Beware Thatcherwocky – Thatcher and the SDP's David Owen fight it out in local
elections, while Labour leader Neil Kinnock grins from a tree: *Sunday Times*, 5 May.

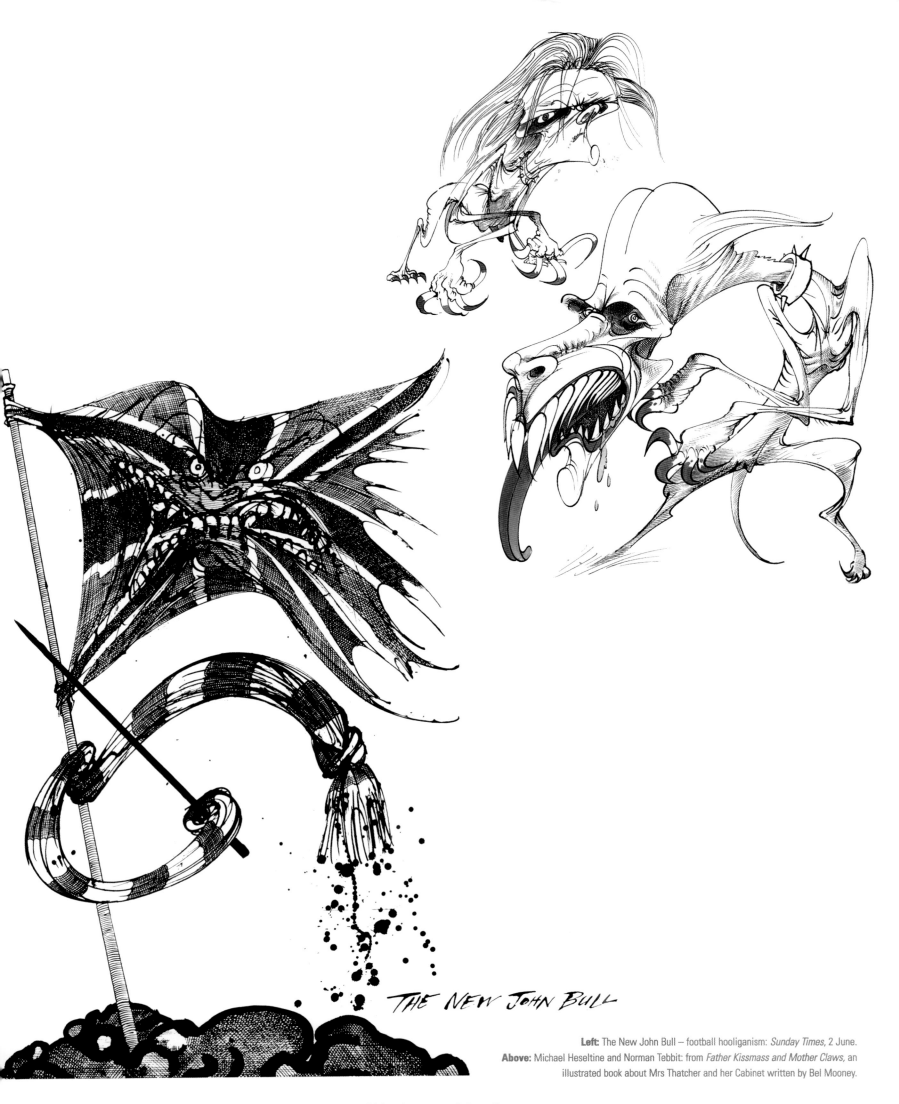

THE NEW JOHN BULL

Left: The New John Bull – football hooliganism: *Sunday Times*, 2 June.
Above: Michael Heseltine and Norman Tebbit: from *Father Kissmass and Mother Claws*, an illustrated book about Mrs Thatcher and her Cabinet written by Bel Mooney.

SCARFE BY SCARFE

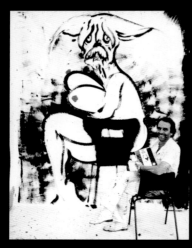
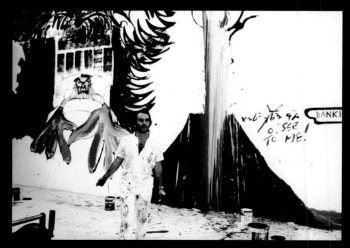

Scarfe by Scarfe: I wrote, directed and appeared in this film, which was to accompany an autobiography being published that year. I painted my life on the walls of a room on camera and at the end of the film I threw buckets of paint all over it and obliterated it.

Opposite:
Top: GS on the set at Ealing Studios.
Below left: Scene from the film: GS throws paint over the wall.
Below centre: GS seated in front of the painted wall showing Harold Macmillan.
Below right: Scene from the film.

Snowdon came to photograph me and my wife while I was making *Scarfe by Scarfe*. I explained to him that I was filming the two sides of my character: one the urbane socialite, the other the artist.

Above left: This is his representation of that idea.
Above right: Snowdon's revenge for my drawing of 1965. Snowdon got me to take a mouthful of ketchup and dribble it out for his picture.

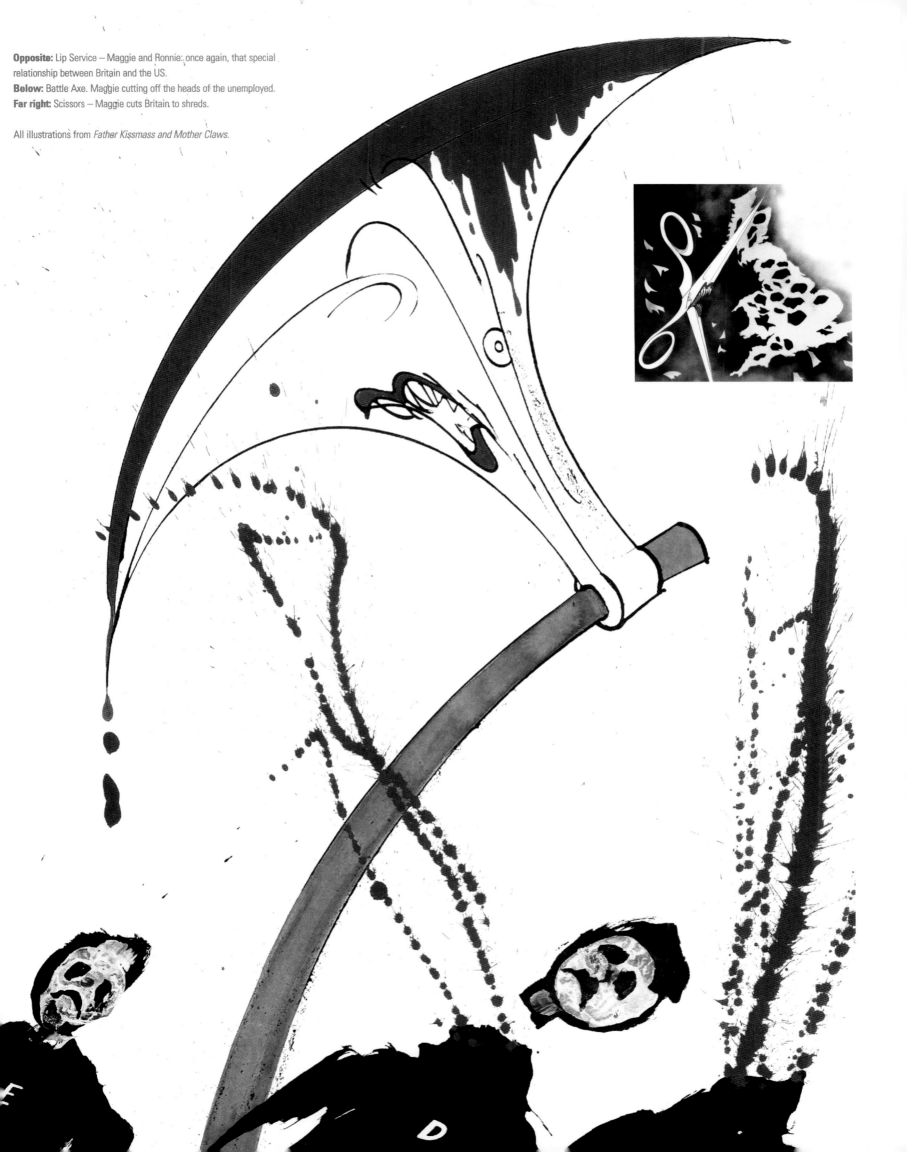

Opposite: Lip Service — Maggie and Ronnie: once again, that special relationship between Britain and the US.
Below: Battle Axe. Maggie cutting off the heads of the unemployed.
Far right: Scissors — Maggie cuts Britain to shreds.

All illustrations from *Father Kissmass and Mother Claws.*

1987

THE GOURMET

SERIOUS

GREED

MONEY FROM 21st MARCH 1987
CARYL CHURCHILL
ROYAL COURT 730.1745

Left: The Gourmet: from *Scarfe's Seven Deadly Sins*. My take on us sinners.
Above: Poster for Caryl Churchill's play *Serious Money* at the Royal Court. Yuppies! Remember them?
Opposite: Adam and Eve: *Sunday Times* colour magazine, 21 June.

IN THE BEGINNING — THERE WAS THE END

SCARFE

SCARFE'S SEVEN DEADLY SINS

GERALD SCARFE AT THE NATIONAL THEATRE

FEB 2 – MARCH 21 1987

LYTTELTON CIRCLE FOYER
10 AM – 11 PM
MONDAY–SATURDAY
ADMISSION FREE

MAGGIE V
ONCE MORE UNTO THE BREACH
DEAR FRIENDS ONCE MORE
OR CLOSE THE WALL UP WITH
OUR ENGLISH UNEMPLOYED

NT
NATIONAL
THEATRE

Opposite: The Drug Trafficker: from *Scarfe's Seven Deadly Sins.*
Above: Cover of *Seven Deadly Sins.*
Right: Poster for a show of my theatrical drawings at the National Theatre.

Following pages left: South Africa – Optical Illusion: *Sunday Times,* 10 May.
Following pages right: Unemployment: *Sunday Times,* 21 June.

WHICH COLOUR HAS THE MAJORITY?

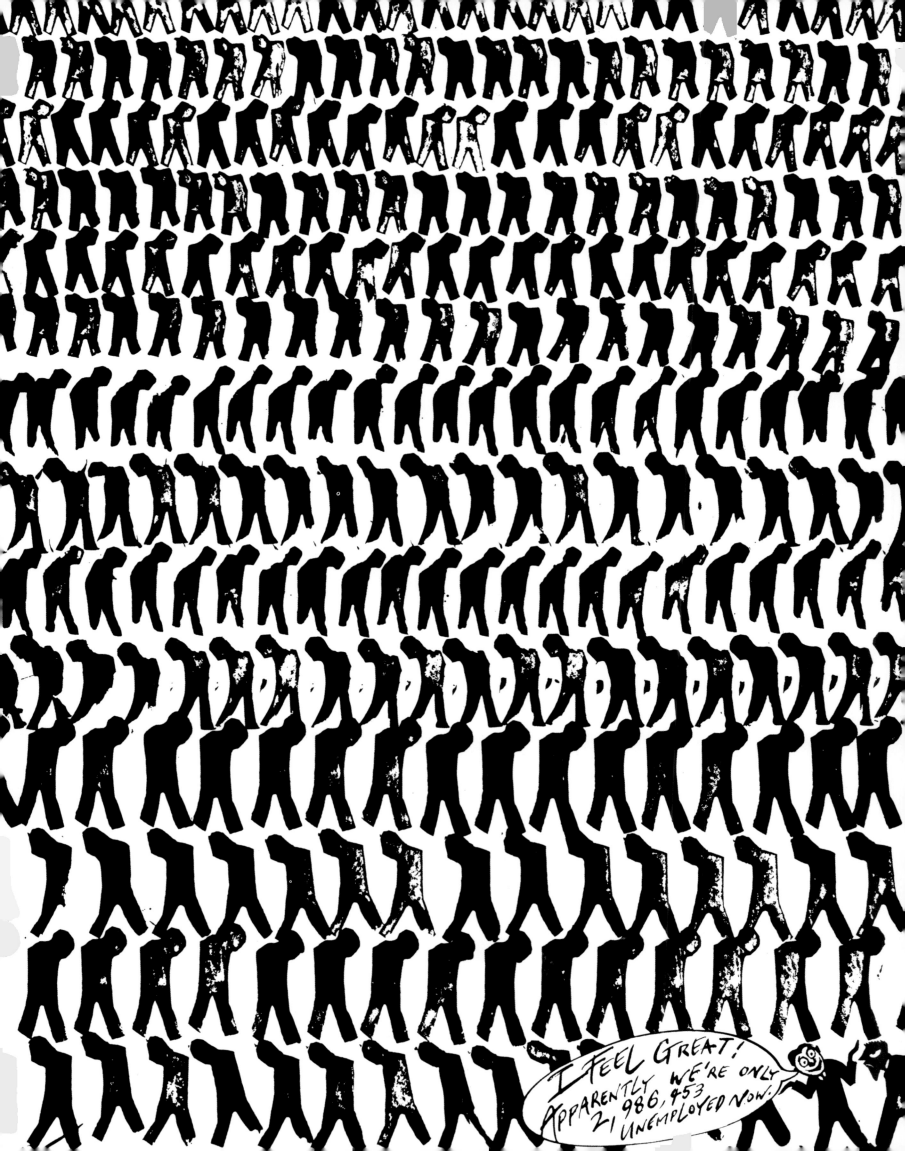

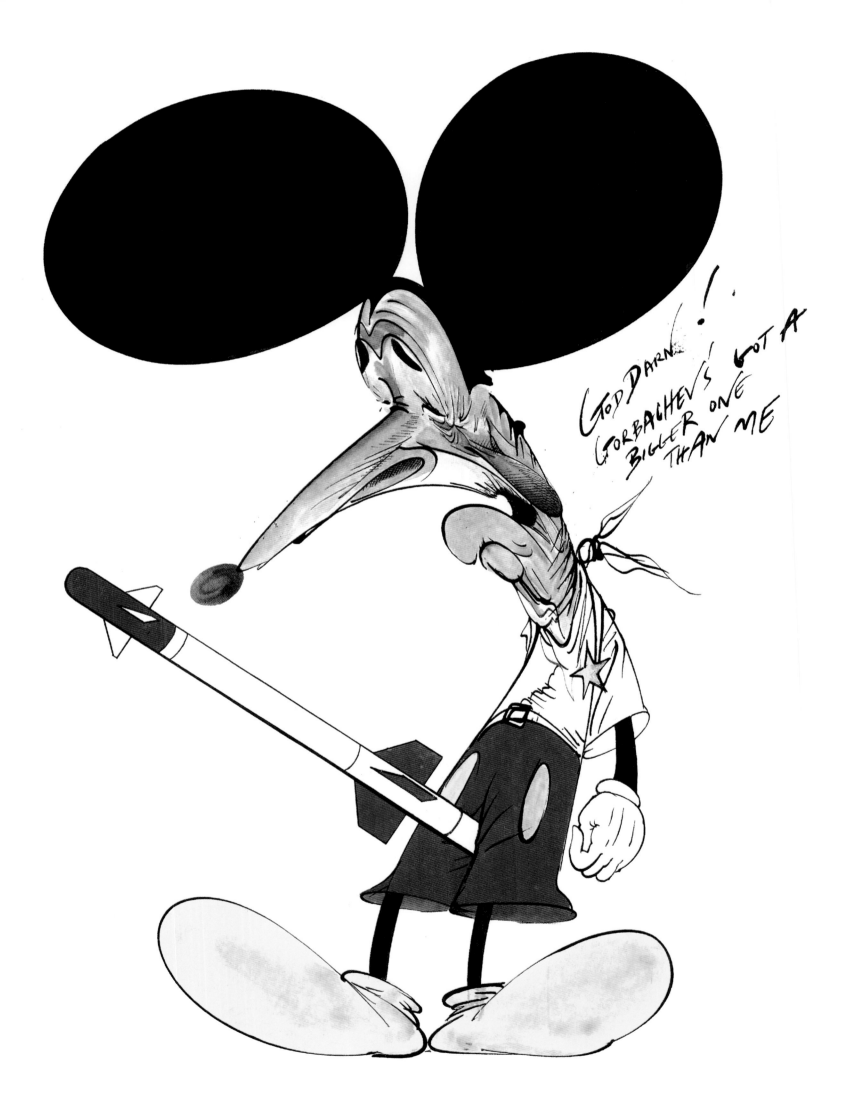

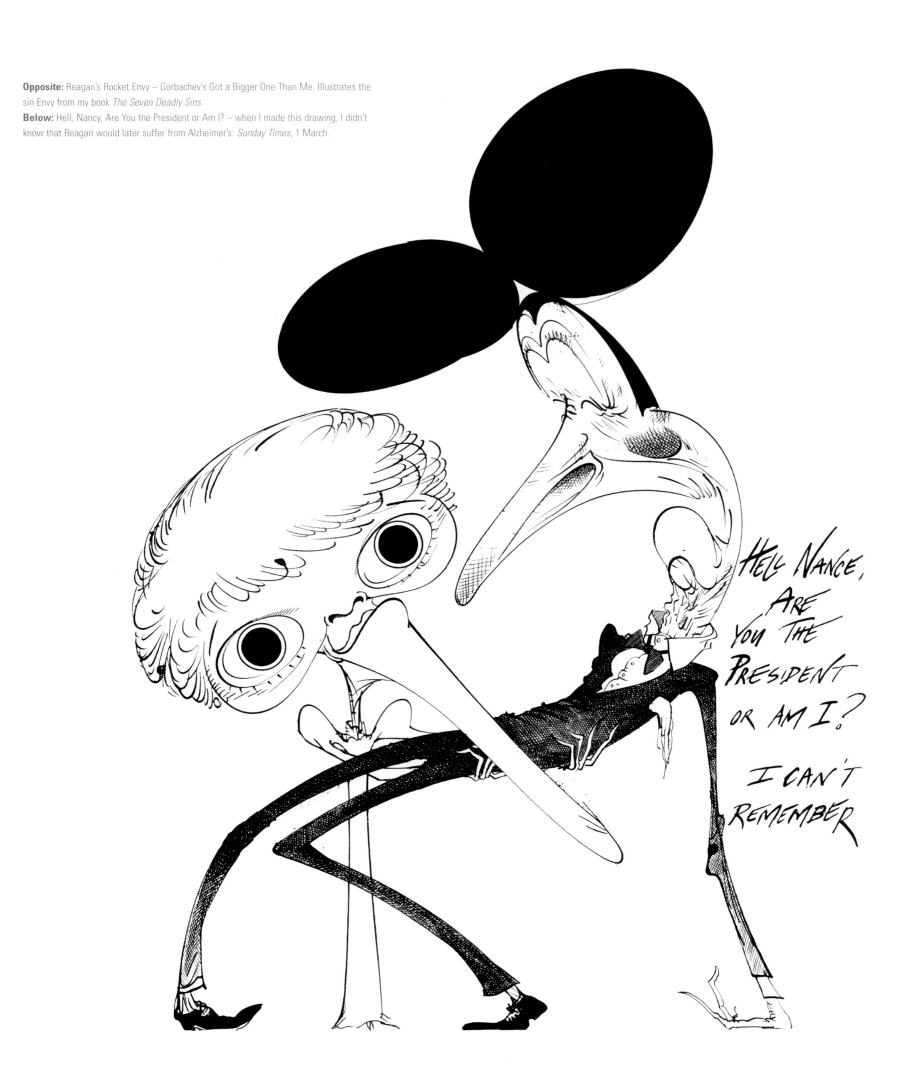

Opposite: Reagan's Rocket Envy – Gorbachev's Got a Bigger One Than Me. Illustrates the sin Envy from my book *The Seven Deadly Sins*.
Below: Hell, Nancy, Are You the President or Am I? – when I made this drawing, I didn't know that Reagan would later suffer from Alzheimer's: *Sunday Times*, 1 March.

HELL NANCE, ARE YOU THE PRESIDENT OR AM I?

I CAN'T REMEMBER

Scarfe's Follies

Scarfe's Follies: after winning a BAFTA and a Canadian BANF award for my film *Scarfe by Scarfe*, I was suddenly flavour of the moment in the BBC documentary department, and was asked to make a film about follies. I filmed myself trekking around Britain on a series of strange beasts – camel, elephant, llama, etc. – looking at follies in order to build one of my own.

Top left: GS and the Folly Girls.
Top right: The finished Folly.
Above: Ian McKellen plays the part of a drunkard in *Scarfe's Follies*.

A Hermit: Bob Geldof inspects the folly. All follies should have a hermit, I read, so I duly placed an advert in *The Times* and, in the film at least, Bob turned up. 'It's a bit rough,' Bob said. 'I thought you hermits liked it rough?' I said. 'Yes,' he replied, 'but there's rough and rough.'

Crossing the M4 on an elephant. The elephant took it very well, but some of the motorists swerved.

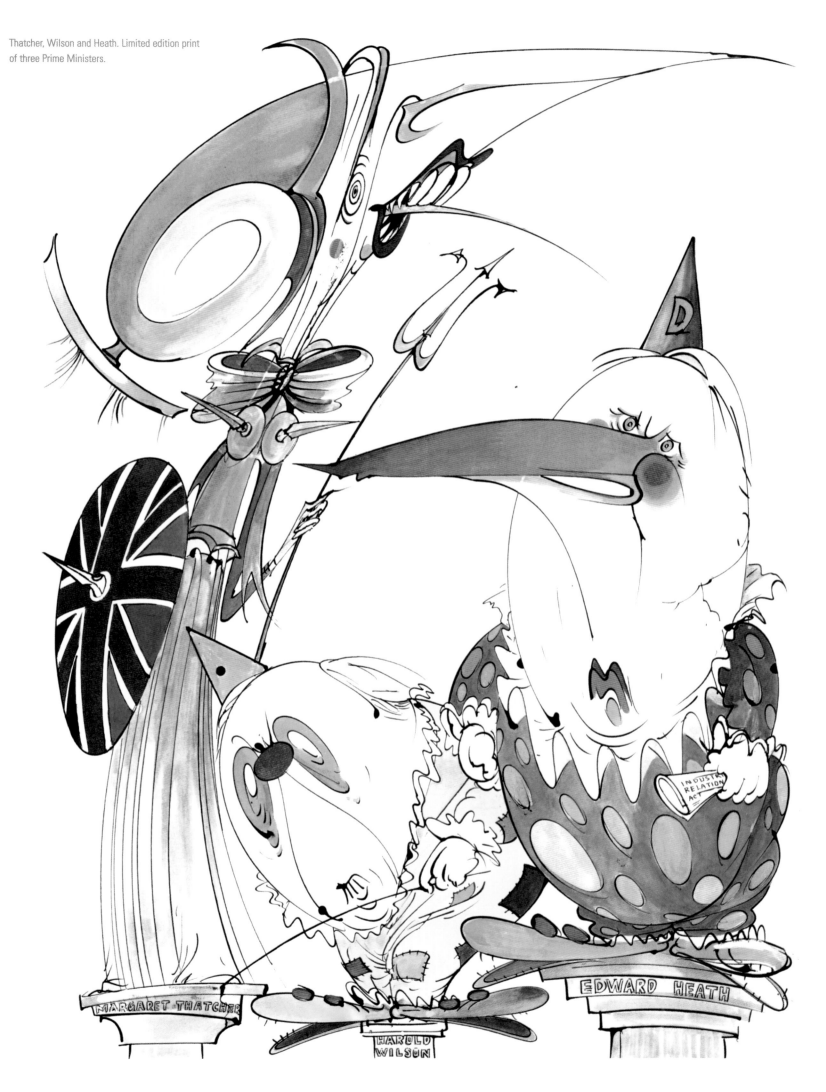

THE TERRORIST

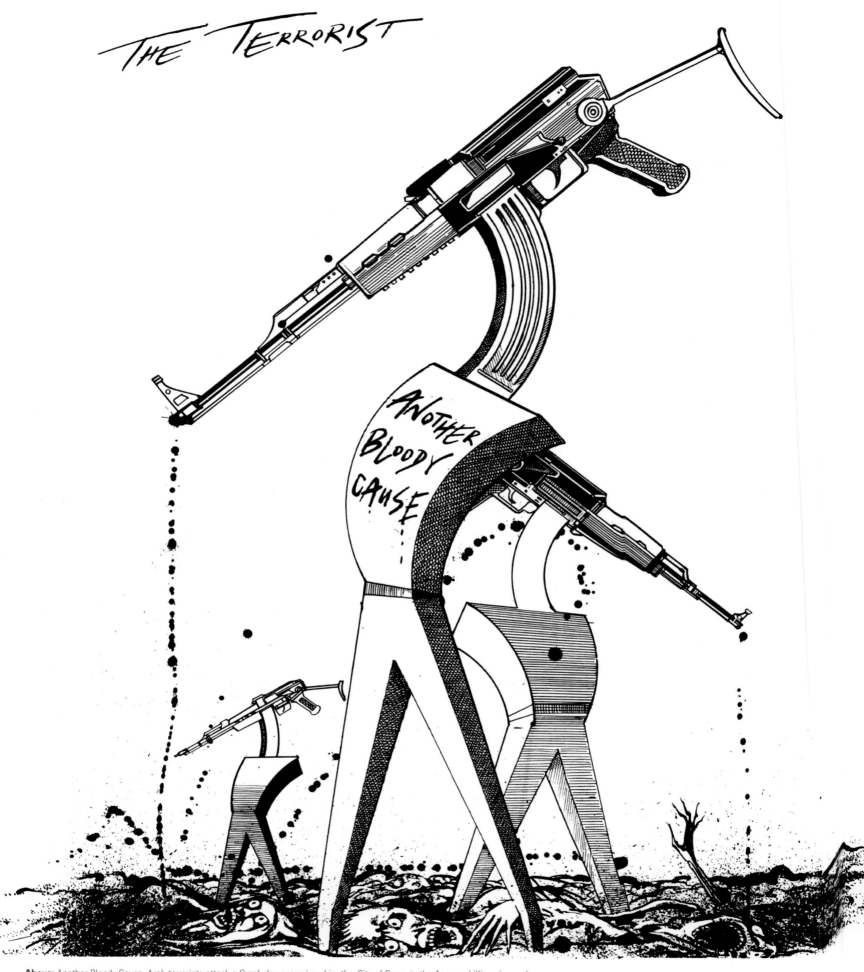

Above: Another Bloody Cause. Arab terrorists attack a Greek day-excursion ship, the *City of Poros*, in the Aegean, killing nine and wounding nearly a hundred: *Sunday Times*, 17 July.
Opposite: The Price of Oil. An explosion on the Piper Alpha oil platform in the North Sea kills 167 men: *Sunday Times*, 10 July.

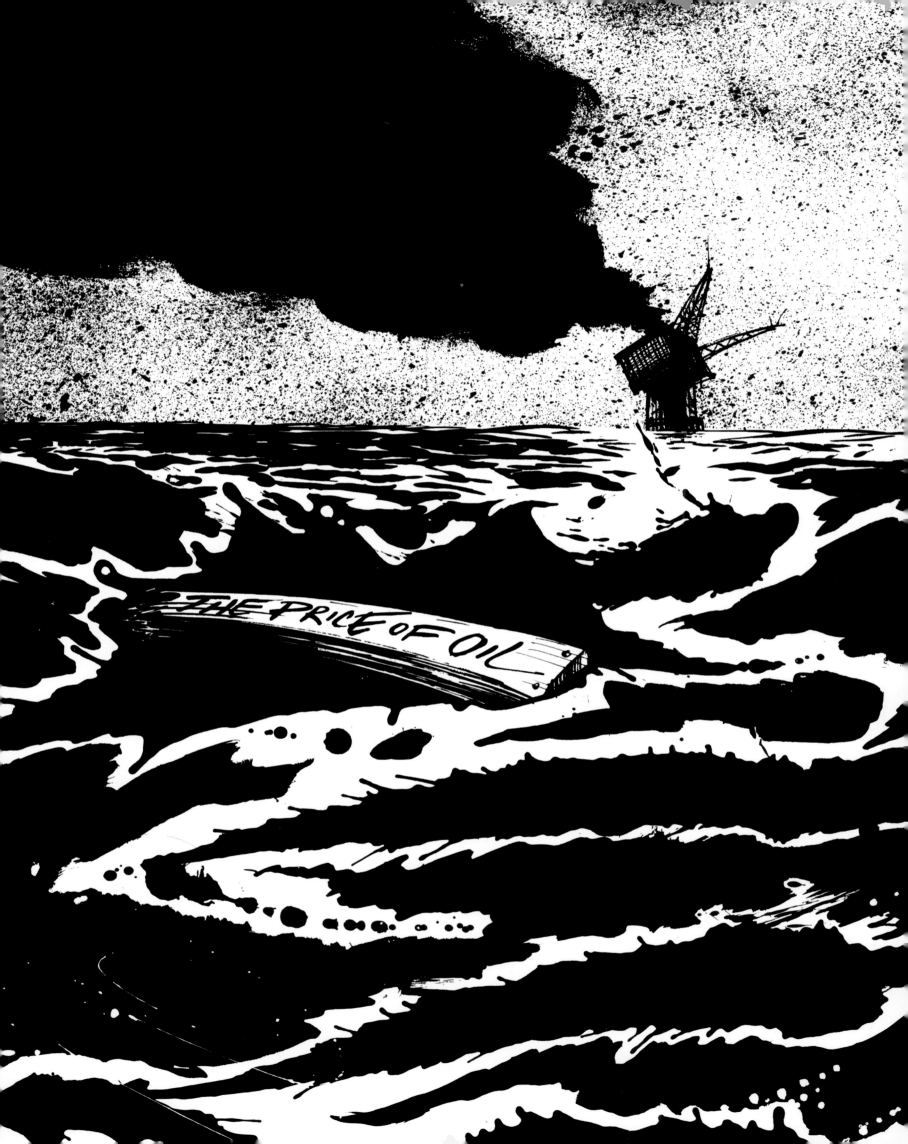

1989

The cover of *Scarfeland*: Thatcher as the Torydactyl. I took a journey deep into the concrete wastelands and the raised plains of the desolate world of the lost, where the dreadful and fantastic creatures of Scarfeland dwell. I've always loved drawing people as animals.

The Queen as the Royal Lion (*Reign Hanoverus*). Habitat: Buckingham Palace. Cry: My bustard and I. Remarks: Appears on Christmas Day, just after the pudding. The Queen of the Beasts lay in her den, idly eating corgis dipped in honey. It was a wonderful day. Her husband, the Great Aukward Bustard Edinbird, was killing some animals down on the estate.

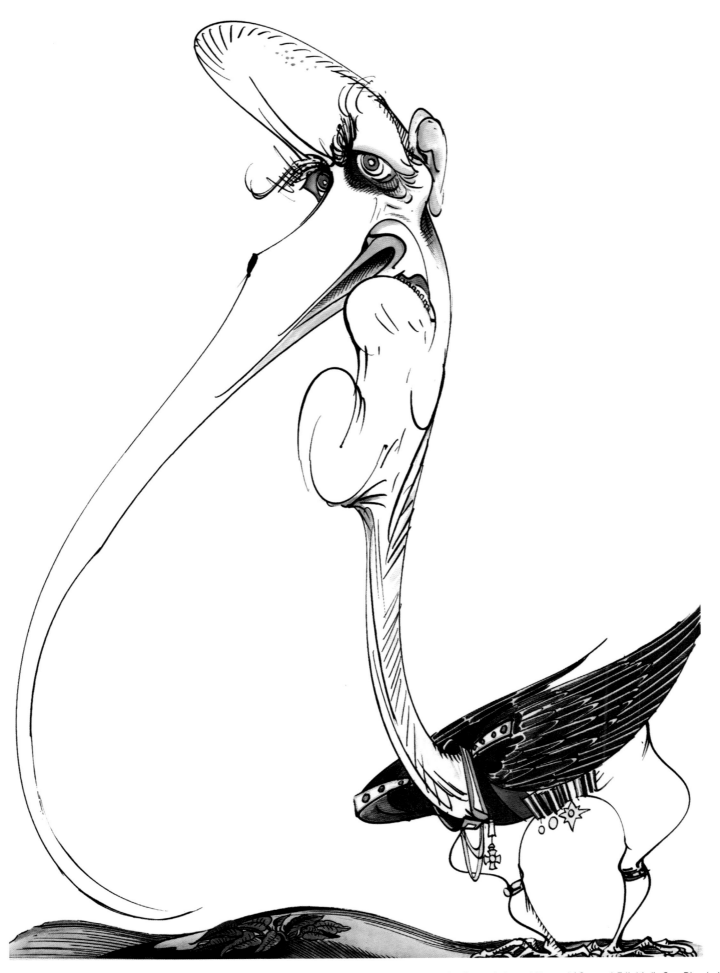

The Duke of Edinburgh as the Great Aukward Bustard (*Crested Edinbird*). Cry: Bloody Hell. Remarks: Irritable, foul-mouthed creature, who preserves other species by hunting and killing them. Opinionated, unsympathetic, intolerant and tetchy. Bugger! An irritable, foreign-looking bird stuck his head out of the royal bunker. 'Out of my way,' he bellowed, pushing past. 'You're buggering up the environment!'

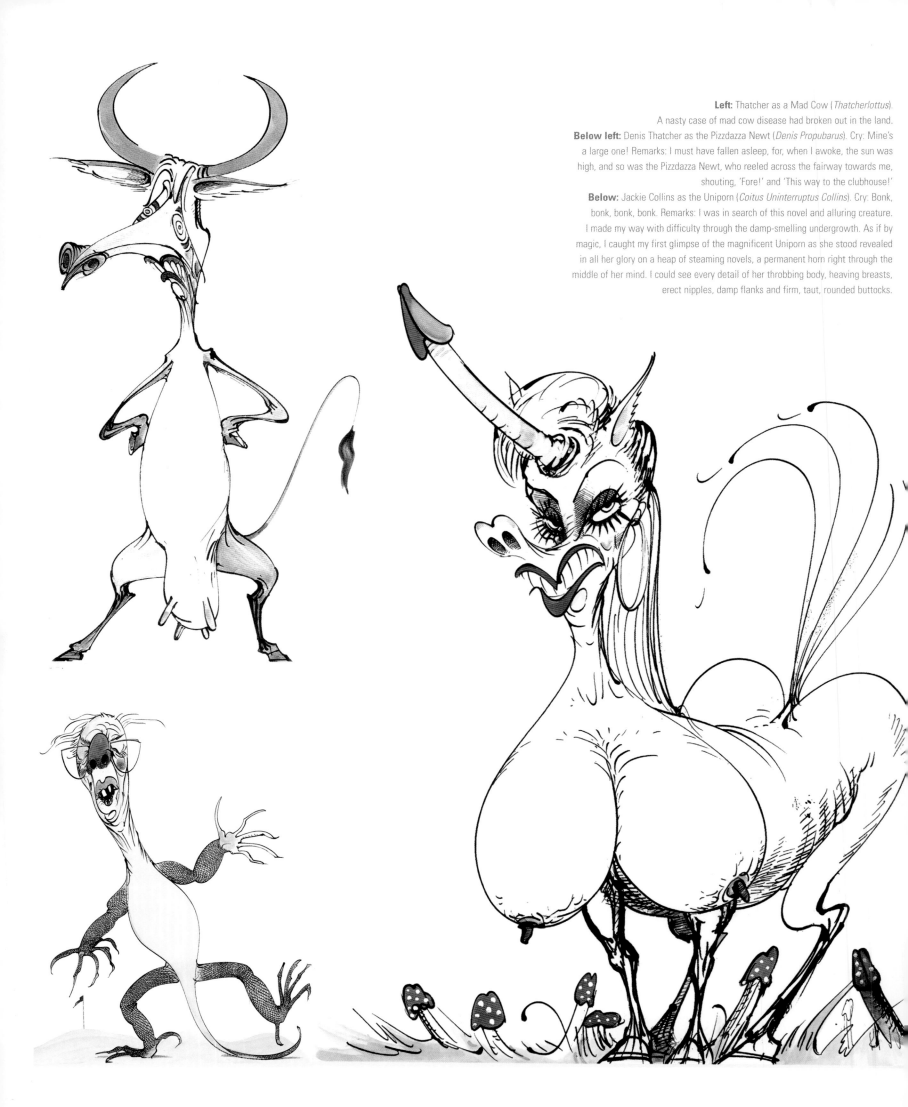

Left: Thatcher as a Mad Cow (*Thatcherlottus*).
A nasty case of mad cow disease had broken out in the land.
Below left: Denis Thatcher as the Pizzdazza Newt (*Denis Propubarus*). Cry: Mine's
a large one! Remarks: I must have fallen asleep, for, when I awoke, the sun was
high, and so was the Pizzdazza Newt, who reeled across the fairway towards me,
shouting, 'Fore!' and 'This way to the clubhouse!'
Below: Jackie Collins as the Uniporn (*Coitus Uninterruptus Collins*). Cry: Bonk,
bonk, bonk, bonk. Remarks: I was in search of this novel and alluring creature.
I made my way with difficulty through the damp-smelling undergrowth. As if by
magic, I caught my first glimpse of the magnificent Uniporn as she stood revealed
in all her glory on a heap of steaming novels, a permanent horn right through the
middle of her mind. I could see every detail of her throbbing body, heaving breasts,
erect nipples, damp flanks and firm, taut, rounded buttocks.

Far left: Norman Tebbit as the Tebbitsorearse (*Normanis Gargantua*). Cry: On yer bike! Remarks: The gargantuan coarse-hided Tebbitsorearse stood in the doorway, his tail switching mechanically. A Heffer, returning late from a Union meeting, had the misfortune to cross the Tebbitsorearse's path. The huge monster bent forward with surprising swiftness and with his yellow, poisonous teeth bit off the Heffer's head. 'On yer bike,' he snarled. 'On yer bike!'

Left: Edwina Currie as the Cold Curried Chicken (*Salmonella Vindaloo*). Cry: Wrap Up. Remarks: An ambitious, pushy hen bird but also talks cock. Although she'd been completely plucked several times (they even complained about her smelly eggs), she had always been proved right in the long run. Foot in mouth disease.

As a sickly and bedridden child I would sit surrounded by books, drawing paper and plasticine, listening to the radio. The radio helped me escape from reality and I loved comedy programmes and comedians. A particular favourite was Max Miller, whose 'dangerous' humour delighted me. When the BBC planned a film I jumped at it.

Above: Four Max Millers line up for the opening sequence of *I Like the Girls That Do*.

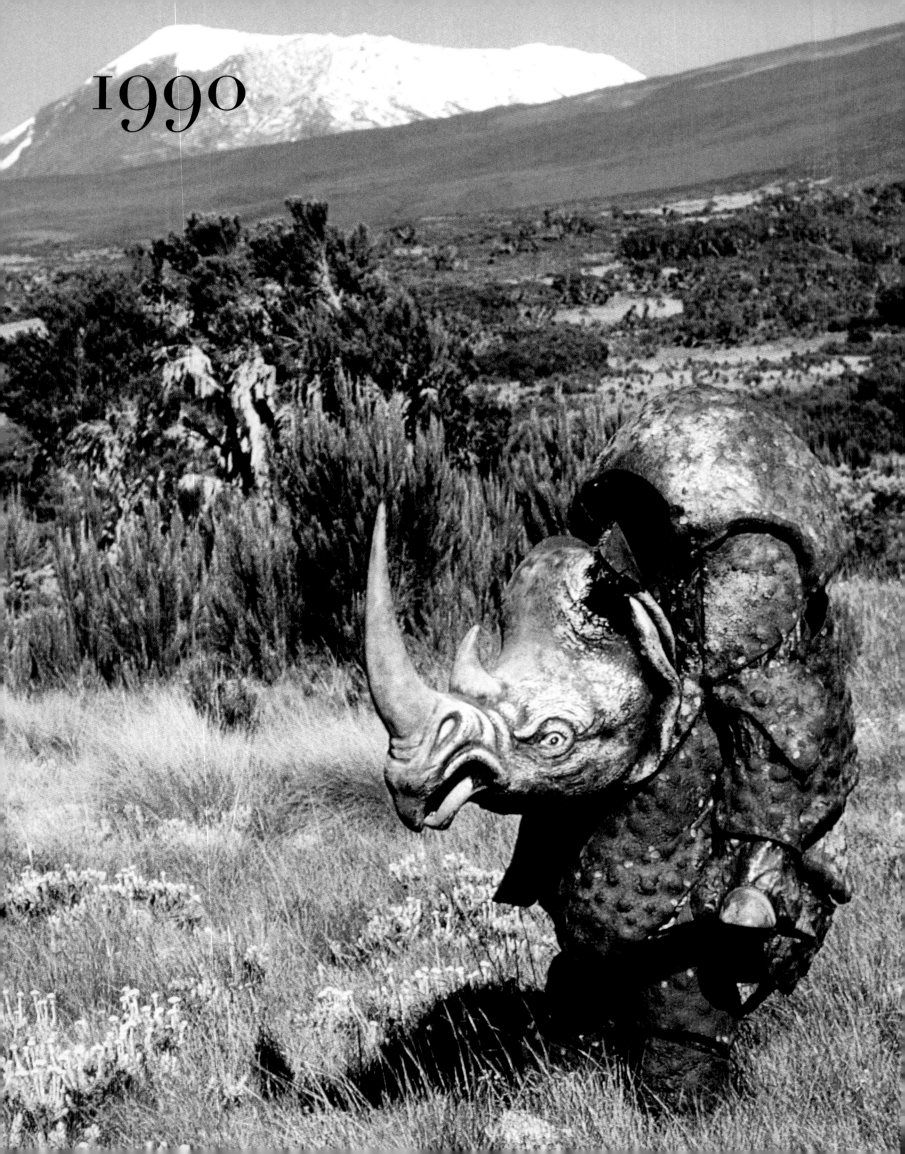

1990

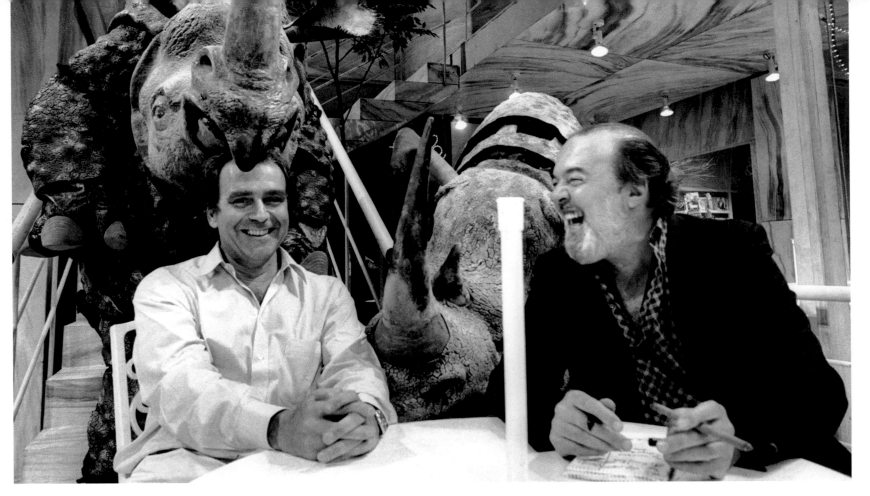

I first met Peter Hall in 1964, when he was directing *Hamlet* at Stratford-on-Avon. I remember being slightly unnerved when Hamlet, played by David Warner, began haring around the stage like there was no tomorrow. I next met Peter in 1990, when we shared a box at the BBC Proms in the Albert Hall. 'I've been meaning to contact you,' he said. 'I think we should work together on a new project I have in mind. I'll ring you tomorrow.' Oh yes, I thought – heard that one before. But the next day he rang and described a new musical he intended to produce at Chichester, based on Eugène Ionesco's play, *Rhinoceros*, in which members of the public one by one become brutalised and metamorphose into rhinos. He wanted me to design the set – a shopping mall – two full-size rhinoceros and twelve

two-legged upright dancing rhinoceros. There was one theatrical *coup de théâtre* that I was very pleased with in this production: midnight in the mall, and the glass and steel elevator rises through the centre of the stage, bearing a full-size rhino that smashes down the elevator sides and advances on the audience. For several seconds I thought that the first few blue-rinsed rows of the Festival Theatre were going to have heart attacks. A proud moment.

Although *Born Again* – as the musical was called – didn't make Broadway, the rhino costumes proved ever useful. Each year they run in the New York, Los Angeles, Tokyo and London marathons, raising money for Save the Rhino, so, in a way, the play did run and run.

Above: With director Sir Peter Hall and the rhino costumes, during the staging of *Born Again*.
Far left: The two rhinos on stage at Chichester Festival Theatre.
Left: The Chichester Festival Theatre poster for the musical, *Born Again*.
Below: The rhinos cross the finishing line at the London Marathon. I can feel the shame of the man who's been beaten by a rhino.
Opposite: The rhino climbs to the top of Mount Kilimanjaro for the Save the Rhino Fund.

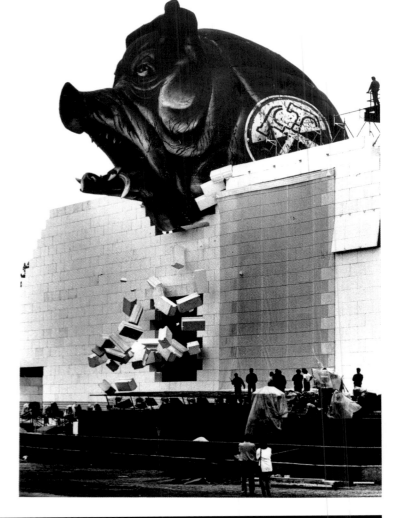

When the wall came down in Berlin, Roger Waters felt it would be a good opportunity to restage *The Wall*, but this time to include enormous regiments from the Russian and German armies and stars from the stage and rock world.

Above: Drawing for the gross pig that peers over the Wall during the Pink Floyd concert in Berlin.
Right: The pig demolishes the Wall.
Below: Giant inflatables haunt the stage as the Wall is slowly built.

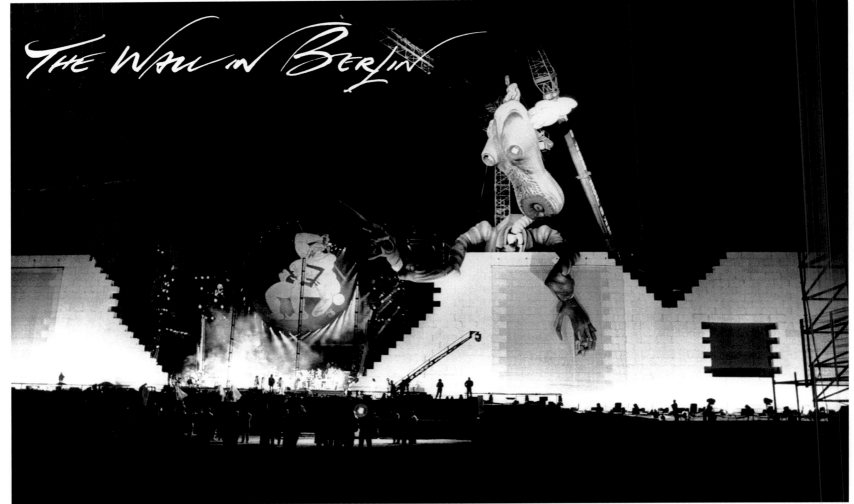

Luciano Pavarotti sketched from life at the Savoy Hotel. He said he had been dieting, but apparently he was still using a golf cart to get from his dressing room to the stage.

Above: The New Slim-line Pavarotti. *Sunday Times*, 11 March.

Left: Madonna in one of her many guises: *Sunday Times*, 22 July.

1991

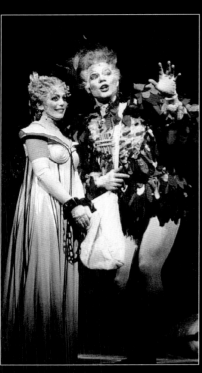

I remember I was working in the garden during the summer when Peter Hall rang and asked if I'd be interested in designing *Die Zauberflöte*. You bet! It was to be produced at Los Angeles Opera, where my *Orpheus in the Underworld* had been staged.

Partly because of the Masonic and Egyptian themes, my main design feature was a giant pyramid that dominated the stage in Act I. On seeing my designs, Peter decided that the pyramid motif should be employed throughout all acts – that it should be omnipresent and transform itself into a temple, a mountain and a crypt. So the pyramid was designed to split in half and become hillside stairs. The backgrounds were not painted back-cloths but were projected, meaning that I could have many changing sky moods throughout as blood-red sky gave way to black and thunderous sky.

Most fun of all were the animals that Tamino enchants out of the forest with his magic flute. These I made half one animal and half another: Tigoon was half tiger, half baboon; and there was a Crocoguin, a Giraffstrich (on stilts), and a Zebkey.

Since then the *Flute* has played on for many years, most recently in Washington. When I go back to see a production after some time, it's like visiting one's children. It's good to see them again and find out how they are doing.

Above: Papegeno and Pamina from *The Magic Flute*.
Above right: GS with the Tigoon from *The Magic Flute*.

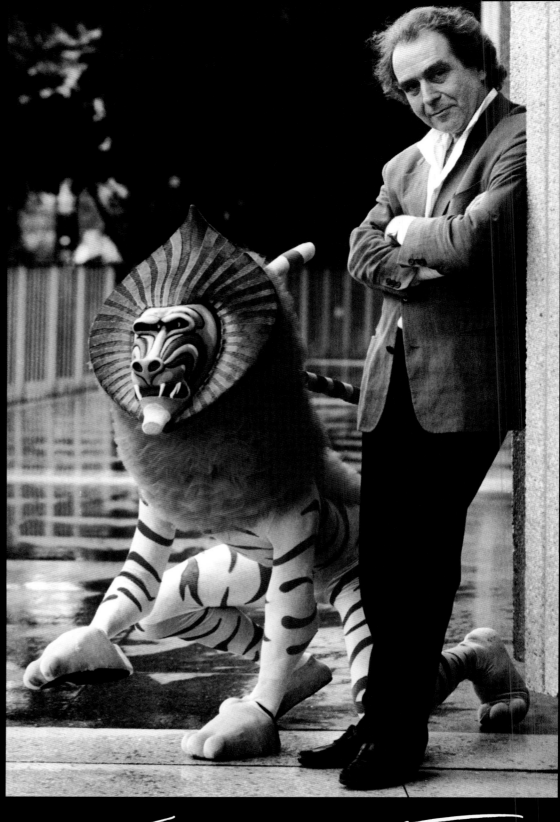

THE MAGIC FLUTE

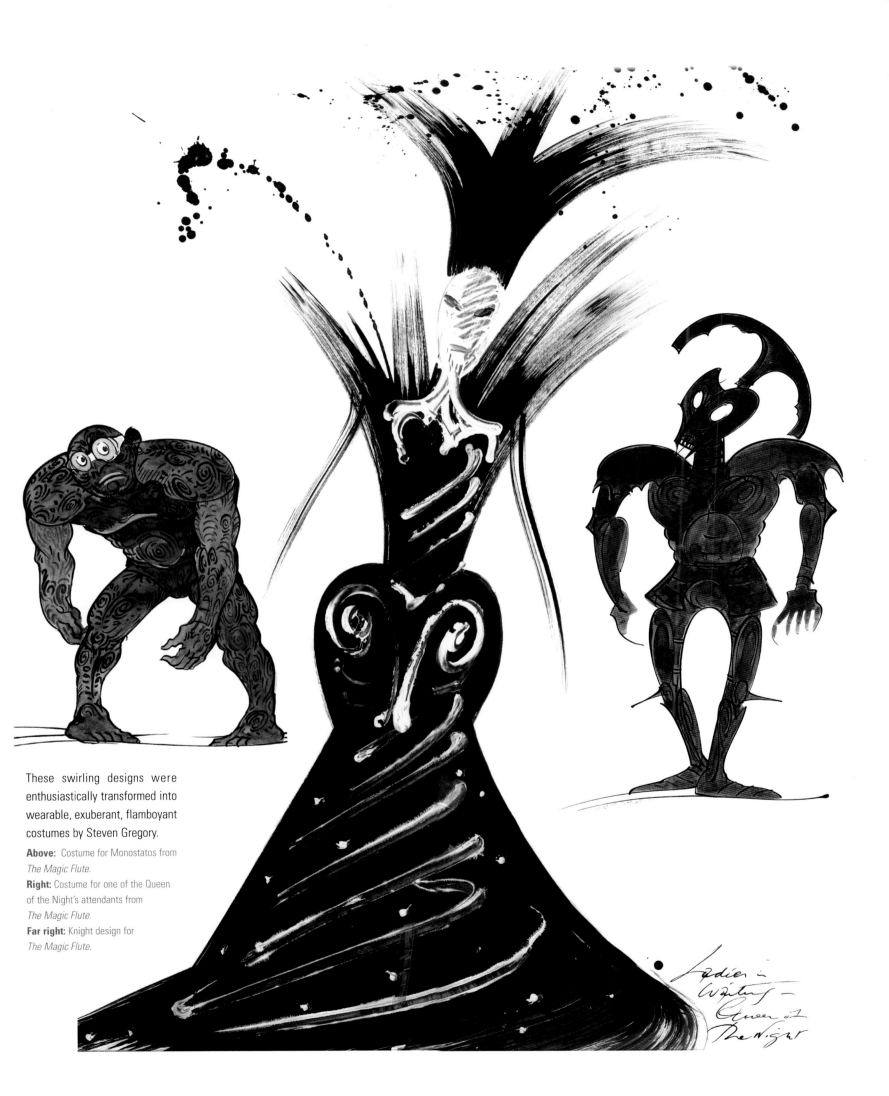

These swirling designs were enthusiastically transformed into wearable, exuberant, flamboyant costumes by Steven Gregory.

Above: Costume for Monostatos from *The Magic Flute.*

Right: Costume for one of the Queen of the Night's attendants from *The Magic Flute.*

Far right: Knight design for *The Magic Flute.*

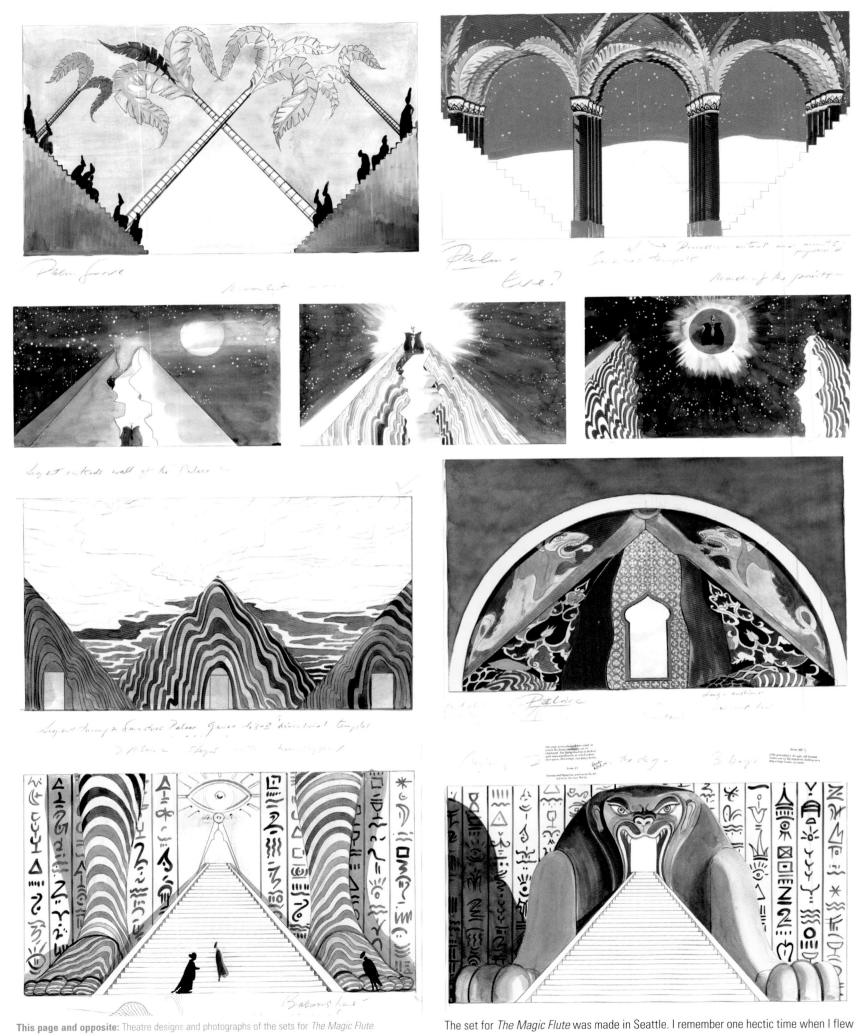

This page and opposite: Theatre designs and photographs of the sets for *The Magic Flute*.

The set for *The Magic Flute* was made in Seattle. I remember one hectic time when I flew to Seattle to look at the progress and four hours later was on my way back to London.

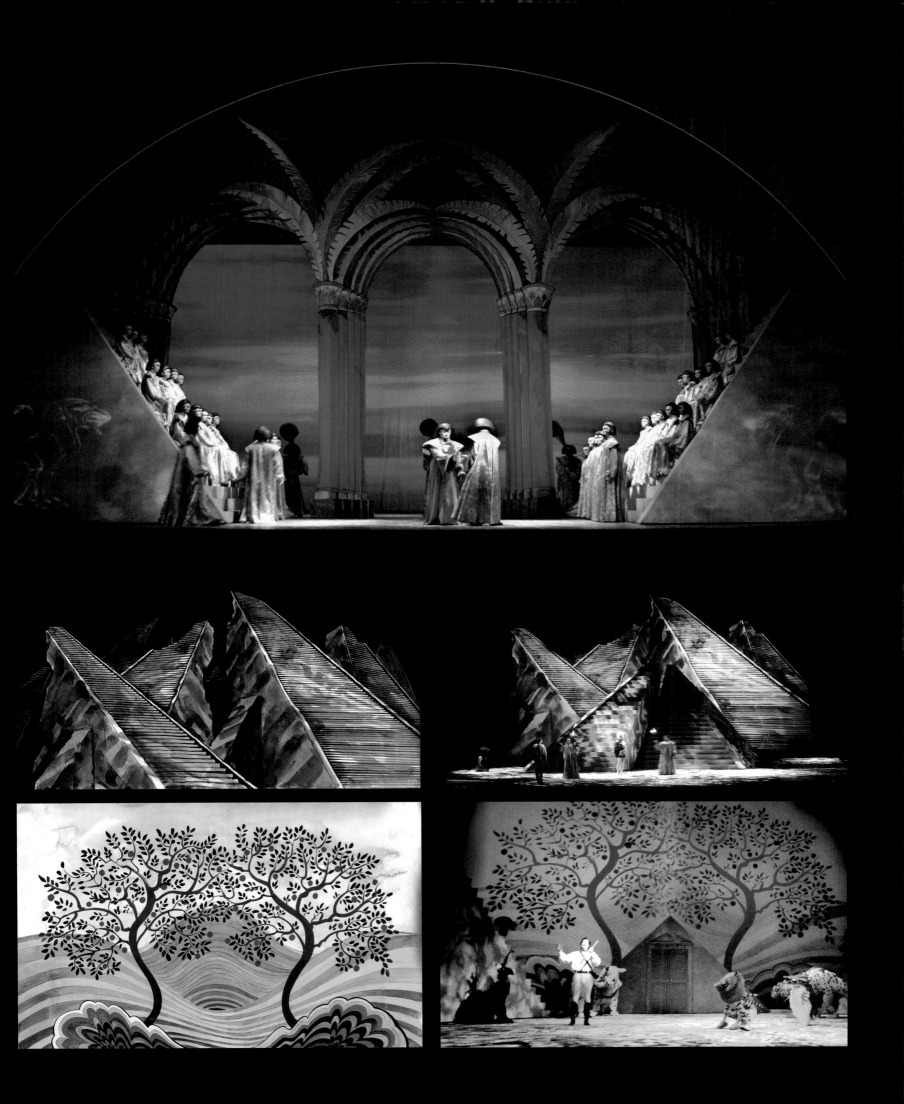

Scarfe on . . . a series for the BBC. I tried to take an off-beat approach and make visually quirky films that were hopefully witty and humorous. The trouble with producing films is that it takes at least six months of one's life – three months' preparation and three months' shooting, editing and dubbing etc. Also, after about fifteen films, I increasingly felt that making films was my 'mistress' and that drawing and painting were my 'wife'. I eventually decided to abandon the mistress and return to my wife. I miss the life, though, especially the 'best train set in the world' aspect, which is how Orson Welles described film-making.

Above: Poster for *Scarfe on Class.*

Above right: *Scarfe in Paradise.* This film was written by Richard Curtis, and one of his great lines was 'death is one of life's big moments'. The film was an attempt to explore the afterlife. I used a real incident, when I was held up at gunpoint in a Montmartre hotel by two gunmen, while they were robbing the cashier at the reception desk, and within the film I imagined I had been shot.

Right: Poster for *Scarfe on Art*: art as a commodity – the craziness of the art world in 1991, when the Japanese were paying astronomical prices for impressionist paintings and collectors were buying famous paintings, putting them into vaults and hanging copies over their fireplaces.

Below: Poor old Van Gogh did not receive recognition until he was dead.

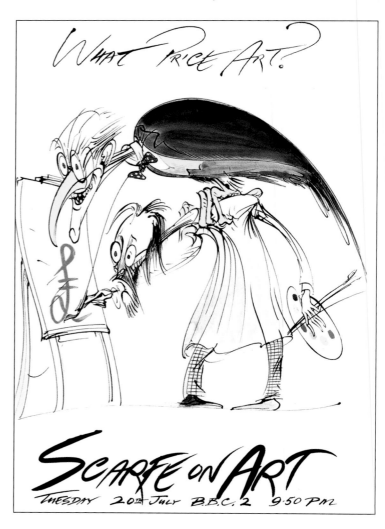

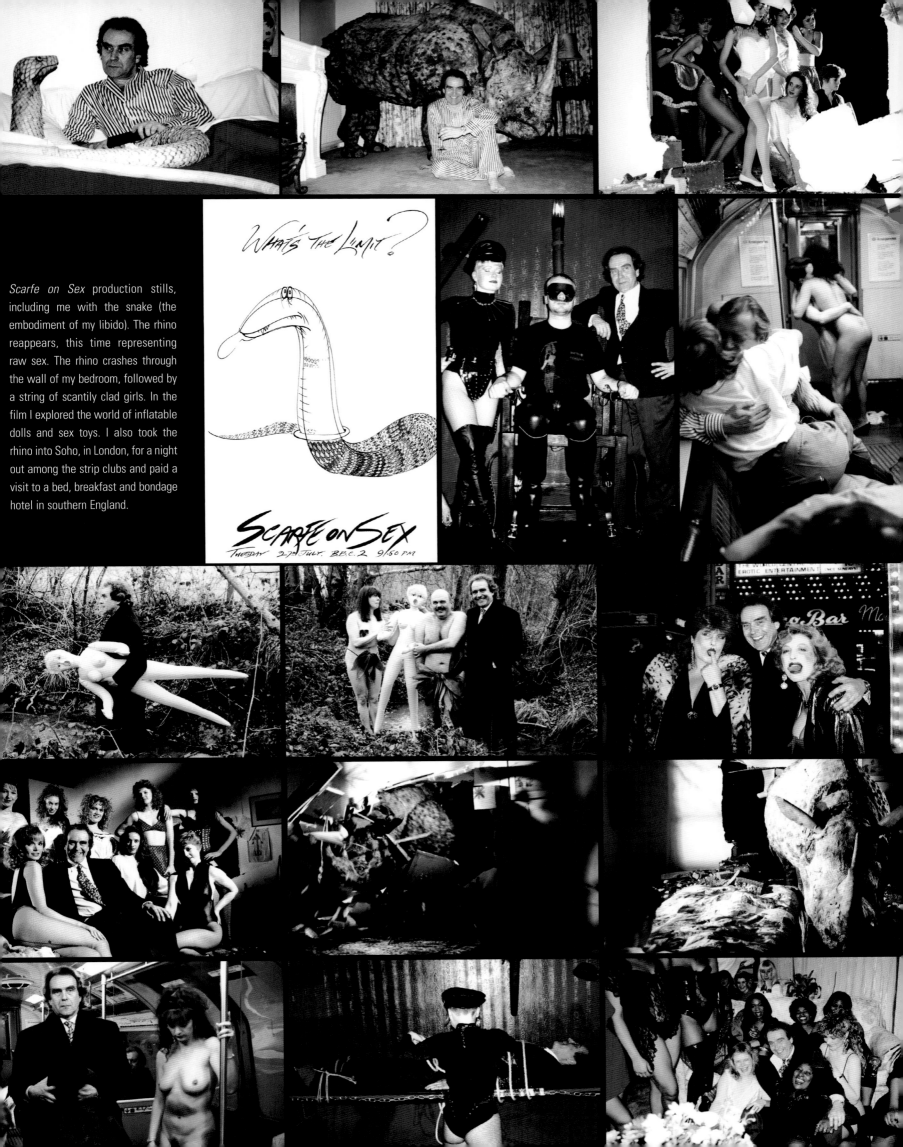

Scarfe on Sex production stills, including me with the snake (the embodiment of my libido). The rhino reappears, this time representing raw sex. The rhino crashes through the wall of my bedroom, followed by a string of scantily clad girls. In the film I explored the world of inflatable dolls and sex toys. I also took the rhino into Soho, in London, for a night out among the strip clubs and paid a visit to a bed, breakfast and bondage hotel in southern England.

WHAT'S THE LIMIT?

SCARFE on SEX

TUESDAY 27th JULY. B.B.C. 2 9/50 PM

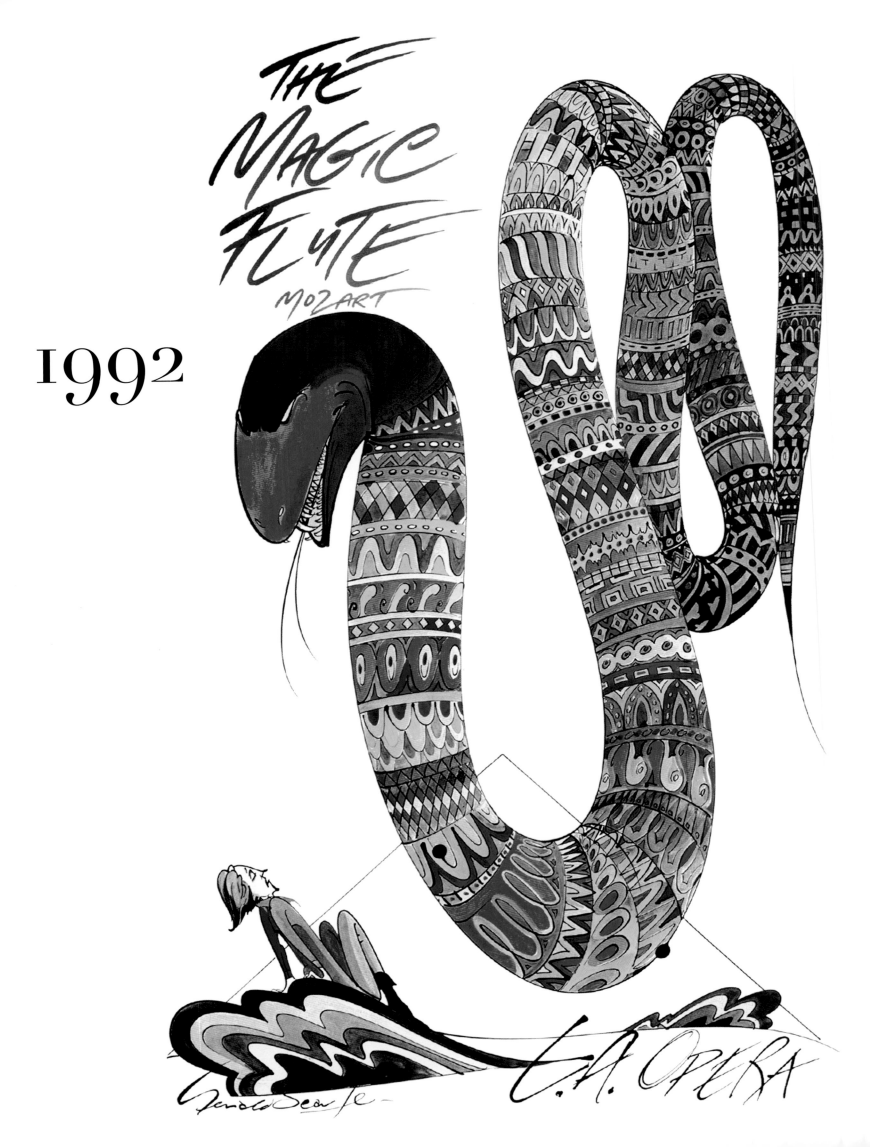

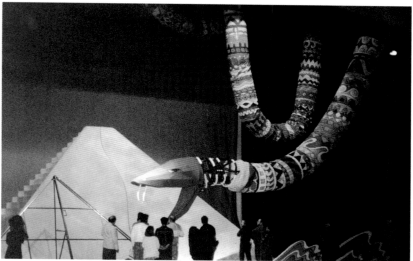

Gerald Scarfe is a great stage designer – yet you could hardly call his talent neutral or ambiguous. He is, of course, a superb draughtsman in the English tradition. He has a line which is graceful, witty and eloquent. But underneath the humour, you always sense his ferocious dislike of stupidity, hypocrisy and rapaciousness – particularly the rapaciousness which demands power. Sometimes his indictments make up a bestiary, in which the men and women who are his targets are the beast. But these beasts fight for domination, not survival. Like all great satirists, Gerald Scarfe is an idealist. If he didn't believe strongly, he would not castigate so passionately.

As a friend or as a fellow-worker in the theatre, he is wise, witty and gentle. But encouraged by the licence of ink, he can be a terrible scourge – particularly of public characters who pretend to be what they are not.

All this puts him among the great English satirists, and hardly, one would have thought, fits him for the stage. But his art has grace, a wonderful sense of colour and a paradoxical ability to make ugly images quite beautiful. He takes reality and distorts it, but ends up with an image which is surreal – more real than reality, and therefore very potent in the theatre. Gerald Scarfe makes the theatre surreal again.

SIR PETER HALL.

Opposite: Los Angeles Opera poster for *The Magic Flute*.
This page: Storyboard and designs for the Pyramid from *The Magic Flute*. From top left to bottom right – the smoking volcano, the volcano erupts, the first loop of the snake's body appears, the snake's head follows, the full snake emerges and menaces Tamino and, finally, the resulting design on stage.

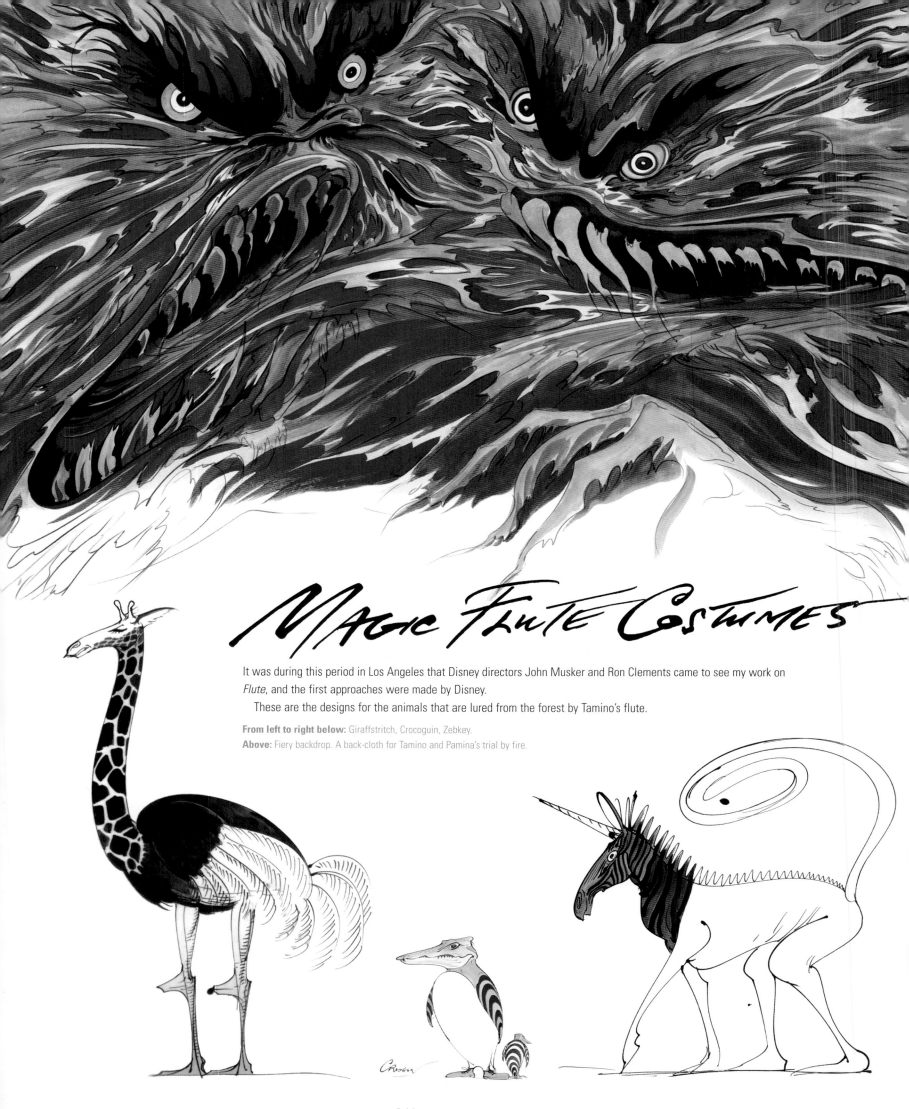

Magic Flute Costumes

It was during this period in Los Angeles that Disney directors John Musker and Ron Clements came to see my work on *Flute*, and the first approaches were made by Disney.

These are the designs for the animals that are lured from the forest by Tamino's flute.

From left to right below: Giraffstritch, Crocoguin, Zebkey.
Above: Fiery backdrop. A back-cloth for Tamino and Pamina's trial by fire.

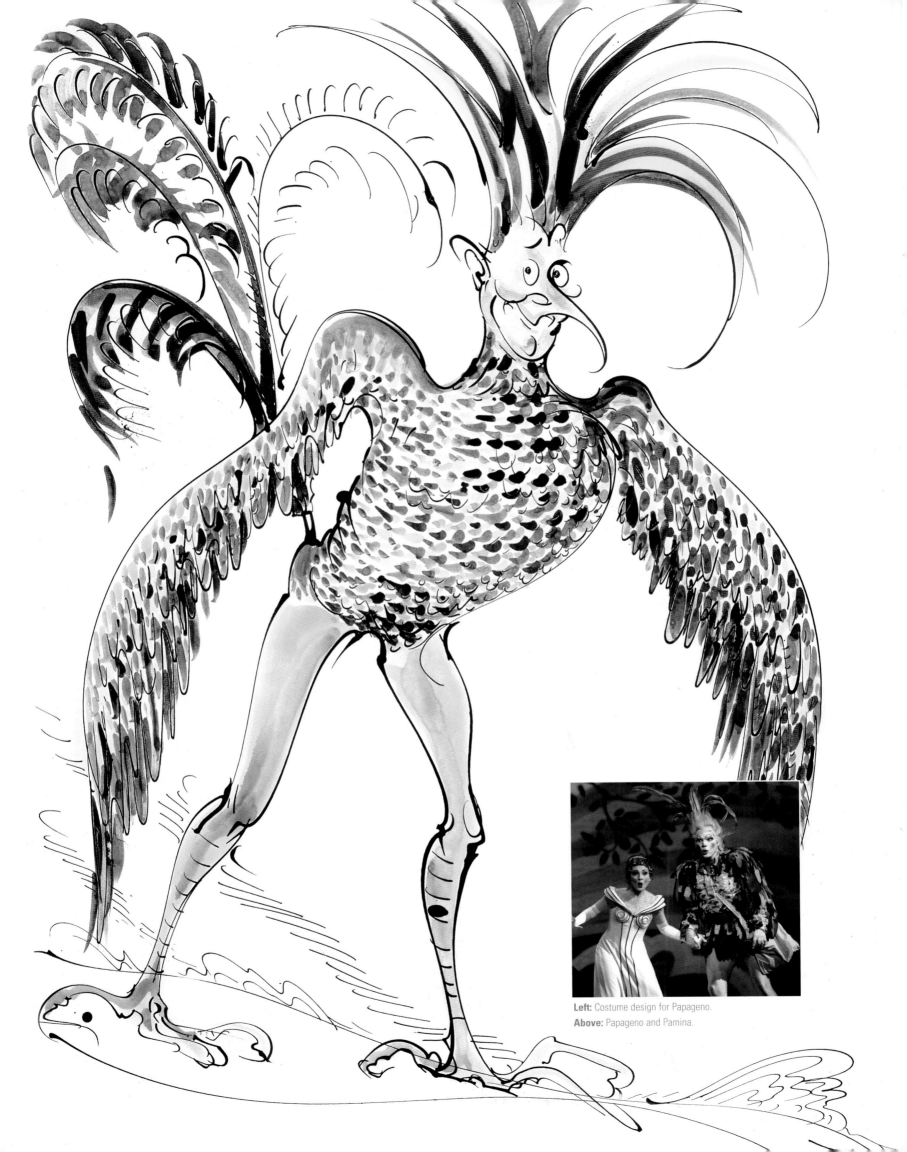

Left: Costume design for Papageno.
Above: Papageno and Pamina.

This year I started my long association with the *New Yorker* magazine. It was the first to print my *Magic Flute* designs, and soon after, Tina Brown, the editor, flew me to New York. The next day, over breakfast at the Royalton Hotel, seated at Tina's personal banquette, I agreed to work with the magazine, and have done so for twelve years.

Although the *New Yorker*'s offices are 3000 miles away, I could still get my drawings there on time. A drawing required for the next day could be worked on until five o'clock in the morning (if necessary). A courier would then come to my house and take it to Heathrow. Concorde left at 9 a.m. and arrived in New York four hours later, at eight o'clock local time, getting the drawing to the magazine by ten in the morning. Now I send them electronically, which is even quicker.

1993

Tina sent me to Wimbledon, with Martin Amis, to make a set of drawings.

Above: André Agassi at Wimbledon with Barbra Streisand cheering him from the stands: *New Yorker*, 26 July.
Left: Jim Courier serves (GS's collection).
Opposite: Pete Sampras prepares to serve: *New Yorker*, 26 July.

Following page: New Year's Eve at the Zeitgeist café: Heidi Fleiss, Howard Stern, Joey Buttafucco, Barry Diller, Dr Kevorkian, Ed Rollins, Yasser Arafat, Colin Powell, Yitzhak Rabin, Boris Yeltsin, Michael Jackson, Woody Allen: *New Yorker*, 27 December.

Pete Sampras
Men's Final

Independence

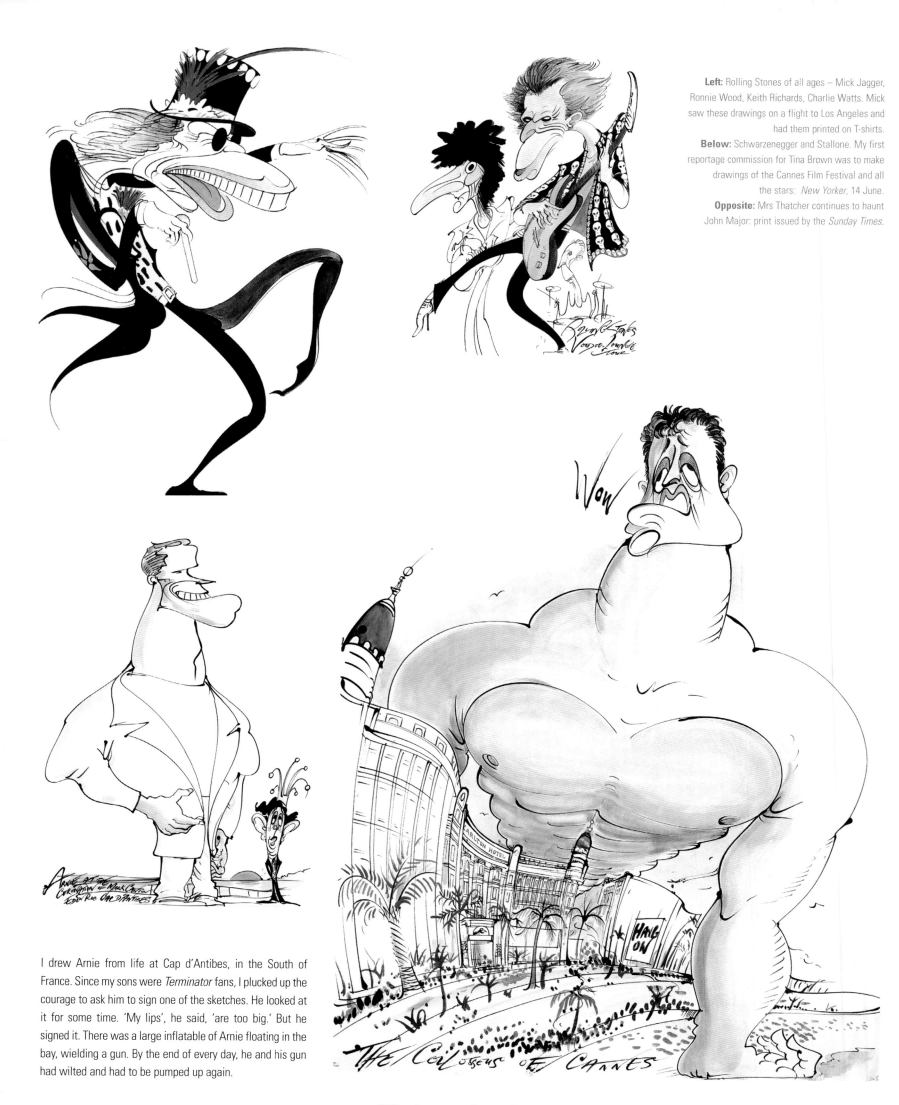

Left: Rolling Stones of all ages – Mick Jagger, Ronnie Wood, Keith Richards, Charlie Watts. Mick saw these drawings on a flight to Los Angeles and had them printed on T-shirts.
Below: Schwarzenegger and Stallone. My first reportage commission for Tina Brown was to make drawings of the Cannes Film Festival and all the stars: *New Yorker*, 14 June.
Opposite: Mrs Thatcher continues to haunt John Major: print issued by the *Sunday Times*.

I drew Arnie from life at Cap d'Antibes, in the South of France. Since my sons were *Terminator* fans, I plucked up the courage to ask him to sign one of the sketches. He looked at it for some time. 'My lips', he said, 'are too big.' But he signed it. There was a large inflatable of Arnie floating in the bay, wielding a gun. By the end of every day, he and his gun had wilted and had to be pumped up again.

1994

Above left: The poet Philip Larkin: *New Yorker.*
Above right: Writer V. S. Naipaul: *New Yorker*, 23 March.
Opposite: Novelist Salman Rushdie: *New Yorker*, 21 February.

254 nineteen ninety-four

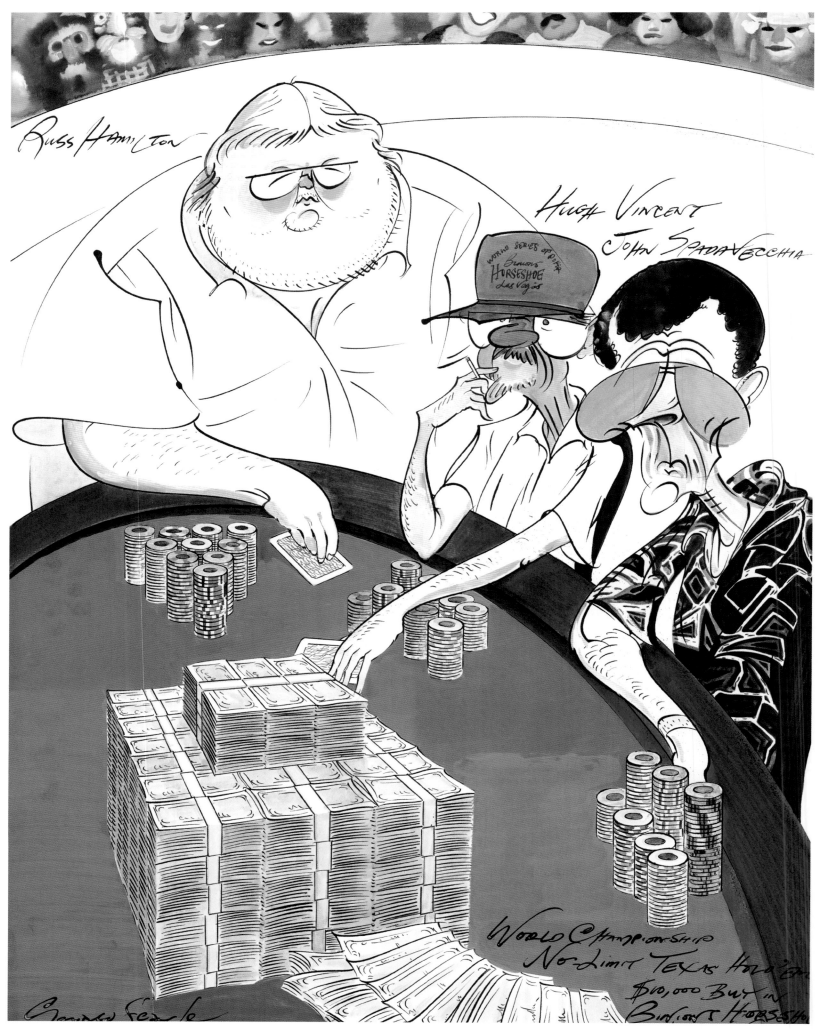

Above: The $10,000 Dollar Buy-in No Limit Texas Hold'em World Championship, Las Vegas: *New Yorker*, 8 August.

My next collaboration with Peter Hall was a West End production of the Feydeau farce *Le Dindon*, which he translated as, rather riskily, *An Absolute Turkey*. Luckily it was a huge hit.

Left: Poster for *An Absolute Turkey*.

I worked for Italian *Vogue* for some time. The editor asked me to make a drawing of famous fashion designers. This was the result, and she was appalled. 'Ah no! These designers are the biggest prima donnas, bigger than opera stars, bigger than film stars.' She didn't print the drawing and I have not been commissioned by Italian *Vogue* since.

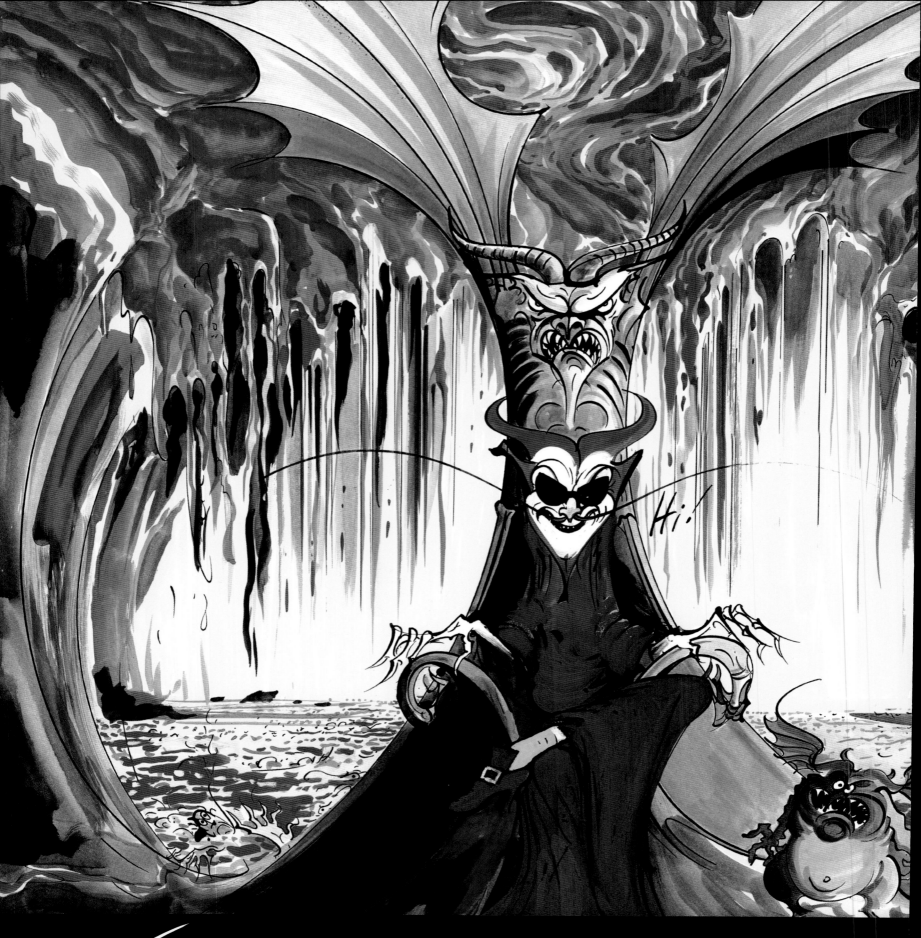

Hi!

WALT DISNEY

I received a call from Disney, asking if I would be interested in working on their new animated feature, *Hercules*. This seemed perfect, as I'd always been a Disney fan, and, from the age of sixteen, very interested in Greek art. They flew me to Los Angeles, and there I met the directors, Ron Clements and John Musker. John had been aware of my work, since seeing the Sears Vincent Price Gallery show as a student in 1969 in Chicago. I

THE UNDERWORLD

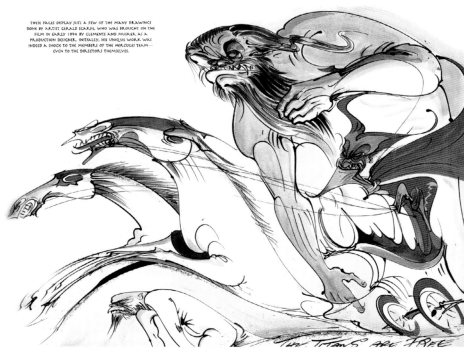

THESE PAGES DISPLAY JUST A FEW OF THE MANY DRAWINGS DONE BY ARTIST GERALD SCARFE, WHO WAS BROUGHT ON THE FILM IN EARLY 1994 BY CLEMENTS AND MUSKER AS A PRODUCTION DESIGNER. INITIALLY, HIS UNIQUE WORK WAS INDEED A SHOCK TO THE MEMBERS OF THE HERCULES TEAM— EVEN TO THE DIRECTORS THEMSELVES.

THE TITANS ARE FREE

I had been saving and collecting things about Gerald since my childhood in Chicago. I had reproductions of his lithograph of Aristotle Onassis with Jacqueline Kennedy and I love the papier mâché Time *cover he did of the Beatles. Rick Maki at Disney had brought Gerald by the studio when he was in town for a Los Angeles Opera Company production he had designed of* The Magic Flute. *We got to talking, like, 'It would be great for him to do some drawings on Hercules.' It started small, with him working in London, but his role grew because he had a real sense of what he called the power and elegance of Greek art, coupled with the rhythmic, calligraphic element in his own work.*
JOHN MUSKER, DIRECTOR OF DISNEY'S *HERCULES*.

I had the great fortune on a trip to London to climb the four or five flights of stairs in Gerald's home to his top-floor studio. I walked in and I thought I was going to fall over. From floor to very high ceiling, a wall of enormous-scaled drawings looked down on you that had such motion, such beauty, such color and line, it was like an ocean wave just smacking you. We pulled all the artwork off the wall, I loaded into a portfolio, and flew it right back to Los Angeles. **THOMAS SCHUMACHER, EXECUTIVE VICE PRESIDENT OF WALT DISNEY FEATURE ANIMATION.**

Extracts from the Hyperion book, *The Art of Hercules: The Chaos of Creation.*

was the first outside designer to work with Disney since Walt asked Salvador Dali in the 30s, but that film was never made. I heard rumours that Dali's drawings were somewhere in the vault, but despite asking several times I never saw them. They gave me a brief outline of the film and a script, and I returned to London.

Above left: Jack Nicholson was to be the voice of Hades but he proved to be too expensive, so it went to James Woods. This is one of the first drawings. In animation, the voices of the actors are recorded first so that the animators have a soundtrack to draw to, and they make their drawn mouth movements, etc. fit the existing track.
Above: *The Shock of the New* cover.

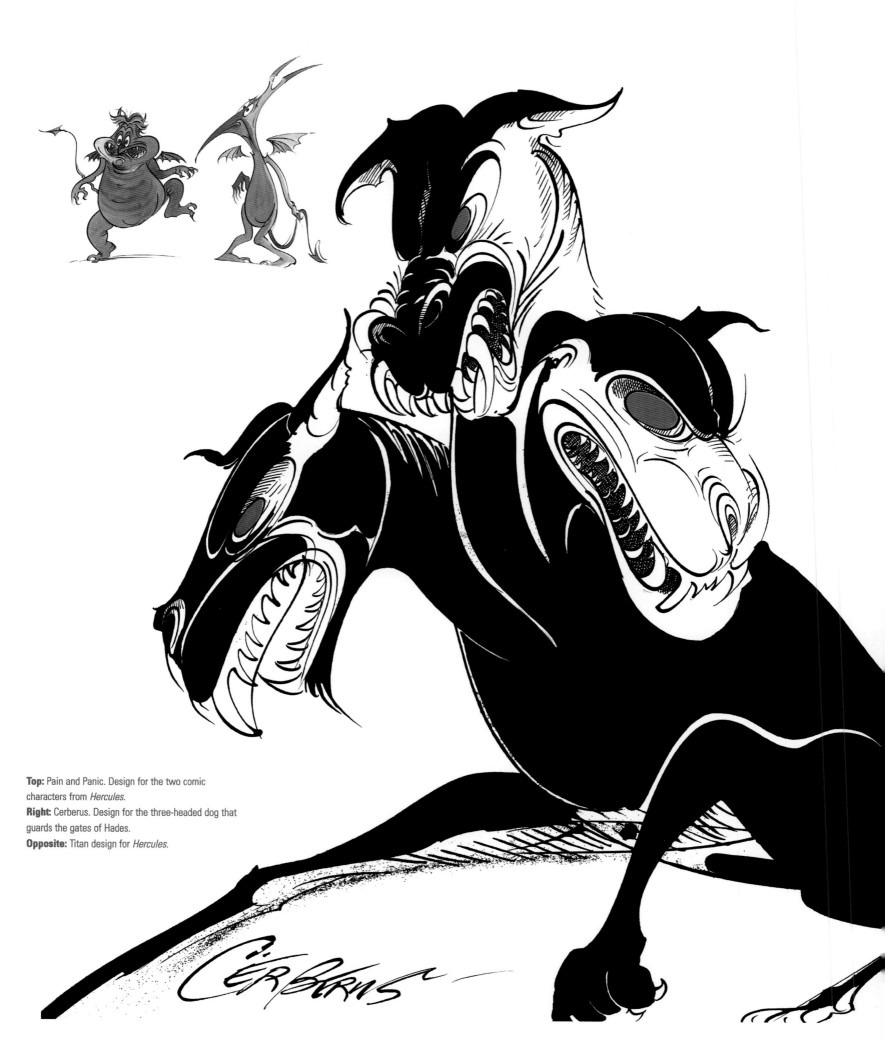

Top: Pain and Panic. Design for the two comic characters from *Hercules*.
Right: Cerberus. Design for the three-headed dog that guards the gates of Hades.
Opposite: Titan design for *Hercules*.

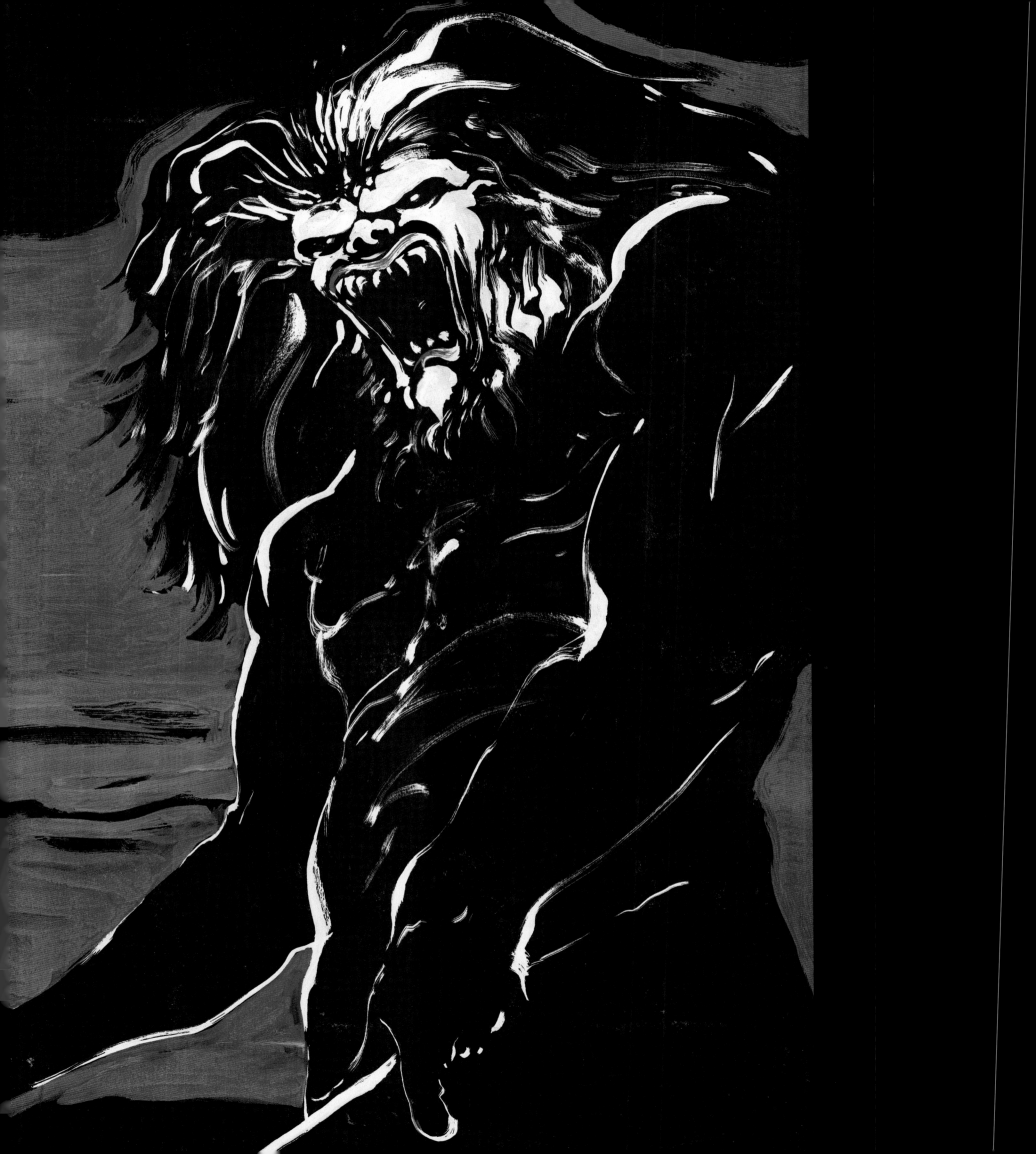

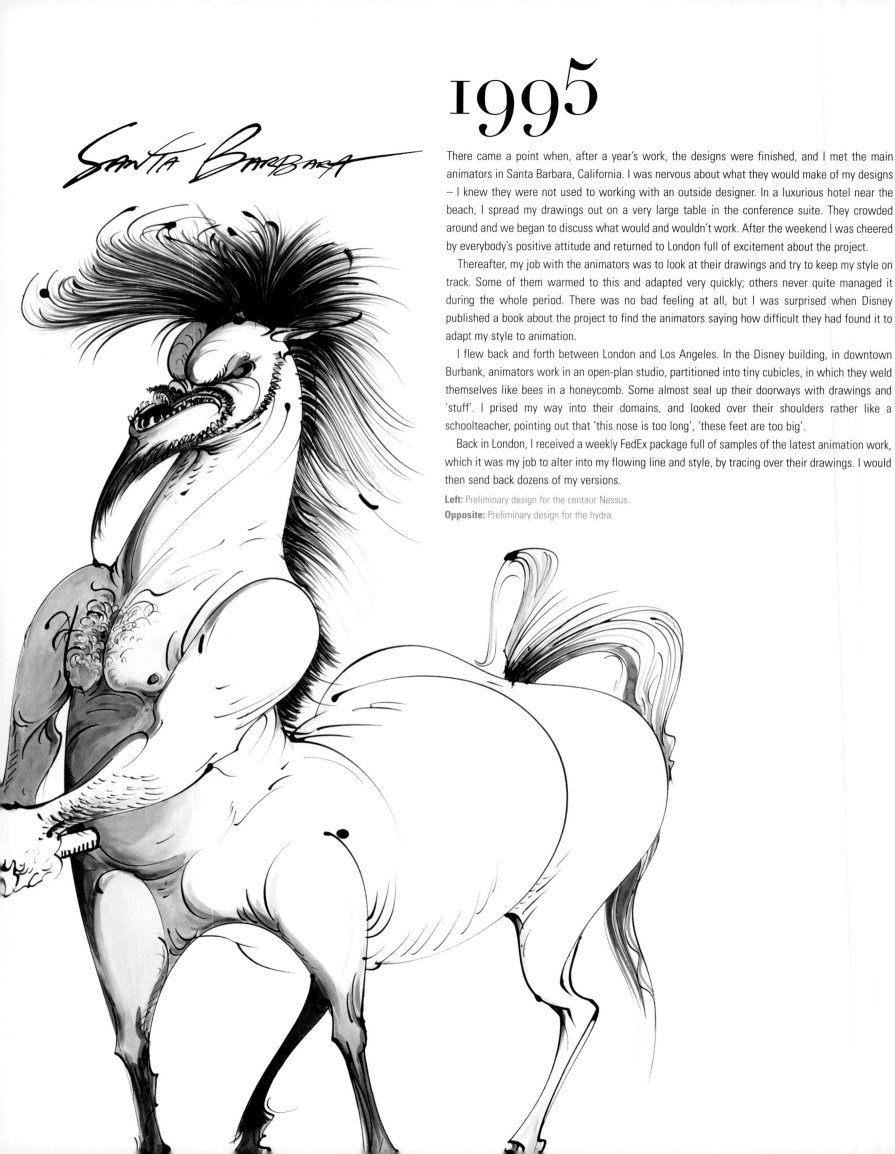

1995

There came a point when, after a year's work, the designs were finished, and I met the main animators in Santa Barbara, California. I was nervous about what they would make of my designs – I knew they were not used to working with an outside designer. In a luxurious hotel near the beach, I spread my drawings out on a very large table in the conference suite. They crowded around and we began to discuss what would and wouldn't work. After the weekend I was cheered by everybody's positive attitude and returned to London full of excitement about the project.

Thereafter, my job with the animators was to look at their drawings and try to keep my style on track. Some of them warmed to this and adapted very quickly; others never quite managed it during the whole period. There was no bad feeling at all, but I was surprised when Disney published a book about the project to find the animators saying how difficult they had found it to adapt my style to animation.

I flew back and forth between London and Los Angeles. In the Disney building, in downtown Burbank, animators work in an open-plan studio, partitioned into tiny cubicles, in which they weld themselves like bees in a honeycomb. Some almost seal up their doorways with drawings and 'stuff'. I prised my way into their domains, and looked over their shoulders rather like a schoolteacher, pointing out that 'this nose is too long', 'these feet are too big'.

Back in London, I received a weekly FedEx package full of samples of the latest animation work, which it was my job to alter into my flowing line and style, by tracing over their drawings. I would then send back dozens of my versions.

Left: Preliminary design for the centaur Nessus.
Opposite: Preliminary design for the hydra.

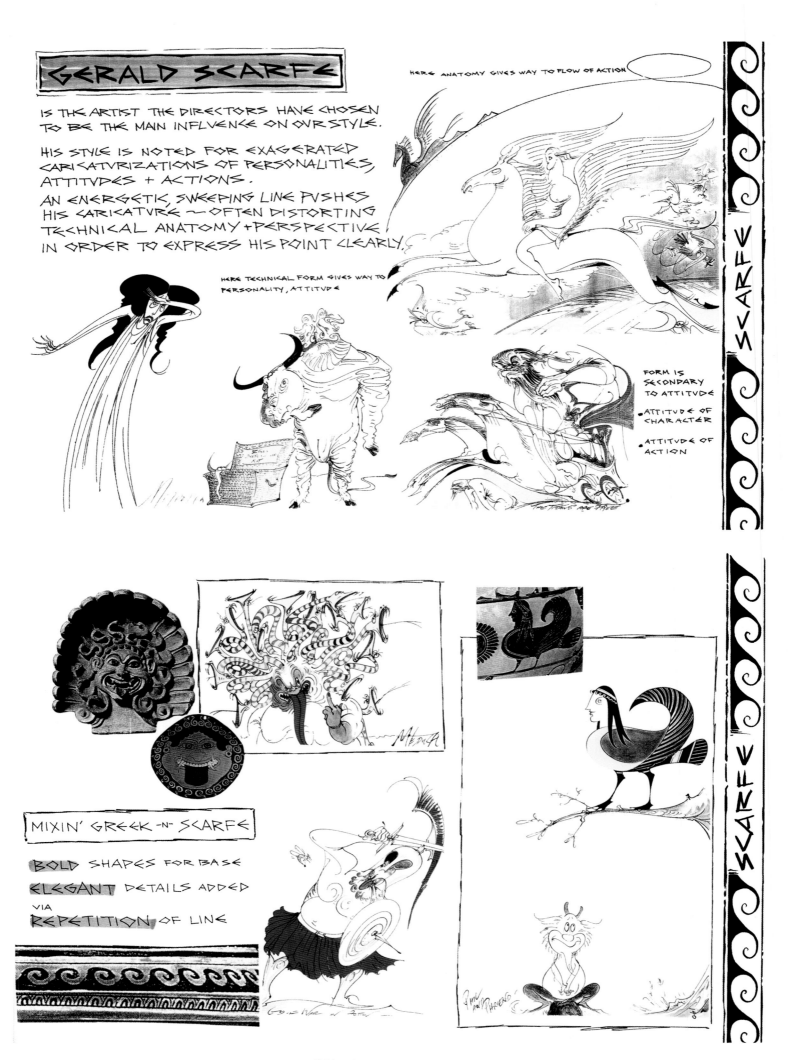

GERALD SCARFE

IS THE ARTIST THE DIRECTORS HAVE CHOSEN
TO BE THE MAIN INFLUENCE ON OUR STYLE.

HIS STYLE IS NOTED FOR EXAGERATED
CARICATURIZATIONS OF PERSONALITIES,
ATTITUDES + ACTIONS.

AN ENERGETIC, SWEEPING LINE PUSHES
HIS CARICATURE — OFTEN DISTORTING
TECHNICAL ANATOMY + PERSPECTIVE
IN ORDER TO EXPRESS HIS POINT CLEARLY.

HERE ANATOMY GIVES WAY TO FLOW OF ACTION

HERE TECHNICAL FORM GIVES WAY TO
PERSONALITY, ATTITUDE

FORM IS
SECONDARY
TO ATTITUDE

- ATTITUDE OF
CHARACTER

- ATTITUDE OF
ACTION

MIXIN' GREEK -N- SCARFE

BOLD SHAPES FOR BASE
ELEGANT DETAILS ADDED
VIA
REPETITION OF LINE

SCARFE

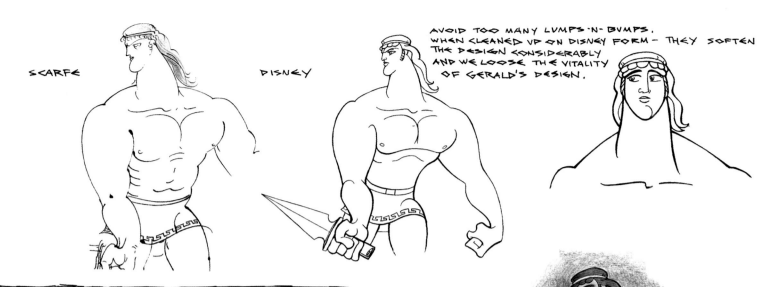

SCARFE DISNEY

AVOID TOO MANY LUMPS-N-BUMPS.
WHEN CLEANED UP ON DISNEY FORM — THEY SOFTEN
THE DESIGN CONSIDERABLY
AND WE LOOSE THE VITALITY
OF GERALD'S DESIGN.

MIXIN' DISNEY -N- SCARFE

- FIND THE SIMPLE, BASIC SHAPE
- NAIL REST OF DETAILS DOWN TO THAT SHAPE
- WHEN SIMPLIFYING FOR ANIMATION/CLEAN-UP
 REMEMBER —
 ### SCARFE = CARICATURE
 CHOOSE SHAPES/LINES THAT PUSH
 BIG vs SMALL — BOLD vs ELEGANT
- REMEMBER "REPETITION"
 OF SHAPES + LINES (BUT BEWARE OF LINE MILAGE!!)

NEO-GRECO-DISNEY-SCARFIAN STYLE

Opposite and top: Design guides by production stylist Sue Nichols
for the animators to help them copy my style for *Hercules.*
Left: Apollo's chariot.
Above: Early design for Hercules. He proved to be the most
difficult character to design. The good are always harder to
realise than the wicked. We all seem to enjoy the baddies best —
just think of the pantomime. It was suggested early on that the
young Elvis Presley or the young Paul Newman could be models
for Hercules, but he wandered away from that and I drew him as
a simple hunk. The animator, Andreas Deja, interpreted him as
the figure you see in the film.

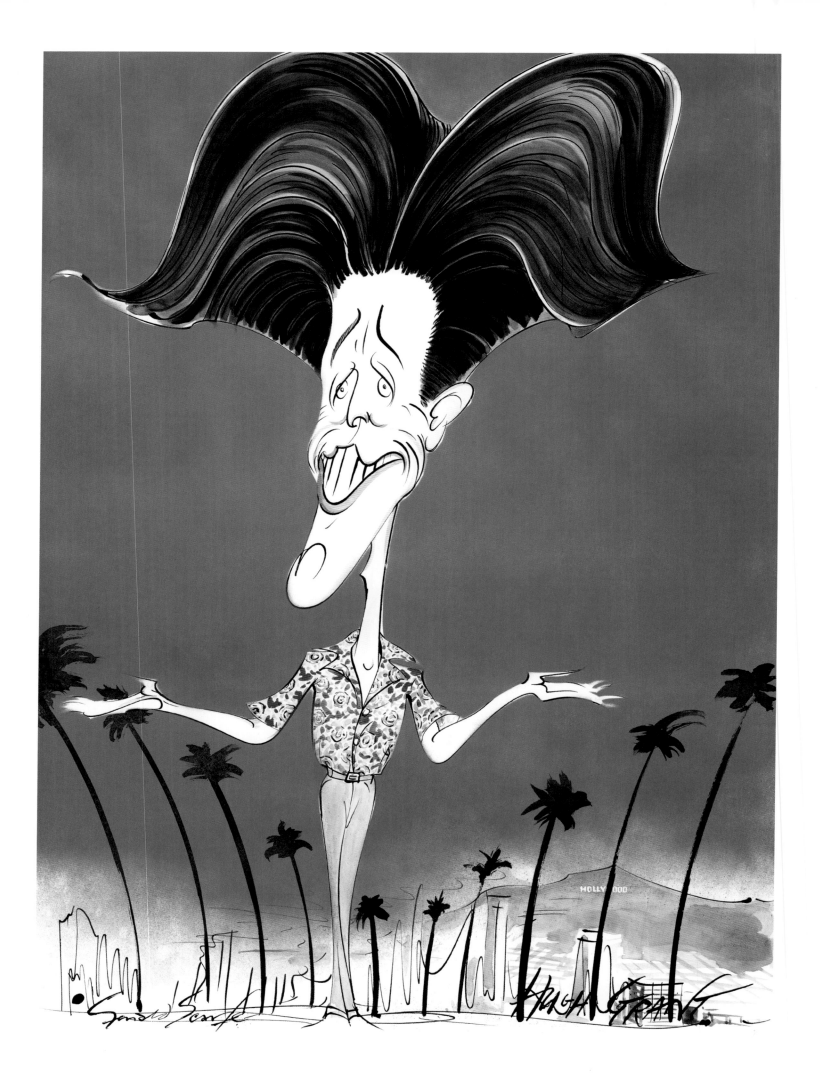

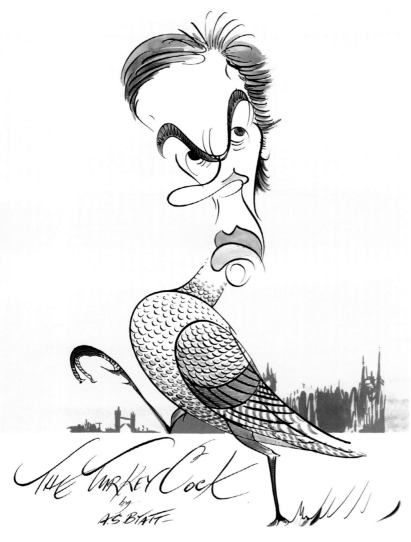

Opposite: Looking Divine or Looking for Divine – Hugh Grant: *New Yorker*, 24 July.
Above: The Turkey Cock – Martin Amis: *New Yorker*, 6 March.
A. S. Byatt accused fellow writer Amis, who had secured a big advance, of 'turkey-cocking'.
Top right: Poster for *The Beggar's Opera* for Opera Northern Ireland.
Below: *The Beggar's Opera*: drawings for the backdrop. Whores, lawyers and a beggar.

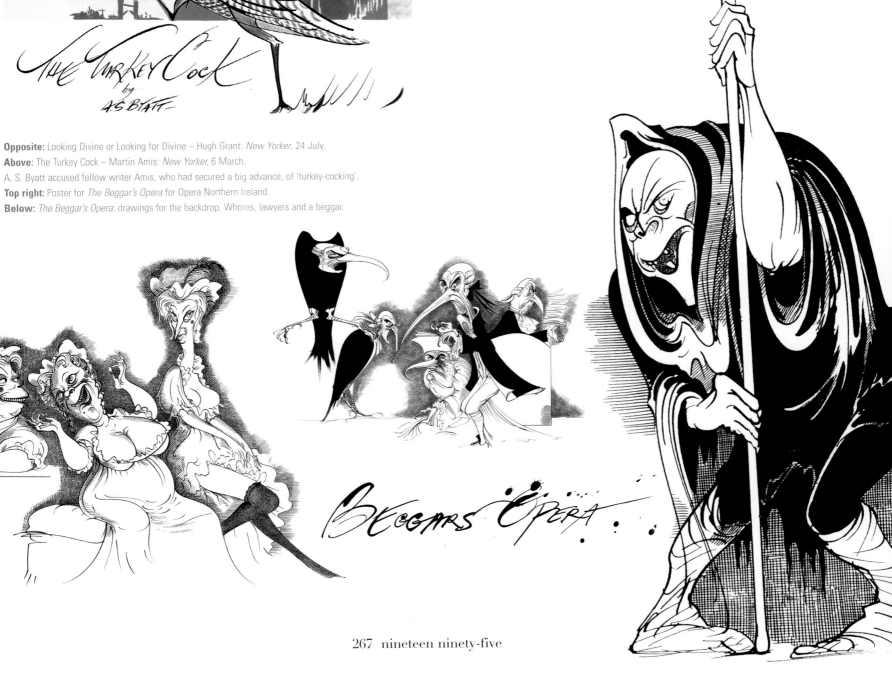

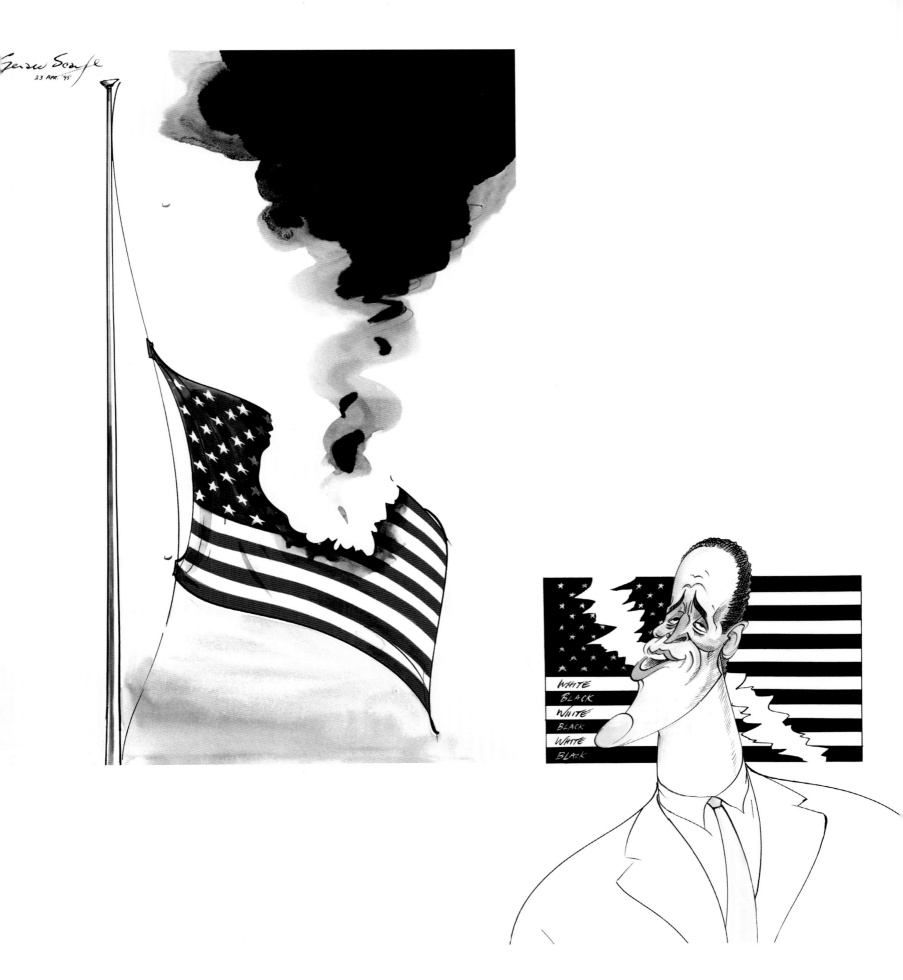

Opposite: The permanently berated John Major: *Sunday Times*, 18 June. Poor old John Major – the only fun he had was with Edwina Currie.

Above: Oklahoma bomb: *Sunday Times*, 23 April.

Right: O. J. Simpson: *Sunday Times*, 8 October.

Following page: The Rock and Roll Hall of Fame – Bill Haley, Ray Charles, Elvis Presley, Jimi Hendrix, Fat Elvis in Las Vegas, Roy Orbison, Stevie Wonder, Tina Turner, Bob Dylan, Janis Joplin, Frank Zappa: *New Yorker*, 21–28 August.

Elvis in Las Vegas

Roy Orbison

Tina Turner

Stevie Wonder

Bob Dylan

Janis Joplin

Frank Zappa

Gerald Scarfe

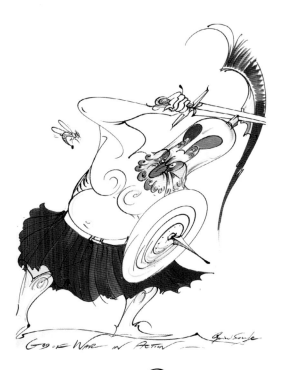

GOD OF WAR IN ACTION

1996

Above: Design for Ares the God of War, in some trouble with a bee.
Right: Design for Lachesis, one of the three Fates.
Below: GS in front of Disney storyboards, in the Disney Building, downtown Burbank, Los Angeles.

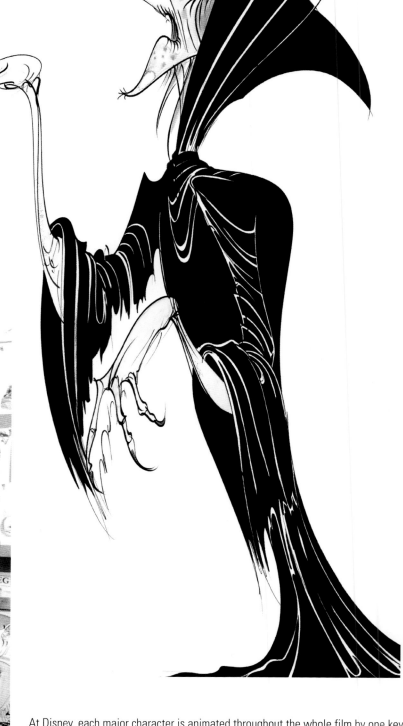

At Disney, each major character is animated throughout the whole film by one key animator and his or her team. So, for example, the main movements of *Hercules* would be drawn by the key animator, and other animators, the 'inbetweeners', would fill in the missing movements. In the old days, these drawings were put onto cellophane and inked by hand. The 'cell' was then passed to the paint department, turned face down and coloured with inks and paints on the reverse, matt, side. This was then filmed. Today, when the animators have finished the drawings, they are scanned straight into the computer and coloured onscreen.

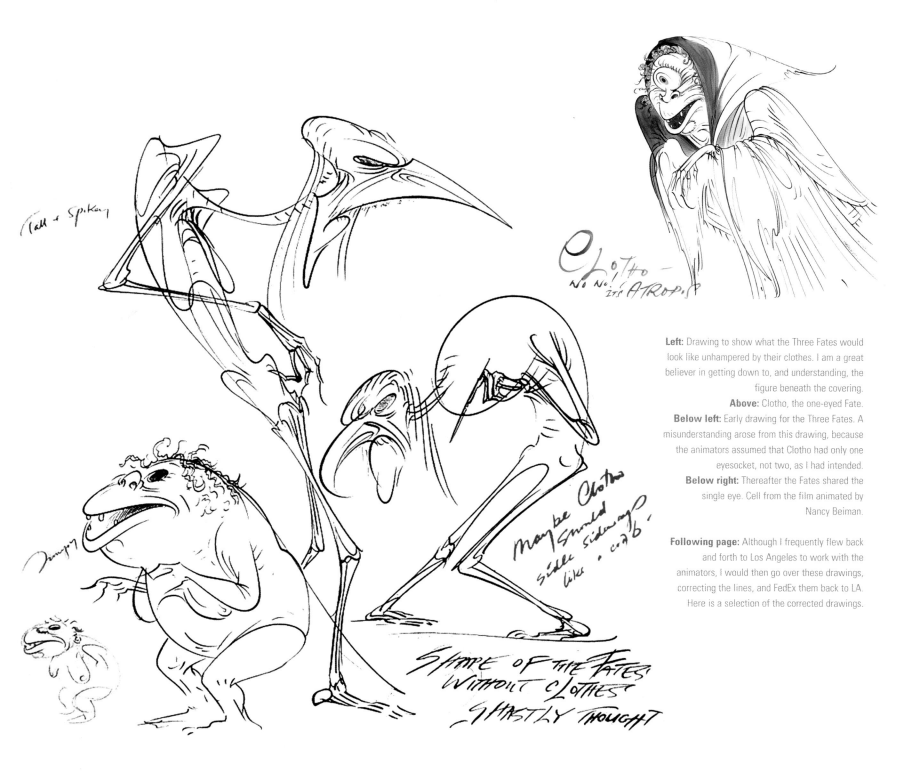

Tall + Spikey

Clotho—
NO NO! ITS ATROPOS!

Maybe Clotho
should
sidle sideways
like a crab.

SHAPE OF THE FATES
WITHOUT CLOTHES!
GHASTLY THOUGHT

Left: Drawing to show what the Three Fates would look like unhampered by their clothes. I am a great believer in getting down to, and understanding, the figure beneath the covering.
Above: Clotho, the one-eyed Fate.
Below left: Early drawing for the Three Fates. A misunderstanding arose from this drawing, because the animators assumed that Clotho had only one eyesocket, not two, as I had intended.
Below right: Thereafter the Fates shared the single eye. Cell from the film animated by Nancy Beiman.

Following page: Although I frequently flew back and forth to Los Angeles to work with the animators, I would then go over these drawings, correcting the lines, and FedEx them back to LA. Here is a selection of the corrected drawings.

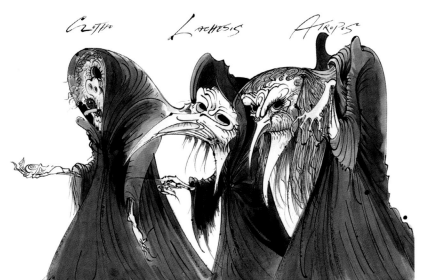

Clotho Lachesis Atropos

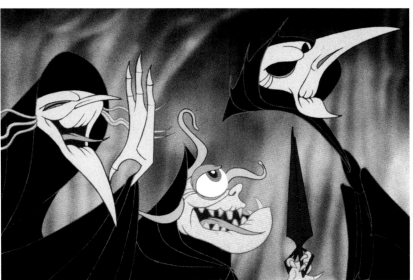

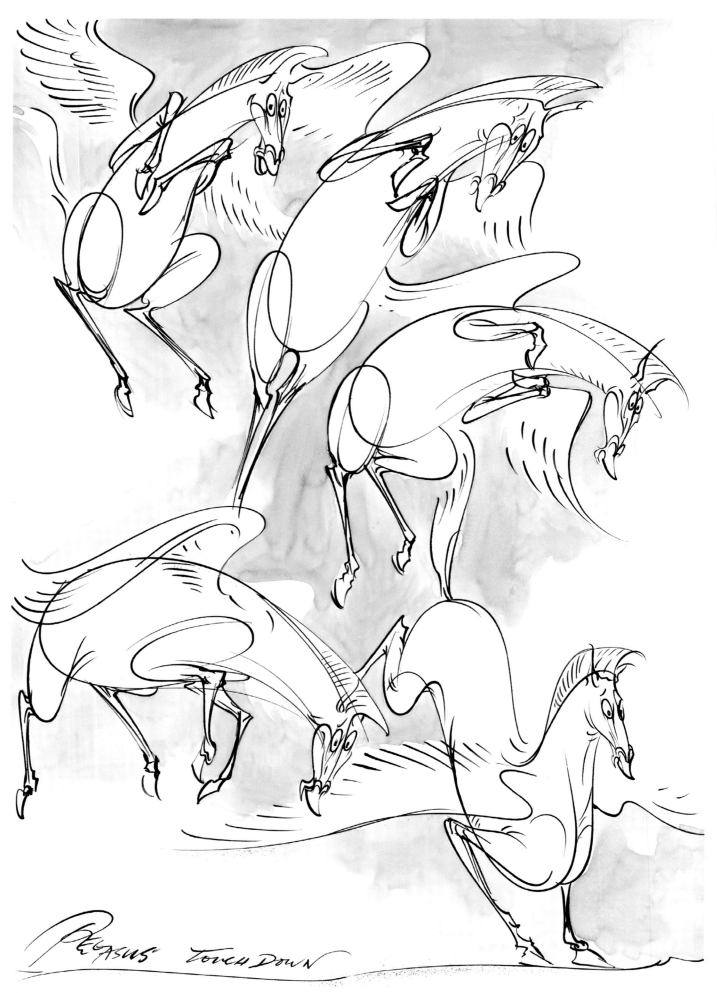

Pegasus touchdown: a drawing to explain movement to the animators. These drawings of Pegasus descending were not only to give them the idea of the movement but to indicate the elegance of this horse of the gods. I didn't want the usual old Disney Dobbin. I spent a certain amount of time at the British Museum, studying the sculptures and the Greek vases. The elegant, flowing line of the Greek artists had always attracted me, and I determined to include that in my designs. I bought a resin reproduction of a horse's head from the Parthenon to inspire me.

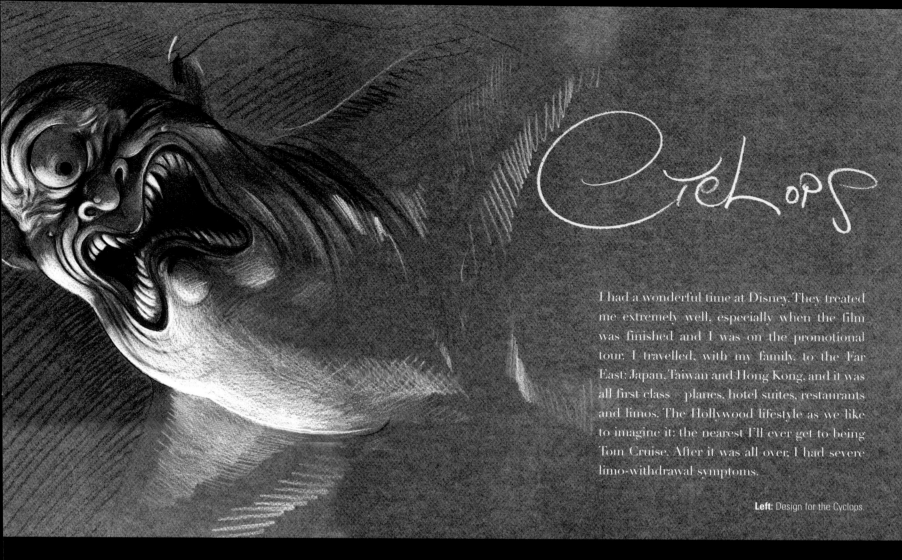

Cyclops

I had a wonderful time at Disney. They treated me extremely well, especially when the film was finished and I was on the promotional tour. I travelled, with my family, to the Far East: Japan, Taiwan and Hong Kong, and it was all first class — planes, hotel suites, restaurants and limos. The Hollywood lifestyle as we like to imagine it: the nearest I'll ever get to being Tom Cruise. After it was all over, I had severe limo-withdrawal symptoms.

Left: Design for the Cyclops.

Poster for the Feydeau farce *Mind Millie for Me* at the Theatre Royal, Haymarket. I designed the costumes and the sets. This was the second Feydeau farce I designed for Peter Hall.

Left above and below: Designs for the Mayor's parlour from *Mind Millie for Me*.

Kim il Blair

BOSNIA

Opposite:

Top: Kim Il Blair – Tony Blair burning old Labour: *Sunday Times*,
1 September. Blair appears on the scene.

Below left: Most Popular Man in Britain – John Major:
Sunday Times, 29 December.

Below right: Sleaze – money for questions: backhanders for
Parliamentarians: *Sunday Times*.

This page:

Top: The War in Bosnia: *Sunday Times*, 28 January.

Right: Crisis in Zaire: *Sunday Times*, 27 October.

1997

I decided that because Hades lived in an underworld of fire and darkness, he was a saturnine, sardonic creature, capable of bursting into flame at any moment. He was the element of fire himself, able to rise from a smouldering ember into a blazing inferno. I always drew him with his hair alight, flame flickering along his fingertips: a cool, blue flame when he was sardonic, and a blazing, orange burst of fire when he lost his temper – which was frequently. I was drawn to Hades – evil is often attractive.

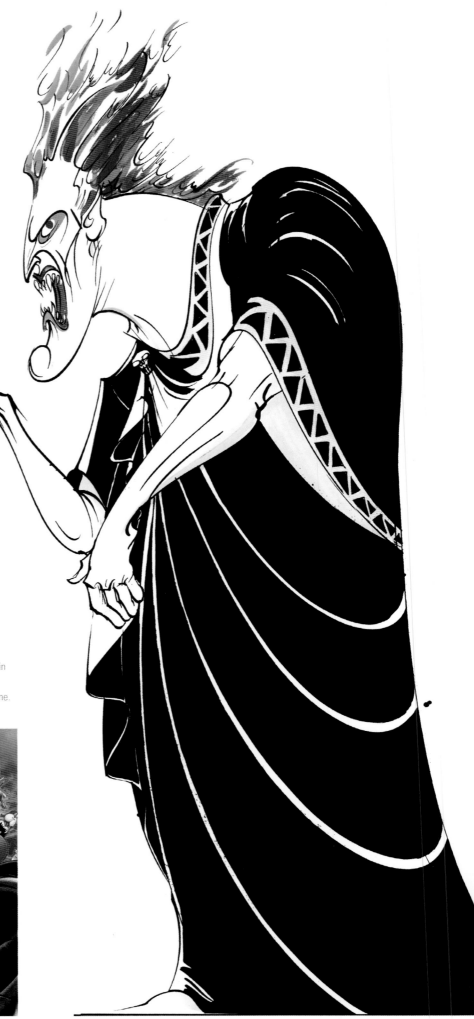

Above: Shock Horror – Scarfe designs Disney. *Sunday Times Culture* magazine.
Right: Hades. This is almost the final design for Hades. The way he appeared in the film is seen in the poster below.
Below: Poster for *Hercules*. The film premiered at the New Amsterdam Theater, New York, 14 June.

Disney thought that the hydra would be a perfect character to render in computer graphics because it was many headed. A 3-D model was made from my design and the dimensions were fed into a computer. The hydra's head could then be generated whenever necessary. After many months, the short sequence was finished, and I thought it looked what it was – computerised. Disney had to spend the same amount of time going over the whole sequence again to make it look graphic and match my style. Wouldn't it have been quicker, and cheaper, I said, to draw it by hand in the original Disney method? Yep, probably, they said. Of course, as an artist, I am biased towards the magic of real drawings giving the impression of movement. Real paintings moving – real, live art. Whereas computer graphics don't in any way feel 'real', just as in live action films, I would like to feel that a real flesh and blood stuntman had actually skied off the cliff as James Bond, rather than the stunt having been generated in a computer.

Left: A drawing showing the complete hydra, from the book *Hades – the True Story*.
Top: Final design for the hydra.
Right: 3-D model of the hydra made by Kent Melton.

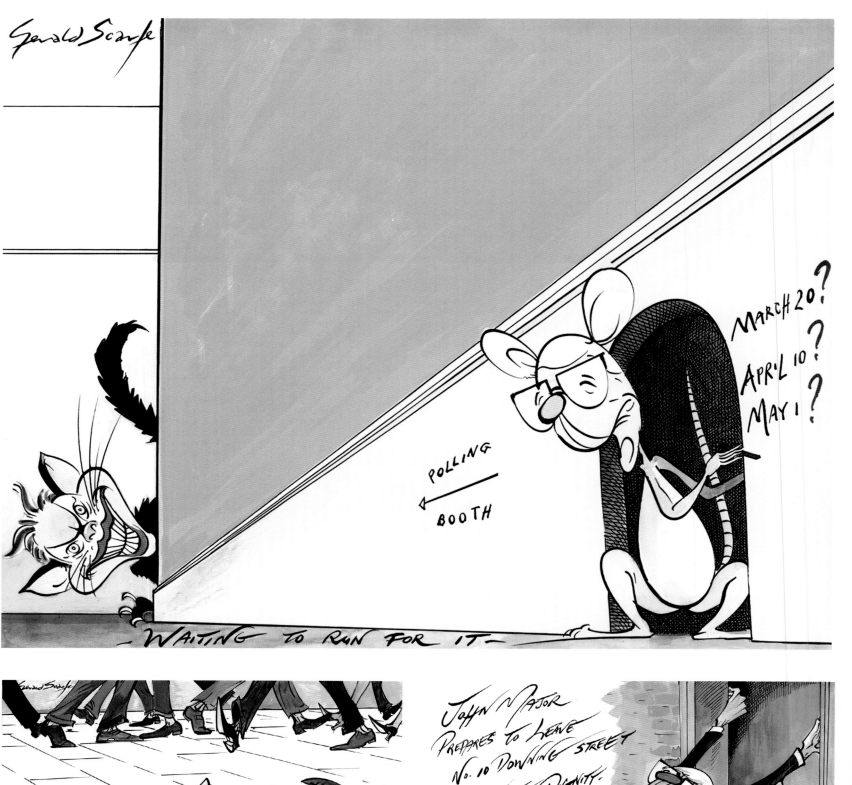

Top: Waiting to Run for It – Tony Blair and John Major: *Sunday Times*, 19 January. John Major tries to pick the most advantageous date for the election.
Above left: Only Four More Days of Informed Political Debate: *Sunday Times*, 27 April.
Above right: John Major prepares to leave No.10 Downing Street with dignity: *Sunday Times*, 6 April.

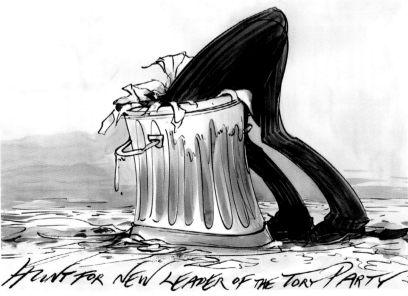

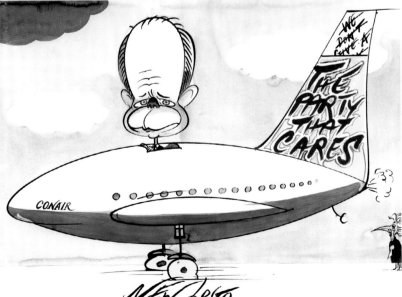

Top: Cruel? John Major is attacked by his backbenchers: *Sunday Times*, 13 April.

Above left: Hunt for the New Leader of the Tory Party: *Sunday Times*, 25 May.

Above right: New Logo – William Hague: The Party That Cares: *Sunday Times*, 12 October.

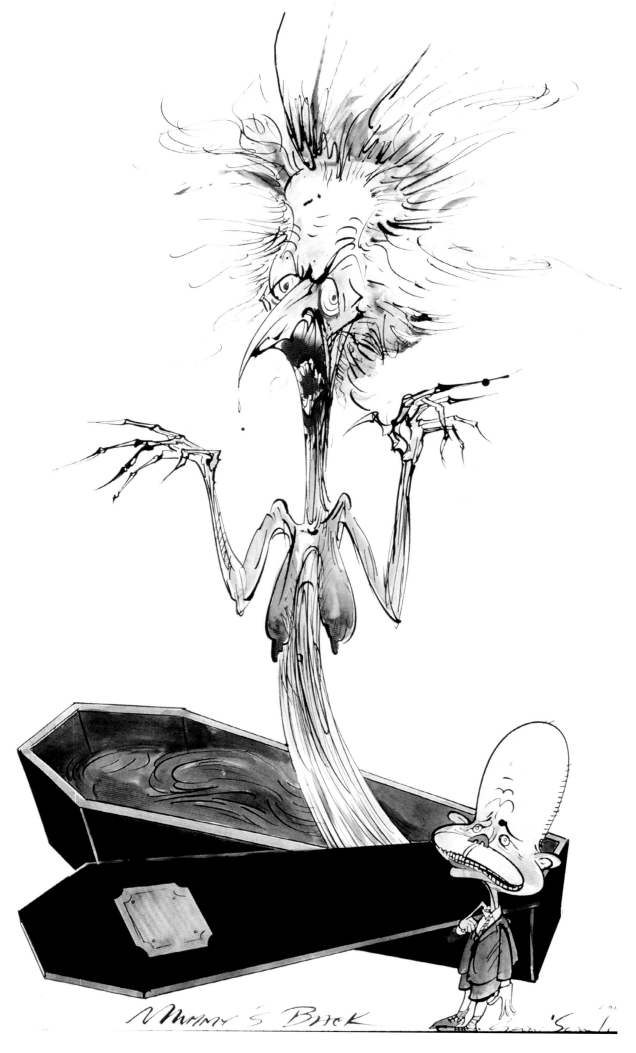

Mummy's Back – William Hague is now the one to be haunted by Mrs T (GS's collection).

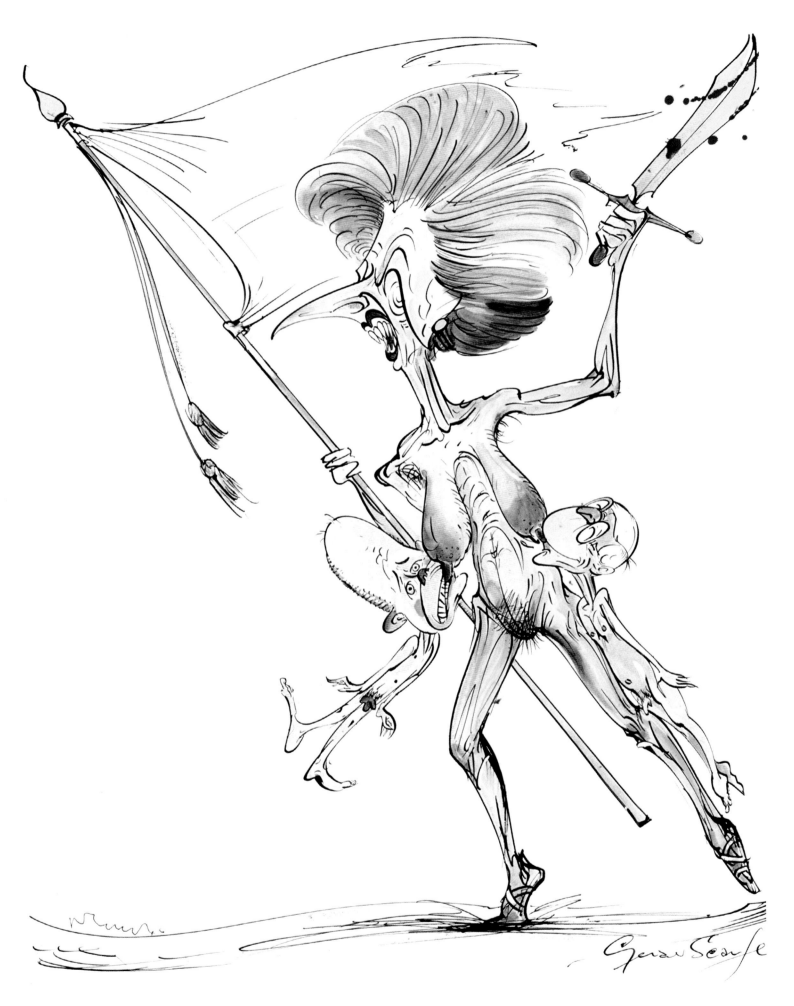

Margaret Thatcher and her suckling babes, Hague and Major (GS's collection).

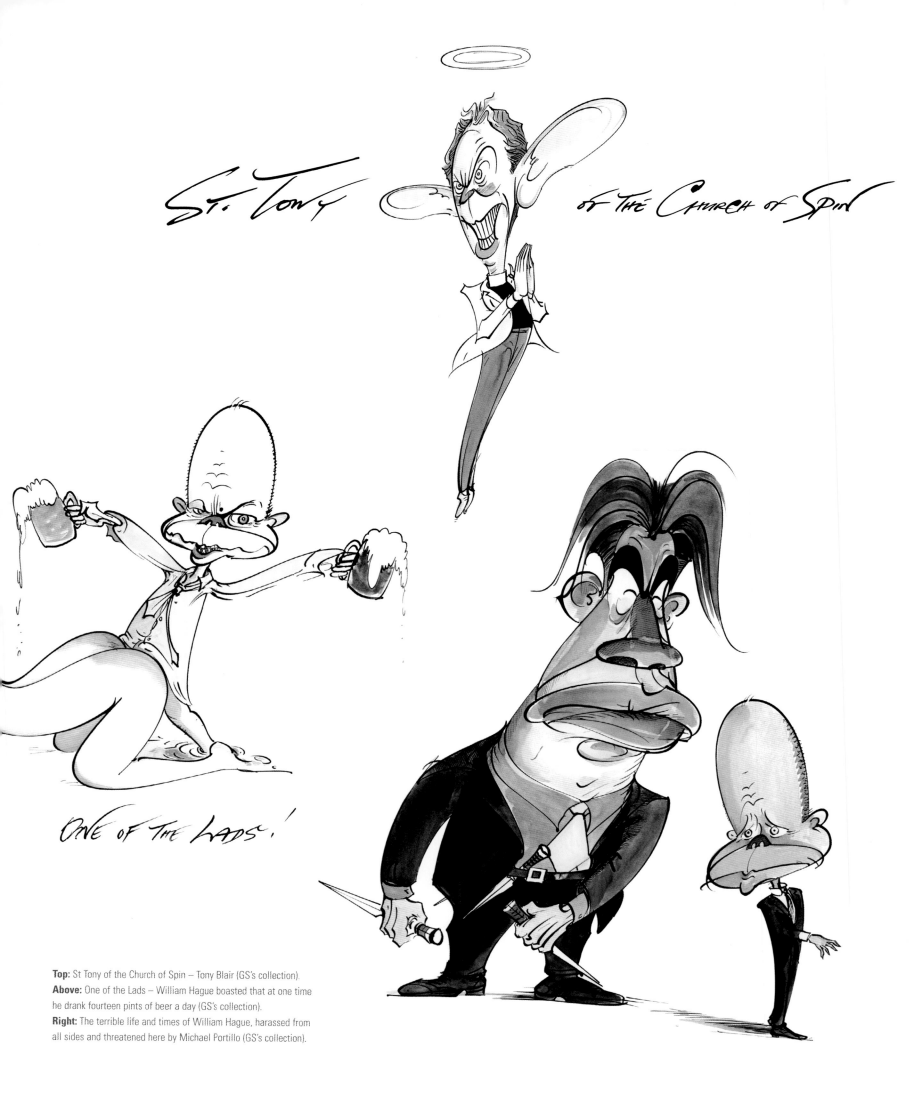

St. Tony OF THE CHURCH OF SPIN

ONE OF THE LADS!

Top: St Tony of the Church of Spin – Tony Blair (GS's collection).
Above: One of the Lads – William Hague boasted that at one time he drank fourteen pints of beer a day (GS's collection).
Right: The terrible life and times of William Hague, harassed from all sides and threatened here by Michael Portillo (GS's collection).

KEEPING HIS BALANCE

Above: Keeping His Balance – the Hang Seng Index in trouble: *Sunday Times*, 26 October.
Right: The Lease Runs Out in Hong Kong – Chris Patten, Governor of Hong Kong, sails off into the sunset: *New Yorker*, 12 May.

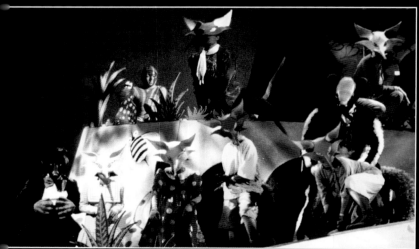

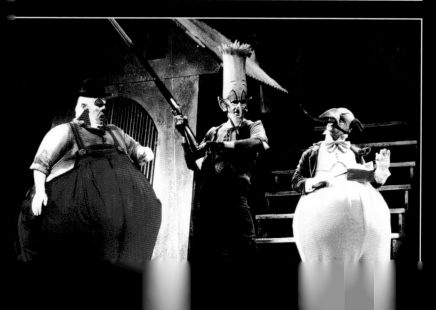

Fantastic Mr. Fox

1998

Peter Hemmings, the director of Los Angeles Opera, asked me to design the costumes and scenery for Roald Dahl's *Fantastic Mr Fox*, a new opera by Tobias Picker, to be directed by Donald Sturrock. We designed a set which revolved to show the foxes' den, the house where the wicked farmers Boggis, Bunce and Bean lived, and then the destroyed den. wanted the singers to wear masks, as ears and whiskers stuck onto the human face would be feeble. I also wanted children to see the full animal. Opera singers detest having anything around their throats and ears, so I designed the cotumes to leave those areas free. The masks were not very popular, but they wore them with cheerful fortitude creating a dashing Mr Fox, a handsome porcupine, a drunken rat called Rita and a singing farm tractor.

This page: Three scenes from *Fantastic M*
Opposite: Three posters for the Los Angeles production of *Fantastic M*

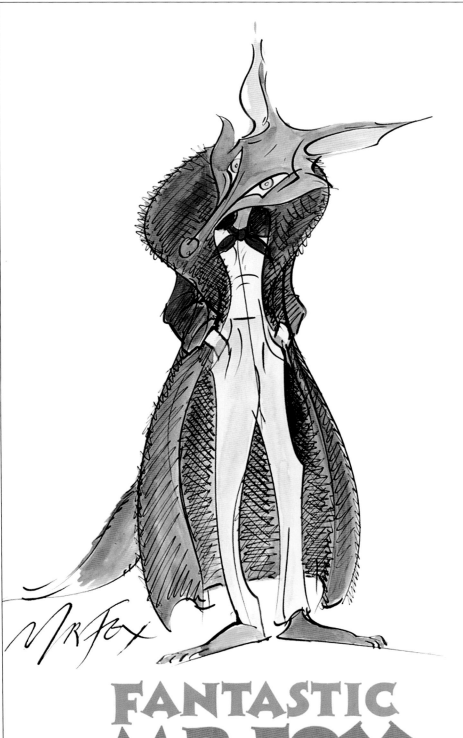

FANTASTIC MR·FOX

AN OPERA BY
TOBIAS PICKER

LIBRETTO BY DONALD STURROCK
BASED ON A STORY BY ROALD DAHL

Commissioned for the Roald Dahl Foundation
An L.A.Opera production in association with Music Link International

DECEMBER 9, 12M, 15, 19M, 20, 21, 22M, 1998

L.A.OPERA

TICKETS AVAILABLE AT MUSIC CENTER BOX OFFICE OR THROUGH *Ticketmaster* 213/365-3500

O'MELVENY & MYERS LLP

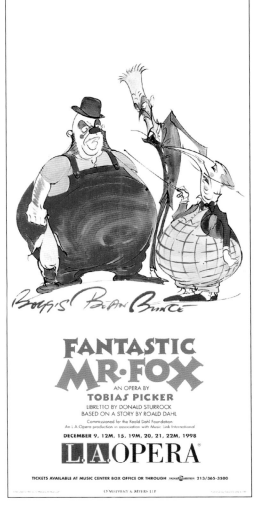

FANTASTIC MR·FOX
AN OPERA BY
TOBIAS PICKER
LIBRETTO BY DONALD STURROCK
BASED ON A STORY BY ROALD DAHL
Commissioned for the Roald Dahl Foundation
An L.A.Opera production in association with Music Link International
DECEMBER 9, 12M, 15, 19M, 20, 21, 22M, 1998
L.A.OPERA
TICKETS AVAILABLE AT MUSIC CENTER BOX OFFICE OR THROUGH *Ticketmaster* 213/365-3500
O'MELVENY & MYERS LLP

FANTASTIC MR·FOX
AN OPERA BY
TOBIAS PICKER
LIBRETTO BY DONALD STURROCK
BASED ON A STORY BY ROALD DAHL
Commissioned for the Roald Dahl Foundation
An L.A.Opera production in association with Music Link International
DECEMBER 9, 12M, 15, 19M, 20, 21, 22M, 1998
L.A.OPERA
TICKETS AVAILABLE AT MUSIC CENTER BOX OFFICE OR THROUGH *Ticketmaster* 213/365-3500
O'MELVENY & MYERS LLP

Top left: Face Off! GS confronts himself on the front of the *Sunday Times Culture* magazine, 27 December.

Above: Scarfe at the National Portrait Gallery is announced on the front of the *Daily Telegraph*, 3 October.

Top right: Poster for Scarfe at the National Portrait Gallery, 2 October–6 April. A retrospective exhibition.

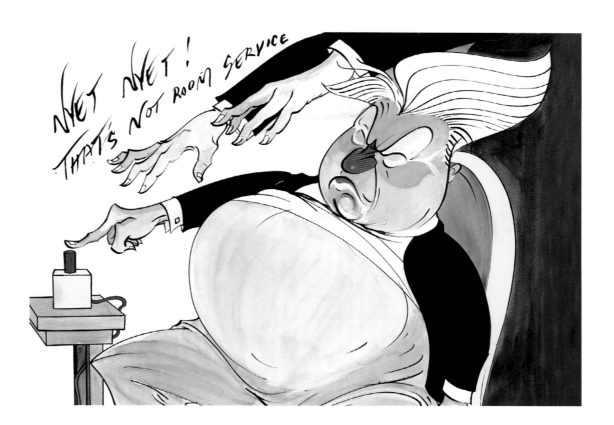

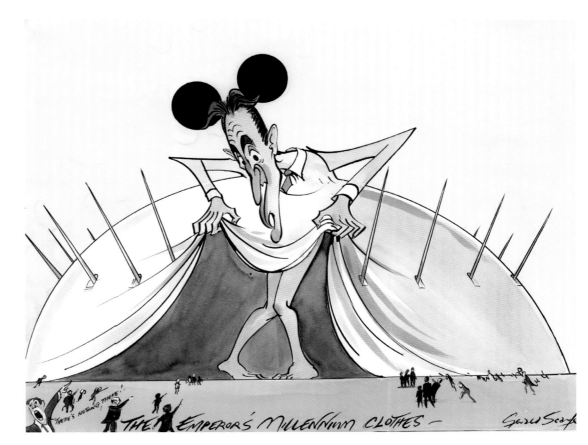

Above: Set of Royal Mail stamps featuring comedians – Peter Cook, Les Dawson, Joyce Grenfell, Eric Morecambe, Tommy Cooper (Royal Mail).
Top right: Boris Yeltsin – Boris had a reputation as a heavy drinker: *Sunday Times*, 29 March.

I thought the Dome was a bad idea but when they offered me a job I decided it was not so bad after all (see p.300).

Above: The Emperor's Millennium Clothes – Peter Mandelson looks under his skirts to find nothing in the Dome: *Sunday Times*, 11 January.

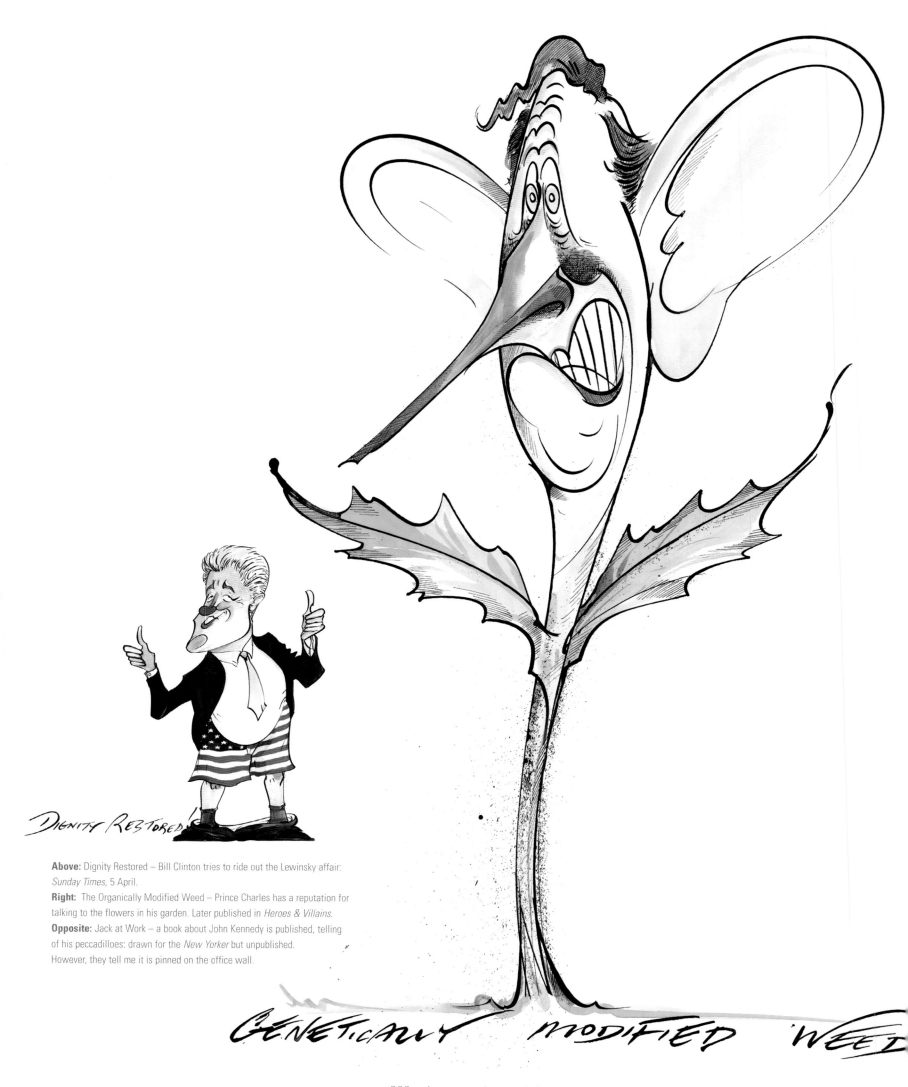

DIGNITY RESTORED!

Above: Dignity Restored – Bill Clinton tries to ride out the Lewinsky affair: *Sunday Times*, 5 April.

Right: The Organically Modified Weed – Prince Charles has a reputation for talking to the flowers in his garden. Later published in *Heroes & Villains*.

Opposite: Jack at Work – a book about John Kennedy is published, telling of his peccadilloes: drawn for the *New Yorker* but unpublished. However, they tell me it is pinned on the office wall.

GENETICALLY MODIFIED WEED

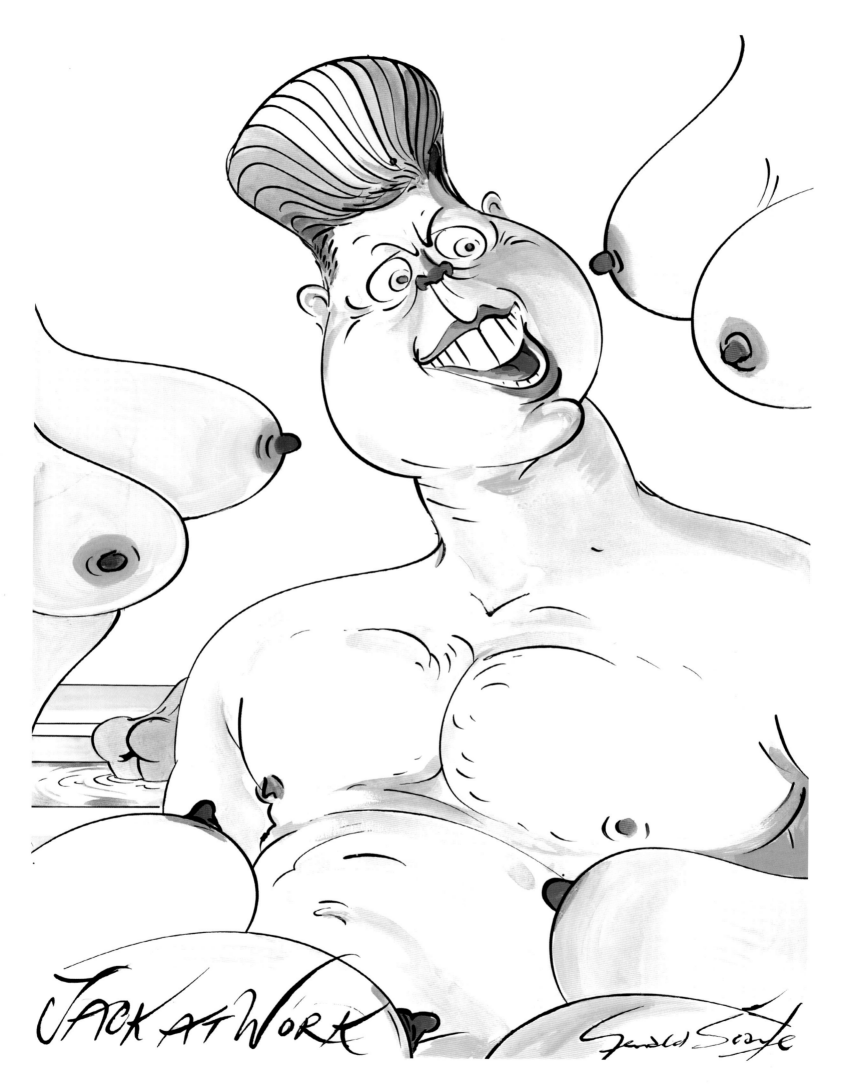

JACK AT WORK

Gerald Scarfe

1999

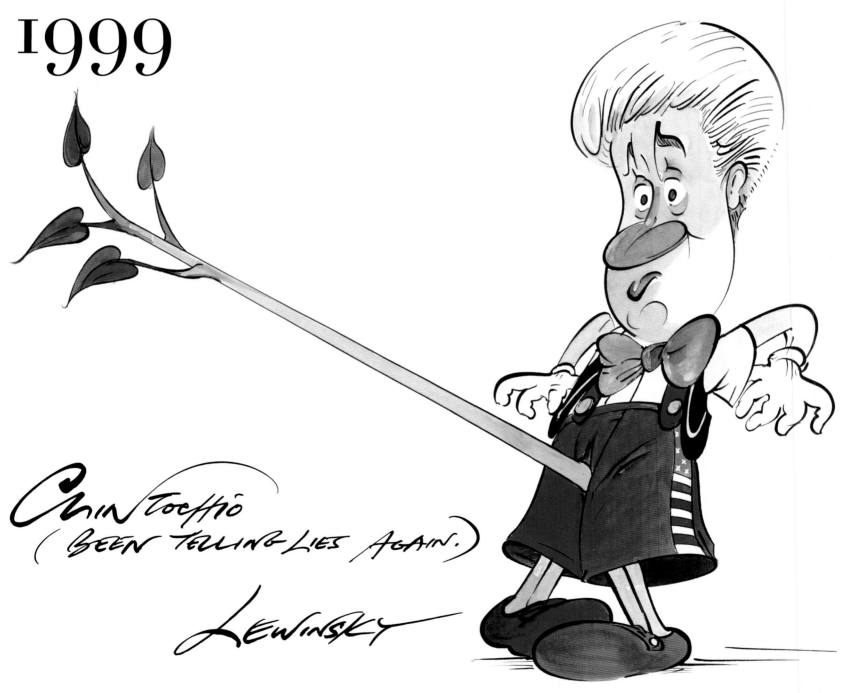

Clintocchio – Bill's been telling lies again (GS's collection).

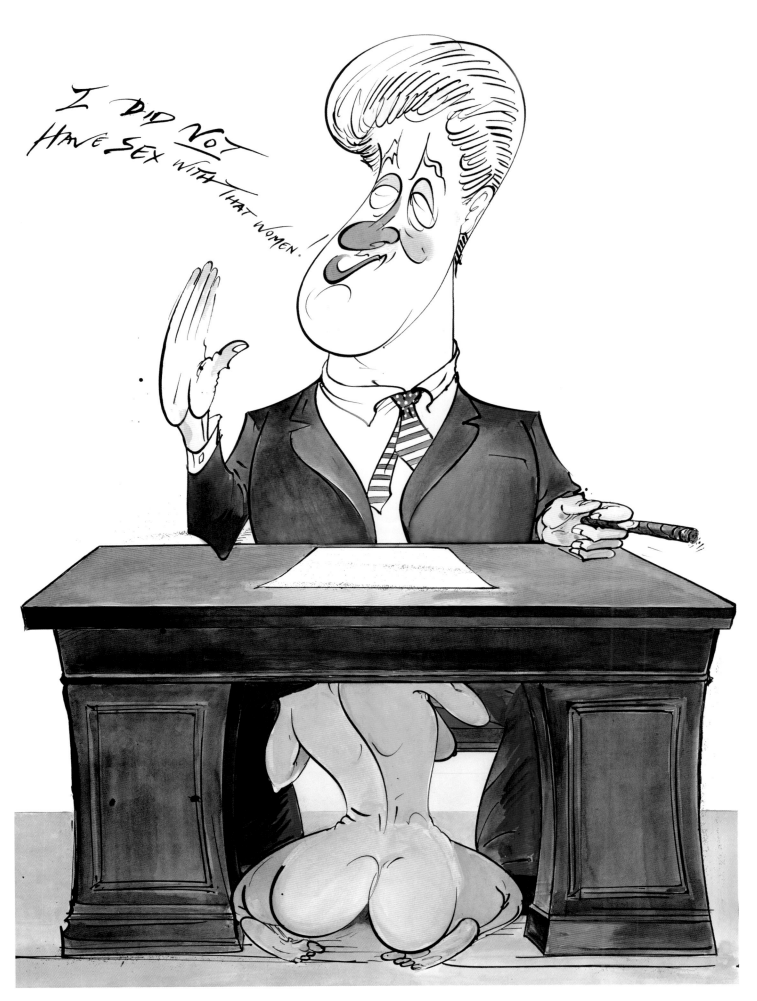

I Did Not Have Sex With That Woman – Bill Clinton (GS's collection).

Clockwise from top left: Diane von Furstenberg, D. L. Hughley, Peta Wilson, Prince, George Plimpton, Robert Hughes, Sir Ian McKellen: *Talk* magazine, November issue.

JIM CAREY
DANNY DeVITO IN
MAN ON THE MOON

JIM BROADBENT
AS W.S. GILBERT
IN
TOPSY-TURVY

MATT DAMON
GWYNETH PALTROW
IN
THE TALENTED
MR. RIPLEY.

Clockwise from top left: Danny DeVito, Jim Carrey, Jim Broadbent, Matt Damon and Gwyneth Paltrow in films of the day: *New Yorker*, 27 December–3 January.

The Dome.

Simon Jenkins, the journalist, rang me to see if I would be interested in making some sculptures for the Dome. I was completely against the Dome, and thought it had the smell of failure about it from the start, but when they offered me a job, I saw it differently . . . They wanted me to work in a pavilion called the Self-Portrait Zone. Jenny Page, who was chief executive of the New Millennium Experience Company, said she felt that the Zone, which was intended to give a picture of who we, the British, are, was becoming rather self-congratulatory, bearing messages about what wonderful sportsmen we are, how impressively multi-racial we are, and so on. It would be my job to show the other side of the coin. For Sport, I made a beer-bellied, boot-headed football hooligan. I showed us as couch potatoes, watching a vomiting television, clutching a remote control and beer can, while we became part of the fabric of our armchairs. British Comedy, which I consider to be very scatological and *Carry On*, was a laughing lavatory, with boob eyes, condom hat, lavatory brush in one hand, sausage in the other and, naturally, trousers down.

Jenny Page rang me soon after the Dome opened. 'It's absolutely ghastly,' she said, 'British Comedy burnt down in the night.' I later learned that when Special Branch were checking the Dome for bombs before the arrival of Tony Blair at the Millennium Eve party, one of them had peered into British Comedy's lavatory-pan face and dislodged the seat, creating an electrical fault. Later, this short caused the laughing lavatory to burst into flames. 'Yes, it's terrible,' Jenny went on. 'It's been taken away to be repaired, so – have you got another sculpture to put in its place? It's too embarrassing to have a gaping space in the Self-Portrait Zone?' 'Well,' I said, after some thought, 'I have got a rhino . . .' 'Splendid!' she said. 'Can we have it?' 'But what', I asked, 'has a rhino got to do with the British character?' 'Never mind about that. We can't have an empty space.' And so there the full-size Chichester rhino stood for the following month. When I was in there one day, a respectable lady visitor asked me what it was doing there, and I told her the story. 'Oh,' she said, 'I thought it meant that we, the British, are thick-skinned and horny.'

Opposite: The Thug: sculpture for the Dome (leather and metal).

Top left: British Comedy: sculpture for the Dome (cloth and metal).

Top right: The Burden: sculpture for the Dome, depicting life's burdens – the law, the Church, fat cats etc. Twenty feet tall (polystyrene and cloth).

Above left: The Couch Potato: sculpture for the Dome (plastic and cloth).

Above right: P-Y Gerbeau, who had replaced Jenny Page at the Dome, in front of Traditional Cool Britannia – with the Queen as a lion and Tony Blair as a unicorn.

The Racist: sculpture for the Dome. Beneath this apparently normal urban
gentleman lies the monster. Nine-foot figure (cloth and aluminium).

DOME BRIC-A-BRAC SALE

Dome Bric-a-Brac Sale: Lord Falconer (the minister with responsibility for the Dome), Tony Blair, Peter Mandelson (GS's collection). The Dome closed at the end of the year and the contents were sold off.

The Sower – Monsanto: Seen as the place where people have manipulated nature to create Frankinfoods. *New Yorker*, 10 April.

Sing-a-Long-a-Sound of Music at the Prince Charles Cinema, London: a camp cult Dadaist happening in the Tottenham Court Road. The theatre was a place of pilgrimage for *Sound of Music* fanatics – the film had played there for over three years. Many of the audience, including men, came dressed as nuns, some with guitars; and some as shapeless brown paper packages tied up with string. I heard about one, who came in a bright yellow skin-tight lycra suit. He puzzled people and when asked who he was, replied, 'I'm Ray, a drop of golden sun.'

New Yorker, 14 February.

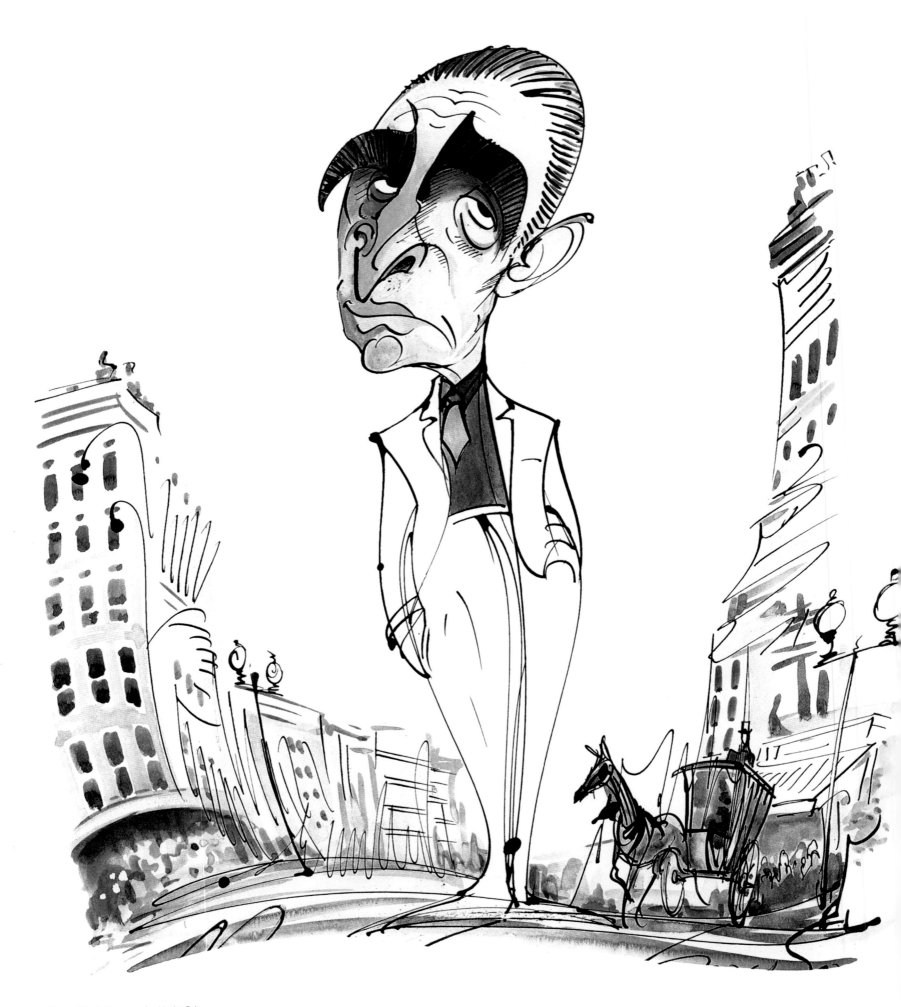

Above: Martin Scorsese for *Vanity Fair*.
Opposite: The Wolf's head from the *Peter and the Wolf* ice-show. I was the costume designer for this Holiday On Ice show in Paris.

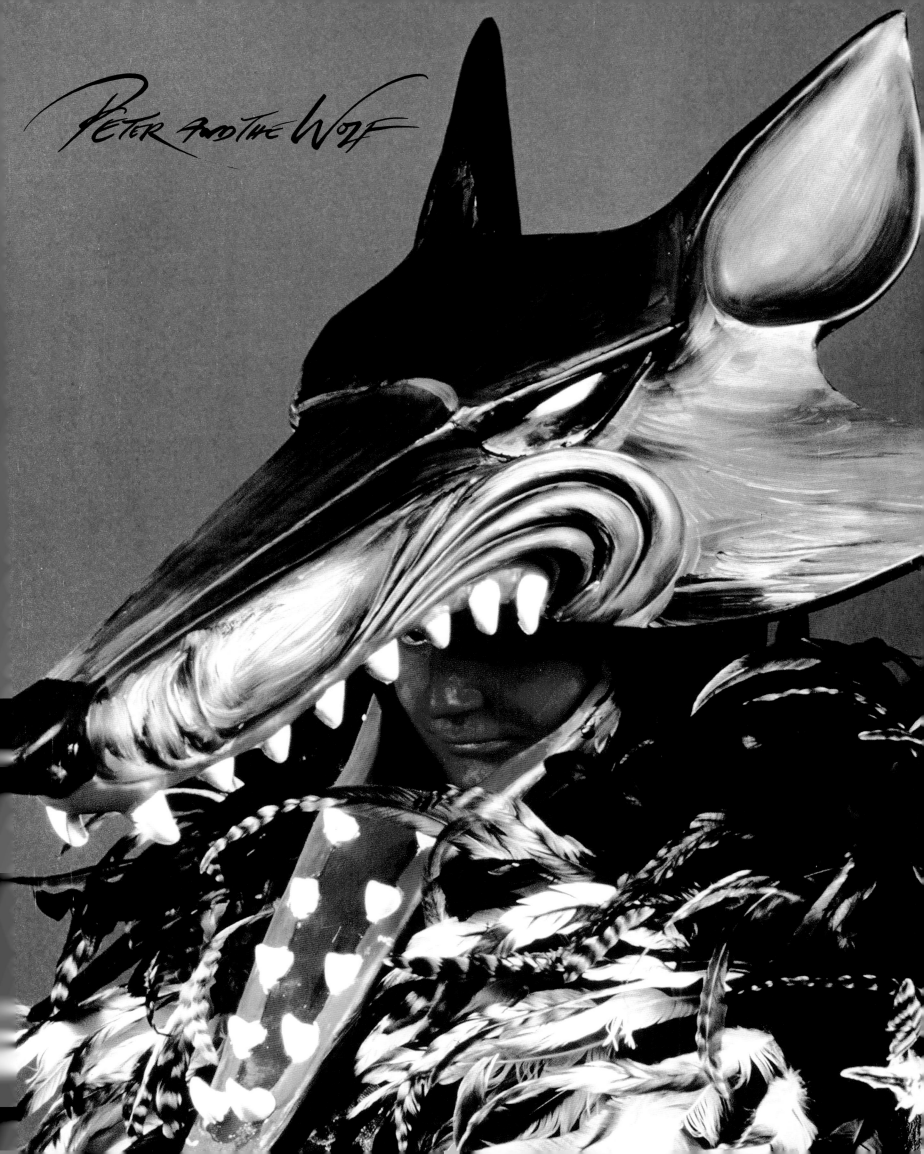

BUSH ARRIVES!
THEN Afghanistan

Six montage drawings of
George W. Bush.
Above: How It All Began – Bush is
elected: *Sunday Times*, 21 January.
Top centre: Hearts and Minds – Bush
and Blair: *Sunday Times*, 14 October.
Top Right: The Maze – Blair enters
Afghanistan: *Sunday Times*, 28
October.
Below left: The Dove Returns – Blair
and Bush: *Sunday Times*, 4 November.
Below centre: The Puzzle – Bush and
Afghanistan: *Sunday Times*, 18
November.
Below right: Afghanistan aftermath:
Sunday Times.

9·11

I saw the World Trade Center disaster on television as it happened. At first, I felt I was watching a disaster movie and then couldn't believe what I was seeing. I felt inadequate when I tried to sum it up on paper.

Right: Twin towers (GS's collection).
Below: September 11th – America's Heart Torn
Asunder: *Sunday Times*, 16 September.

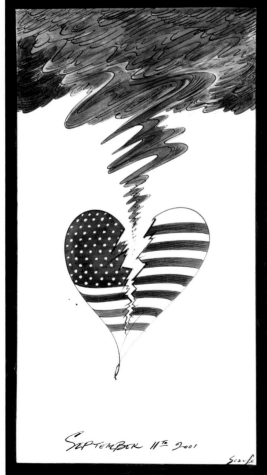

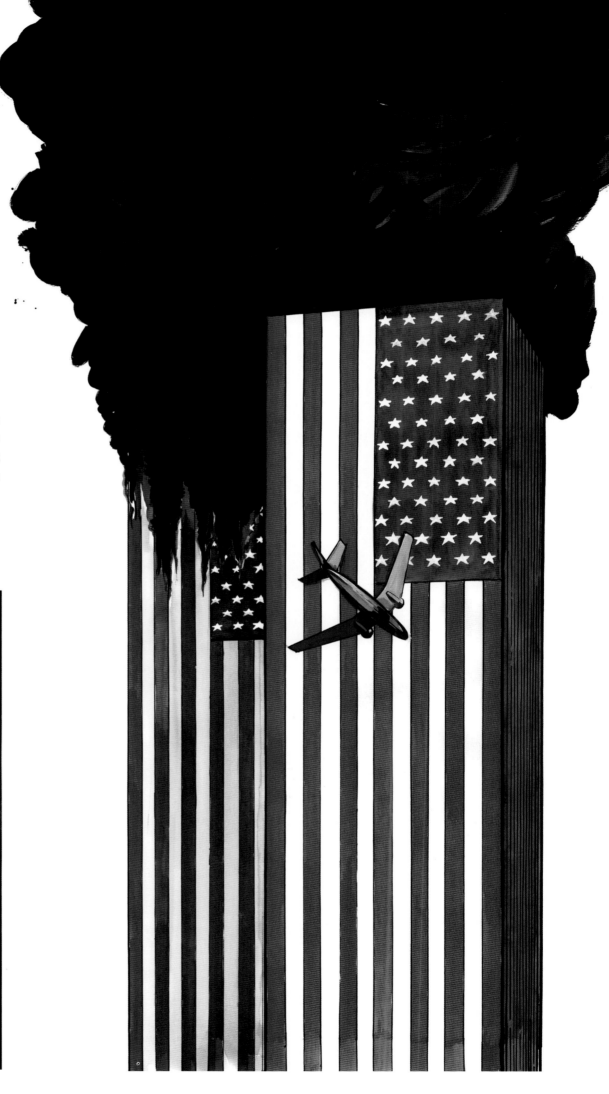

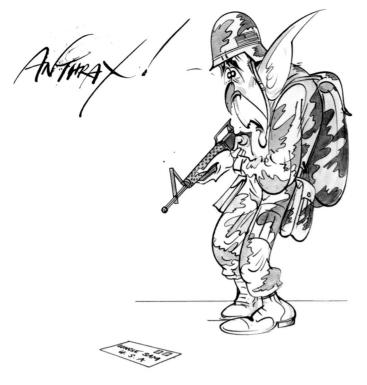

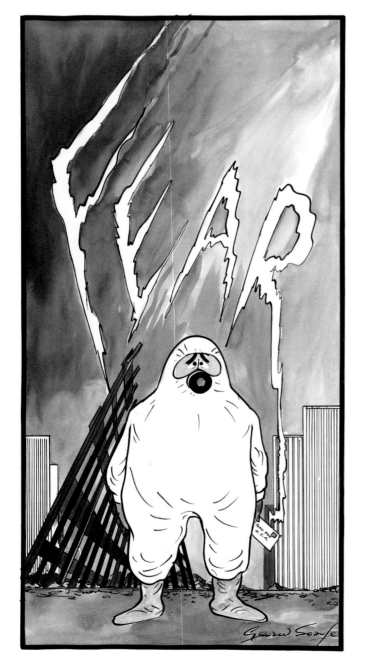

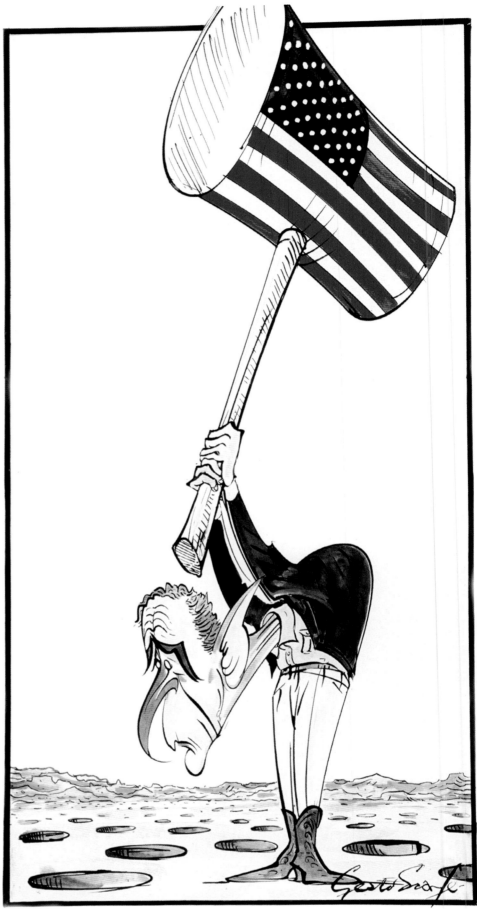

Above left: Anthrax! (GS's collection).

Left: Fear on the Streets of New York (GS's collection).

Above: Looking for Osama – George Bush: *Sunday Times*, 23 September.

Opposite: New England couple in gas masks: *Sunday Times*, 21 October.

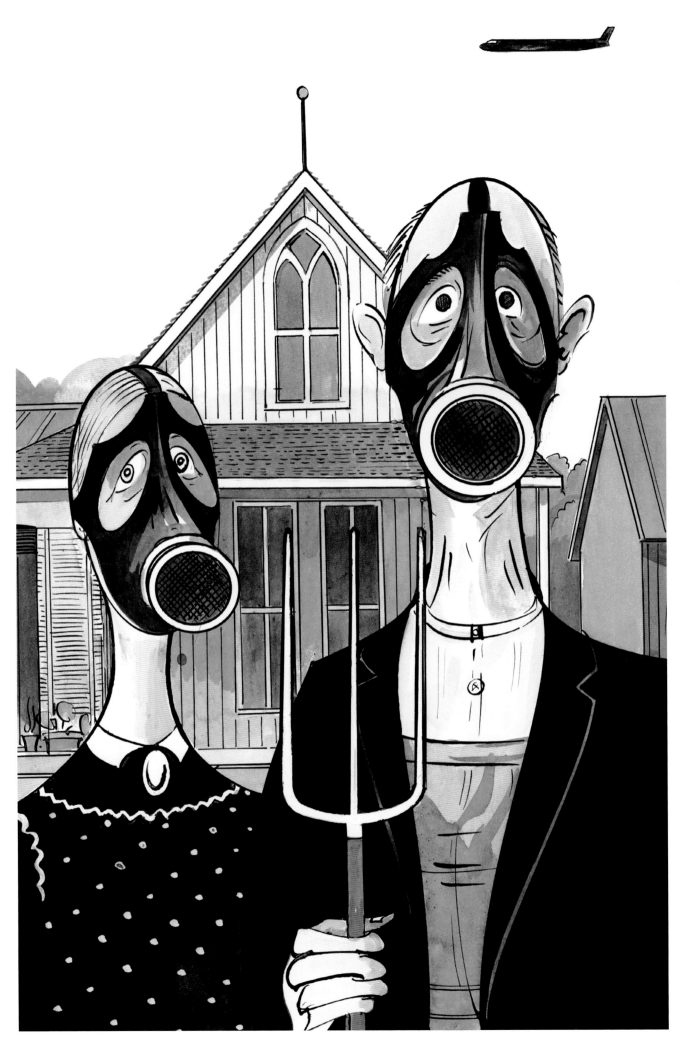

311 two thousand and one

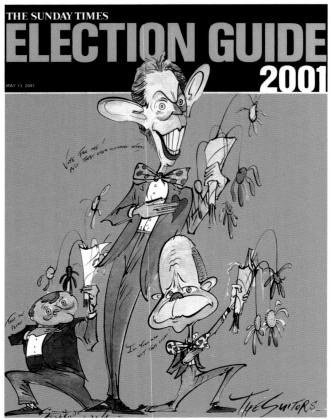

Above: Election Guide 2001 – Blair, Hague and the Liberal Democrats' Charles Kennedy: *Sunday Times*, 13 May.

Blair had announced that McDonald's would be funding the Labour Party Conference.

Right: Silly Burger – Blair as Ronald McDonald: *Sunday Times*, 9 September.

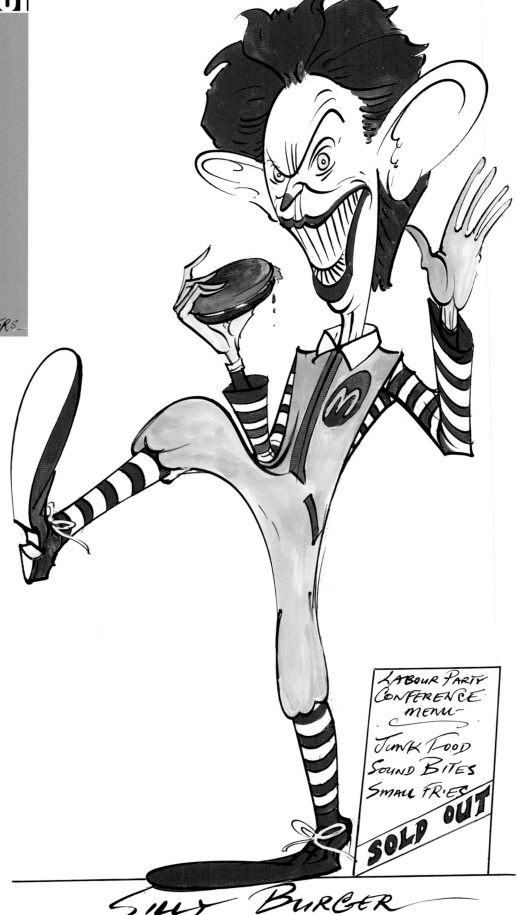

LABOUR PARTY
CONFERENCE
MENU-

JUNK FOOD
SOUND BITES
SMALL FRIES

SOLD OUT

SILLY BURGER

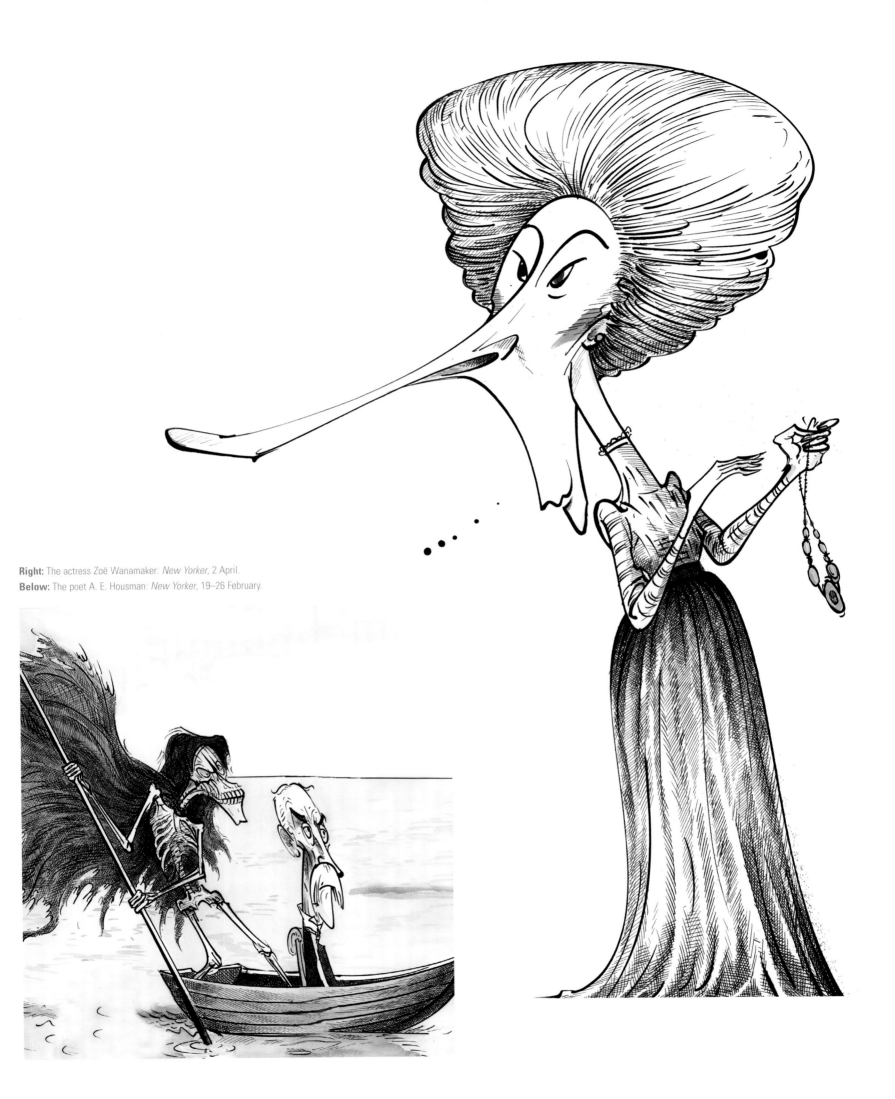

Right: The actress Zoë Wanamaker: *New Yorker*, 2 April.
Below: The poet A. E. Housman: *New Yorker*, 19–26 February.

2002

The Nutcracker

My first ballet, *The Nutcracker* for the English National Ballet, was, I reasoned, for children as well as for ballet fans. I thought that if I could make it entertaining for my five-year-old granddaughter Ella, I would have achieved success on at least one level. I made it colourful and fun, hoping to introduce a young audience to the world of ballet. I had soldiers landing by parachute, snowflakes jumping out of a fridge, Grandpa dancing with his zimmer frame, and terrorist mice that live in a giant fruitcake.

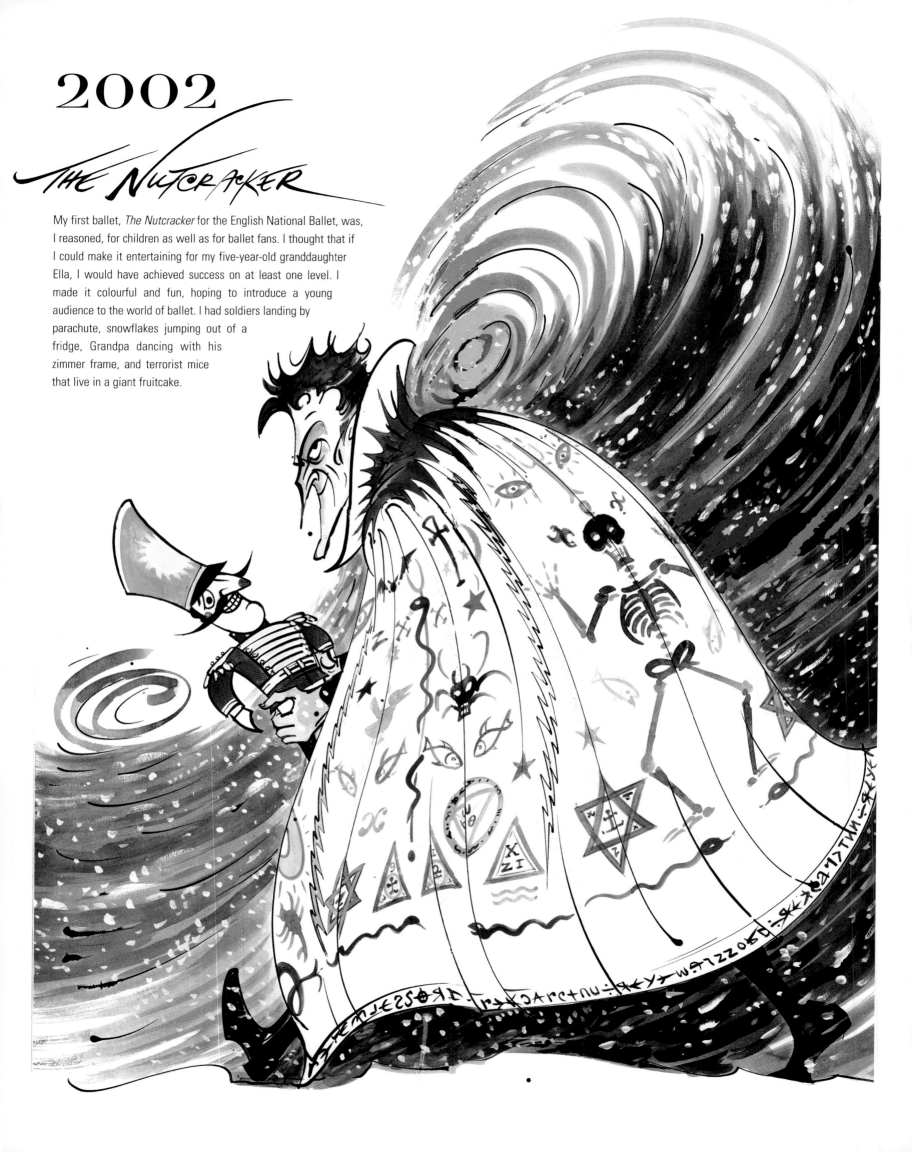

Clara and Fritz found themselves in their parents' drawing room on the evening of a wonderful Christmas party.

A glittering array of guests began to arrive...

The curtain goes up to reveal, centre stage, a gigantic copy of E. T. A. Hoffmann's book. Drosselmeyer opens the first page and from the centre of the illustration dance characters from the ballet. Pages form back-cloths, and a large origami bird made from a torn page flies, with the Prince and Clara, to the world of sweets and ice-creams to meet the Sugar Plum Fairy.

Far left: Character designs for *The Nutcracker*: two sketches for the Brigadier, the Party-goer, the Mime, Uncle Ted and a Mirliton. As with *Hercules*, these characters were not in the original and therefore had to be invented by the designer.
Above: Two back-cloth designs for *The Nutcracker*, featuring Miss V. Agra, Grandpa, the Bishop, Agnes and the Brigadier.
Below: *The Nutcracker*: ensemble photograph.
Opposite: *The Nutcracker*: design for the magician Drosselmeyer's cloak.

315 two thousand and two

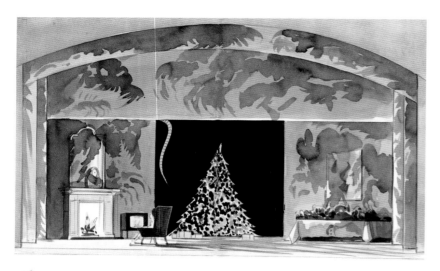

FIRST APPEARANCE OF THE MICE
MENACING SHADOWS ON ALL WALLS·BORDERS ETC·
ENORMOUS FLESHY RATS TAIL DROPS FROM ABOVE
SECOND TAIL UNDER TABLE·?

THE TREE GROWS + MIRROR BALL EFFECT
BLAZE OF LIGHT
THE TREE CONTAINS MANY MANY REFLECTIONS
LIGHTS · FACETED GLASS · SEQUINS · ETC·

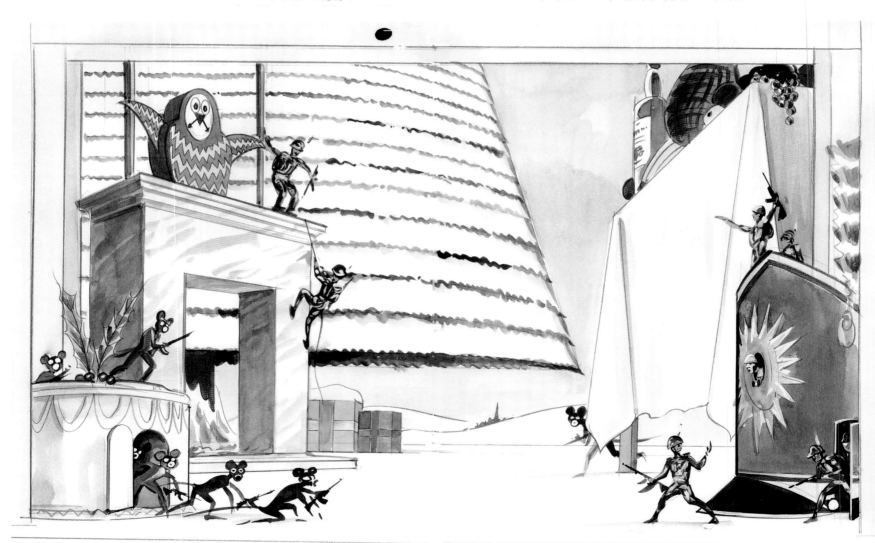

SOLDIERS IN THE HAT

Three set designs for *The Nutcracker*:

Top left: The dining room at night – the mice appear.

Top right: The Christmas tree glows and grows.

Above: The battle between the mice and the soldiers.

I thought it much more fun and memorable for the snowflakes to come out of a fridge, rather than having them leap from the wings.

Above: Set design for the snowflake scene from the *The Nutcracker*.

Left: *The Nutcracker*: a snowflake leaps out of the fridge while Drosselmeyer holds the door. It's an upmarket fridge, containing lobster and champagne.

Below: Nutcracker! First-night card from *The Nutcracker*.

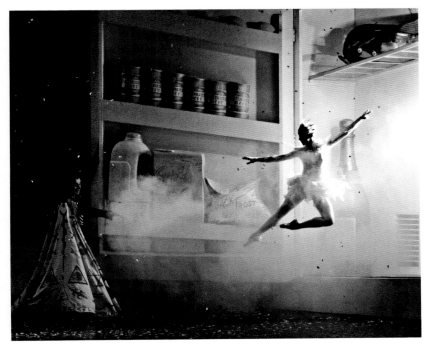

CRACK A NUT!

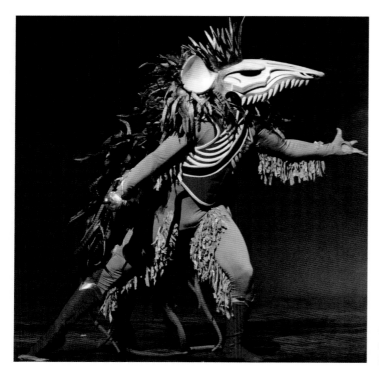

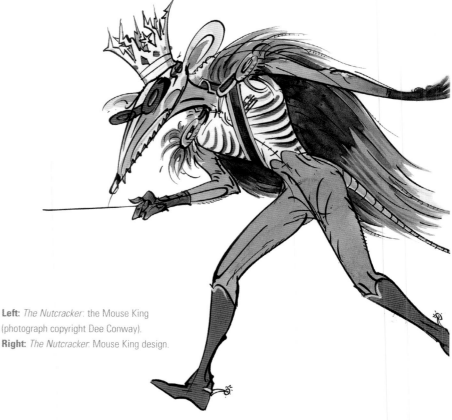

Left: *The Nutcracker*: the Mouse King (photograph copyright Dee Conway).
Right: *The Nutcracker*: Mouse King design.

The *Independent* newspaper had the headline 'Outrage as Gerald Scarfe Turns *The Nutcracker* into a Tale of Terrorism'. The article read:

The children's ballet The Nutcracker *has been given a controversial makeover by the caricaturist Gerald Scarfe – featuring an attack by 'terrorist' mice armed with Kalashnikov rifles. The reworking is causing outrage before it has even been staged. A spokesman for ENB denied that the new production would frighten children, pointing out that the guns were clearly plastic and loaded with nothing more sinister than champagne corks.*

The Independent on Sunday | 22 September 2002

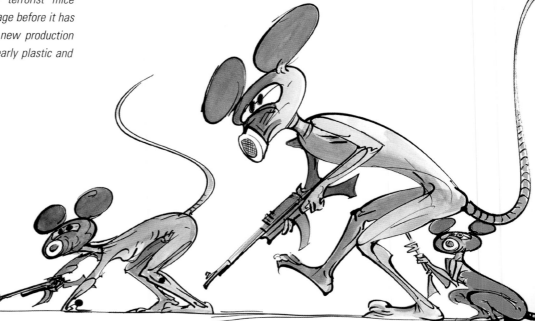

Outrage as Gerald Scarfe turns 'The Nutcracker' into a tale of terrorism

By James Morrison
Arts and Media Correspondent

The children's ballet *The Nutcracker* has been given a controversial makeover by the caricaturist Gerald Scarfe – featuring an attack by "terrorist" mice armed with Kalashnikov rifles.

The reworking is causing outrage before it has even been staged. The Tory

opposed to the trend towards "modernising" time-honoured classical favourites.

A spokesman for ENB denied that the new production would frighten children, pointing out that the guns were clearly plastic and loaded with nothing more sinister than champagne corks.

"There's nothing gratuitous about it," he said

recall terrorists in *The Nutcracker* before. I woul want to be assured that it isn't just being done for shock value, rather than artistic merit. If it is a sho interpretation I hope the will make it absolutely cl in their advertising.

"There will be a lot of parents wanting to take th children and they will be very upset if they are

CRITICS CIRCLE

Some critics were desperately upset by what I had done to their darling *Nutcracker*. This is my revenge on carping ballet critics.

(GS's collection)

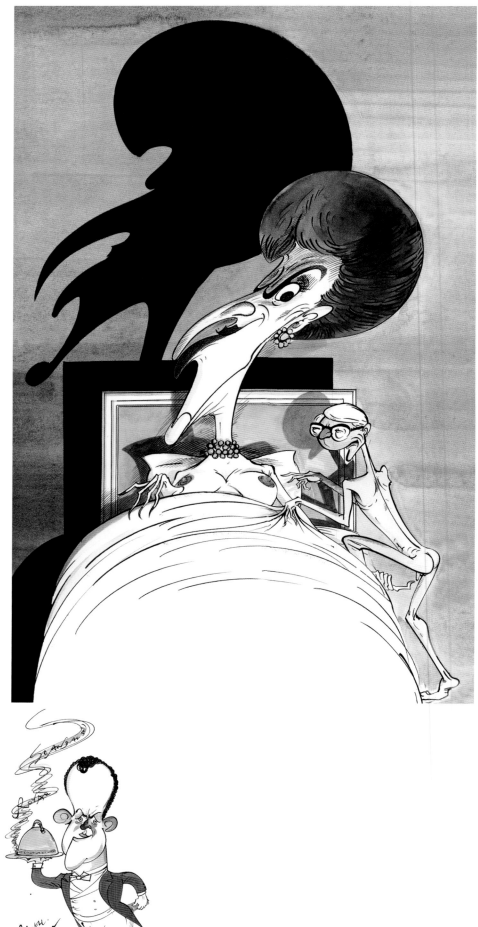

THE SURPRISE WITNESS -

Above: A Ghastly Thought – John Major and
Edwina Currie (GS's collection).
Far left: The Queen suddenly remembered that she had
asked Paul Burrell to look after some of Princess Diana's
belongings: *Sunday Times*, 3 November.
Left: The Butler Done It – Paul Burrell (GS's collection).

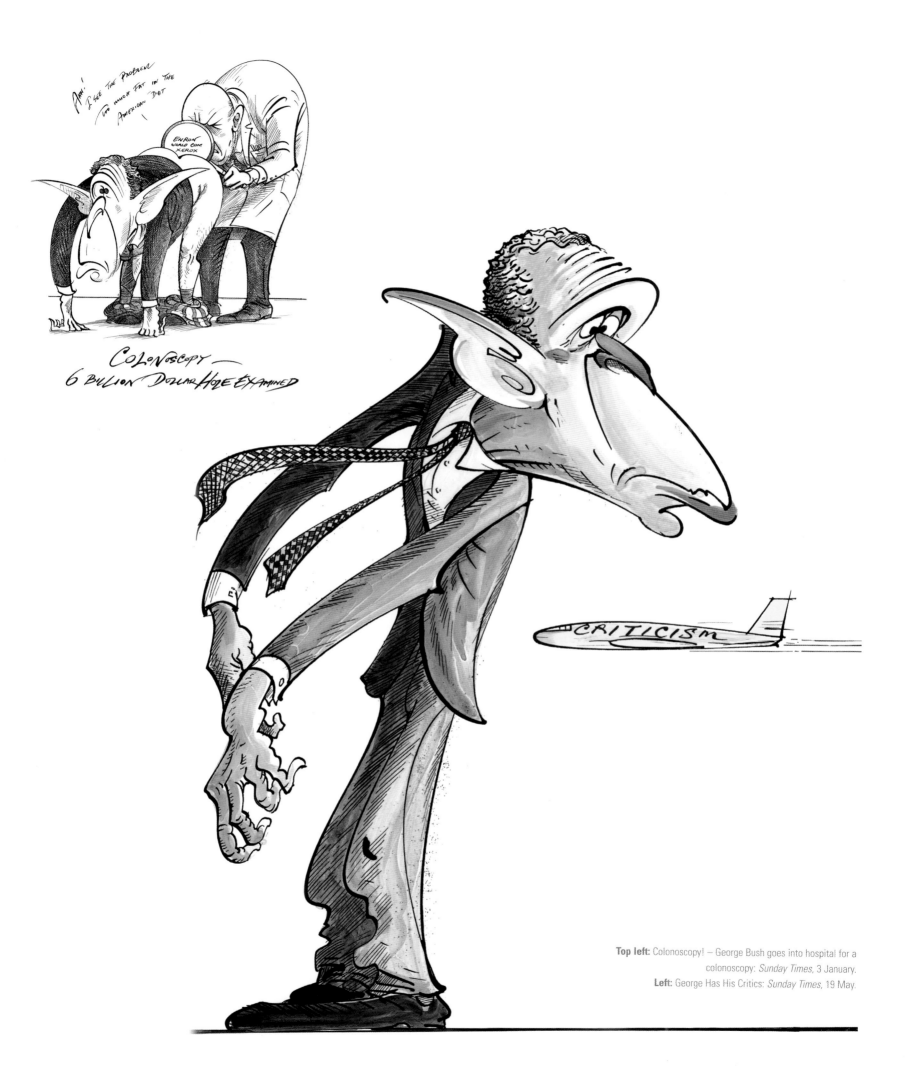

Ahh! I SEE THE PROBLEM TOO MUCH FAT IN THE AMERICAN DIET

EN RON
WORLD COM
XEROX

COLONOSCOPY —
6 BILLION DOLLAR HOLE EXAMINED

CRITICISM

Top left: Colonoscopy! — George Bush goes into hospital for a
colonoscopy: *Sunday Times*, 3 January.
Left: George Has His Critics: *Sunday Times*, 19 May.

2003

Is she being raped or is she going along with it? This drawing was produced for a BBC TV documentary about GS, called *Drawing Blood*.

Right: The Princess of Wales and the Press (GS's collection).

Princess Diana: from *Heroes & Villains*, an exhibition at the National Portrait Gallery that juxtaposed portraits from its collection with caricatures by the author. The Princess's pure white dress is sullied by her association with the pigs of the press.

Below: Live by the Sword, Di by the Sword from *Heroes & Villians*.

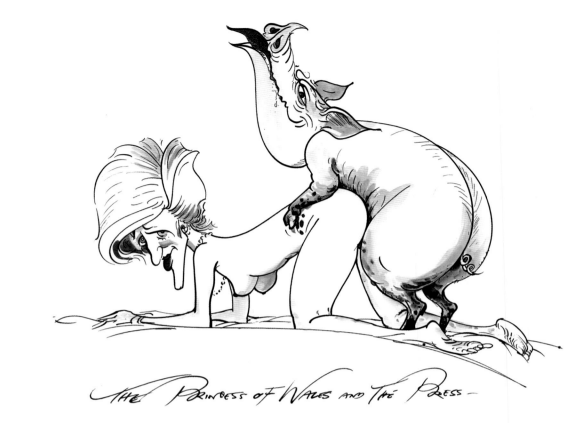

THE PRINCESS OF WALES AND THE PRESS

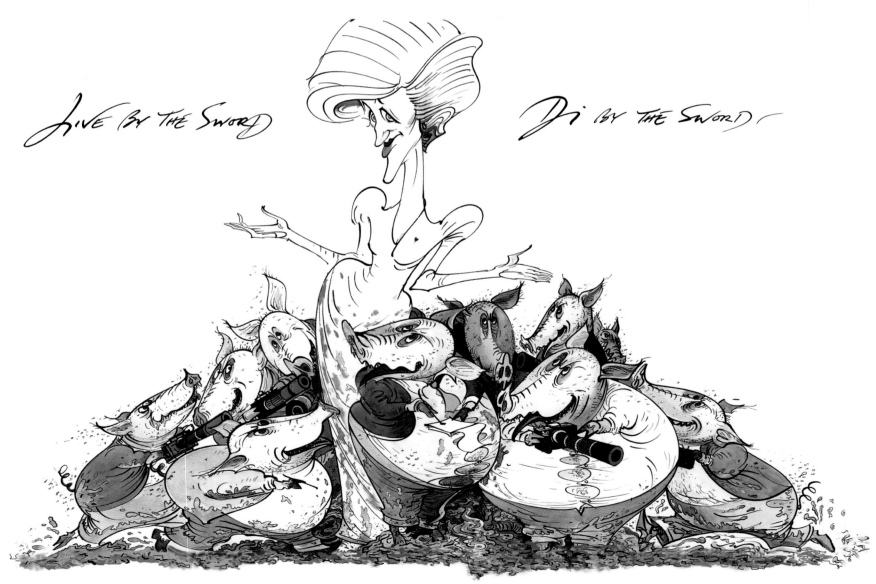

LIVE BY THE SWORD Di BY THE SWORD

Charles mentioned this possibility for a future existence during a phone call that was, unfortunately for him, overheard by a radio ham.

Below: Charles and Camilla for the BBC documentary *Drawing Blood* (GS's collection).
Right: Horribilis – Her Majesty the Queen (GS's collection).

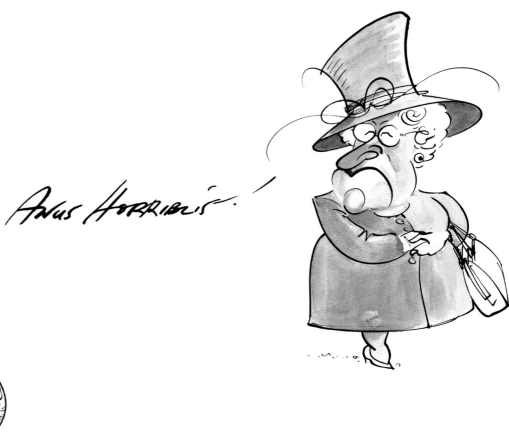

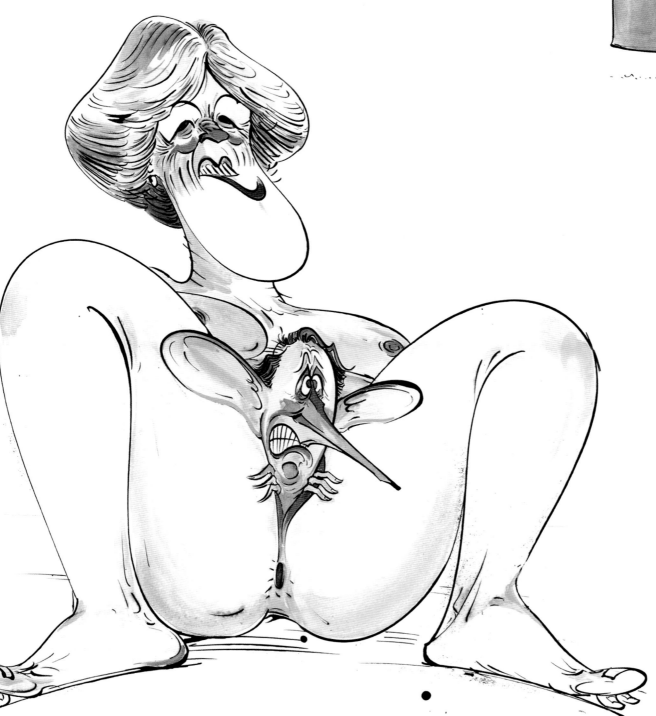

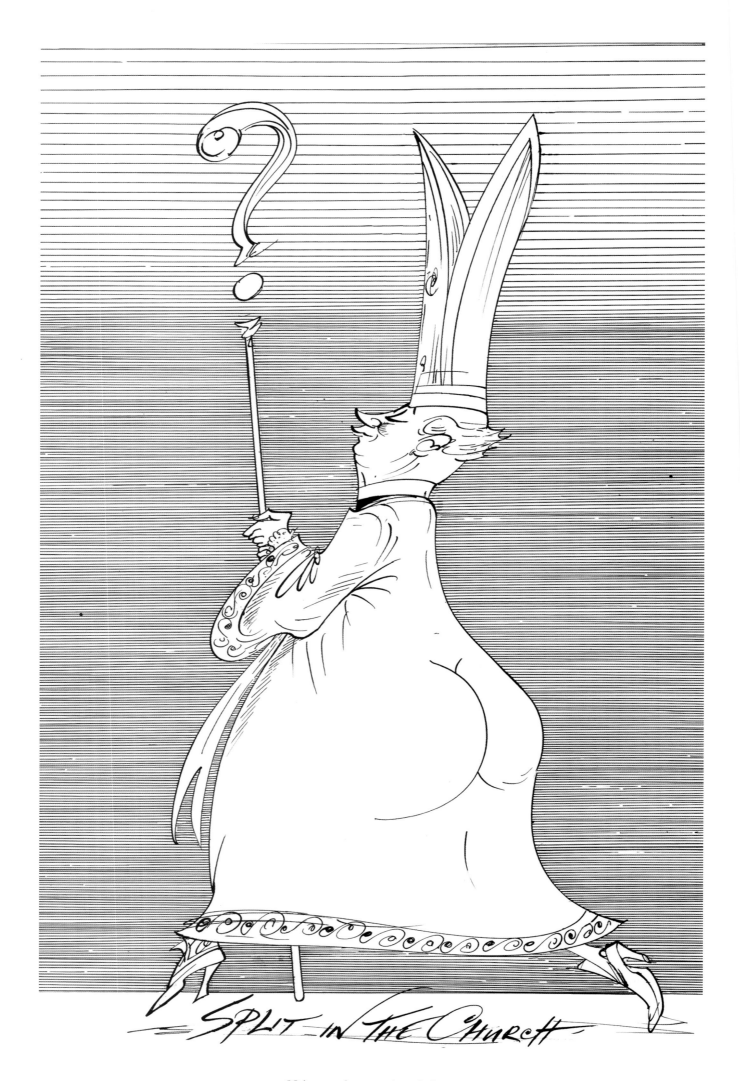

SPLIT IN THE CHURCH

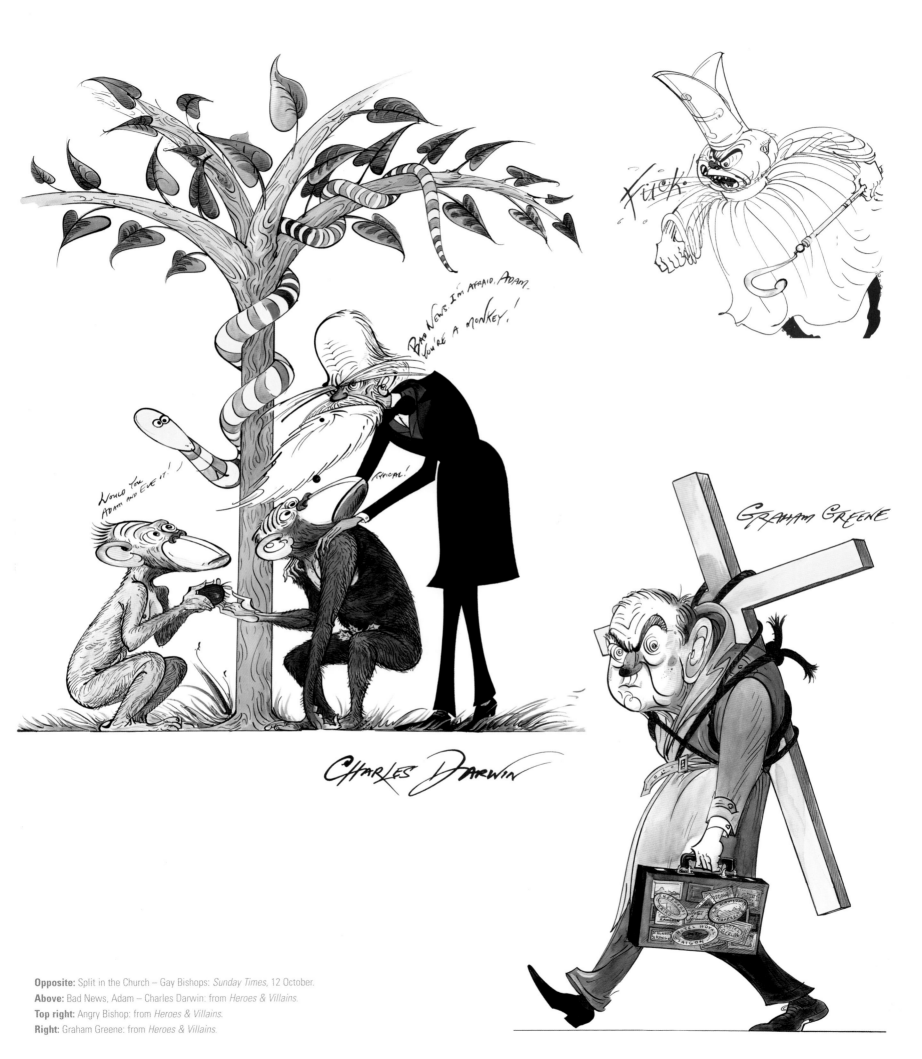

Opposite: Split in the Church – Gay Bishops: *Sunday Times*, 12 October.

Above: Bad News, Adam – Charles Darwin: from *Heroes & Villains*.

Top right: Angry Bishop: from *Heroes & Villains*.

Right: Graham Greene: from *Heroes & Villains*.

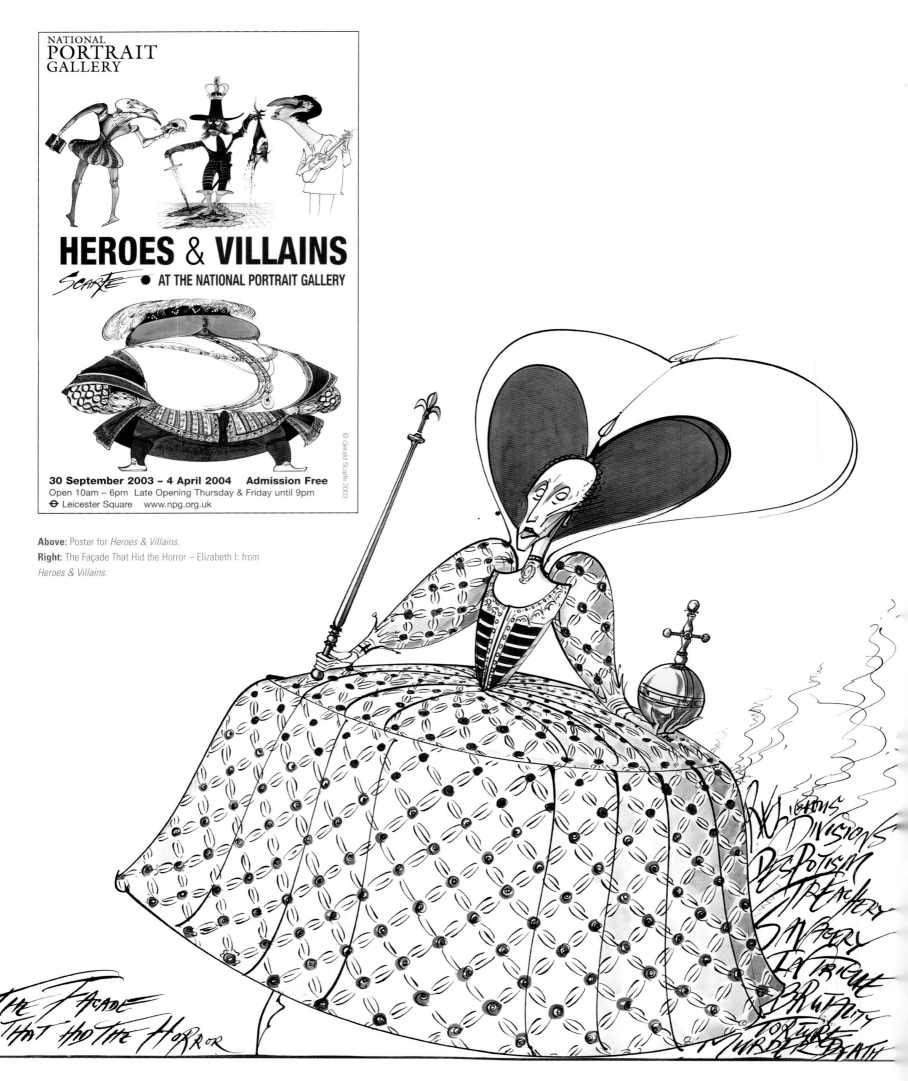

Above: Poster for *Heroes & Villains*.
Right: The Façade That Hid the Horror – Elizabeth I: from *Heroes & Villains*.

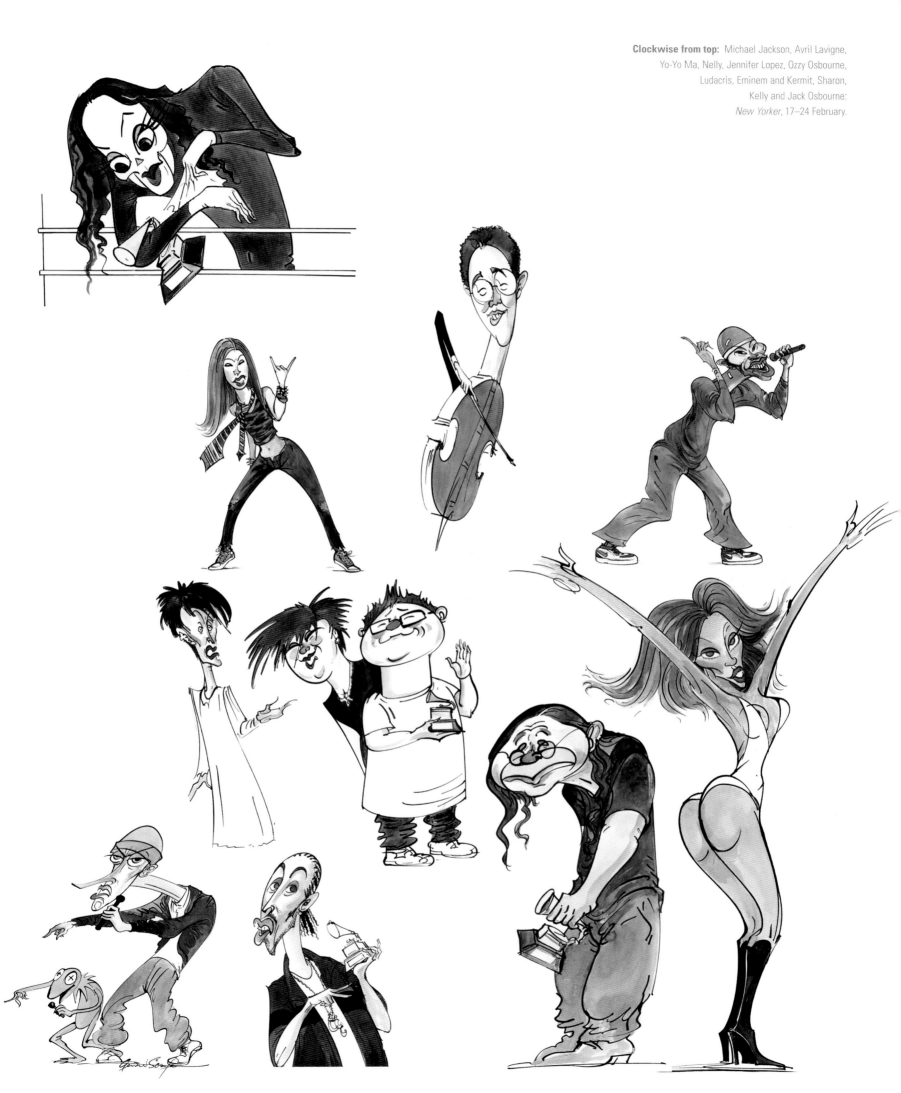

Clockwise from top: Michael Jackson, Avril Lavigne, Yo-Yo Ma, Nelly, Jennifer Lopez, Ozzy Osbourne, Ludacris, Eminem and Kermit, Sharon, Kelly and Jack Osbourne: *New Yorker*, 17–24 February.

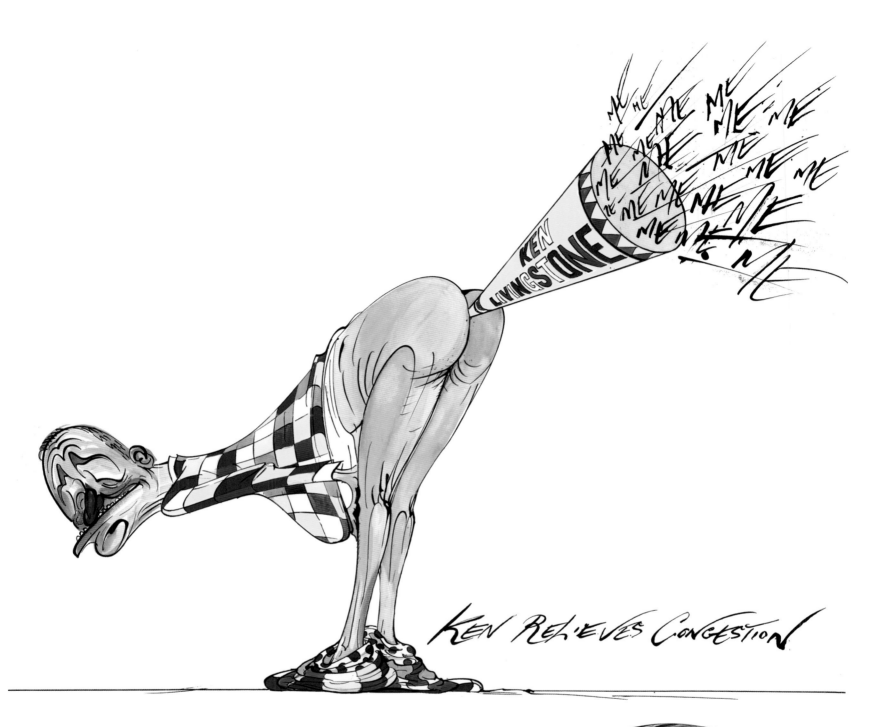

Above: Ken Relieves Congestion – the Mayor of London Ken
Livingstone: from *Heroes & Villains*.
Right: Hector Berlioz: *New Yorker*, 31 March.

I showed this drawing to Tracey, and she was appalled. 'Oh no!' she said. 'Not on the loo!' 'But Tracey,' I said, 'you live your whole life in public; your whole artistic life is concerned with your lovers, your abortions and other intimate details.' 'I know,' she said, 'but on the loo! It's *so* private. I wouldn't have minded', she added, 'being seen throwing up in the loo.'

Above: Me in the Fucking Shithouse – the artist Tracey Emin: from *Heroes & Villains*.
Right: Couch Potato – John Logie Baird: from *Heroes & Villains*.

OUT WITH THE OLD!......

AND... IN WITH THE OLD

THE LOST BITE

Above and right: Michael Howard: *Sunday Times*.

BUSH COMES TO TOWN

Onward Christian soldiers – Bush and Blair: *Sunday Times*.

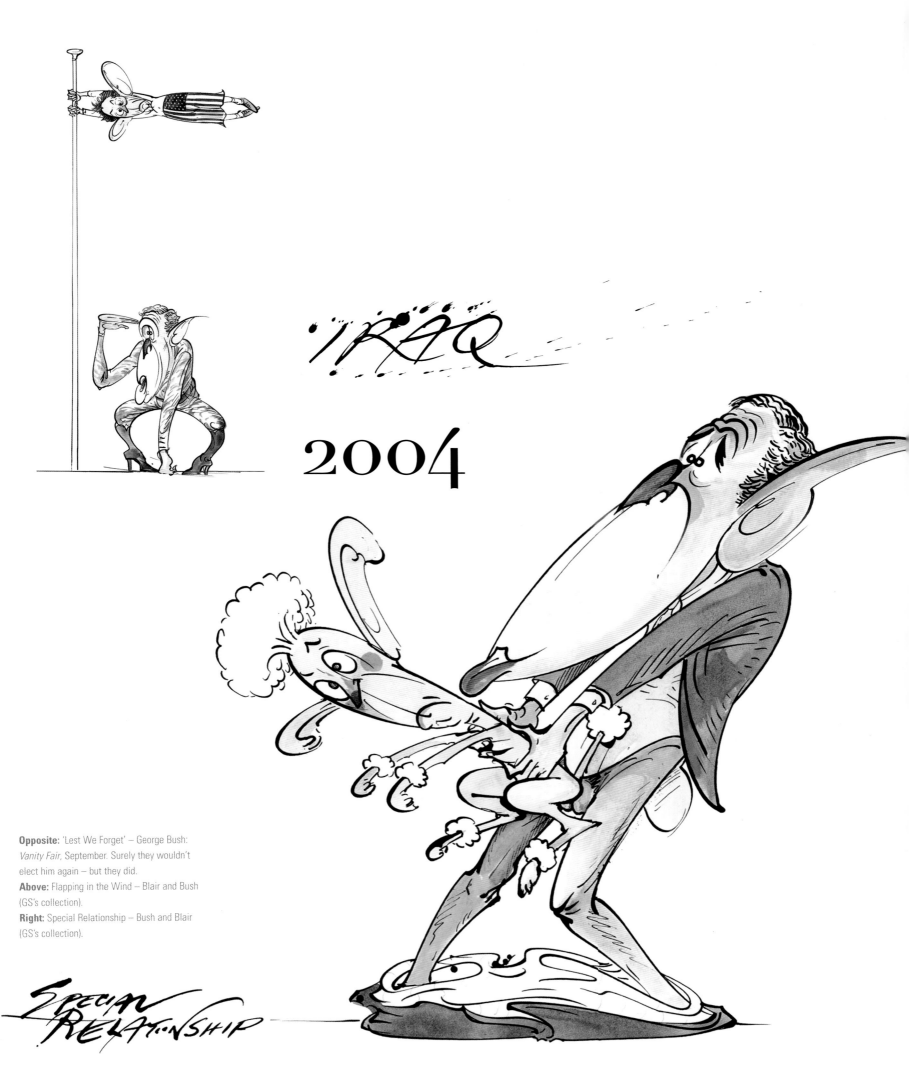

IRAQ

2004

Opposite: 'Lest We Forget' – George Bush:
Vanity Fair, September. Surely they wouldn't
elect him again – but they did.
Above: Flapping in the Wind – Blair and Bush
(GS's collection).
Right: Special Relationship – Bush and Blair
(GS's collection).

SPECIAL RELATIONSHIP

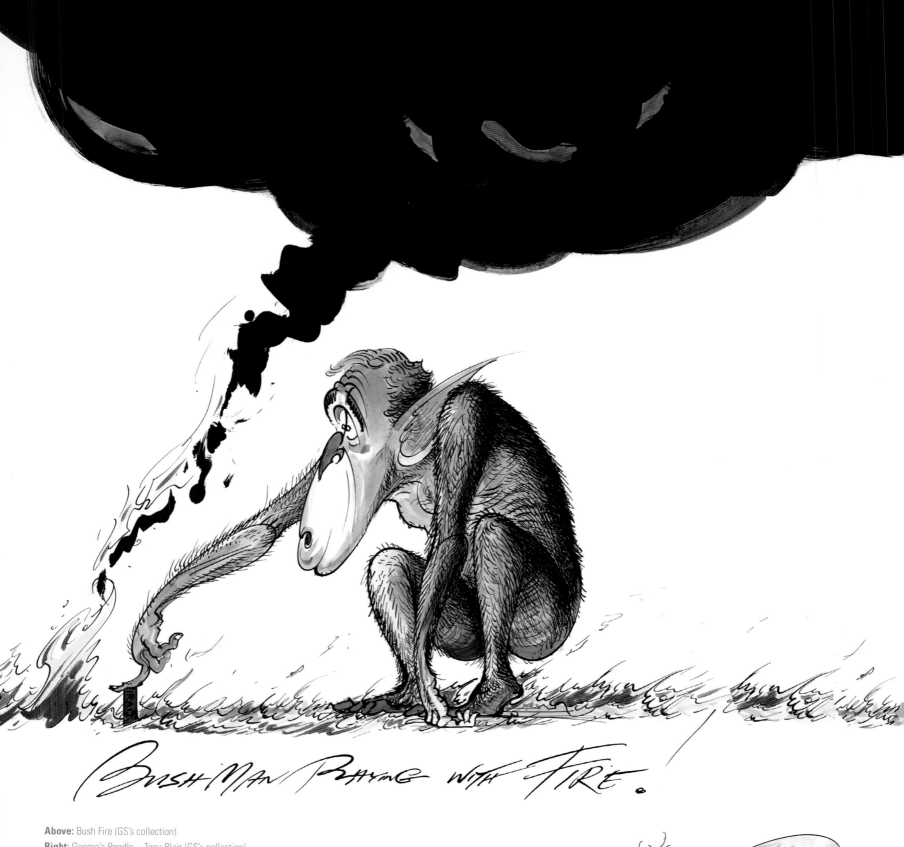

Bushman Playing with Fire.

Above: Bush Fire (GS's collection).
Right: George's Poodle – Tony Blair (GS's collection).

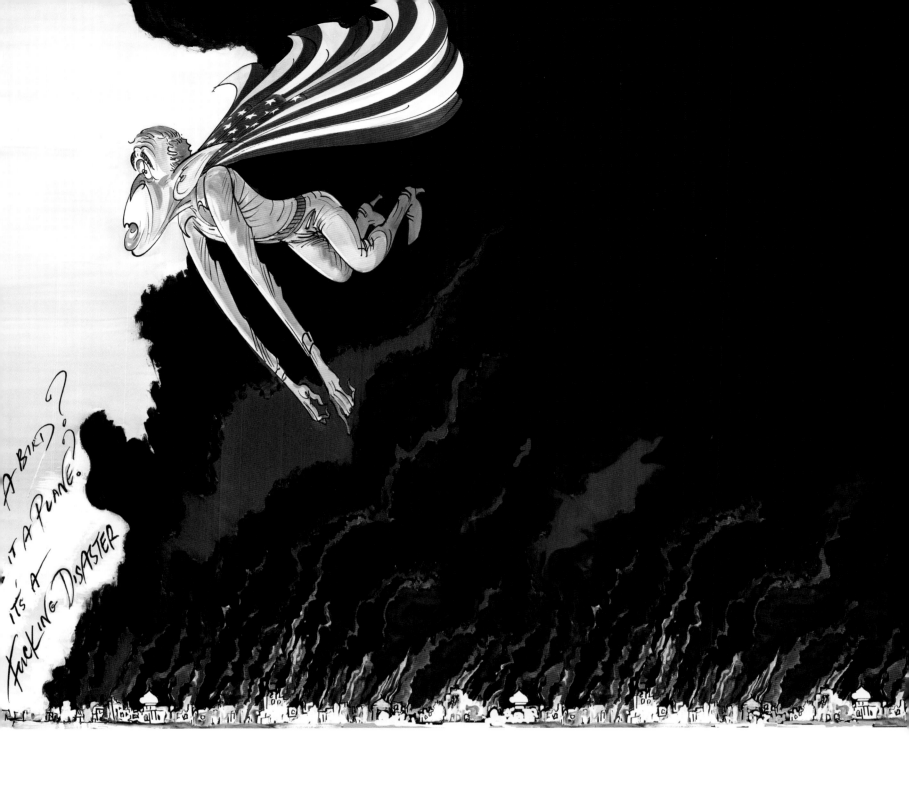

Above: Is It a Bird? – George Bush (GS's collection).
Right: Boy, Do I Need This – George Bush in Iraq (GS's collection).

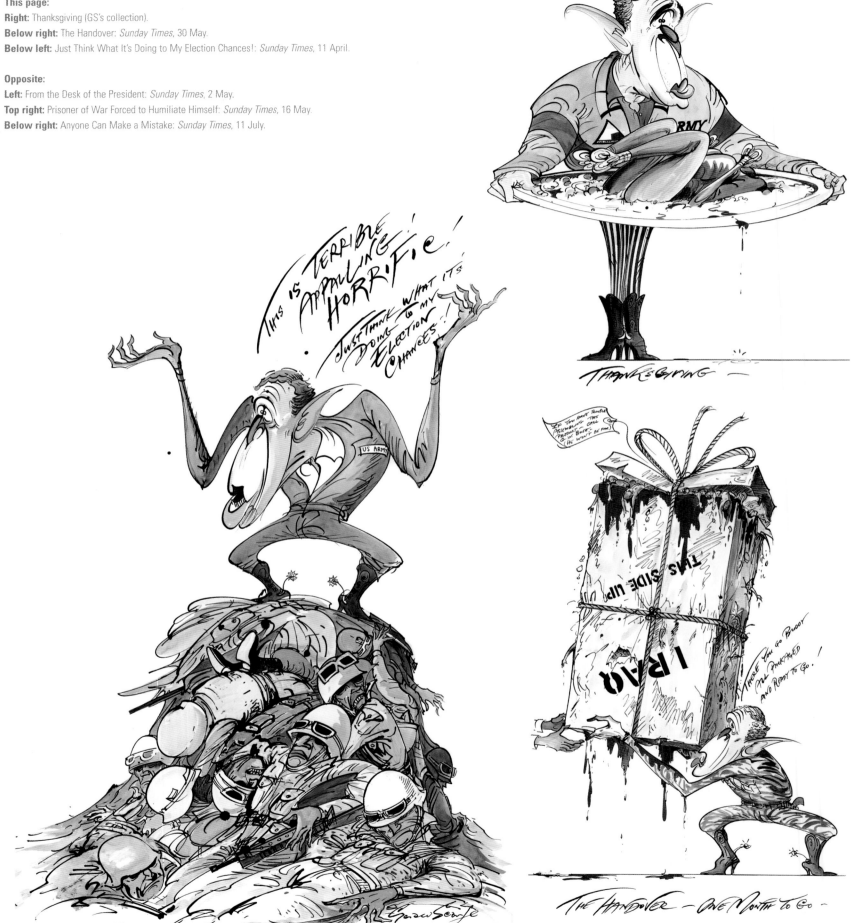

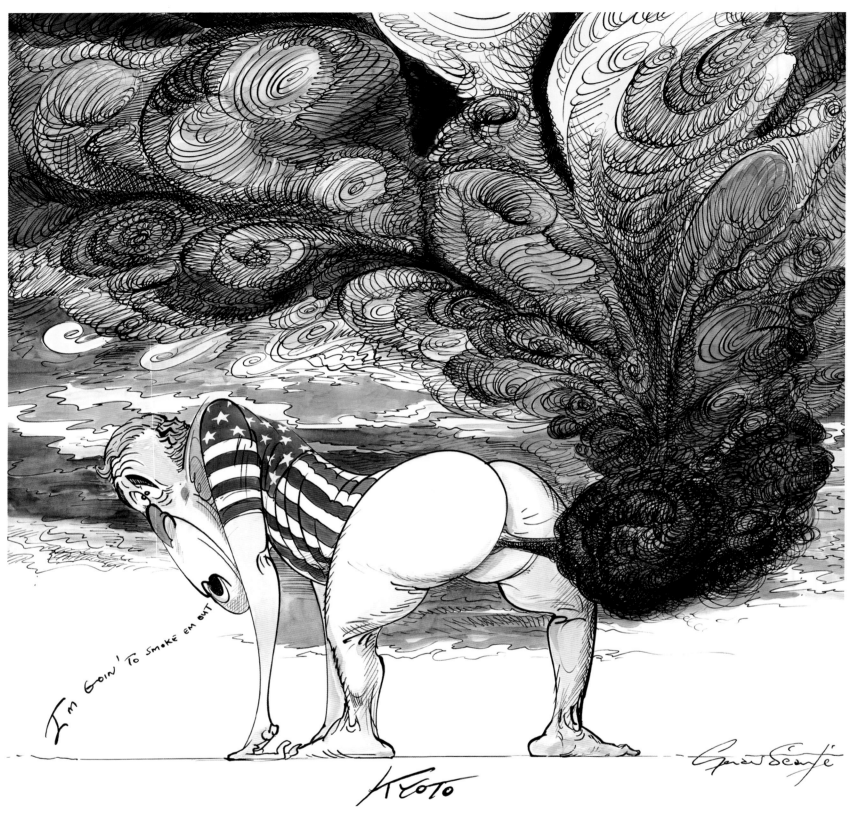

Above: I'm Goin' to Smoke 'Em Out – Bush and the Kyoto Protocol on climate change (GS's collection).
Right: You Looking for Trouble, Arsehole? (GS's collection).

Above left: US elections 2004 – George Bush and John Kerry: *Sunday Times,* 31 October.
Above right: Guarding the President's Ass: *Sunday Times,* 24 October.
Below: Bush's Re-election – Born Again. Three versions – the one on the right was published:
Sunday Times, 7 November.

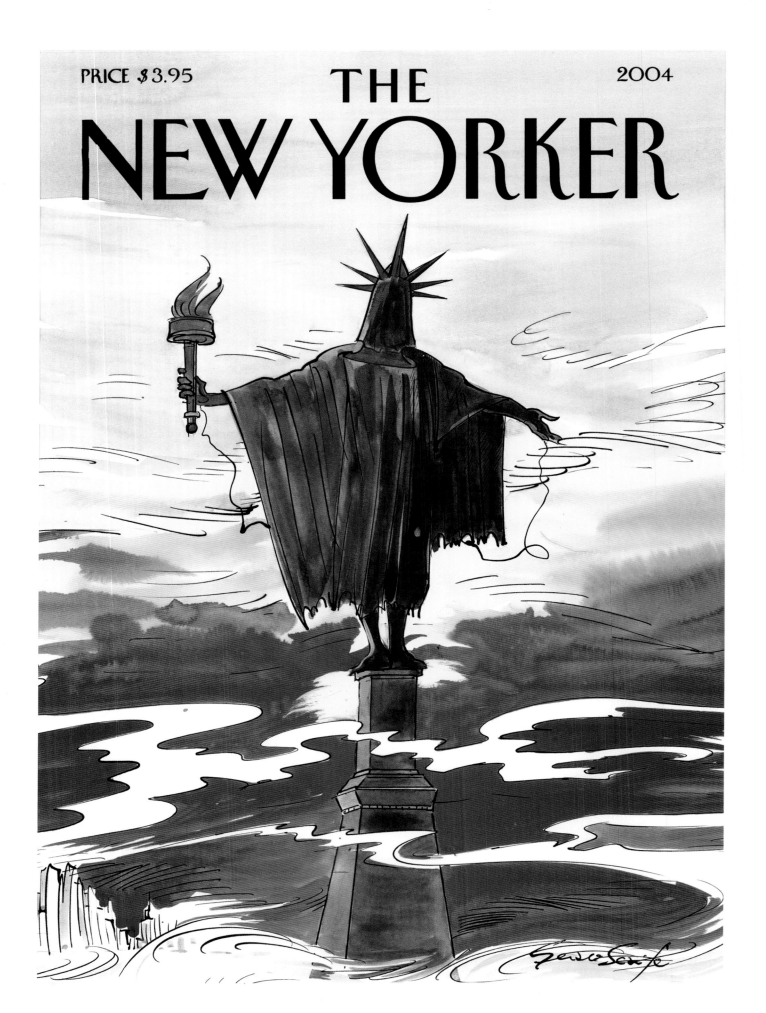

PRICE $3.95

THE NEW YORKER

2004

Above: Unpublished cover for the *New Yorker* (GS's collection)).
Opposite: Blood, More Blood – Mel Gibson and his film, *The Passion of the Christ*. *New Yorker*, 1 March.

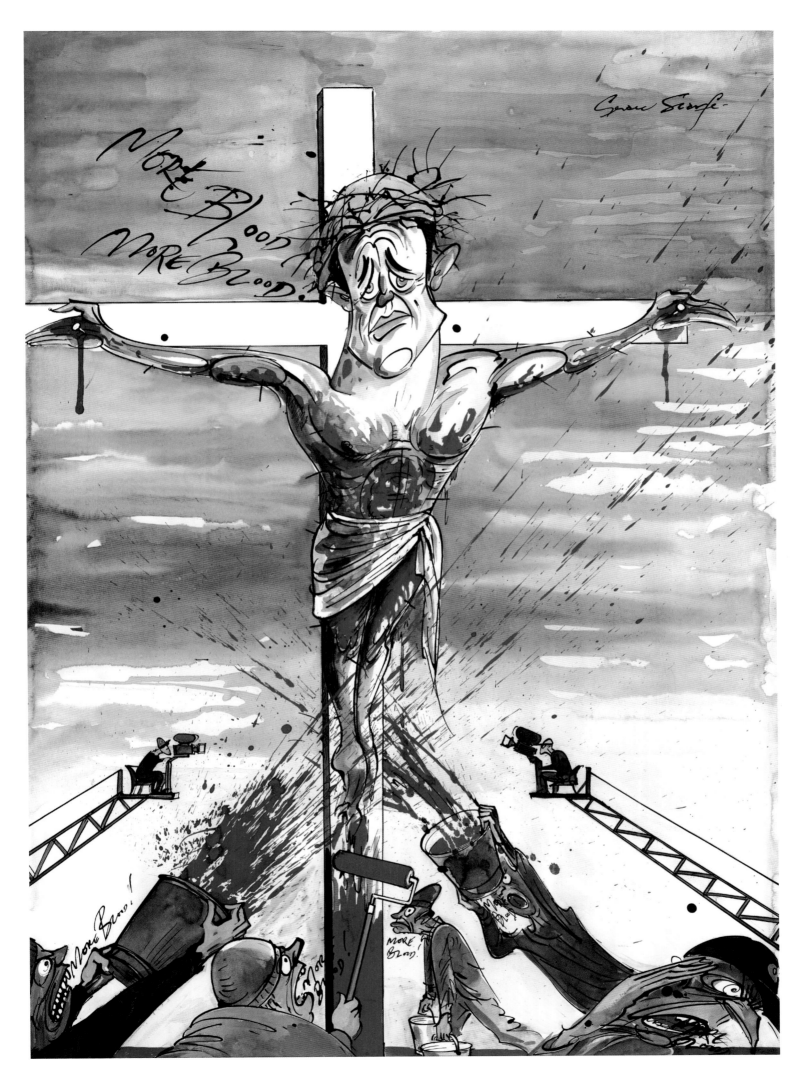

341 two thousand and four

Miss Saigon
The American Dream

Cameron Mackintosh rang me out of the blue, asking me to animate a small sequence for *Miss Saigon*. He wanted me to illustrate the song 'American Dream', in which the main character is a Saigon pimp who dreams of going to the United States, believing that all things there are bigger and better – bigger dollars, bigger tits and better everything.

Right: Screwing the Dollar: design for *Miss Saigon*, Claude-Michel Schönberg and Alan Boublil's reworking of Puccini's *Madame Butterfly*.
Below: Top strip: storyboard for animated sequence, showing the Statue of Liberty coming to life and doing a striptease. Bottom strip: the engineer pumps Miss America's breasts with silicone.

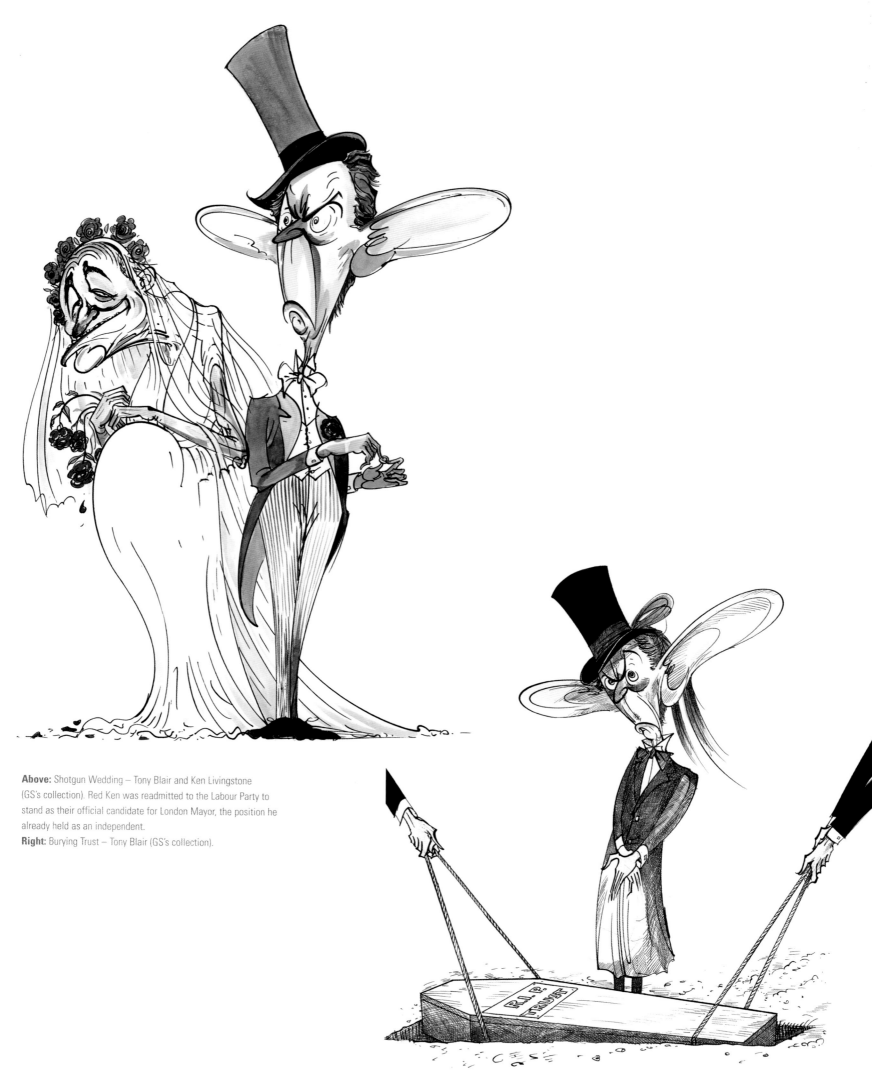

Above: Shotgun Wedding – Tony Blair and Ken Livingstone
(GS's collection). Red Ken was readmitted to the Labour Party to
stand as their official candidate for London Mayor, the position he
already held as an independent.
Right: Burying Trust – Tony Blair (GS's collection).

2005

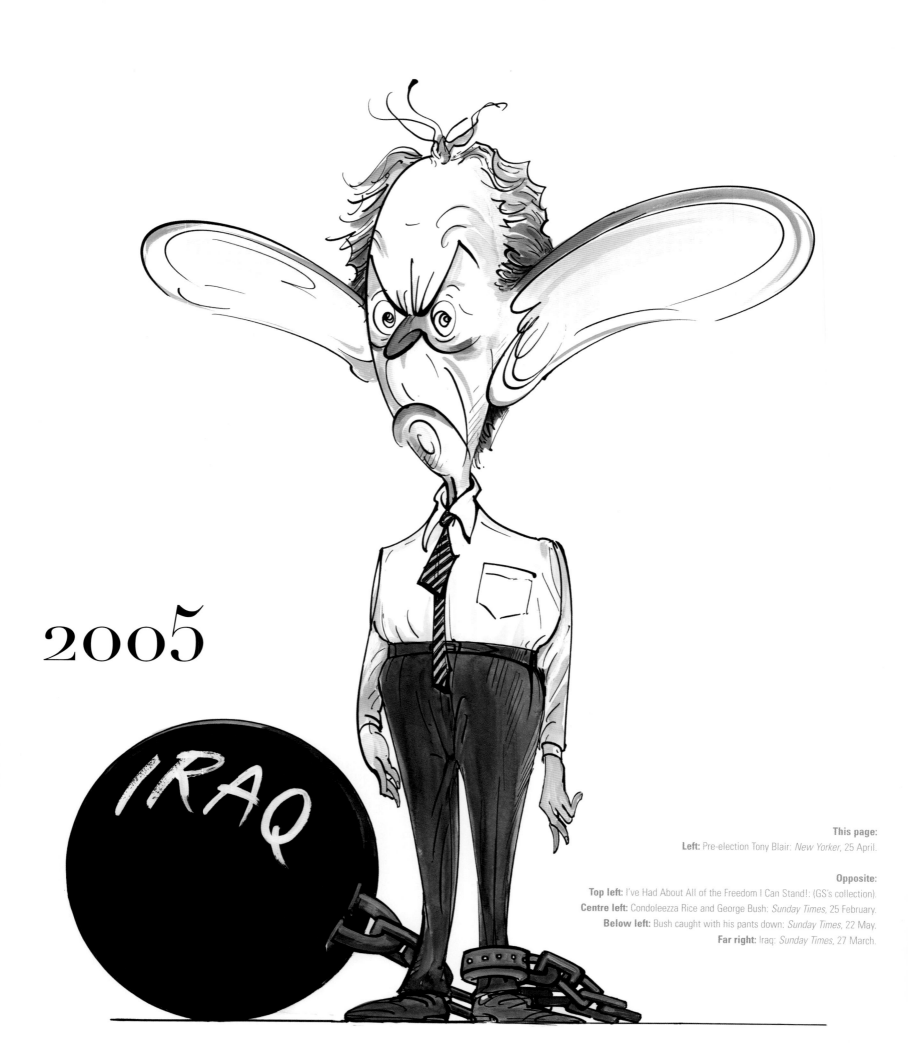

IRAQ

This page:
Left: Pre-election Tony Blair: *New Yorker*, 25 April.

Opposite:
Top left: I've Had About All of the Freedom I Can Stand!: (GS's collection).
Centre left: Condoleezza Rice and George Bush: *Sunday Times*, 25 February.
Below left: Bush caught with his pants down: *Sunday Times*, 22 May.
Far right: Iraq: *Sunday Times*, 27 March.

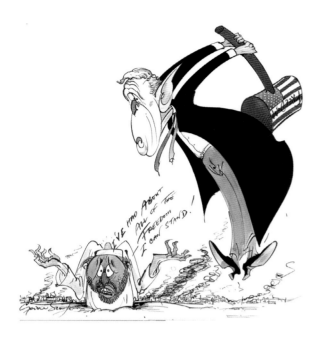

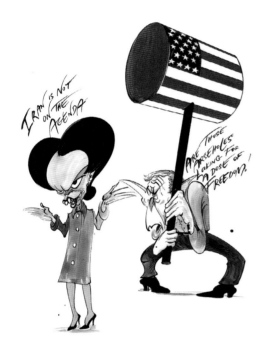

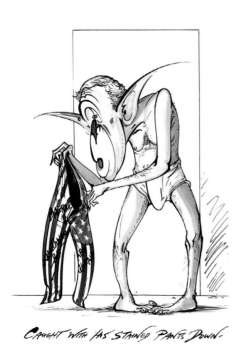

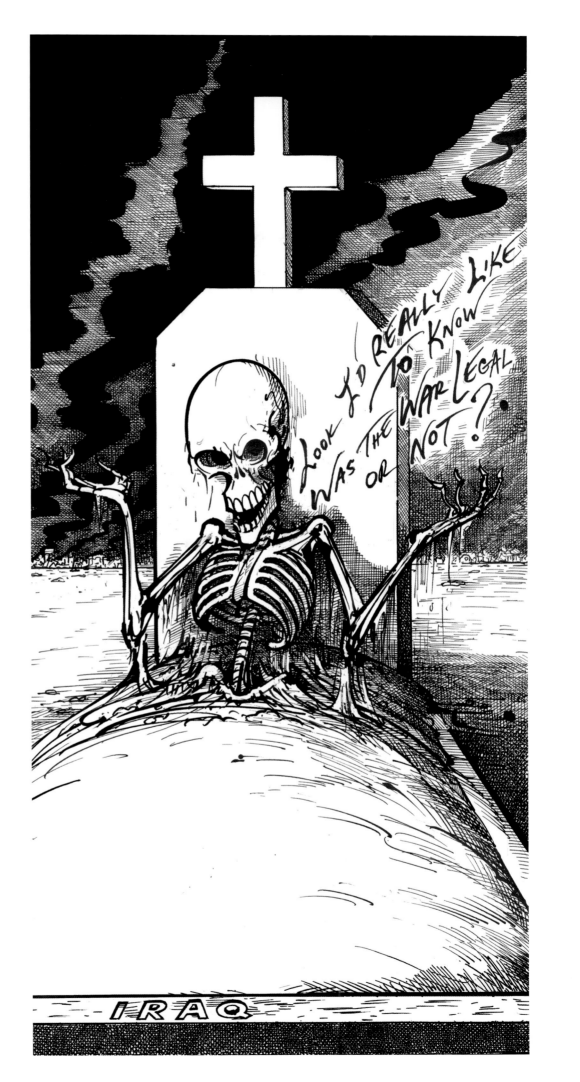

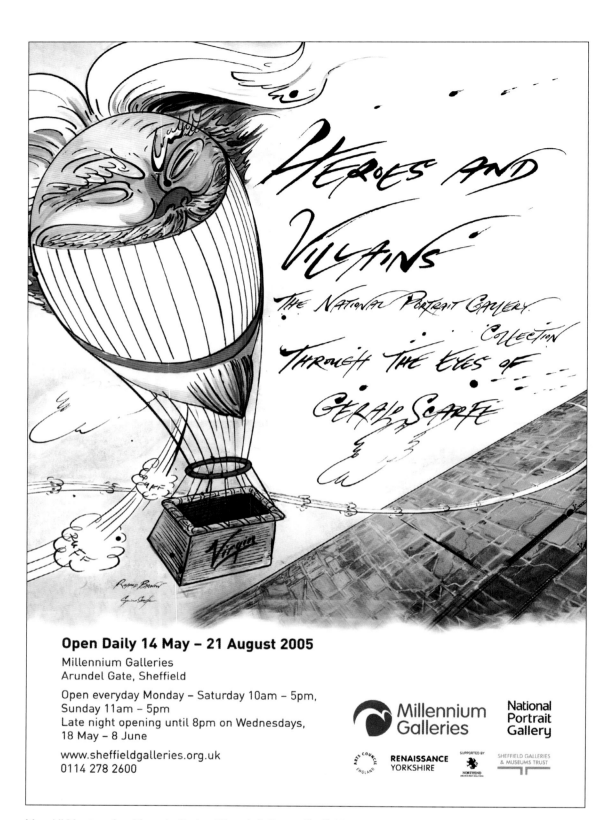

My exhibition transferred from the National Portrait Gallery to Sheffield, and on this occasion my drawings
were shown alongside famous portraits from the NPG.

Above: The poster for *Heroes & Villains*, Sheffield.

Right: Chirac's Coq Up – the day the French delivered a gigantic 'NON' to Europe: *Sunday Times*, 29 May.

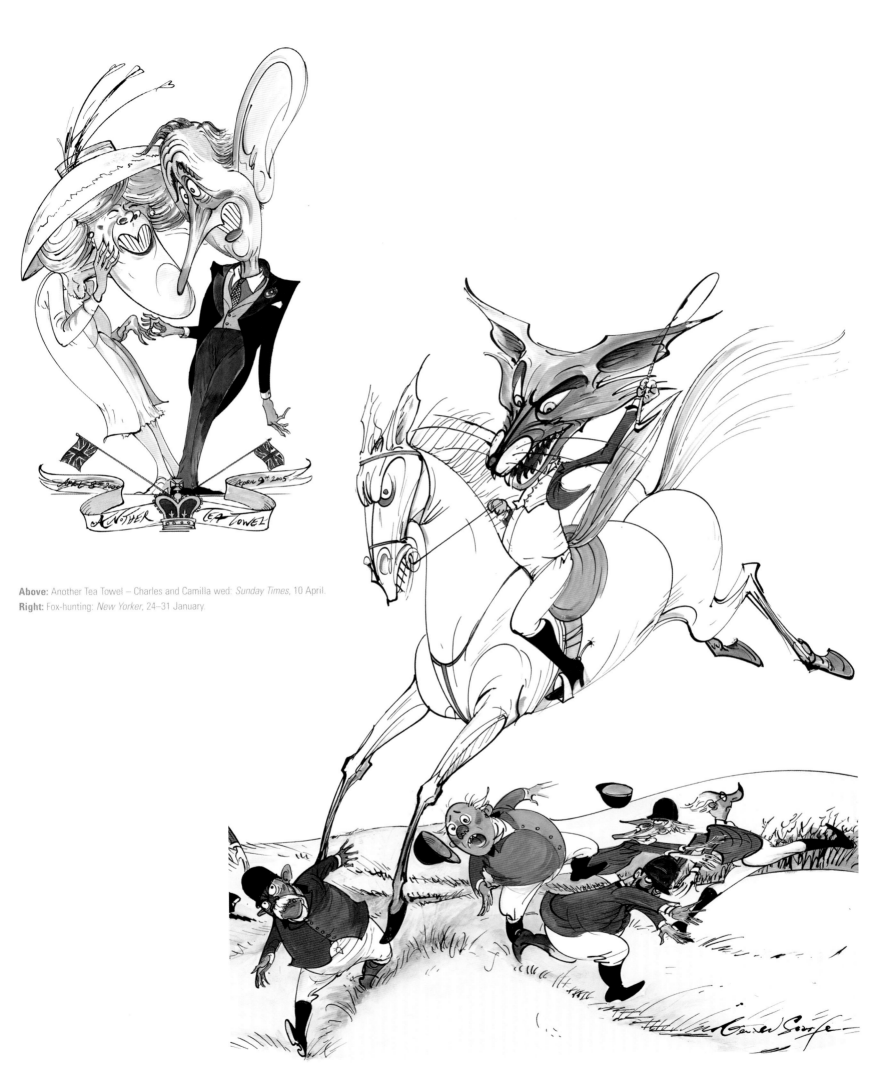

Above: Another Tea Towel – Charles and Camilla wed: *Sunday Times*, 10 April.
Right: Fox-hunting: *New Yorker*, 24–31 January.

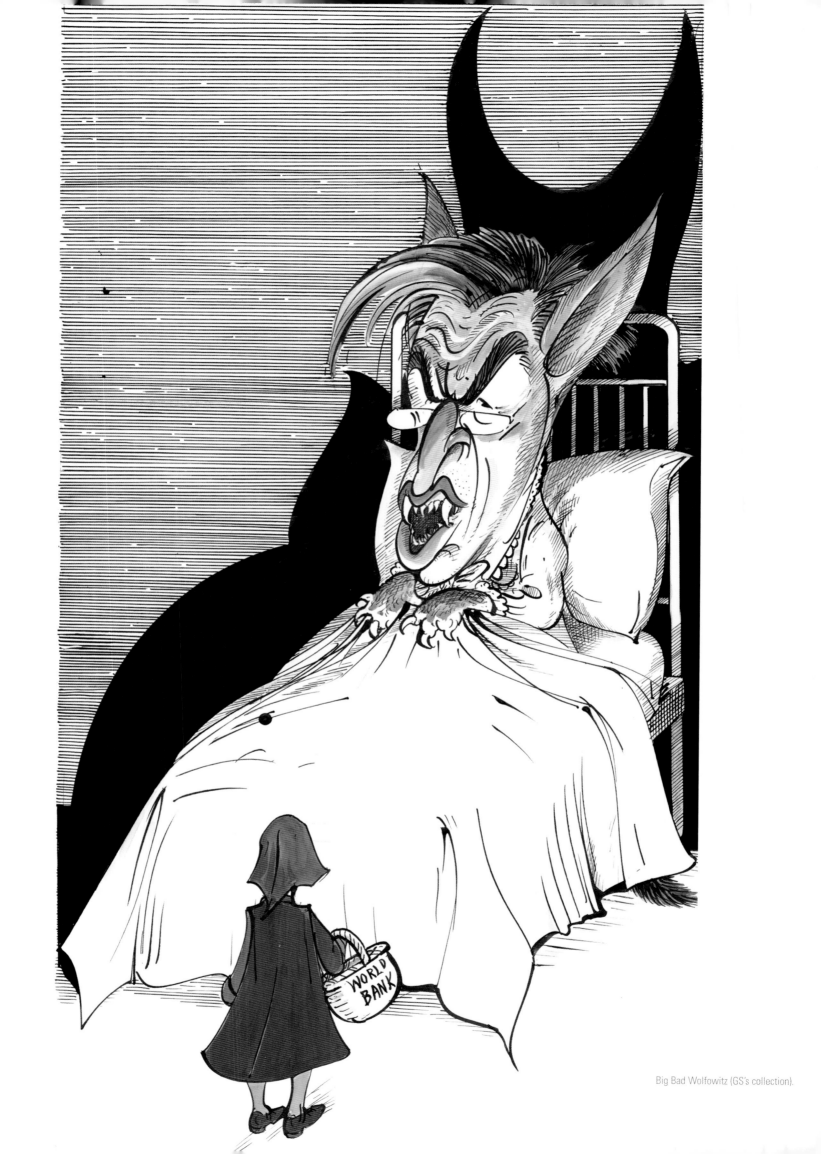

Big Bad Wolfowitz (GS's collection).

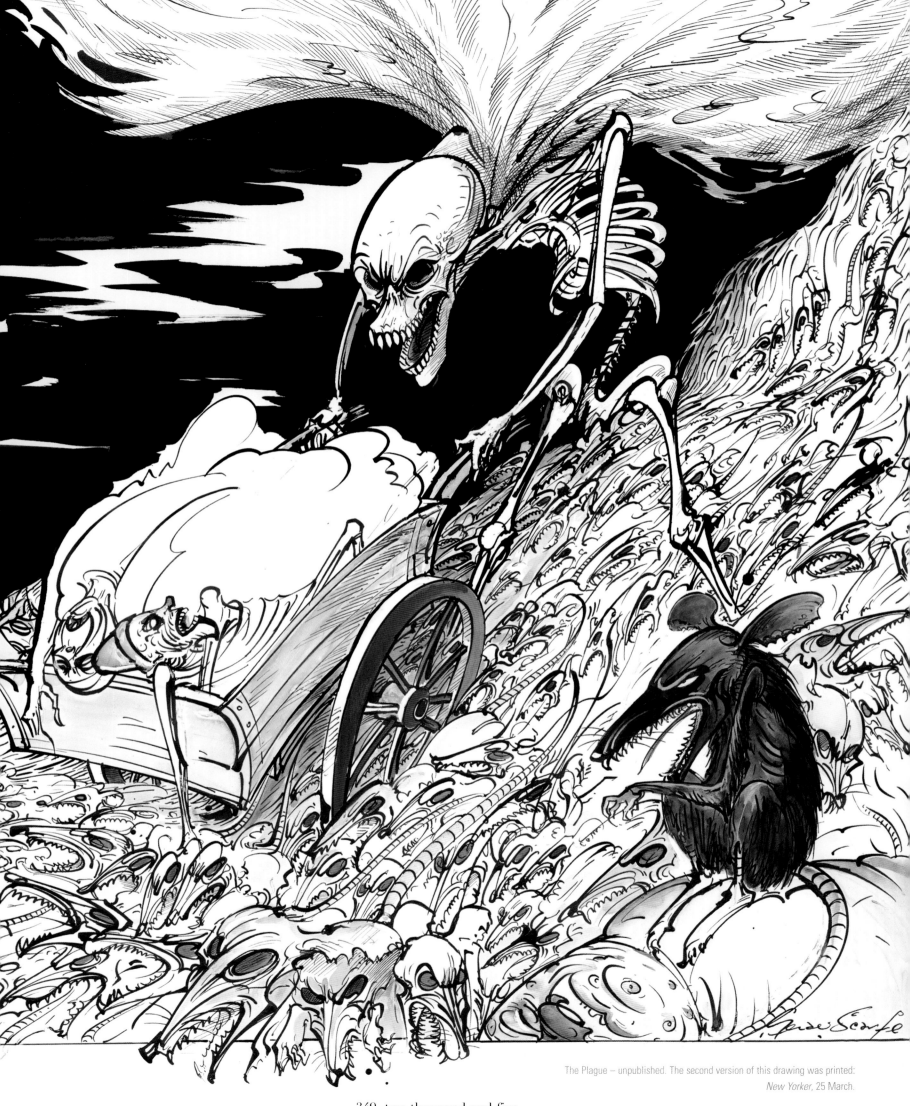

The Plague – unpublished. The second version of this drawing was printed:
New Yorker, 25 March.

349 two thousand and five

To Be Continued

My enormous thanks to:

Julie Davies, who scanned and helped collate the majority of this book

Vin Burnham, for organising and making my sculptures, models and costumes over many years

And to the following for their encouragement and professional support, the results of which appear in the preceding pages:

Tony Banks, John Berger, Melvyn Bragg, Jill Brooks, Louise Brooks, Tina Brown, Ron Clements, Vanessa Courtney, Richard Curtis, Chris Curry, Liccy Dahl, Alice Dewey, Walt Disney animators, Geoff Dunbar, Craig Dodd, English National Ballet Costume and Scenery Department, English National Opera Costume and Scenery Department, Ali Enyon, Harold Evans, Robin Gibson, David Gilmour, Sally George, Steven Gregory, Peter Hall, Simon Jenkins, Katie Lander, Los Angeles Opera Costume and Scenery Department, Niki Lyons, Cameron Mackintosh, Kenneth Mahood, Manchester Royal Exchange Costume and Scenery Department, Nick Mason, Day Murch, John Musker, Sandy Nairne, Pink Floyd animators, Owen Phillips, David Pountney, David Remnick, Leslie Richardson, Tony Rushton, Charles Saumarez Smith, Gordon Scarfe, Ray Scott, Christopher Sinclair-Stevenson, Matz Skoog, Brian 'Smiffy' Smith, Mike Stuart, Donald Sturrock, Alan Thomson, Traverse Theatre Costume and Scenery Department, Anthony Wall, Roger Waters, Marcia Williams, John Witherow, Alan Yentob

FOR THE USE OF THEIR PHOTOGRAPHS: David Bailey, Dee Conway, Patrick Eagar, Mark Harrison, Richard Holttum, Lord Snowdon, Brian Wharton

TO THOSE WHOSE WORDS ARE QUOTED: John Berger, Paul Griffiths, Paul Grinke, George Melly, John Musker, Tom Schumacher, Ken Wlaschin

FOR WORK APPEARING IN: *Daily Express, Daily Mail, Daily Mirror, Daily Telegraph, Encounter, Esquire, Independent on Sunday, Ink* magazine, *New Statesman, New Yorker, Private Eye, Punch, Sunday Times, Sunday Times* colour magazine, *Swill* magazine, *Talk* magazine, *Time* magazine, *Vanity Fair, Vogue*

FOR EXTRACTS FROM FILMS (WRITTEN & DIRECTED BY GS): *Will the Real Mr Hogarth Please Stand Up* – BBC *Omnibus, Scarfe by Scarfe* – BBC *Arena, I Like the Girls That Do* – BBC2 – *40 Minutes, Scarfe's Follies* – BBC2 – *40 Minutes, Scarfe on Sex* – BBC2, *Scarfe on Class* – BBC2, *Scarfe on Art* – BBC2, *Scarfe in Paradise* – BBC2

FILMS ABOUT SCARFE: *I Think I See Violence All Around Me* – BBC *Omnibus, Scarfe Meets Disney* – ITV *The South Bank Show, Drawing Blood* – BBC2/BBC4

THANKS TO THE FOLLOWING GALLERIES: The Grosvenor Gallery, London, Museum of Moving Image, London, National Portrait Gallery, London, Sears Vincent Price Gallery, Chicago, Tate Gallery, London, The Waddell Gallery, New York

FOR THEIR HELP AND SUPPORT WITH THIS BOOK: David Costa, Stephen Guise, Ursula Mackenzie, Philip Parr, Sian Rance, Viv Redman, Nick Ross, Tim Whiting

All Walt Disney works are the property of Walt Disney,

Special thanks, as always, to my wife Jane

UNCENSORED

WISH YOU WERE HERE

MR. FOX BEGGARS OPERA

THE NEW YORKER

REPORTAGE EXPLETIVE

WAR REPORTER ST. LONG

SENT TO COVENTRY THE

SCARE BY SCARE

ALBUM

FILMING TIME